BLACK AND WHITE
DIGITAL PHOTOGRAPHY
PHOTO WORKSHOP

Chris Bucher

WILEY

Wiley Publishing, Inc.

Black and White Digital Photography Photo Workshop

Published by
Wiley Publishing, Inc.
10475 Crosspoint Boulevard
Indianapolis, IN 46256
www.wiley.com

ISBN: 978-0-470-42193-2

Manufactured in the United States of America

10 9 8 7 6 5 4 3 2 1

For general information on our other products and services or to obtain technical support, please contact our Customer Care Department within the U.S. at (877) 762-2974, outside the U.S. at (317) 572-3993 or fax (317) 572-4002.

Wiley also publishes its books in a variety of electronic formats. Some content that appears in print may not be available in electronic books.

Library of Congress Control Number: 2011924134

About the Author

Chris Bucher is an award-winning, Indianapolis-based photographer and author whose work, assignments, and clients are extremely diverse. Chris has editorial and commercial photo projects across the country, and he takes every opportunity to return to the deserts of the Southwest, where his fascination with natural light is fueled by the harsh but striking landscapes. His artwork has appeared in shows, galleries, and museums throughout the country and overseas. When not behind the camera, Chris enjoys mountain biking and serving the Humane Society of Indianapolis as a foster parent.

Credits

Acquisitions Editor
Courtney Allen

Project Editor
Chris Wolfgang

Technical Editor
Haje Jan Kamp

Copy Editor
Lauren Kennedy

Editorial Director
Robyn Siesky

Business Manager
Amy Knies

Senior Marketing Manager
Sandy Smith

Vice President and Executive Group Publisher
Richard Swadley

Vice President and Executive Publisher
Barry Pruett

Project Coordinator
Patrick Redmond

Graphics and Production Specialists
Jennifer Henry
Andrea Hornberger
Jennifer Mayberry

Quality Control Technician
Robert Springer

Proofreading and Indexing
Laura Bowman
Infodex Indexing Services, Inc.

Acknowledgments

So many talented people have added their time and expertise to make this book a success. Thanks to Courtney, Rayna, Haje, Kristin, and Lauren for working so hard to help me achieve my vision for this book, and for the opportunity to work together on such a great project. Also, a special thanks to Chris Wolfgang for her hard work, determination, and meticulous editing. She made the best of my words.

Thanks to Lamar Richcreek at the Herron School of Art for helping me get back into the black-and-white darkroom where I rediscovered my artistic passion and vision. The amount of help and good photo conversation that I get from good friend and assistant Kenneth Rhem is always appreciated. I also want to thank my two interns, Nicole Fraga and Justin Jett, for all of their help, especially when the projects weren't particularly fun or interesting; they were both immensely helpful in making sure these projects happen on time.

I will be forever indebted to Coach Pat, Tevin, Dajon, Denzell, Cody, and Dewayne for letting me into their lives for a while and showing me what can come of great passion and focus.

Most important, thanks to my wife and partner Jennifer for the encouragement, for crafting new ideas, and for working with me on a million different things at once.

For my mom, Lee Bucher

Contents

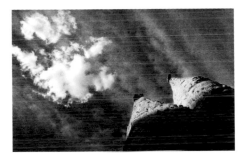

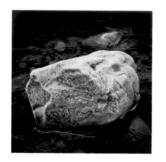

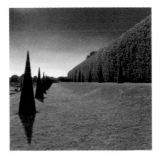

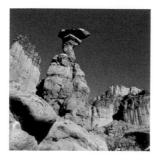

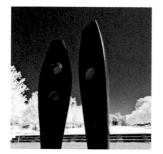

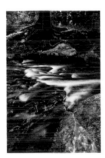

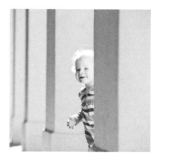

CHAPTER **9** Toning, Coloring, and Special effects 229

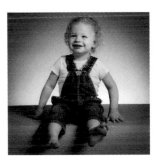

Introduction

Now that digital cameras are just called cameras, and film can be the added modifier, some might think that black-and-white photography is passé and no longer of interest, but that couldn't be further from the truth. There has actually been a revitalization of black-and-white imagery because there are so many options for creating new visions in black-and-white photography.

From the many monochrome options now onboard any digital camera to the black-and-white photo apps for today's camera phones, opportunities for black-and-white images are all around us. The ability to create fantastic black-and-white images is right there in every digital image that is taken (even when taken in color).

It wasn't too long ago that as a budding photographer, I put together a makeshift darkroom in my studio apartment. With an enlarger in the closet, chemistry trays perched across the sink and commode, and the shower to wash the prints, I attempted to create my own black-and-white masterpieces of the deserts in the Southwest. Those bathroom prints were mediocre at best, but it fueled my passion to become a photographer and to build on what I learned about black-and-white photography in that makeshift darkroom.

The advent of digital black-and-white photography opens all types of creative doors. By moving a slider or clicking a button, you can affect exposure, contrast, and tone greatly or subtly, and get immediate feedback. The learning curve is often greatly shortened, as is the amount of time it takes to create a masterpiece. Don't hesitate to spend a few extra moments to push the envelope a bit more to create something that you couldn't have even imagined a few minutes before.

This book looks at many different avenues of black-and-white photography in the digital world. The book focuses on how to expand your black-and-white vision and the creative options that digital black and white affords you. There are discussions on how to handle different effects and options using various image-editing programs; even if you don't use one particular program for all your editing, the theories hold true from one program to another with minor differences.

While there are people who simply push the black-and-white button on their cameras and have done with it, there are plenty of photographers out there who are constantly trying to create better black-and-white photos. This book is for those of you who know that your inner Ansel Adams or Richard Avedon is just ready to break out. The examples in this book show you that there is a great black-and-white photographer in every one of you if you just try a few new things; and that while there are so many avenues to take, one of them will make sense for you depending on your thought process and how you look for a solution.

My hope is that this book will push you to create your own black-and-white masterpieces as you learn to think critically about your own work, and to recognize the opportunities around you. While plenty of photographic and computer techniques are discussed, the book is not a technical manual documenting every step of the digital-imaging process. Photography should be fun, so use the directions, and examples of the imagery, to create the photographs that you want.

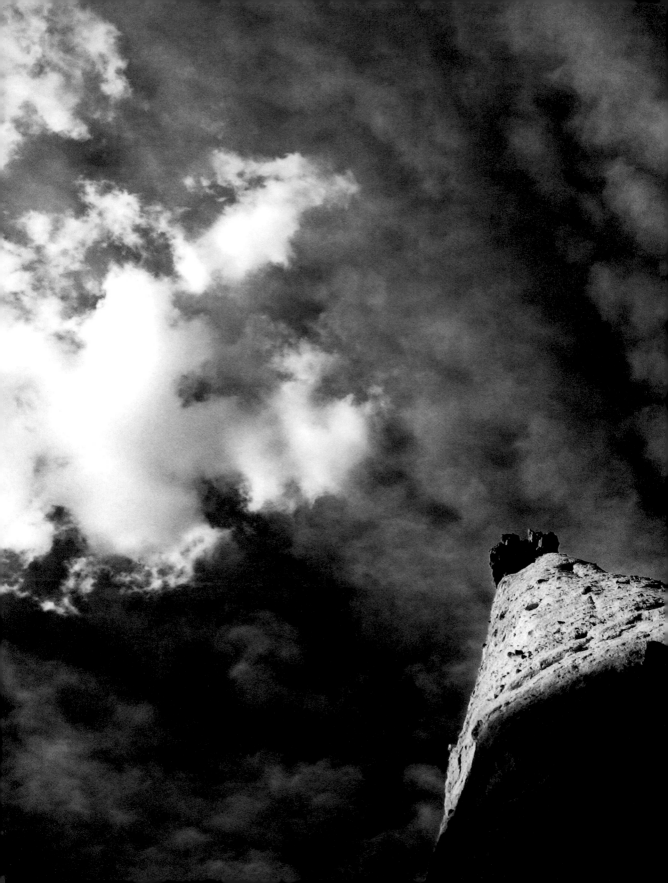

BLACK-AND-WHITE VISION

In this age of multimedia, moving pictures, over-saturated colors, and digital speed, the desire to create good black-and-white images remains as great as ever. Whether it is the allure of distinct graphic lines, nostalgia, or the simplicity of the contrast (see 1-1), people continue to be drawn to black and white.

Even though you can simply and easily convert any digital image to black and white right there in the camera, that may not always be the best option. It's important to first take a critical look at black-and-white images to see what makes them work, and why people can be more drawn to them than to color images.

WHY BLACK AND WHITE?

When I was explaining the title of this book and its creation to a friend of mine who knows nothing about photography, he asked, "People still take black-and-white pictures?"

I reminded him of the black-and-white portrait I shot of his family hanging over his mantle. Not only do people still take black-and-white pictures, but these photos are all around us — they are still very much part of our culture and everyday lives.

Although there are many different types of photography, black-and-white photography is usually considered the classic form, the birthplace of

1-1

ABOUT THIS PHOTO *This swimming pool at an old hotel had interesting shapes, lines, texture, and tones, which made me want to create a black-and-white image. Taken at ISO 400, f/7.1, and 1/40 second.*

photography. However, today black and white can be used for much more than just fine art photography or Ansel Adams–type landscapes. In fact, it is one of the most prolific tools a photographer can use to realize his creative vision. Without going overboard on art-speak, black and white can make a mediocre image more dynamic, as shown in 1-2.

Removing color from an image enables the viewer to see the essential parts of that image — the textures, tones, shapes, and composition — all without the distraction of color. There is a

visceral connection between a viewer and a black-and-white photograph that does not exist with color photography. While color creates its own excitement and emotion, it can also add unwanted distraction, as was the case in 1-3.

Black-and-white photographs are limited (but not in a bad way) to gray tones. As a result, the voice of the image can become greater as the focus becomes clearer. Black-and-white images can also create not only a feeling of nostalgia, but also of pastoral or timeless beauty. This holds true for many different sorts of images, but especially for landscapes and portraits.

Whether a color photograph has been painstakingly color corrected to exactly match the original scene or is very stylized, it is based on reality. Black-and-white images, on the other hand, are based in the creative process. The creative choices regarding the tone and emotion of a black-and-white photograph are there for the photographer to make right from the start, and the possibilities are limitless.

There is really only so much saturation and manipulation possible with a color photograph. The limits on color-photo manipulation are not only part of today's digital photographic rules, but exceeding these limitations often creates unattractive or incorrect images, because they no longer appear realistic. However, when extreme saturation and manipulation are applied to black-and-white images, they can still look correct. The practice of using extreme dark and light tones in black-and-white images existed long before digital photography, and the photographer's artistic freedom has always been built into shooting in black and white.

There is really only so much saturation and manipulation possible with a color photograph. There are limits to the amount of saturation and contrast that can be added to a color photograph before the

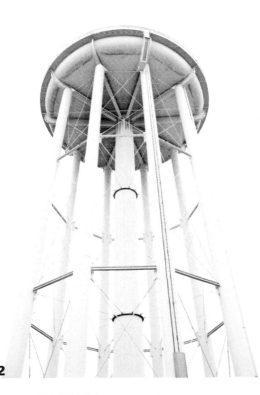

1-2

ABOUT THIS PHOTO *The lines and shape of the water tower create interesting contrast with layers of white on white. Taken at ISO 500, f/4.5, and 1/125 second with an 18-200mm zoom lens.*

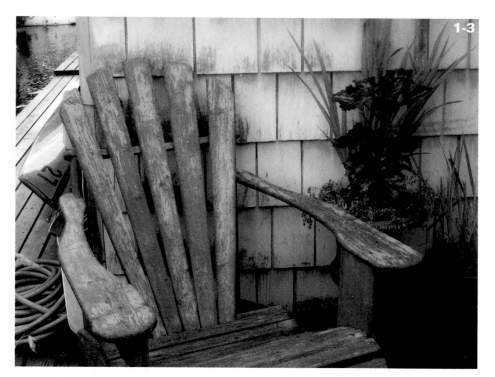

ABOUT THIS PHOTO
A red chair in front of a blue house with a yellow boat and green hose in the background create a visual mess, but in black and white, the texture of the scene creates the mood. Taken at ISO 200, f/4, and 1/200 second with a compact digital camera.

image can becomes incorrect, or worse, unattractive. These limits are due to two things: what is visually possible and realistic, and the *color gamut* of the image. The color gamut is the level of potential color in a digital image that can be reproduced, whether the output is on a screen or on paper.

However, when extreme contrast and manipulation are applied to black-and-white images, they can still look correct. The practice of using extreme dark and light tones in black-and-white images existed long before digital photography, and the photographer's artistic freedom has always been built into shooting in black and white.

CREATING BLACK-AND-WHITE IMAGES

With digital photography, the ability to create great black-and-white images, as well as the available creative options, has increased greatly from

the days of the wet darkroom. There may be purists who still embrace the hours in front of an enlarger and a sink, the chemicals, and the whole process of creating a black-and-white print from a negative, but I find there are so many more options with digital photography that I struggle to return to the wet darkroom.

Furthermore, I create more (and better) black-and-white imagery with digital technology than I ever did in the darkroom. Perhaps the single greatest option with digital photography is that you can create color and black-and-white images from the same digital file.

There are countless advantages to creating black-and-white photos digitally. One is the ability to change a digital image from color to black and white, or vice versa. It only takes a second to switch the camera so it creates a black-and-white, rather than color, JPEG. To get the best results, convert a RAW color image to black and white

on the computer. This doesn't slow you down at all while you are shooting. You can shoot away in color and make your decisions later (see 1-4). The days of carrying multiple cameras or film backs, each with a different type of film, are thankfully long gone.

The technical part of creating a black-and-white photograph from a color digital file might seem easy — just use the Picture Styles menu or Picture Contol menu to set the camera to black and white and off you go. However, I find that a lot more goes into creating good black-and-white photographs. Simply taking the color out of the image is not the only issue. Black-and-white photography has a lot more to do with contrast than a mere lack of color. Without color in an image, contrast is what creates depth and texture and accentuates the subject of the photograph.

VISUALIZING IN MONOCHROME

The act of visualizing a photograph is something you must do not with your eyes, but with your mind. I discuss some techniques to help you with visualization later in this book, but first, ask yourself what sort of photograph you want to create. What is the emotion or feeling that you want to present to the viewer? Should it be somber or

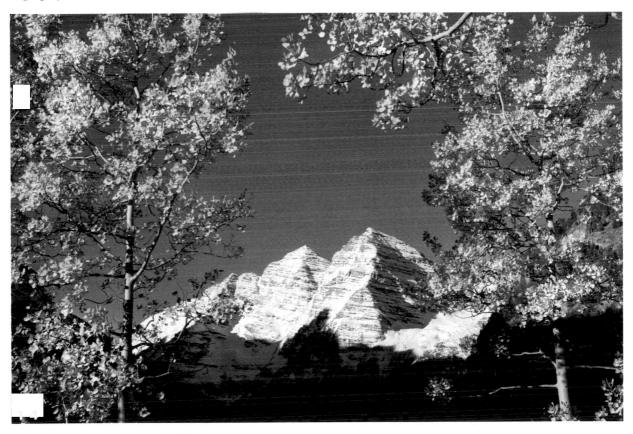

ABOUT THIS PHOTO *Aspen leaves turning yellow on a crisp morning make for an amazing color image, and a brilliant black-and-white. The conversion to black and white happened after the shot was made, and could never have happened with film. Taken at ISO 200, f/11, and 1/500 second.*

airy, delicate or melancholy, exciting or bright? The possible ways these can be expressed in black-and-white images are limitless.

Some people, such as great landscape photographer Ansel Adams, have called this thought process *previsualization*. It entails attempting to see the image in your mind's eye and imagining what emotions or feelings the image will evoke before the exposure is ever created.

The world does not appear in black and white. Everyday color images oversaturate our senses in an attempt to tell us what we need. Vegetables in the grocery store are covered with wax to make them more colorful and desirable. The television and Internet are chock-full of ever brighter, ever more colorful images to get our attention. However, sometimes less is more, and it is in those instances that black-and-white images become even more powerful.

The amount of contrast in an image is what builds the composition; how the contrast is applied to the scene builds the emotional tone of the photograph. On a misty, overcast day, a low level of contrast with more dark tones accentuates the feeling of the weather that is in the scene (see 1-5).

Begin to look more at shapes, textures, and forms rather than color in potential images. Study how the contrast within those elements enhances the image. Although you will likely change the final tones and fine-tune the image later on your computer, it helps to try to look at the composition critically, examining the contrast of the tones in the scene. For example, a bright expanse of green grass or a light blue sky look great in color, whereas the same elements in a black-and-white photo often end up as a vast expanse of light gray.

Think critically about your vision of the photograph and work toward creating the emotion you want a viewer to experience. This does not mean

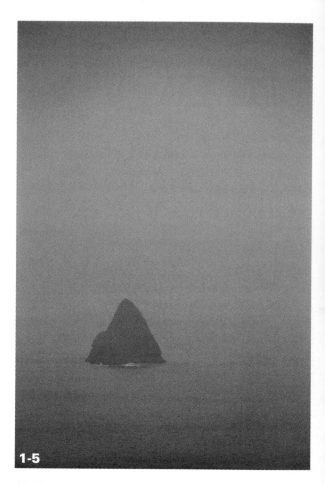

1-5

ABOUT THIS PHOTO *To accentuate the weather and show the overall tone of the image, I underexposed the image and then increased the contrast slightly to make the dark rock stand out from the gray. Taken at ISO 320, f/7.1, and 1/320 second with an 18-200mm lens set to 200.*

you should only photograph dramatic, moody, or exciting images. Just as much effort goes into a softly lit scene, or a stark, austere one. Each has its place, and it is up to you to create the image for the viewer.

Without the color information, the contrast of a scene becomes even more important. This doesn't mean that high-contrast images are better in black and white, but being mindful of the contrast in an image will help make the photograph better. In some cases, scenes with a lot of hard

blacks and whites (that is, high contrast) will be exactly what is needed, whereas in others, subtle changes of gray (that is, images with virtually no highlights or deep shadows) may be perfect.

SELECTING YOUR IMAGES

If you have been photographing in color for a long time, it may be a challenge to start viewing the scenes in front of your camera in black and white. As you move to shooting in black and white, you gain a new level of attention to the contrast and form in an image.

> **tip**
>
> You often come across subjects that are monochromatic — that is, scenes with only one or minimal color. Stones, concrete, and steel can all create monochrome-like images while still being a full-color photograph. Studying such scenes can help you easily visualize what it might look like in black and white.

CREATING PHOTOGRAPHS

Think more critically about the scenes in front of you, and truly imagine what the image will look like as a finished work. Remember that your vision is exclusive to you in your individual place and time, so create photographs that are interesting and compelling to you.

Being passionate about what you want to create will help you select the right image to shoot. This may mean that you need to create an entirely new vision of how you like to photograph, what the subject matter will be, and the style with which you shoot. Listen to your instincts about how to proceed. Look at photographs that inspire you. The idea is not to emulate these images, but to gain inspiration — see what makes them important or interesting and how they inspire you to create better images.

Try an entirely new style of photography to help build your black-and-white vision. If you have mostly enjoyed landscape photography, start creating portraits. If you have always photographed still lifes, get out and capture what is going on in the street. Shooting in black and white allows you to rethink the possibilities of your photography. When you have started seeing the world anew in black and white, returning to where you were will be even more exciting.

Use the rules of design (discussed further in Chapter 2) to create good composition in photographs. Learn to use the tools in your camera to create great exposure. Once you learn the proper exposure for each scene and good compositional rules, you will feel comfortable breaking those rules and experimenting with new things. This helps build your personal vision.

PREVISUALIZATION

Take the time to look around you at shapes, textures, tones, and the contrast between them. As I write this, I see the repetition of my neighbor's white fence against a dark shadowed lawn and accordion blinds with glowing light tones between alternating white and dark lines. Use these common things in your everyday view to help you previsualize how those things will look in your black-and-white photography.

It is often a great idea to stop where you are, evaluate the scene in front of you, and really see if that is the image you are trying to create. Take a moment to think, "What if …" and go beyond what might be considered normal. This could mean making a compositional or exposure change.

Sometimes you'll make a change, say, "Yikes," and quickly revert to where you were. However, other times there will be a breakthrough, and you will have created an image beyond what you

imagined. Going forward, apply these ideas to your photography. They can be useful tools for building your photographic vision.

While photographing a group of boxers, I spent a bit of time working to get technically good images in challenging situations. There were plenty of images that I was happy with that were interesting enough to share and display, but it seemed as though I needed to add some interest or (more likely) soul. So, I tried something totally new: I simply slowed down the shutter speed and started to recompose a little bit. I realized that I wasn't shooting reportage. I was trying to create art from violence and I needed to show more of that movement and motion (see 1-6).

As soon as I started trying a few new things, the imagery changed into exactly what I had intended to shoot from the beginning. I had a purpose and a vision, and I was taking good photographs. However, it wasn't until I connected with my vision that the images came into their own.

But it takes more than just trial and error.

A few years ago, I had the opportunity to interview legendary photographer Pete Turner, who is best known for pioneering the bold use of color. One thing he said was appropriate to any genre of photography: "Go out to photograph with a purpose. Have an image in your head and a plan to create it before you leave the house. If you just go

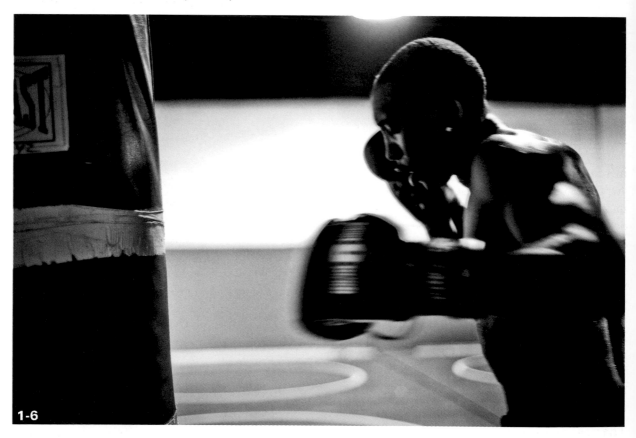

1-6

ABOUT THIS PHOTO *By slowing down the shutter speed to capture the motion of the boxing glove, I was able to create an image that captured the feeling I had envisioned. Taken at ISO 1000, f/1.8, and 1/80 second with a 50mm lens.*

with the idea that you're 'going to take a great photo today,' your photographs will be as aimless as your plan. If you have a plan and a new opportunity arises because you were prepared for something, you are much more likely to have great images."

Even if you are simply making photographs at a family event or during a photo-walk, think ahead and envision those photographs. This gives you a purpose and the focus to create the images you desire. Make sure that your eyes are open to opportunity; when chances for new photographs come to you, take advantage of them.

In black-and-white photography, your selection of images should reflect your ability to see contrast in the scene; for example, the way that light wraps around a subject, or the simplicity of a single subject against a stark background. As you practice seeing and shooting in black and white, the subjects that work best for your photography will become more obvious.

THE PROBLEM WITH DIGITAL

It cannot be disputed that the digital camera is a great teaching tool. Immediately after it's shot, the image and the information used to make it appears on-screen so that you can correct your mistakes — or at the very least review what you did.

However, digital photography also introduces issues of volume and management. I often remind photography students that, not that long ago, they would have been shooting with film and having to keep track of every exposure, meter reading, focal length, and weather conditions. Now, virtually all of that information is attached to the photograph in its *metadata* so that it is easy to get and learn from.

The volume and management issues come in when a photographer fills an entire memory card with photographs she doesn't really care about.

Try to think through the photograph before you make it and then create an image that is compelling to you. This way, your enthusiasm and passion for the image will not only come more easily but will show in the photographs.

Although the term *taking photographs* is common, and I even use it quite a bit in this book, I believe that there is a difference between taking photos and making photographs. If you are reading this book, or any of the *Photo Workshop* titles, chances are you are probably attempting to make photographs with your own creative tools.

Work at creating new images that you love, rather than just taking a bunch of photos. In the end, if you aren't excited about the images you have created, you'll just fill up your hard drive with images that you won't ever learn from.

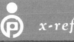

x-ref

More thoughts on being comfortable with your camera and its settings are discussed in Chapter 4.

TIMING THE MOMENT

Photographers such as Robert Doisneau and Henri Cartier-Bresson were masters of real-life reportage and street photography. Their photographs are classic examples of timing the shot to capture a precise moment just as it happens. Cartier-Bresson coined the term *decisive moment*, which describes the precise moment that the pivotal action occurs in any event. This event could be anything from a fleeting glance or a stolen kiss, to the moment the running back crosses into the end zone.

Cartier-Bresson describes the decisive moment as the "creative fraction of a second when you are taking a picture. Your eye must see a composition or an expression that life itself offers you, and you must know with intuition when to click the

camera. That is the moment the photographer is creative." He then goes on to explain that if the moment is missed, it is gone forever. This process and this timing is what can separate a good from a great photograph.

HURRY UP AND WAIT

Timing the moment takes practice in many ways. The first thing you need to have is familiarity with the equipment that you are using. It is vital that you know how your camera works — that you are comfortable with the controls and settings, so you are ready to shoot when the moment is upon you. Being ready is the first step, but having the patience to wait for the right time is of equal importance.

Good timing takes a quick eye on the scene. While you are walking through the city, you might see an interesting background.

In the case of 1-7, I saw that a couple was approaching my scene as they were on their way home from the market having a conversation. I quickly framed my composition and waited until they were where I thought they should be for the composition I had in mind. Just as they were in place, the man turned to listen to the woman, and that was the decisive moment — the moment I was looking for. I took a few more frames as they walked away, but at that point I had the image I had envisioned. The rest of the images were inconsequential, as the couple was too far away and I had only captured photos of the backs of their heads.

Many new digital cameras have motor drives that can capture so many images in such a short time, it seems impossible. There are digital cameras that capture four, five, six, or even up to 11 frames in one second. That capability is fantastic

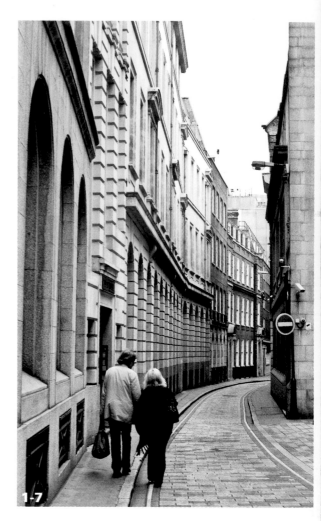

1-7

ABOUT THIS PHOTO *Because I composed before the subjects entered the scene, it took only patience and timing to capture the decisive moment. Taken at ISO 200, f/5.6, and 1/125 second with a 14-45mm m4/3 zoom lens set to 29.*

for sports or action photos, when you are looking for series of images or when the speed of the subject is too fast for you to be certain of capturing the correct frame with one click.

Many sports photographers and photojournalists take advantage of camera speeds like that; and it may be helpful for you to do so in many

photographic situations, so make sure to time even those brief bursts of images well. Be ready by having your camera set to its highest frame rate, usually designated by an icon with multiple rectangles or something that indicates *continuous high*. In addition, setting your camera to *continuous autofocus* is a must when capturing a quickly moving subject.

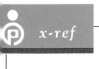

x-ref More thoughts on setting up your camera for high-speed photography are discussed in Chapter 4.

Next, you have to compose the image, and make sure the exposure settings are correct. Only after you have those things ready can you sit with your eye pressed to the viewfinder and wait for the action to come in front of your lens. Keep in mind that there are often photographic moments between those frames, and the autofocus cannot always keep up with the speed of high-speed capture.

As you can see there's a lot more to timing the decisive moment with high-speed continuous drive than just smashing down on the shutter button. Even with all of that speed, knowing the sport, the event, the athletes, and how the action flows is a much better way to time the images. It is imperative to know the subject matter and how the action tends to work so you can try to predict what will happen next.

Even though the camera was set to the highest speed continuous frame rate — that is, nine frames per second— the image in 1-8 was captured because of the attention paid to the boxers and how they were performing up to a single moment. Just as a flurry of quick jabs to the

body may wear down an opponent but a big roundhouse to the head wins the match, several frames taken in a series may make for some nice images, but it is the one that is perfectly timed that captures the emotion and vision of the event. With practice and patience, you learn to pay close attention to a scene and be ready for that moment that defines the creative process.

Timing the moment still comes into play with landscape photography. Although the precision of the timing might be slightly less critical, being in the right place at the right time is very important.

The sun moves quickly (well, the earth spins quickly), and that movement is shown by the sun appearing to cross the sky. If you take a moment to see some sunlight coming through a window and mark where shadows hit, it is a very short time before the shadows change. Compared to the speed of a camera's shutter, the light's movement may not appear to be very fast, but in just a few minutes, the shadows will move a few inches.

Getting this timing right can be tricky. If the sun is waning towards the horizon, it may seem like the sunlight you desired was only there for a precious few seconds. With such fleeting moments, it is imperative that you have your camera ready (double-check that the right lens is on or at least in your bag), and that a memory card with ample space, and any other accessories, such as filters or tripods, are on hand.

Those long shadows and warm sunlight at sunset help create very dark blue skies, which, in black-and-white images, appear as dark gray or black. The contrast between the light hitting the landscape and a dark gray sky is very dramatic in black-and-white photography. As the light moves closer

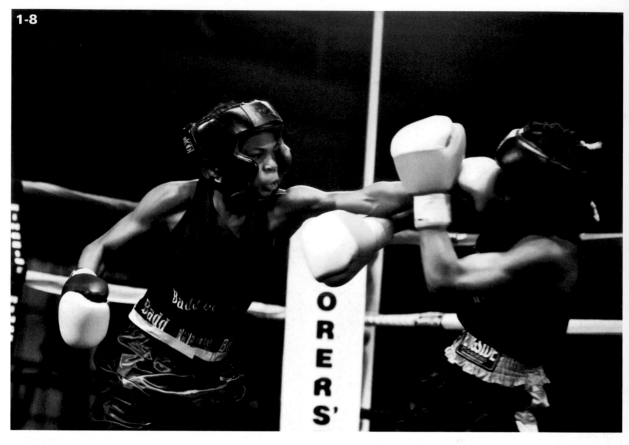

1-8

to the horizon, the contrast slightly lessens as it becomes slightly diffused, adding texture to the rocks as the light comes across the scene (see 1-9).

> **note** Is the theme of preparation starting to hit home yet? It is something you will hear about time and again, both in this book and whenever you are talking to serious photographers. Most views on the importance of being prepared are based on experience and mistakes made in the field.

Days with clouds have their own timing issues. The beauty of a blue sky with bright, white puffy clouds is really fantastic, and makes for, perhaps, the most dramatic looking skies in black and white. The contrast between those white clouds

and the dark gray or black sky is striking, and those are the kind of days that cry out to be photographed in black and white.

The clouds move even faster than the light from the sun, so timing their movement is critical to the image. Make certain that the sun is hitting the subject as you want it to be seen. You may have to wait for the sun to pop out from behind a cloud to get the light right. This may be not only a timing issue, but also an exposure issue. Make sure that you get the correct exposure for the scene in front of you as the light changes.

If you are exposing for a scene with clouds creating a shadow in the foreground or on the subject, when clouds move and brighten the scene, you

1-9

ABOUT THIS PHOTO *Because I waited for the sun to near the horizon at Hound Tor in the English moorland, there were opportunities for great black-and-white images. The textures and contrast of the light near that time of day often make timing your images well worth it. Taken at ISO 200, f/8, and 1/80 second with an 18-200mm lens set to 18.*

will need to reset the exposure; otherwise the photograph will be far too bright. If you don't wait for the sun to come out from behind the cloud, it is possible to get a decent exposure, but the foreground may be dull or dark with a sky that is too washed out.

By simply timing the clouds, you are bound to get a much better image. Take a look at the clouds and watch the direction they are going. Estimate

how long it might be until the sun strikes your scene, or until there is enough blue sky to get the image you desire. The day shown in 1-10 was mostly overcast, with a few patches of blue sky, a stiff breeze, and some fast-moving clouds. That made me think that some nice sunlight and blue skies were on their way. A short hike around the area was all the time it took for the scene that I was looking for.

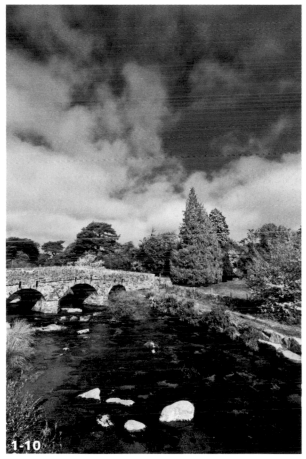

1-10

ABOUT THIS PHOTO *Timing cloud movement can help you get texture and drama in a black-and-white image. Look for good clouds to come on either side of inclement weather patterns, and time the sunlight with your cloud cover. Taken at ISO 100, f/11, and 1/100 second with a 12-24mm zoom lens set to 12.*

CREATE PERFECT TIMING

Shooting photographs of people is possibly one of the most challenging things when it comes to timing. In these situations, it is important that your subject feels comfortable. These images are about expression, and people express emotions with their entire bodies — more than just their faces, where they put their hands, and how they are seated — so capturing an image with the expression you are after often requires split-second timing.

Often, when people get in front of a camera, the photographer just says, "Okay, smile." However, is this really the best way to encourage the emotion and personality you want in the photograph? It is okay to take photographs of people who are smiling, but what is most important is that the expression captured is genuine.

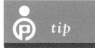

x-ref For more on people and portrait black-and-white photography, see Chapter 3, where lighting for portraits is covered in greater detail.

When taking photos of people, you often benefit from the speed of the continuous drive in your camera. There are usually tiny differences between expressions as people relax or even between breaths. Making people feel comfortable is the first order of business. Moving them into positions where they feel relaxed and confident only takes a moment, but pays off hugely.

Once your subject is comfortable, use some conversation to get her face to relax. Have your subject think about her family or pets, or simply ask

tip There might be many times when the best expression comes when you are not looking through the camera's viewfinder. Use a cable or wireless remote so you can trigger the camera whenever your subject's expression is best, not necessarily when she is smiling directly into the camera.

her some questions so she's not thinking about having her photograph taken. Being a good photographer means being a good listener as well.

Using your practiced timing skills, you'll be able to press the shutter release button at the exact moment those perfect expressions occur. This is particularly important when working with kids. Young people are only just beginning to have a sense of themselves. Often, they are only capable of coming up with big, cheesy smiles, as they are asked to do by their parents and grandparents.

Wait for better expressions with kids. It may not be the big smile that is expected, but it is probably more genuine. While taking a photograph of my friend's daughter, I made sure to get down on her level. As soon as I had the camera up to my eye, she gave me a frozen, posed smile in a valiant attempt to hide some missing teeth. With some questions about school, her room, and boyfriends, I quickly captured the skeptical smirk seen in 1-11. This is exactly the look that her mother was hoping for in the image because of the bright and joyful look in her daughter's eyes.

Getting your portrait timing down takes not only practice and a quick shutter finger, but also dedication, the ability to push until you get what you want, and enough experience to know when you're done. Practicing your portrait timing on kids will hone your skills because of how quickly their expressions come and go.

1-11

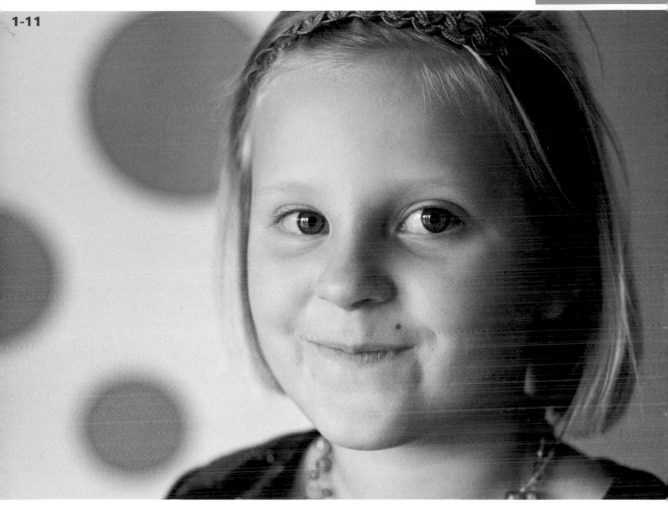

Catching these moments between moments is like capturing gold. The expressions between perfectly planned poses (which can be just slightly off) can end up being the perfect images when you have perfect timing and are prepared. When a child who is fussy from being posed too much finally jumps down and starts running towards the camera with a great big smile, great timing captures that priceless image of freedom (see 1-12).

Even when I work in a very conservative studio setting, after I have shot a number of solid head-shots as requested by a client and know that I

have captured the right one, I'm free to open things up a little. In the case of 1-13, I decided that it was time to mix it up, so I changed the lighting to something more dramatic and started asking much more pointed questions. This subject is the host of a local radio show and has quite an acerbic wit. He is used to being the interviewer, not the respondent, and quickly lost his composure. In fact, he began laughing hysterically, which is true to the persona that I feel I know.

ABOUT THIS PHOTO *It is generally pointless to try to force a child to remain in one position for a long period of time. As soon as this boy became too squirmy, we let him go; because I was ready for the next move — his newfound freedom — I got the shot. Taken at ISO 400, f/2.8, and 1/250 second with a 70-200mm zoom set to 100.*

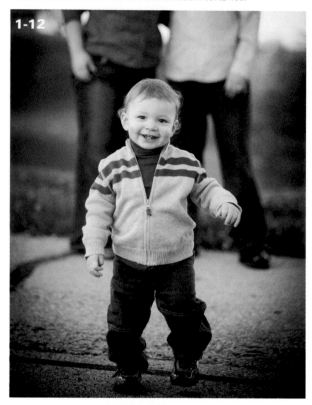

1-12

WHEN SHOULD YOU USE BLACK AND WHITE?

Black-and-white photographs work for almost any situation.

Although bright, saturated colors in photographs are always a draw, there are truly very few situations where black-and-white photographs will not work. Whether or not black and white is the best approach for the image that you are trying to create is another issue. If you are trying to record something exactly as it is in the real world, naturally you would chose to do so in color. But the reality is that there are just so many ways to create fantastic black-and-white images. Therefore, when I am shooting for myself, black and white is the default, thus leaving all creative options open.

For example, one of my favorite magazine editors asked me to update her portrait. When I arrived to take the photograph, I looked at a few different locations to see which was most suitable. After

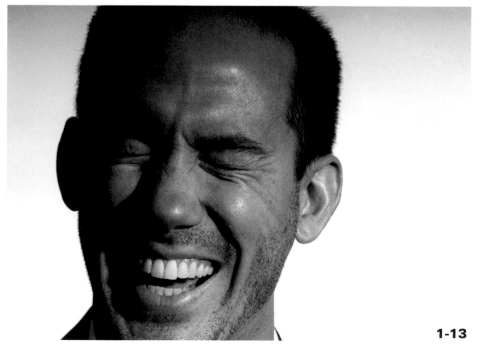

ABOUT THIS PHOTO
Catching the brightest part of a laugh requires the best timing a photographer can have. It is a moment of genuine happiness, and I wish I could interact with subjects this way every day. Taken at ISO 200, f/5.6, and 1/180 second with an 80-200mm zoom at 200.

1-13

finding a great place to shoot, I realized that it would only be exactly what she was looking for if we shot it in black and white. I asked her if this would be okay and she said, "Oh, absolutely! Black and white covers a multitude of sins!" Now this person is quite lovely and would look fantastic no matter how she was photographed. However, she knows that black and white can create fantastic looking skin (see 1-14), whereas a color photo might not be as forgiving.

Every aspiring photographer has attempted to re-create classic black-and-white photographs taken by the masters, whether he is shooting at a national park or creating a still life in the

note This is not to say that a photographer should use black and white as a crutch, but simply that the possibilities for creating beautiful skin tones in black and white are abundant, whether the subject is a beautiful bride or a weathered grandfather.

kitchen. Instead, try shooting black-and-white snapshots at the next family event, such as a birthday party or bowling night. Plain old snapshots can suddenly take on a whole new life and become classic heirlooms or pieces of art. Because there are color images all around our everyday life, working in black-and-white makes the entire process of photography a new and exciting experience.

1-14

ABOUT THIS PHOTO
Sunlight streaming through a large picture window illuminated the background, and the reflected light from all around made for a softly contrasting, high-key portrait. Taken at ISO 320, f/2, and 1/50 second with a 50mm lens.

Go on a photo-walk with fellow photographers around your town or at the park, or take a camera to lunch. Scenes you might have missed because of their familiarity could lend themselves to new possibilities (see 1-15). Suddenly the high-noon, harshly lit scene of your local downtown area becomes a black-and-white jewel. Attempt to see only the contrast in an image and see past the color. Make the viewer feel the texture of the steel and grease.

shoot. Scenes that might be otherwise nondescript and plain suddenly become studies in soft texture and fine contrast.

While I was in the Pacific Northwest for a too short visit, gray days were common. However, an overcast sky is no reason to forgo taking photographs (see 1-16). Use the weather to your advantage. With black-and-white photography, you can focus on the essential parts of an image or create a different mood than expected.

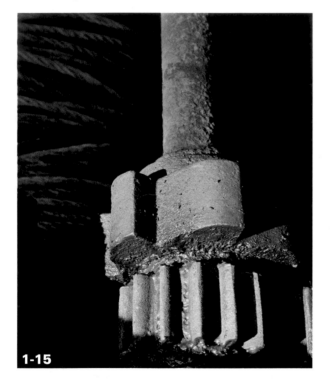

ABOUT THIS PHOTO *Noon-time sunlight hit the grease-covered gears and cable, creating some very high-contrast texture. In order to keep the highlight detail in the metal, the shadows are very black. Taken at ISO 125, f/9, and 1/60 second with a 45mm lens on an m4/3 camera.*

Many places have a reputation for inclement weather and can be quite dreary. That does not mean for one minute you should stow your camera away. In fact, a cloudy, foggy day while I am on vacation can be one of my favorite days to

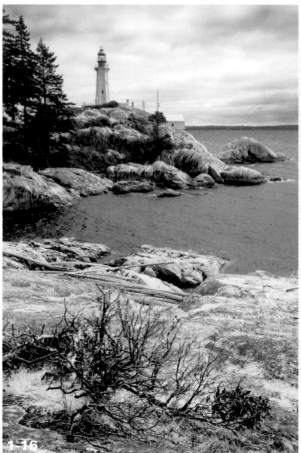

ABOUT THIS PHOTO *Overcast days have their own feel and dynamic. Mixing the texture of the clouds with the rocks makes an image that is just as dramatic as one captured on a sunny day. Impart the emotion of the day to the viewer. Taken at ISO 200, f/13, and 1/160 second with a 35mm lens.*

FINDING PHOTOS WHEREVER YOU ARE

Black-and-white photography is such an amazing medium — just when you think you've seen something a million times, you see it in black and white. Suddenly, it is new and fresh, or old and nostalgic, or gritty, or has a cool, clean contemporary look that is totally surprising. All of these can be in the same image depending on how you look at it and how you shoot it.

It is not imperative that you travel far to take effective and impressive black-and-white photographs. No matter what the weather is like or what the light looks like, photographs are there to be found. Studying things that are close — the things that you see every day — creates a greater challenge, but the lessons you will learn by shooting black and white in your neighborhood will help you develop your vision and prepare you for shooting things that are new and different.

The obvious first step is to have your camera with you. For example, there was nothing to stop me from shooting this little guy peering out at the action outside his yard (see 1-17). His face is bathed in the soft light of open shade, which

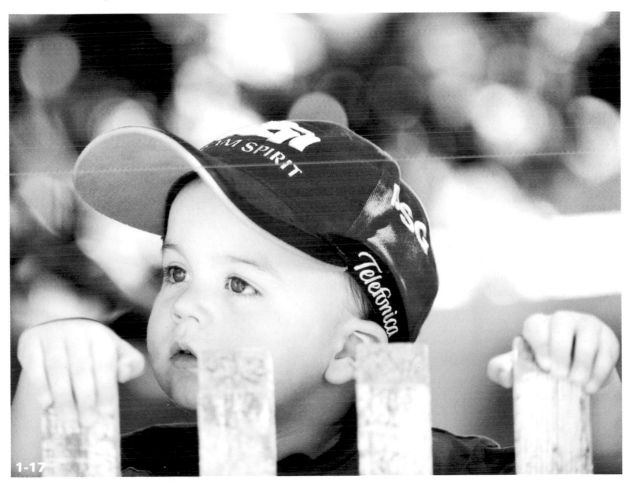

1-17

ABOUT THIS IMAGE *Using a telephoto lens helps isolate the subject, giving him sharp focus in contrast to the soft background. In black-and-white photography, it can be important to make sure that the subject is separated from a busy background. Taken at ISO 100, f/2.8, and 1/125 second with a 300mm lens.*

WHEN BLACK AND WHITE DOESN'T WORK. Inevitably, there will be images that you may think will be great in black and white, but no matter how much you work on them on your computer, they just don't have what it takes. These are usually images with a lot of fussy texture, too much foliage, and not enough shapes. Remember to look for contrast within the scenes to create good black-and-white images.

draws the viewer to observe the contrast of his eyes on his pale skin. Because I used a telephoto lens with a wide aperture, the shallow depth of field isolated his face against a softly textured, natural background, which is important in black-and-white portraiture.

Farmers' markets and open-air local groceries are always a great source of interesting textures and tones for black-and-white images. In many cases you will find displays that already have great designs or at least a nice aesthetic of mixed goods. Look for contrasts in the light, in textures, and especially in colors.

> **tip** When you shoot at markets and other public places, most proprietors will have no problem with you taking photos of their displays of goods — especially if you purchase something from them, which is a small price to pay for a nice image. Use common sense. If signs are posted for no photography, please respect the wishes of the shopkeeper. Try not to be intrusive or hamper other shoppers from getting their goods. A smile, a compliment, and a quick query for permission go a long way.

The contrast between color and texture makes for interesting studies in black and white. Placing rough, light green artichokes over the soft, round, richly dark tomatoes nicely juxtaposes the textures and tones. At first glance, this image was too flat, but by making the reds a darker tone, and the pale green of the artichokes lighter, things fell into place. A normal focal-length prime lens set at a wide aperture

helped to isolate the artichokes, and also made it possible to shoot in the lower-light of the market (see 1-18).

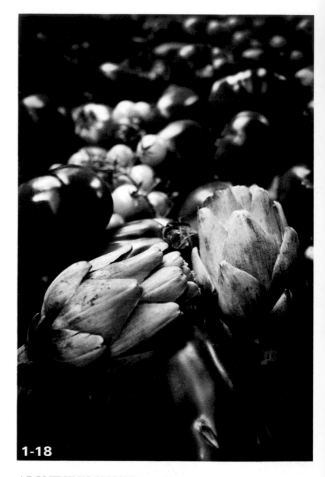

1-18

ABOUT THIS PHOTO *There were about a million different opportunities for interesting compositions at the local market this day, with my favorite being this contrast between the artichokes and tomatoes. The textures here are fascinating, even though this may be a somewhat busy image for black and white. Taken at ISO 500, f/3.2, and 1/80 second with a 20mm lens on an m4/3 camera.*

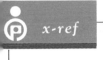 *x-ref*

> Changing the tones within your black and white is discussed in much greater detail in Chapters 7 and 8.

Architectural details are also interesting places to look for black-and-white imagery. Keep in mind that you are looking for shapes and contrast. Even a simple bandstand shell can make for an interesting composition, as shown in 1-19. With the sun illuminating the front of the structure, the internal ribs are mimicked by the shadows of the shapes repeating behind the bright front arc. The arc cuts a bright curve through a scene of dark tones. By intentionally underexposing the scene, the front shape is properly exposed for the sun striking it, making for a high-contrast dynamic.

For this particular shot, being at the scene at the right time of day was very helpful. The sun was low and is reflected practically right off the front of that arc. This makes the arc as bright as it will likely be for that day and angle, and lets the inside of the shell and the sky fall into dark tones.

Other times of day might be good for this west-facing structure, but the result would be very different. A morning shot would be more of a silhouette and a midday shot might be good, but there would likely be more shadow on the front arc. None of these are good or bad per se, just different versions and options available to you as the photographer. Black-and-white enables you to walk by a scene at any time of day, any time of the year, and perhaps get an entirely different image.

1-19

ABOUT THIS PHOTO *On a walk before dinner I found this excellent example of a black-and-white shape creating contrast. The repetition of the arc and the ribs underneath the shell are what initially drew me to the scene, but it was the bright arc that gave me the impetus to shoot. Taken at ISO 100, f/5.6, and 1/1250 second with a 20mm lens on an m4/3 camera.*

Assignment

Something Out of Nothing

Look at the things around you to create a new black-and-white image. This could be an image of something inside your home or apartment, something down the street, or a shot of your family. The only requirement is that the subject be something nearby that you see often. Use some of the ideas discussed in this chapter about tones, shape, and contrast to locate things right under your nose that would make interesting photographs.

The smokehouse in this image is not far from my home. The tones and texture were created by the light just before sunrise. This photograph was taken with an exposure of ISO 400, f/5, and 1/125 second.

You will be amazed at what you find when you look with black-and-white vision.

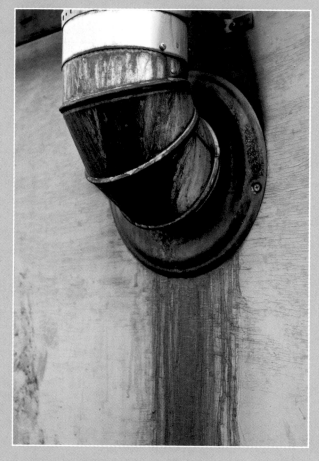

Remember to visit www.pwassignments.com after you complete this assignment and share your favorite photo! It's a community of enthusiastic photographers and a great place to view what other readers have created. You can also post comments, read encouraging suggestions, and get feedback.

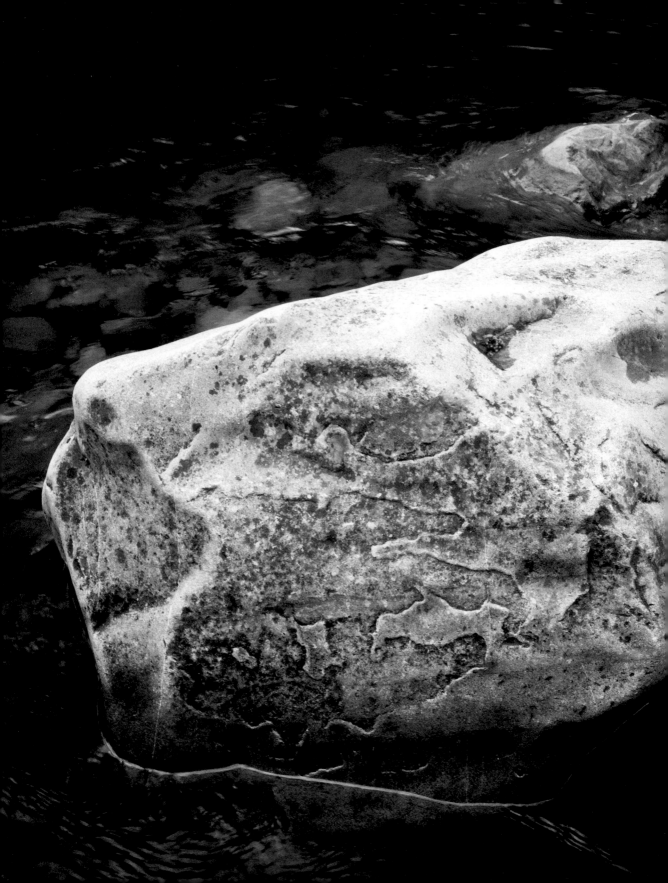

What f-stop are you using?

For people brand new to cameras with manual controls, this question can make them very uncomfortable, as if there is a right or wrong way to it. There are rarely wrong settings to take a photo; different settings will cause different things to happen in a photograph, and thus some settings are better for a particular scene. Learning the basics of photography and how the camera actually works is not particularly easy or initially intuitive.

Photographers have created their own lingo, which can sometimes further confuse people who are still beginners. This chapter aims to make you more comfortable with how a photograph is actually made. Some of the elements can be somewhat technical, but once you have figured them out, deciphering the words and numbers associated with photography should be a snap.

As you learn this information, it is helpful to read with your camera close at hand. Although hands-on work with the camera is covered in depth in Chapter 3, becoming familiar with your camera's controls enables you to make quick and sure decisions when you start shooting.

EXPOSURE

The *exposure* of the image refers to the amount of light that hits the digital sensor or the film. A light meter on the camera tells you what the exposure is, and suggests settings to get the proper

ABOUT THIS PHOTO
In this photo of a snowy morning, the camera's meter gave a perfectly reasonable exposure — for a grass field — but snow is white, and the exposure needed to be adjusted for this change in tone. Taken at ISO 100, f/8, and 1/100 second with a 14-45mm lens set to 29.

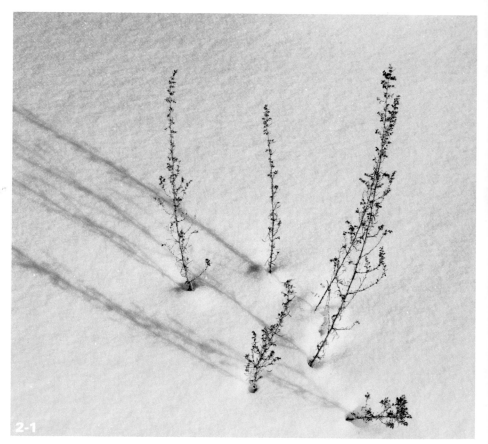

2-1

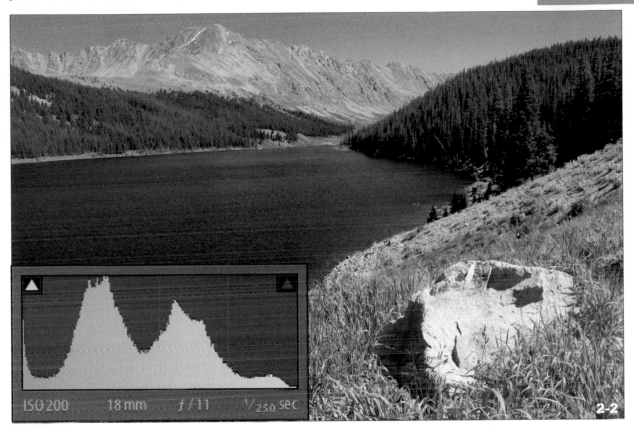

2-2

exposure. Today's digital camera has a meter that reads the amount of light that comes through the lens. The meter then segments the light into different sections (some cameras use over 1000), taking into account the color and contrast among all these different segments, in order to determine the proper exposure.

The metering information will often help you create perfectly good exposures. The art of the exposure is using that information to break the rules just a bit (or sometimes a lot) to get exactly the photo you have envisioned. Creating an image that is lighter or darker can drastically change the feel of your photographs; just relying on the settings that the camera suggests may not make the photograph you want.

Breaking the rules does not mean that you should expect to be able to fix the photograph in Photoshop. It does mean you should get the exposure right in the first place, and that sometimes you will need to change what the meter tells the camera to get the exposure right.

A light meter attempts to get the exposure to a middle gray tone. This has classically been called 18 but is actually more like 12 percent gray, also called *middle gray* or *medium gray*. Many types of tools help ensure that the exposure is at that middle gray point. However, most photographs aren't all gray. Learning to visualize just how dark or light your photograph really is will help you make the necessary adjustments to your camera.

The snowy morning seen in 2-1 is anything but gray. The camera's meter might suggest settings that would create a darker photograph than desired, because the meter is averaging the scene to make the photo a middle gray.

LEARNING THE HISTOGRAM

The *histogram* is the light meter for the digital age. You don't do anything to the histogram; it is simply a tool to help you read the exposure and tones in the image. The histogram can guide you to the correct exposure for the image you are making.

With the technology in digital cameras, many professional photographers pay far more attention to reading the histogram of the photo in the camera than looking at the image on the back of the camera to get the actual exposure correct (see 2-2). Even with as good as the LCDs are on today's cameras, it can still be a challenge to see the image in certain light and get a good grasp on the image's exposure. This is where the technology of the histogram really pays off.

The histogram is a simple graph representing the tones in the photograph. The levels of brightness are distributed in 256 levels along the bottom, or horizontal, axis of the graph; 0 at the left represents pure black and 255 at the right represents pure white. The bars, or vertical axis, of the graph show how many pixels are at a particular brightness.

Generally in a well-exposed photo, the pixels are lumped mostly in the middle areas, with some pixel bars spreading out to the sides (see 2-3). In an *underexposed* (dark) image, most of the pixel bars are biased to the left (see 2-4), and in an *overexposed* (light) image, most of the pixel bars are biased to the right (see 2-5).

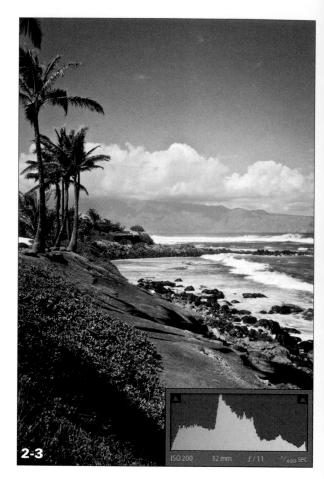

2-3 ISO 200 32 mm f / 11 ¹/₄₀₀ SEC

Think about the histogram as a gradation from black to white, broken into five sections (see 2-6), with the left side showing the distribution of blacks to shadows, the middle section going from shadows to midtones, and the right side moving to light tones and then highlights and pure white. If you have more pixel bars on the left side, the photograph will have more dark or black tones, and if you have more on the right, the photograph will have more light or white tones.

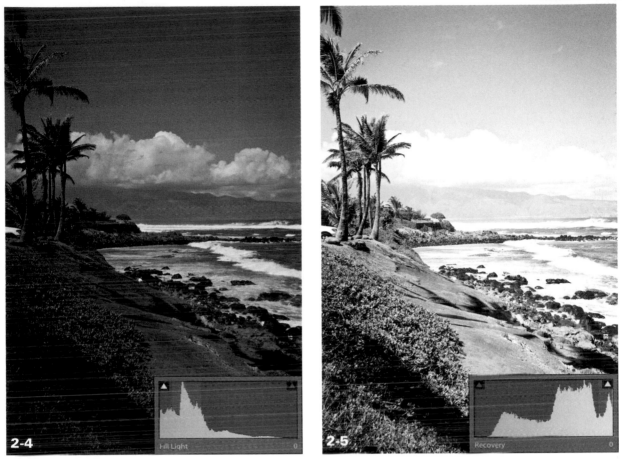

ABOUT THESE PHOTOS *A beautiful morning at the beach show a scene with a wide range of tones. We can see virtually every tone in the scene, from white clouds to dark shadows in the rocks. The exposure of 2-3 at 1/400 second captures the movement of the waves, and an f-stop of f/11 shows depth of field throughout the scene with an ISO setting of 200. In image 2-4, the scene is approximately 1 ½ stops darker, and in image 2-5 the scene is approximate 1 ½ stops brighter, and you can see the change in the histogram with those changes.*

Each of the five areas expresses approximately one f-stop worth of exposure. Each area has 50 levels of brightness that are expressed in the graph. There is no such thing as a good or bad histogram, but there are exposure problems in an image that the histogram is able to show to the photographer.

Virtually all digital cameras include a histogram display. You access it by pressing the Display button on the back of your camera, sometimes scrolling through several different screen overlays. It's likely that your camera includes various options for you to view the histogram in different ways.

In some cameras, the display is available all the time and appears overlaid, along with other shooting information, on a small part of the image. Even so, you can view it only after the shot has been taken (see 2-7).

I find it is most useful to have my image appear full-screen on the camera's LCD, and then customize my camera so that with one button press, the histogram appears over the top of the photograph (see 2-8). This way you can compare the histogram directly with the image. Comparing the image and histogram not only helps to ensure the exposure is correct, but also teaches you how the exposure and histogram correlates to the corresponding image.

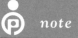

note Remember that in different environments (ones that are extremely dark or bright), the image displayed on the camera's LCD may not give the best representation of the image in its final form. Our eyes adjust to the ambient light level automatically, while the camera does not.

It's important to learn how to access the histogram quickly (as important as it is to get the correct exposure, it is probably more important not to miss a moment) and to understand how the information in the histogram relates to the look of the photograph. So start paying attention to the histogram in both your black-and-white and your color images to get a better handle on your exposure.

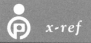

x-ref You can find more information on histograms, exposure, and timing the moment in Chapters 3 and 4.

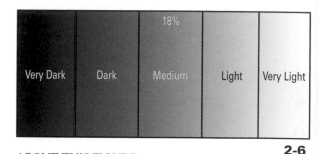

2-6

ABOUT THIS FIGURE *This illustration shows the gradation of the tones of a histogram from blacks to white.*

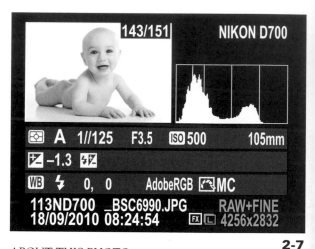

2-7

ABOUT THIS PHOTO *It may be helpful to view the histogram along with a small version of your photo, the exposure information, white balance information, the time the photo was shot, and so on.*

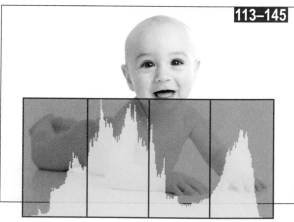

2-8

ABOUT THIS PHOTO *With a press of a button, you can display the histogram over the top of a full-screen image for immediate review.*

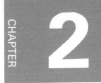

OVEREXPOSURE

An overexposed photograph is one that is considered too light or too bright. On a technical level, overexposure happens because the amount of light hitting the sensor is simply too much for the sensor to handle. In digital photography, this usually means that the bright sections of the image, the *highlights*, become pure white with no detail at all. Sometimes, an overexposed image is simply one that looks pale or washed out (see 2-9).

Highlights that are all totally white are called *blown-out highlights* and can be found in images of bright skies, reflections off of shiny objects, or when part of the image is in deep shadow and part of the image is in bright light (see 2-10). In histogram terms, overexposure is also described as *clipped whites*.

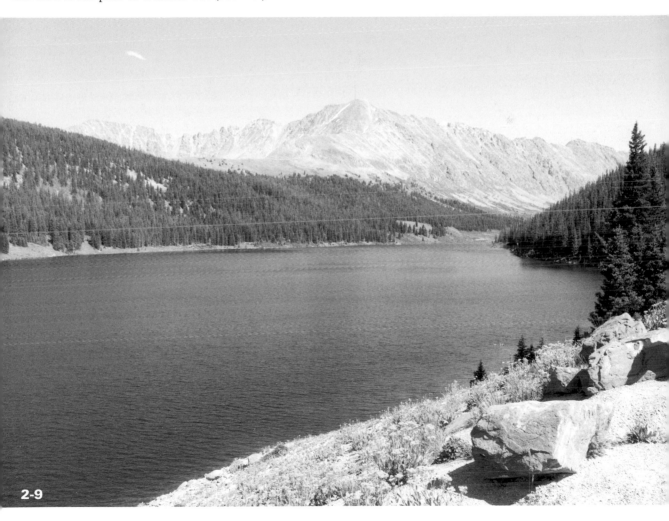

2-9

ABOUT THIS PHOTO *A simple mountain lake scene looks washed out and pale because it is overexposed. Taken at ISO 200, f/7.1, and 1/200 second with an 18-200mm zoom lens.*

ABOUT THIS PHOTO *Because I exposed for the railroad sign (which is in some shadow), the sunlight hitting the white cloud totally overexposes the clouds. In the histogram, there are several bars of exposure hitting the right side of the graph, clipping any detail out of the white. Taken at ISO 200, f/2.8, and 1/800 second.*

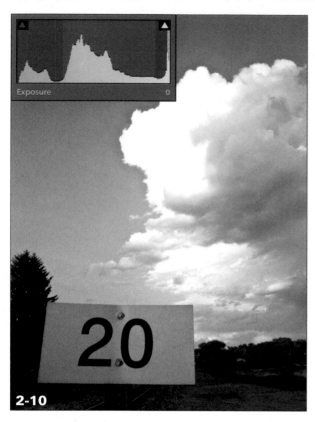

2-10

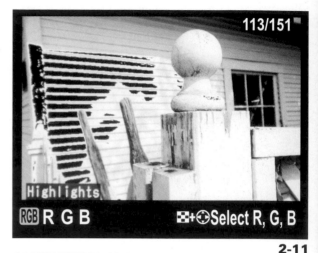

2-11

ABOUT THIS PHOTO *Because of the harsh sunlight hitting the wall behind the post, it is much brighter than the rest of the image, causing the siding to blow out. The Highlights warning flashes black where there is no detail.*

Many digital cameras have a built-in overexposure warning, usually called *Highlights*, which can alert you to clipped or blown-out highlights in your images. Such a setting will show all blown-out areas with blinking black patches (see 2-11).

When you are learning about exposure or are in a situation where the chance of blown-out areas is high, the camera's Highlights display can be a fantastic tool to guard against overexposure.

However, in bright situations, overexposure may actually be necessary. The meter will be telling the camera that this scene with a lot of snow (see

2-12) is middle gray, and the photo may end up too dull or murky. In such a case, the normal exposure is too dark, and the histogram shows that the pixel bars are too far to the left for the scene. In this situation, you need to overexpose the image. Overexposing the image adds more light to the exposure, brightening the scene and making the white in the photograph actually look white.

Another case where overly bright photographs are desirable is with *high-key* images. A *high-key photograph* is a brightly lit image on a white or bright background (see 2-13). High-key can also mean that there is simply a lack of dark shadows, such as the lighting seen on a television sitcom; the lighting is bright all over the set, evenly lighting every actor.

34

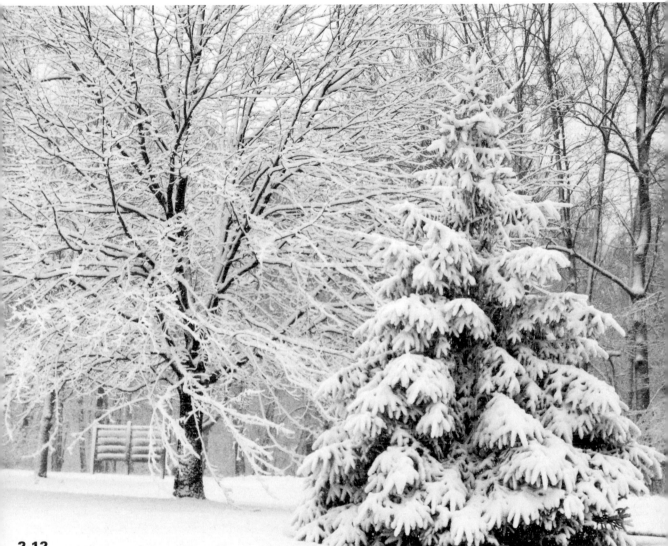

2-12

ABOUT THIS PHOTO *With the vast amount of snow in this photo, a camera's meter may tell the camera that the correct exposure is just too dark for the scene. The meter is fooled by all the white, and wants to see it as gray. By overexposing the image, you can get the desired brightness. Taken at ISO 400, f/8, and 1/400 second.*

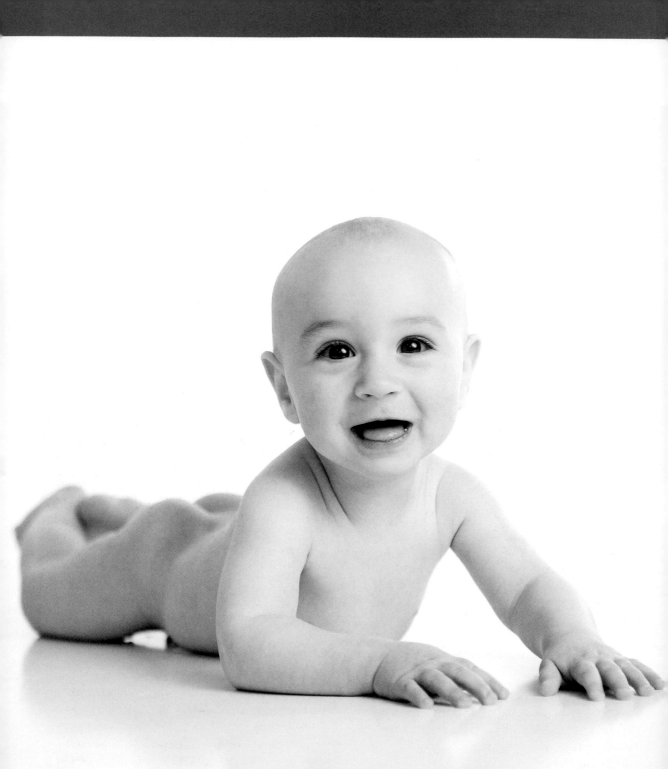

2-13

ABOUT THIS PHOTO *This high-key photograph of Linus has a brightly lit subject on a totally white background. This image was taken in a small studio lit with hot shoe flashes. Taken at ISO 200, f/3.5, and 1/200 second with a 24-70mm f/2.8 lens.*

2-14

ABOUT THIS PHOTO *A cloudy day might seem a little dark for a portrait, but overexposing from the meters setting, the image takes advantage of the soft light of the cloud cover to create a bright portrait. Taken at ISO 200, f/2.8, and 1/320 second with a 300mm lens.*

There is another situation where you can use overexposure to your advantage. Working on an overcast day can tend to make images look a little darker than it seems to the eyes; overexposing them, setting the exposure slightly brighter than the meter's recommendation, can brighten them to the point that a viewer might not realize they were taken on a gloomy day. This is particularly helpful when you are shooting portraits (see 2-14).

In the soft light of a cloudy day, you don't have harsh highlights, so when you set the camera to overexpose the scene a little (either with exposure compensation if you are in one of the auto exposure modes, or manually), you are overriding the meter, and voilá — a perfect portrait, with an actual correct exposure.

UNDEREXPOSURE

Underexposed photographs are considered to be too dark and murky. One of the biggest issues with underexposure is simply the lack of detail in the shadows in the photograph. Another large problem with underexposed photos is the increased noise in the dark areas of the photograph. If a reasonably well-lit image is simply underexposed, it will be too dark, the areas in the photograph with shadows and very dark tones will become black, and those shadow tones will look *blocked up*, having little to no detail.

Underexposure can be beneficial at times. If an image is only slightly underexposed, it also might make the image a little richer at the cost of losing only a little bit of the shadow detail (see 2-15). When a photograph looks washed out, especially a landscape, underexposing the scene from the meter's recommendation by 1/3 to 2/3 of an f-stop can be just the ticket to make the photo more dramatic and lively.

When you look at a histogram of an underexposed photograph, most of the pixel bars will be grouped to the left side of the graph, meaning that a bulk of the pixels in the image are dark, shadows, or even black. When an image is underexposed and is not supposed to be, trying to lighten the image in the computer usually creates a lot of noise in the image. So while there still may be detail in those dark shadows, bringing the details out needs to be done judiciously.

Underexposed photographs often have histograms with what is referred to as *clipped* blacks. Having clipped black tones means that the pixel bars of the histogram are not only on the left side of the graph but also all bunched up against the top edge of the graph.

In a normal scene, let's say daytime with some sunlight on the subject, an image with the pixel bars pushed to the far-left side of the histogram means that any shadows are totally black, midtones are very dark, and any highlights are dull gray at best. But with a much darker scene, such as after dusk, before dawn, or indoors, it's often just fine to have what would be considered a very underexposed image.

ABOUT THIS PHOTO *With hard afternoon sun hitting this stump, much of the wood may have looked too bright. By underexposing the image somewhat, the richness of the scene comes out, with a minimum of loss of shadow detail. Taken at ISO 200, f/11, and 1/100 second, with a 28mm lens.*

2-15

In 2-16, you see a subject whose skin tone is dark, is wearing dark headgear, and is shot in a totally black background. Because of all the dark tones in this image, it is considered *low-key*. The histogram for this image is exactly as described previously — pixel bars all to the left — and yet, for this image, it is the perfect exposure.

Just like the camera meter might be fooled by a bright scene, it can also be fooled by a dark scene, causing the rich blacks in the scene to be rendered as tones of gray that look somewhat washed out. This sort of thing happens in a night scene pretty regularly. As the light level is reduced, things look darker and darker, and the meter tells the camera to make correspondingly brighter images because it is trying to get a middle gray photograph.

2-16

ABOUT THIS PHOTO *This scene is composed entirely of very dark tones. To ensure that the final image stays dark, the image is underexposed from the meter's setting. Only the highlighted areas of the subject's skin are even close to being considered midtones. Taken at ISO 3200, f/2.8, and 1/320 second with a 200mm lens.*

While there is no Shadow warning (remember the Highlights warning for overexposure?), it is possible to use the histogram as a guide to make sure that the exposure is what you desire no matter if it is "correct" or underexposed. In the case of falling darkness that causes the meter to show a brighter than desired exposure, simply turn the Exposure Compensation dial toward the minus side to make the exposure darker, manually speed up the shutter, or use a smaller f-stop than the meter suggests.

A photograph with a silhouette is also generally created through underexposure. A normally exposed photograph would have shown some of the red rock detail of the arch, but the sky would have been virtually white and the sun would have been just a massive highlight blob (see 2-17). By underexposing the scene, the sky becomes a rich gray, the stone becomes black, and the sun ends up being a very cool, multi-pointed focus area, creating some excitement in the image.

A silhouette needs some different elements than a regular photograph. The subject of the image should be backlit, or have some background that is brighter than the subject. In most cases, a bright sky becomes both the light source and the background for a silhouette. The next element is the use of underexposure.

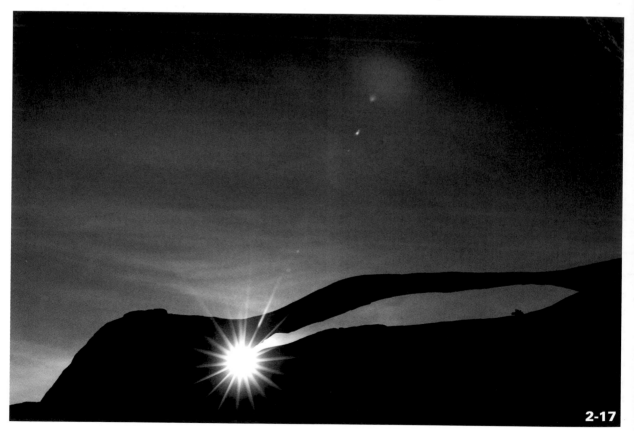

2-17

ABOUT THIS PHOTO *By underexposing the image, a backlit image that would have been washed out and dull becomes a dramatic silhouette. Taken at ISO 100, f/9, and 1/1250 second with a 17-35mm f/2.8 lens set to 23.*

While each scene is different, the amount of underexposure for a silhouette may be anywhere from 2/3 f-stop to three full f-stops. Without underexposing the scene, the photograph may simply appear like a bad exposure or one with a poor lighting technique, and in the case of a silhouette, creating a subject that is totally black is just fine. The correct exposure is one where the background of the scene is correct and full of rich tones.

EXPOSURE COMPENSATION

With all this talk about exposing photographs darker or lighter than what the meter recommends, I am sure there are plenty of readers who are asking how to do this. *Exposure compensation* is a way to override the bias of a camera's automatic exposure modes. It is easy to use and is available on virtually all digital cameras, especially dSLRs.

Whether you are a seasoned pro or just picked up your first compact digital camera yesterday, learning to use exposure compensation is key to getting your exposure correct. You can usually access exposure compensation through a button or menu setting with a +/– symbol on it, as shown in 2-18 and 2-19.

The exposure modes on digital cameras are covered in more depth in Chapter 4, but to get you started, you should know it is possible to use exposure compensation in all of the exposure modes: Program, Aperture Priority, Shutter Priority, and, in some cameras, Manual. In most cameras, exposure compensation will not work with the Scene modes or in fully automatic modes where the camera makes all the decisions.

2-18

ABOUT THIS PHOTO *The button with the +/–icon (white + and black –) is the Exposure Compensation button. Pressing this button and then turning a dial moves the exposure darker or lighter depending on which way you turn the dial and how you envision the image. In this case, exposure compensation is underexposing the scene 2/3 f-stop.*

2-19

ABOUT THIS FIGURE *On most compact digital cameras, you adjust the exposure compensation through a menu that then displays on the LCD which way you are compensating your exposure. In this example, the camera is trying to get to –2/3 f-stop, or –.7 stops, of underexposure.*

The scene in 2-20 is another photo of a snowy day, but this time with a white barn. Because I recognized that this was a bright scene with a lot of bright tones, I knew to overexpose the image. So I turned the Exposure Compensation dial to the + (plus, or overexposure) side of the exposure display. In this case, it was + 2/3 stop of compensation. For a scene that you want to make look darker, you would turn the Exposure Compensation dial to the – (minus, or underexposure) side, creating a darker than metered exposure (see 2-21).

Setting exposure compensation with the auto-exposure modes does the same thing as setting the exposure manually by following the meter's recommendation and then increasing or decreasing the exposure to get the desired result. The advantage of using exposure compensation in an auto-exposure mode is that it is one less thing to worry about. The camera may be making all the exposure decisions (if set in Program mode) or some of the decisions (if the camera is set to Aperture Priority or Shutter Priority mode), which enables you to quickly adjust the darkness or lightness beyond the meter recommendation.

In Manual mode, use exposure compensation carefully. Remember that in Manual you are making all the decisions about the exposure, so exposure compensation adds one more variable to consider. Some cameras do not even allow you to use exposure compensation in Manual. While there are photographers who use exposure compensation in Manual mode as a guidepost to remind them where the exposure should be, others will simply find it confusing.

Using exposure compensation is the first step in using the tools in the camera to make more interesting and creative, and technically better, photographs. Take the time to learn how to get to the exposure compensation settings when you are using any of the auto-exposure modes. Practice the steps it takes to get there and set the exposure

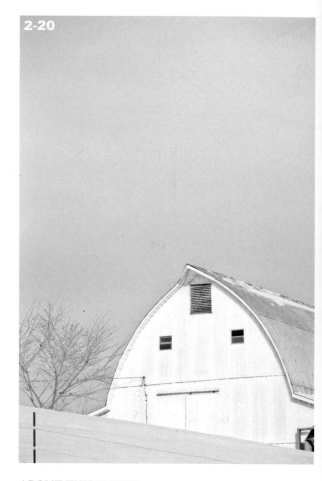

2-20

ABOUT THIS PHOTO *By adjusting the exposure compensation to +2/3 stop, the white sky, white barn, and white snow all retain their bright tones without the image becoming too dark or murky. Taken at ISO 200, f/9, and 1/500 second with an 18-200 zoom lens set to 150.*

where it is needed. In most cases, you can do this with the press of a button and a turn of a dial, but in other cases, you may have to access the settings through a menu, especially when using compact digital cameras. Once you have mastered getting to the exposure compensation, the next step is practicing the correct times to use it.

The automatic exposure from today's digital camera will be right on the money many times. But when you know how to make better images by correctly exposing photographs with tricky or

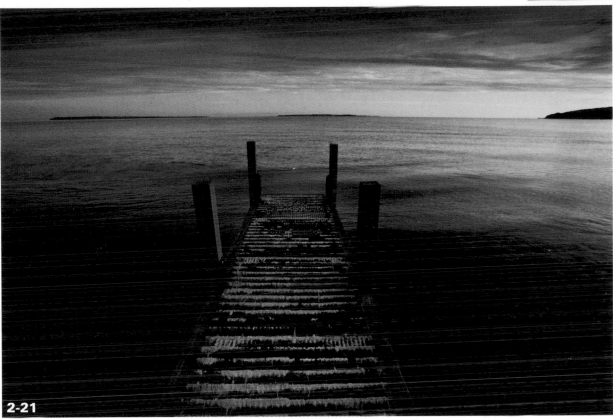

2-21

ABOUT THIS PHOTO *Still well before sunrise, the sky was already starting to fill up with light. The shot I envisioned was much more moody and dark, so I set the exposure compensation to –1 1/3 stop to make for a much darker scene. Taken at ISO 100, f/22, and 1/2 second with a 17mm lens.*

difficult light during a shoot, you will have much better images to work with once you have them on your computer or go to print them.

APERTURE, SHUTTER SPEED, AND ISO

There are three basic elements that create the exposure, and using them reminds me of cooking by a recipe. When "cooking" for exposure, the recipe to figure out is how much light and for how long. The aperture regulates how much light comes into the camera, the shutter speed regulates how long the image is exposed, and the ISO determines the sensitivity of the sensor (see 2-22).

APERTURE

Learning about aperture first is always good because it can sometimes be confusing, yet once you understand how it works, everything else seems to fall into place. The lens on any camera has an adjustable diaphragm called the *aperture*. It works essentially like the pupils in our eyes: The blades of the aperture slide open and closed within the barrel of the lens, and they close to restrict the amount of light coming into the camera or open to let in more light.

Each different stop on the aperture scale has a designated f-stop, with each stop progressively closing the aperture and halving the light coming

43

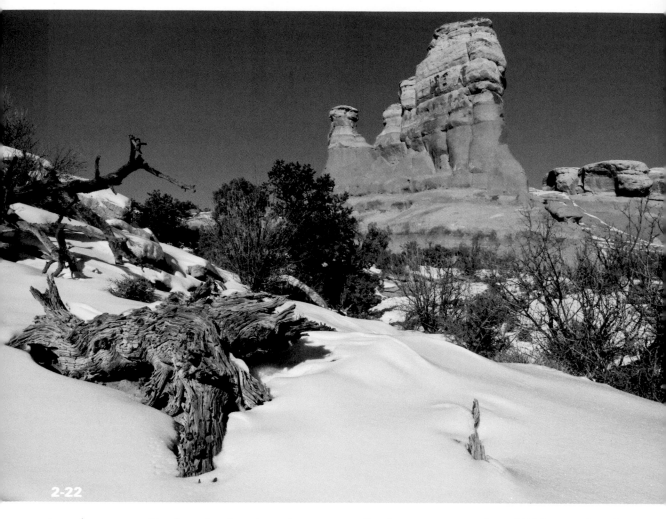

2-22

into the camera. On the other hand, as the aperture opens, it allows twice as much light to come in per f-stop.

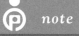 **note**

F-stops are designated with a number that is consistent from camera to camera and lens to lens; these numbers refer to the ratio of the effective aperture diameter to the focal length. In other words, although an aperture might be physically different from a wide angle lens to long telephoto lens, the effective f-stops used for an exposure remain consistent.

So if an exposure such as 1/125 second at f/11 is too bright, it would need to be changed to 1/125 at f/16 to make it one stop darker; if 1/125 second at f/11 is too dark, it would need to be changed to 1/125 second at f/8 to make it one stop brighter.

Table 2.1 shows the progression only of whole f-stops. Remember that digital cameras work along 1/3 or 1/2 f-stop increments in most cases, so there are numerous stops not listed in this table that you will notice in the settings of many photographs in this book.

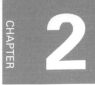

Table 2.1

Whole f-stops from large to small aperture

f/1

f/1.4

f/2

f/2.8

f/4

f/5.6

f/8

f/11

f/16

f/22

f/32

The lower the number of the f-stop, the larger the opening of the aperture. So as the aperture closes, physically making the hole that the light has to go through smaller, the numbers get bigger; this can seem counterintuitive initially. Closing the aperture, or increasing the number of the f-stops, is often called *stopping the lens down* or *closing it down*, while increasing the size of the aperture and lowering the f-stop number is often called *opening it up*.

When all the other variables stay the same, a larger aperture (which would be a smaller f-stop number) lets more light in, making the exposure brighter; a smaller aperture (which would be a larger f-stop number) lets in less light, making the exposure darker.

So if the camera's meter says that the exposure should be f/11 at 1/125 second at ISO 200, but, upon reviewing the image and the histogram, you think the exposure is too dark, simply change the aperture. F/8 will allow more light to strike the sensor and make the image brighter. If, on the other hand, the exposure at f/11 looks too bright, change the aperture to f/16 to make the image darker by restricting the light coming in.

The aperture has another very important function besides changing the amount of light coming into the camera: It is the biggest regulator of depth of field.

Depth of field is the amount of the photograph that is in focus. So a photograph that is taken at an f-stop of f/2.8 will have less depth of field, or a *shallow* depth of field, while a photograph taken at f/16 will have more depth of field. A landscape scene with a lot of subject matter from front to back will probably need to have a smaller aperture, such as f/11, f/16, or f/22, to get as much depth of field as possible. A portrait image typically demands much less depth of field, so shooting at f/2.8 or f/4.0 might be perfect for isolating a sharp subject against a very out-of-focus background (see 2-23).

LARGER NUMBER = SMALLER APERTURE The f-stop number is a fraction; specifically, it is the focal length of the lens divided by the diameter of the aperture's opening. The technical formula is N = f/D where N is the f-number, f is the focal length, and D is the diameter of the opening of the diaphragm. You can think of an f-stop number as the denominator in a fraction, and as you know, 1/4 is larger than 1/8 or 1/16.

There are portrait photographers who use very fast normal length lenses and short telephoto lenses, such as 50mm and 85mm, with maximum apertures of f/1.8, f/1.4, and even f/1.2 to really exaggerate the shallow depth of field. These lenses create extremely soft backgrounds when shot wide open, while the subject remains razor sharp.

Depth of field is a very big part of the whole photographic process, and learning how to get the desired depth of field, whether it be shallow or long, is as much art as science. In the world of black-and-white photography, depth of field is particularly important; without the aid of color, the photographer has only contrast, tone, and

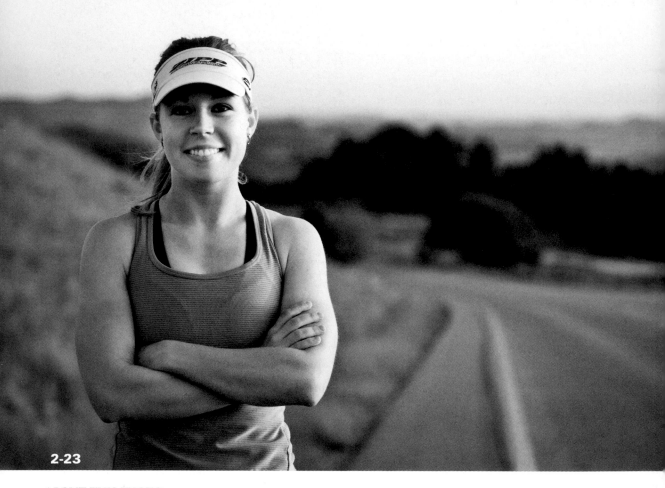

2-23

ABOUT THIS PHOTO *By shooting with a large aperture, what might have been a distracting background becomes soft tones and organic shapes, separating this triathlete from the background with a shallow depth of field. Taken at ISO 400, f/2.8, and 1/160 second.*

texture to build the composition. Therefore, knowing how much of the photograph is in or out of focus is paramount.

SHUTTER SPEED

The second element of exposure is the shutter speed. The *shutter speed* is the amount of time the camera's shutter is open, letting the light strike the sensor to create the exposure.

note Shutter speeds are generally fractions of a second. In this book, shutter speeds appear as 1/250 second, but on most cameras, the numerator of the fraction is gone; therefore, that same shutter speed just says 250 on the camera's display.

1/250 of a second might seem like a very short period of time, but in many cases that speed won't stop the blur of an athlete in action — most of the body would be stopped, but a runner's feet or a boxer's hands would still be blurred as in 2-24. To stop that action, a shutter speed closer to 1/500 or 1/1000 second is needed. On the other hand, a shutter speed of 1/15 second might be too fast (not enough time to let light in) to get a good exposure for a simple indoor scene, and then, the risk of blur from camera shake becomes greater.

But stopping action doesn't always tell the story. Sometimes using a slower shutter speed helps to show the action in a scene as a blur. Whether you are shooting a car race, an athlete in motion, or even the rush of water moving past a rock, using a slower shutter speed can help convey movement in a still image. However, there is a fine line; some blur might show motion, but too much may just show a blurry mess.

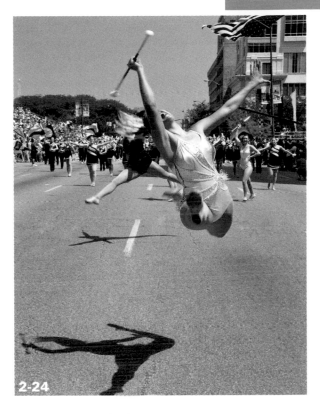

2-24

ABOUT THIS PHOTO *While the shutter speed stops the body of the baton performer, there is still blurring around her feet and the baton. It might have been interesting if this was taken at a faster shutter speed and wider aperture to help isolate her even further. Taken at ISO 100, f/8, and 1/250 second with an 18-200 lens set to 31.*

note Much like in the discussion on aperture, shutter speeds are often discussed in whole f-stop increments, such as 1/30 to 1/60 to 1/125. But digital cameras adjust shutter speed in 1/3-stop increments. This makes for some interesting shutter speeds, such as 1/13 second, 1/400 second, and even 1/1250 second.

Many photographers who are drawn to landscapes use water in their images to help create some action. Blurring water is a favorite, and placing the camera on a tripod to keep the still parts of

the landscape sharp is critical. The lower the shutter speed, the smoother the rush of the water. Depending on the speed of the water, even 1/15 second might be slow enough to show the water blurring out. At 1/4 or 1/2 second, the water is usually quite soft looking, with some occasional jagged lines from water spray (see 2-25). An exposure of several seconds turns rushing water into a soft glow of white blur.

Some digital cameras have shutter speeds as fast as 1/8000 second (although 1/4000 second is more typical for a consumer-level dSLR and 1/2000 second for a compact digital camera). This stops virtually all action, such as a hummingbird's wings or even the white letters on a racing car's tire (see 2-26). The compromise to this extremely fast shutter speed is that there needs to be enough light coming into the camera to actually expose for that short of a time.

For example, a normal exposure in the middle of a sunny day is about f/16 at 1/250 second at ISO 200. To keep that same exposure value, it would be necessary to open the aperture to f/2.8 to achieve a 1/8000 second shutter speed if you made no other changes to the camera (see Table 2.2). For each larger aperture, twice as much light is let in; so to keep the overall exposure the same, the shutter speed must be twice as fast to let in half as much light.

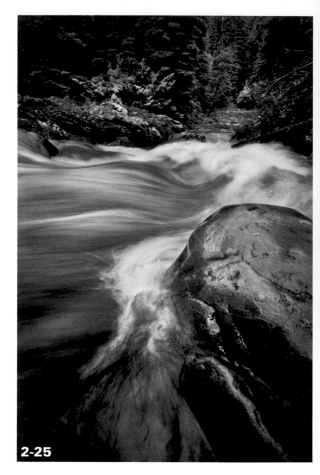

2-25

ABOUT THIS PHOTO *At 1/4 second, there is plenty of blur to the water to convey the motion, yet the exposure is still short enough to stop some of the spray, showing the force of the river. Taken at ISO 200, f/22, and 1/4 second with a 17-35 zoom lens set to 17.*

Table 2.2

Aperture	Shutter Speed
f/16	1/250 second
f/11	1/500 second
f/8	1/0000 second
f/5.6	1/2000 second
f/4	1/4000 second
f/2.8	1/8000 second

2-26

ABOUT THIS PHOTO *It takes a lot of light to max out the shutter speed on a dSLR and freeze every bit of the motion in an image. To get to this camera's top shutter speed, the aperture was wide open. With a wide-angle 28mm lens, there is still plenty of depth of field to keep both karts plenty sharp. Taken at ISO 200, f/2.8, and 1/8000 second.*

ISO

The sensitivity of the sensor is the third element of exposure. The sensitivity is designated by the *ISO rating*. The steps between ISO settings carry the same 1 stop change in exposure as a 1 stop change in aperture or shutter speed. For example, changing the ISO from 100 to 200 is a 1 stop change, and from 100 to 400 is a 2 stop change. In the case of the former change, ISO 100 to ISO 400, if the aperture and shutter changed, the overall exposure would be 2 f-stops brighter.

It is important to learn when to change the ISO and to use the ISO to your advantage when you need to. The lower the ISO on the camera is, the higher the image quality for your photograph. As the ISO gets raised to higher settings, *noise* comes into play. Noise is similar to grain in film and appears as tiny flecks of color, predominantly in

the dark or shadow areas of the photograph. Raising the ISO also affects the color and contrast, but to a lesser degree.

Digital cameras are getting better and better with each new generation of technology at eliminating noise at higher and higher ISOs. dSLRs really show no appreciable noise, even at ISO 800 or higher. Some of the higher-end dSLRs have settings that go as high as ISO 102400, allowing photographs to be taken in virtual darkness, although these ultra high ISO speeds are still very noisy at this point.

Some dSLR cameras also have extended ranges. Each manufacturer's nomenclature for their cameras' ranges is different, but they are generally similar. The extended ranges are designated with an H or Hi and a number for how much higher the ISO is than the designated settings. There are

also cameras with Lo ISO settings or extended ISOs beyond the base ISO of the camera. These extended ISO settings allow the Auto ISO mode to be limited to only the settings that are really practically used. Also, the extended settings are not as precisely specified as regular ISO settings.

Even with this high ISO technology, professional photographers maximize the image quality of their photographs by keeping the ISO as low as possible. In the case of 2-27, the ISO was kept at the camera's base ISO (100 in this case), and it was as much about keeping the image quality high as being able to keep the aperture open for minimal depth of field.

note

Image quality is usually comprised of a number of factors which include, but are not limited to, noise, sharpness, contrast, color accuracy, and dynamic range. Image quality is often referred to as *IQ* in online discussions and camera ratings. A camera with a high IQ has nothing to do with how smart it is.

If the best image quality is achieved at the lowest ISO, why wouldn't all images be taken at ISO 100? As light levels change, sometimes the ISO must be raised to get the depth of field needed for a particular photograph or to stop the action at a given light level. Yes, this is done at the risk of having somewhat lower image quality, but it is probably more

2-27

ABOUT THIS PHOTO *This image of antique bottles was taken underneath an awning, creating some nice open shade but limited light. It might have been easy to bump up the ISO, but low depth of field was desired. Taken at ISO 100, f/1.7, and 1/320 second with an m4/3 camera set to 20.*

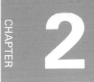

important to get the shot than to worry about the reduction in quality. Additionally, for everyday photography, using ISOs of 200, 400, or even higher than 800 and factoring in the technology gains with today's digital cameras, the loss of image quality will be negligible even when the photograph is enlarged on a print. There are plenty of opportunities to use high ISO in your photographs, such as indoor sporting events which may necessitate an ISO of 3200. With each new generation of camera, these photos just keep getting better.

It is important to evaluate all the factors of your exposure to create an image: What is the light level, how much action needs to be stopped, how much depth of field is necessary to keep the scene sharp. When you are photographing on a sunny day, it may be most important to have all the depth of field the lens can achieve: You can use the camera's lowest ISO setting with no regard for shutter speed if you place the camera on a tripod so long as the subject remains relatively still. If later that day, some dark clouds roll in, or as the sun goes down, the ISO must increase to capture enough light to stop the action and still have depth of field to keep all of your subject in focus.

Just because the light level goes down, it does not mean that the ISO needs to go up. Shutter speeds can be very long to let light in, but the camera must be tight on a tripod to keep the image sharp, as shown in 2-28; and sometimes, you can use lenses with very wide apertures to let in a lot of light (f/1.4, f/1.8, f/2.8) at the risk of very limited depth of field.

2-28

ABOUT THIS PHOTO *In the dead of night, the camera is set to its base ISO (in this case, ISO 200). To get enough light onto the sensor at that low of a sensitivity, a long exposure was in order, more than 9.5 minutes. Taken at ISO 200, f/5.6, and 561 seconds.*

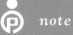
Remember that apertures and shutters are generally discussed in 1 full stop increments and yet digital cameras can make changes on 1/3 f-stop settings? The same is true with ISOs. You can get ISO settings like ISO 160, 320, and 500.

So the ISO setting is just as much of a part of calculating your exposure as aperture and shutter speed, and all three are always working together. When a change is made to any one of these elements, either the exposure changes or one of the elements has to change to keep the exposure consistent. For example, let's say you need more depth of field and the exposure is already correct with settings of ISO 200, f/4, and 1/60 second. Stopping down two f-stops to get to f/8 will increase your depth of field, but you will need to regain the lost light (two f-stops worth of exposure) by either slowing the exposure to 1/15 second or increasing the ISO to 800. You could also adjust both your shutter speed and your ISO by one f-stop to achieve a final exposure setting of ISO 400, f/8, and 1/30 second, as shown in 2-29.

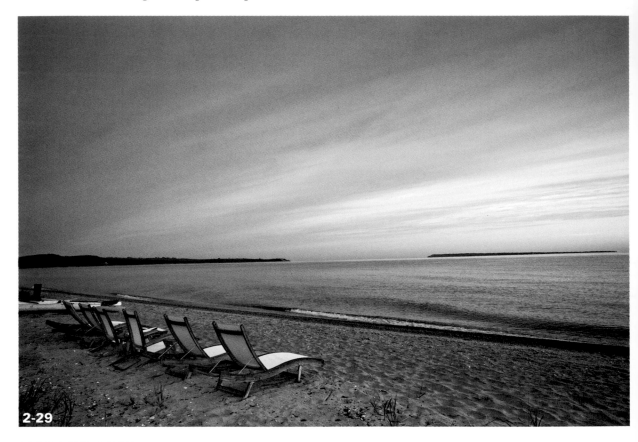

2-29

ABOUT THIS PHOTO *I knew that I wanted to keep as much depth of field as possible to keep the sky and chairs in focus and still maintain the exposure and mood of the image. Because I didn't have a tripod, I compromised both the ISO and shutter speed. Taken at ISO 400, f/8, and 1/30 second.*

WHITE BALANCE

One of the most misunderstood parts of digital photography is white balance. Because the color of light changes depending on the source of light, having the correct white balance is imperative in order to make certain that the colors of the photograph are true to the scene. The human eye does this automatically, or at least our brain makes us think it does. The color of sunlight is far more white, and even bluish, compared to the amber color of an incandescent light bulb. While fluorescent lighting is much more variable, it is usually much more of a green color. Some compact fluorescent bulbs create light colors that are unknown in nature.

By setting the correct white balance for the scene, you have a much better baseline to get the photograph you desire. Even though this book is about black-and-white photography, the effect of color on black-and-white images is immense, as shown in 2-30 through 2-33.

So much of a digital camera's marketing focuses on things like megapixels, while good, accurate, and dependable white balance is just as important. Using the AWB, or Auto White Balance, is fine in many cases, especially if you are going to be using RAW files to make your photographs. In the case of a RAW file, the white balance information is embedded into the file, so making white balance changes in the computer is very easy.

But when you are working with a JPEG file, getting the correct white balance is more important. The image has already been processed by the camera, so changes to the photograph are changes to the actual picture file. This means loss of information with every change, which can lead to inferior image quality.

It is relatively easy to use the White Balance icons to match the light source. When shooting in the sun, set the white balance to the icon with the sun. If it is cloudy or shady, once again, match the white balance to the icon for clouds or shade. Each setting makes things a little *warmer* in tone to balance the *cooler* tone of shaded sun. Flash is also a slightly cool light source, so its white balance setting also tends to warm the image somewhat. Plain-old light bulbs with filaments, often called *tungsten bulbs*, are very amber in color, and the white balance setting in the camera causes the image to be much bluer to keep the photograph from being too yellow.

> **note** *Warm tones* are colors like orange, yellow, and red. *Cool tones* are blues, and you correct them with a white balance that is more red. Warming the image means you increase a red tone in the photograph, balancing a bluish scene to look like true white.

There are two basic ways to fine-tune the white balance in the photograph further. The first option is camera-centric: Use a product like an ExpoDisc or ColorRight Pro. These are essentially white translucent domes that go over the camera's lens, averaging all the actual colors that come into the camera. You make a white balance preset in the camera at that point, and then make photographs at that particular white balance. When shooting JPEGs only, this is a good way to get great white balance, and these tools are not terribly expensive.

To make a white balance preset, follow these steps:

1. **Place the device over the lens so that no extraneous light can come through the lens.**

2. **You can use any exposure mode to capture the white balance preset and then take a photograph, though you may have to turn off the autofocus.**

ABOUT THESE PHOTOS *With different white balance settings come different black-and-white tones and contrast. You can make different settings easily on the computer, but having the correct starting place is important. The warm sunrise tone of 2-30 appears lighter and has less contrast when converted into black and white in 2-31, while in 2-32, the boat with more blue tones seems richer and with more contrast, as is seen when 2-33 is converted into black and white. Neither is right or wrong, but it is important to learn how to interpret the colors as tones. Taken at ISO 400, f7.1, and 1/640 second.*

2-30

2-32

2-31

2-33

3. **Select this new gray frame and then scroll through your camera's White Balance menu until you get to Custom or Preset.**

4. **Select Set.** This process is slightly different on every camera. Refer to your camera's manual or the white balance device for more specific instruction.

The other option is to place some sort of gray or white card, such as a Lastolite EzyBalance, into one of the photographs you are taking in a particular lighting scenario. Once you download the photographs to the computer, it is easy to take a white balance reading from the EzyBalance and then make those changes to all the photographs from that shoot (see 2-34). You usually do this when shooting in RAW, where you can make those changes more precisely.

Using tools like the EzyBalance is fast and easy, especially when white balance is more critical and there is time to place it in a setup shot. Gray cards are great to use with portraits because they help ensure that skin tones are pleasing, or at least neutral, even in mixed or difficult lighting.

COMPOSITION

You can create better images simply by using better composition. Hopefully, some of the compositional ideas and rules in this section may inspire you to explore artistic avenues based on classic elements of design. Black-and-white photography depends more on good and interesting composition than color photography. Without color, you must use stronger design elements to move the viewer's eye to the subject or through the image.

2-34

ABOUT THIS PHOTO *A portrait in mixed lighting calls for more care, so a Lastolite EzyBalance is inserted into the first frame of the shoot. A white balance measurement is then taken from the EzyBalance in Lightroom to get the correct white balance. It is important to get the exposure set and then take the white balance measurement right before you start shooting.*

RULE OF THIRDS

Most of the ideas in this section and the next one are classic ways to build the composition in any work of art, but the Rule of Thirds is truly paramount. It is the first rule taught in virtually every photography or art class there is. When a scene is segmented into three sections horizontally and three sections vertically, the subject should lie on one of the four points of the intersecting lines for an interesting composition (see 2-35). This isn't to say that the Rule of Thirds is the only way to compose a photograph, but it is a great way to get a solid, well-composed image.

BALANCE AND SYMMETRY

When you are creating the composition, you can use many things to create balance. It can be a large background element, a smaller element set away from the subject, or even negative space that balances out the subject matter, as shown in 2-35. Symmetrical images have strong central subjects, or are the same (or similar) side to side or up and down. Often an image with strong symmetry really needs a strong focus to work well and is probably a more serene image, with little compositional tension.

2-35

ABOUT THIS PHOTO *This is one of my favorite photos. As I looked above me, I just quickly composed and snapped, and never thought about it again. The fan is placed exactly on a Rule of Thirds intersection, and just that alone makes the image work. Taken at ISO 200, f/2.8, and 1/20 second with a compact digital camera.*

EXPLORING DESIGN

As you walk through an urban area, you will find it is often filled with fantastic visual elements, such as the architecture, the people, and textures of color and tone. In 2-36, there is all manner of line, a focus with the large planter, and the interest of a person to give the image scale. Using the repetition of the many lines as a design element is always an interesting way to create exciting images.

SHAPE AND SIMPLICITY

No one ever says, "Oh I just love that design, it is so complicated and fussy." I am always taken with the images that are practically stark in their simplicity. Imagine the great fashion and portrait photographer Richard Avedon's fantastic portraits of everyday Americans, all shot with simple lighting on a plain white background to give focus only to the people who are the subjects — nothing more. While that is an extreme, creating images that have only the elements that are needed, and nothing else, is a fantastic assignment.

Use the elements in the photograph to create shapes and find shapes as your subject, as shown in 2-37. Is it a triangle or a chevron? Is it the five-sided shape above the black line, or even the repetition of that triangle subtlety over and over, that encourages a viewer to keep staring?

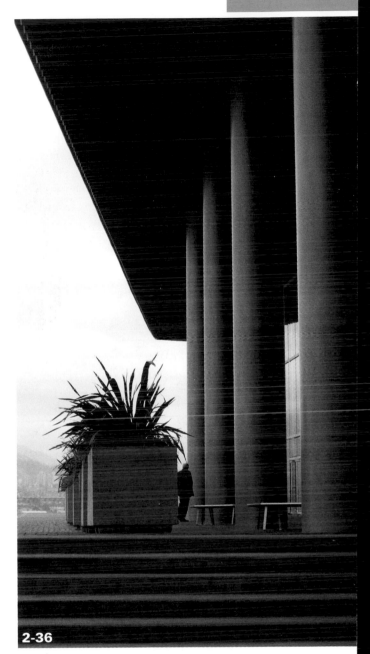

2-36

ABOUT THIS PHOTO *On a gloomy day, the subtleties of the black-and-white tones are very intriguing. The repeating lines and the well-composed elements help to create a harmony, bringing the viewer's eye back to the subject. Taken at ISO 200, f/8, 1/250 second with a 35mm lens on an m4/3 camera.*

2-37

YOUR UNIQUE POINT OF VIEW

Every photographer has his or her own point of view. Everyone is a different height, does different jobs, grew up in different places, has different homes, and takes a different route with their photos. Each of us sees photographs in a different way, so each of us takes photographs in a different way. Use the photos you see in this book and others, online, and in galleries to inspire you and help guide you. The suggestions here are things that simply tend to make photographs better and more than just snapshots.

GET CLOSE TO YOUR SUBJECT

When asked what the best way is to take better photos, a friend of mine used to always say, "Take two steps forward." While this seems like a simplistic answer, and maybe not always possible, trying to get closer to the subject nearly always helps you create better photographs. Think about what you are trying to show and make sure it can

clearly be seen. Moving closer to the subject is one way, but using all of the range of the zoom range can also help.

One thought to keep in mind is to *fill the frame*, making the most of every part of your image; not making things busy, but making them important (see 2-38). One way to practice this is to take a simple travel portrait of a couple or a family in front of some historical building or artifact. Compose the image with the background in the photo, and then have the people move closer to the camera, so that the people can actually be seen in the image.

ANCHOR YOUR PHOTOS

Using a prominent subject as an anchor in the photograph gives you something to build your composition around, as well as a place for the viewer to rest his eyes. This anchor is also the place where you should have the compositional lines in the image move toward and around. In landscape photography, this can be a rock, stump,

2-38

ABOUT THIS PHOTO *Use all the elements in the scene to fill the frame with information and create direction for the eyes to travel around the image. The elements and the textures bring the viewer's eyes in and out and through the composition. Taken at ISO 100, f/11, 1/125 second with a 28mm equivalent lens.*

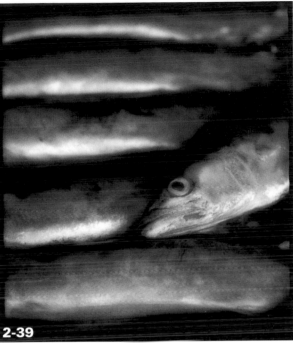

2-39

ABOUT THIS PHOTO *The repeating lines of the fish bodies are interesting on their own, with their organic shapes and tones, but it takes the face of one fish to anchor the image, giving the image a focal point. Taken at ISO 100, f/4, and 1/60 second with a 105mm macro lens.*

flower, or any number of things, such as the fish shown in 2-39. In the case of an image with a lot of repetition in elements or line, it is good to see an anchor, a subject, that breaks the repetition to create more drama and interest.

FIND NATURAL FRAMING

Door frames, buildings, and even a canopy of leaves can help to create a natural frame inside the photograph. Natural framing is a time-tested element of design that helps to draw the focus to the subject and still give the top and edges of the frame some interest. When you are shooting architectural pieces or landscapes, take a look behind you and see where there might be something to frame the image with, such as a tree or overhanging branch; it will not only frame the subject but also might better balance the image, adding compositional weight.

Shooting down a column-lined façade, through an archway, or even down a row of trees are all ways to use natural framing in photography. With black-and-white photography, these natural frames can sometimes be much darker than the rest of the subject, perhaps even creating a shadow or silhouette as a frame, while in a color photo, too much black on the edges is probably distracting and ominous.

GET HIGH AND LOW

The easiest way to create interesting angles on a photograph can be to position yourself high or low. Finding a bird's-eye or worm's-eye view of your subject is a great way to switch up your images.

Shooting the subject from high up can often lead to a broader view, and having more of the ground around your subject can lead to a whimsical look. Viewed from a lower angle, the subject may appear more heroic, larger than life, especially when framed against a sky. Getting all the way to the ground is a fantastic way to see things in a different light, especially with kids, animals, or roads, as shown in 2-40.

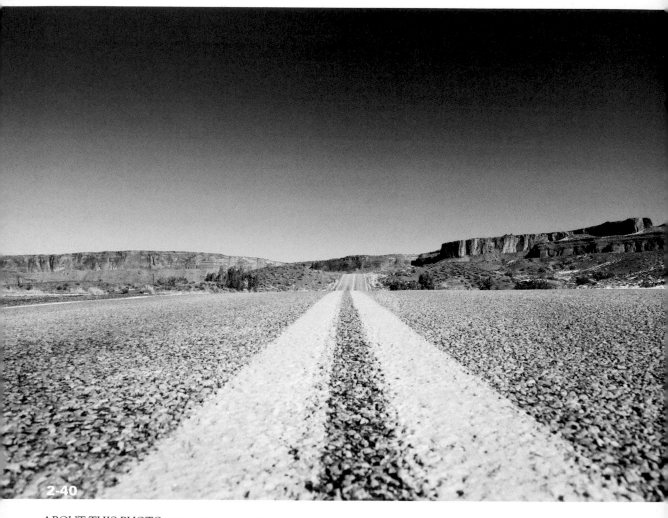

2-40

ABOUT THIS PHOTO *Getting the camera all the way down on the road makes for a very unique point of view on the subject, but don't forget to be careful. Taken at ISO 100, f/8, and 1/500 second with an m4/3 zoom lens set to 14.*

Assignment

Using the histogram to expose

In order to learn how to manage exposure, take the time to find a scene that is predominantly dark or light and use the meter and the histogram to determine the correct exposure. Take a number of photos and then evaluate the images. Think about how the exposure matches the scene and how the meter registered the amount of dark and light tones in the scene.

This white chair in front of a pale wall is a bright subject in rather low lighting. Even though the chair is old and a bit dingy, it is white, and I wanted it rendered as white in the end. Because the room was dark, I had to overexpose the scene +2/3 f-stop to get the tones I desired, which came to an exposure of ISO 100, f/2.2, and 1/40 second. Although the chair is bright, there is still detail and texture in its back.

Remember to visit www.pwassignments.com after you complete this assignment and share your favorite photo! It's a community of enthusiastic photographers and a great place to view what other readers have created. You can also post comments, read encouraging suggestions, and get feedback.

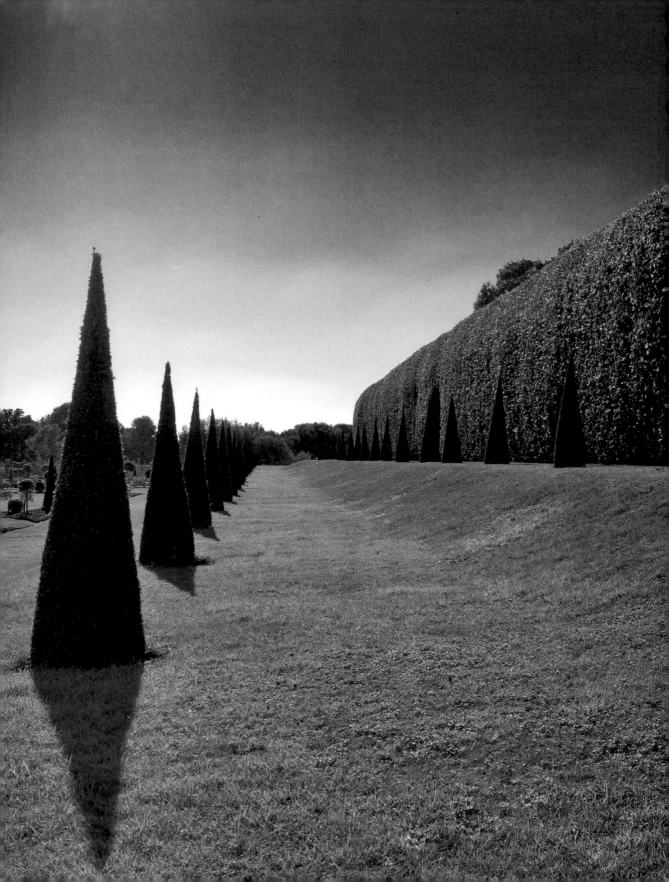

GETTING THE MOST OUT
OF YOUR CAMERA

Many times each week, I am asked which camera I use and, honestly, it's a question I never tire of answering. I often get this during portrait shoots because the subject is thinking about getting a new camera. Sometimes, it comes up during an event because a passerby notices the size of the camera and lens I'm using and is curious about what in the world I have in my hands. Finally, it may come up when my assistant asks me which camera to unpack.

As a professional photographer *and* a photo hobbyist, I own and use a lot of cameras. From pocket-sized digital cameras (see 3-1) to large dSLRs and large-format film cameras, each type of camera has its own function and reason for being in my hands at any particular time. There are so many cameras out there, and they all do a million different things. It is important to know which tools are available on each model, and how to use the different features and functions to create the photographs that you envision.

READ THE MANUAL

Virtually everyone who owns a camera — from my mother and my neighbor to my students — has a question about its operation. Inevitably, I answer that question with another: "Have you looked to see what it says about that in the owner's manual?"

One of my photography professors once shared the contents of his camera bag and I was surprised that, not only did he have the manual with him, he also discussed in great length the importance of keeping it with you at all times.

After a new camera purchase, you should at the very least, do a thorough perusal of the manual. I think it's even better to sit down with the camera, the manual, and a pad of sticky notes for an

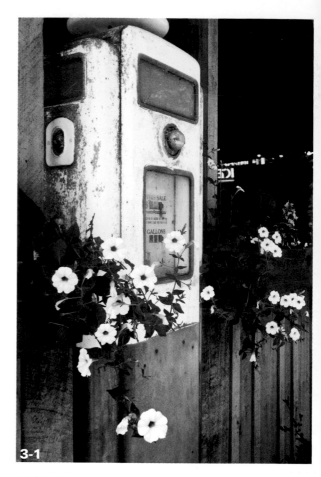

3-1

ABOUT THIS PHOTO *An old gas station makes for an interesting subject when surrounded by some summer flowers. Having a compact digital camera with me while cycling through rural areas enables me to work on some black-and-white creativity without being overburdened. Taken at 1SO 100, f/5.6, and 1/200 second with a 20mm lens on an m4/3 camera.*

evening of flagging new or interesting features. This makes it easier to go back later to things that are important.

Many digital cameras have some sort of quick-start guide, which is fantastic if you are going to be taking snapshots right away. However, to get the most out of all the amazing features your camera has, it is imperative to read the manual from cover to cover.

Most manuals not only explain the tools and fea-tures of the camera but also how to access them, which can usually be done in a number of ways. For example, you might be able to access a partic-ular option both by pressing a button and through a menu.

Given all the amazing things that digital cameras do, if you have the manual at your fingertips, it can help spur your interest in a particular scene (see 3-2). Review it while you are waiting for the sun to move in the right place, or while commut-ing or waiting for an appointment. Inevitably you

will discover something that the camera can do that you weren't aware of or information that will help you with a photographic challenge at the next shoot.

Learning how to change the exposure, focus, white balance, and file format settings are the first and most important steps in setting up the cam-era. Go through the manual to learn where these settings are until they become second nature.

note

If your camera manual leaves some-thing to be desired, check out the Digital Field Guides from Wiley Publishing. They are written by photographers for photographers and pro-vide real-world examples of how to operate the settings on today's dSLRs. They have all the information that the manual has, plus more, in a far more user-friendly format.

3-2

ABOUT THIS PHOTO *The smooth tones and texture of a stone sculpture contrast with the busy foliage in the background. A shallow depth of field helps keep sculpture and the background separate. Taken at 1SO 400, f/5.6, and 1/30 second with an 18-200mm lens set to 112mm.*

There are several settings in the camera that don't affect the photograph but simply manage how the camera operates for ease of use or to allow you to do certain things. These are usually called *custom functions* and help you set up the camera to maximize the camera's functionality.

Custom functions do things like give you access through specific function buttons to various modes, timers, sounds, drive speeds, image aspect ratio settings, and so on. You can set up these custom functions initially to your preferences and then never change them again, or you may change them often, depending on the situation.

You may think all this time and space devoted to discussing reading the camera's manual is overkill, but far too many people don't read their manuals, and until you are comfortable with the equipment you are using and understand how it works, you will struggle to get good results. A photographer who doesn't think she needs to read the manual is exactly the person who needs to read it.

KNOWING THE CONTROLS

Just like reading the manual, getting familiar with the buttons and menus on your camera really is vital to being able to create great photographs. It is important to know where you need to go to access the functions that control your camera. If you don't know where those tools, features, and functions are, you could lose shots while fumbling through the menu, all the while mumbling about focus zones and drive options and not seeing, let alone photographing, your kid getting the winning goal.

While you read the manual, have your camera with you so you can see how the options appear and what the different settings do. Think about how and when you might use a particular feature, and then practice going back to it quickly so that when the scene changes, it is easy to make changes to the camera to get the best photograph possible (see 3-3).

One of my favorite quotes is, "You get good at what you practice." When it comes to the camera, this means going through those settings that are important and often used, so that when it is

3-3

ABOUT THIS PHOTO *Going from using a flash to using window light is a big change. It was important to change the aperture, ISO, and focus mode quickly. Being familiar with the settings on my camera allowed me to quickly switch to the right settings to capture a fast-moving toddler. Taken at ISO 800, f/4, and 1/160 second with a 50mm lens.*

YOUR DSLR AND FOCUSING. The focus mode has three basic settings: Manual Focus, where you turn the focusing ring with your hand to achieve correct focus; Single Focus, where the autofocus lock focuses on a particular point when you press the shutter release halfway down, and then you can either shoot or recompose; and Continuous Focus, which allows the autofocus system to continue to track the subject, keeping it in focus as it moves around within the scene. These modes may have different names depending on the camera brand and model.

Additionally, today's dSLR has many new autofocus features. These features include "smart" focus options such as facial recognition, which selects, focuses on, and then tracks particular faces in a scene; or the smile option, which takes the photo when the subjects are smiling. These options are directed toward inexperienced photographers, but can be useful in situations when it may be easier to let the camera do all the work. Although there are uses for all these tools, most serious photography is still done with the basic single-point autofocus or manual focus settings.

time to shoot, everything is ready for the shot. Know how the camera is set up before it is time to shoot and think ahead about what changes you might need to make after the first exposure or test frame.

It is a good idea to think through the process of setting up the camera by going from the biggest tools to the smallest tools. Think about the most important settings when creating the image — file size, exposure, focus, and white balance, and if those are set correctly, everything else may be just fluff. Knowing those four settings and how to access them are critical. All four are discussed later in this chapter.

If you are moving up to a better digital camera, figure out which settings have changed from the camera you're used to and which are the same. On my dSLR cameras, I prefer some dials and settings to be different from the default settings. Knowing how to easily access important settings makes it easy for me to preset them on a new camera, or on a camera that I borrow or rent, and I can be up to speed very quickly.

USING THE EXPOSURE MODES

The exposure modes allow you to best create an exposure for a given scene. Different exposure modes affect how much you or the camera makes the decision on how the lightness and darkness of the scene is represented. The main exposure modes discussed here are as follows:

- **Program mode (P).** Uses the camera's meter setting to have the camera select both the shutter speed and the aperture for the scene.

- **Aperture Priority mode (A).** Allows the photographer to select the aperture, and then the camera selects the appropriate shutter speed in accordance to the camera's meter reading.

- **Shutter Priority mode (S).** Allows the photographer to select the shutter speed, and then the camera selects the appropriate aperture in accordance to the camera's meter reading.

- **Manual mode (M).** Lets the photographer select both the aperture and the shutter speed.

Each mode has a distinct purpose, with Program providing the photographer with the freedom of not worrying about exposure because the camera makes the exposure decisions. This may be considered the easy way to get photos, and for someone who is learning, in tricky situations, or when the action is happening too fast to make manual changes to the camera, Program might be just the ticket.

However, the limitations of Program mode are obvious: The camera doesn't know what the subject of the photograph is or what sort of look you're going for. Program mode only gives you a good exposure of the scene, not necessarily the correct exposure for the vision that you had in mind. In most cases, you can use exposure compensation to override the exposures chosen by Program mode. This is a great way to take no-brainer photos, but still make the changes to lightness and darkness you desire.

The two semi-automatic modes — Aperture Priority and Shutter Priority — allow you to make some creative decisions and free you up to focus on composition and positioning because the camera helps with the exposure. Every time you make a change in one of these modes, the camera changes accordingly, keeping the actual exposure value consistent until there are light changes that necessitate a change. These modes also help you by maintaining at least one constant (the aperture or the shutter) so that even if the light changes, that most important setting stays constant (see 3-4).

Aperture Priority gives you the ability to set the aperture, and the camera selects the shutter speed to get the correct exposure. Once you decide the amount of depth of field you desire for the scene, you are free to compose at will. A quick check to make sure the shutter speed is adequate for whatever the action is in the scene is a good idea, as is confirming how bright or dark the exposure is. Using exposure compensation is a great and quick way to get the exposure correct with Aperture Priority mode.

Shutter Priority mode lets you determine how much action-freezing speed or blur you want in a scene; the camera decides the aperture. This is the exact opposite to Aperture Priority. Once you determine the amount of blur or action, the aperture changes as needed; however, it is without regard to depth of field, so a quick check of the aperture setting is a good idea to confirm adequate depth of field. Then you can shoot away, knowing that it is possible to easily make the exposure lighter or darker with exposure compensation.

With Manual mode, you can change both the shutter and the aperture independently. Whether you are using the camera's meter as a guide, the histogram and LCD screen, a handheld meter, or simply guessing, Manual mode gives you the most control when creating your image.

ABOUT THIS PHOTO With the sun moving in and out of the clouds, it was important to maintain a good depth of field to keep the grass in the foreground in focus as well as the cloud formation, with the actual focus point aimed at the large dark tree. Taken at ISO 200, f/10, and 1/640 second with a 28-70mm lens set to 28mm.

Not all digital cameras offer manual control, but all dSLRs do, as do most of the higher-end compacts. Manual not only gives you the most creative control to a scene, but it also provides consistency to the exposures. Even if the lighting changes in one part of a scene, if you stay in Manual mode, the exposure stays consistent; conversely, in the auto exposure modes, there could be changes to the exposure that might not be good for the image.

The consistency of Manual mode as opposed to the autoexposure modes becomes most apparent when the background of a scene changes. An example of this might be when you are shooting a portrait: As you explore different angles, the light on the subject remains static, but the light coming in from the back might change drastically with just a small composition change. An autoexposure mode would see this change in brightness and make a correction. By keeping the camera in Manual mode, the exposure on the subject remains correct (see 3-5).

ABOUT THIS PHOTO *Keeping the camera in Manual mode keeps the exposure consistent. Moving the camera around for different composi-tions may mean the brightness in a scene, especially the background, will skew the meter's reading, even though the light on the subject hasn't changed. Taken at ISO 400, f/1.8, and 1/320 second with a 50mm lens.*

3-5

READING THE HISTOGRAM

Minimizing the loss of detail information in both the dark and light parts of the scene is the most important thing that the histogram can help you do. By reading the histogram and evaluating that information along with the brightness, darkness, and contrast in the scene, it is fairly easy to figure out how to get the correct exposure, even in tricky situations.

In a scene that is relatively low in contrast, such as an overcast day (see 3-6) or a portrait in open shade or indoors with no direct sun, there are often very few deep blacks or blown-out whites.

In these cases, the histogram will appear as a bell curve, with all the exposure information, expressed as pixel bars, concentrated in the middle of the histogram. The contrast would be considered low in this scene, as the light is coming from all angles above the scene and the sky itself is not appreciably brighter than the rest of the scene.

As soon as the sun starts to shine, exposure becomes more challenging because of the wide range of the light spectrum within the scene. Sunlight hitting a subject makes the subject very bright, and in most cases, the subject with that sun-

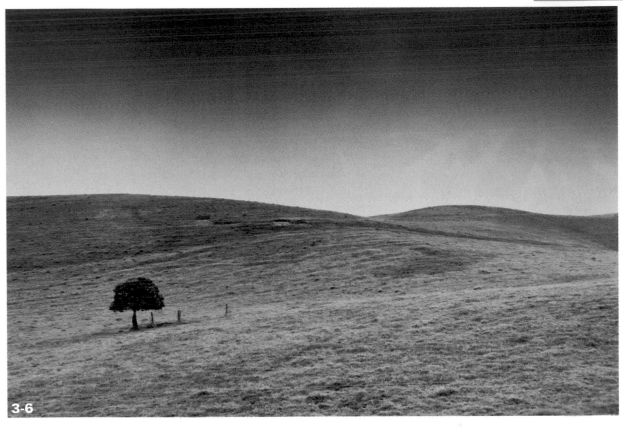

3-6

ABOUT THIS PHOTO *With the soft shapes of the undulating ground as a background, the only real contrast is the dark tree against the light gray tones of the grasses. The darkness of the stormy sky helps create the drama without increased contrast. Taken at ISO 200, f/8, and 1/80 second with an 18-200mm lens set to 35mm.*

light on it becomes the most important part of the exposure to tame. This may come at the expense of shadow detail because the contrast level is just too great to capture in one exposure (see 3-7).

In order to get more detail in the branches, the exposure would have to be brightened, and this would wash out most of the texture in the stone. Paying attention to the histogram in this situation helped get the exposure where it needed to be so that the scene was as bright as possible without blowing out the rocks.

When the subject matter is fully bathed in the same light, whether it is cloudy or sunny, reading the histograms and their exposures is pretty

straightforward, but important nonetheless. Not until there are important parts of the scene that are in different light do these exposure issues really become problematic. This can happen depending on lighting conditions and even simply light direction. When a scene is backlit, it is often a challenge to get the correct exposure, so learning how to read the histogram is vital.

x-ref

For more information on lighting, light direction, and light quality, see Chapter 4.

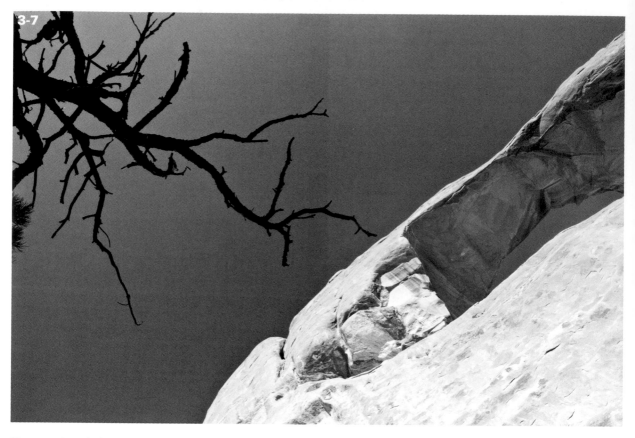

Keep in mind that the meter in a digital camera is very smart but can be fooled: It will attempt to tell the camera what settings are needed for a middle gray. When looking at scenes with large amounts of dark and light tones, pay careful attention to what the histogram is showing so you can make the necessary changes.

To make sure that there is enough detail in both the shadows and the highlights in a scene, you must do careful metering. For example, in order to frame the scene of the valley with the great archway in 3-8, I included a large area of shadow area across the bottom of the archway, which was instrumental in pushing the view out into the valley and mountains. It was also important to show some detail and texture in the overhanging

rock, while making sure the large expanse of shadow didn't affect the meter and wash out the tones of the sun-lit rocks and valley.

As bright as the scene and sun were when I took this photograph, it was very difficult to see the image on the LCD screen to get an accurate view of the exposure. Using the histogram, it was easy to get to an exposure that compensated for the large shadow area, but still had rich enough tones in the rocks.

You can see from the image's histogram that although there are a lot of dark tones, shown by the pixel bars grouped on the left side of the histogram's graph, none of them come all the way up to the left wall of the histogram. Even though there are a lot of light tones in the snow and sky areas, they aren't overexposed and washed out.

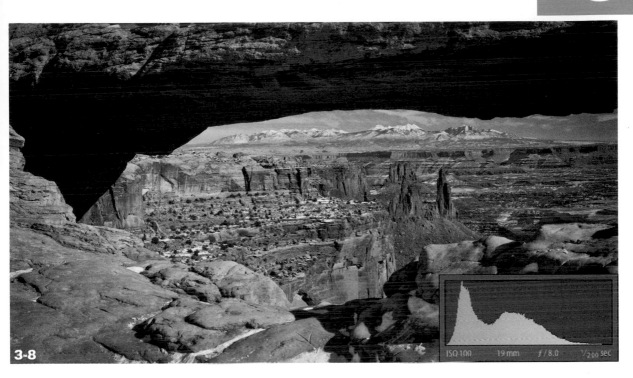

3-8

ISO 100 19mm f /8.0 1/200 sec

ABOUT THIS PHOTO *Making sure there was texture in the shadow underneath the arch and still rich tones where the sun was hitting the stone was a struggle, but by creating an exposure guided by the histogram, it was easy. Taken at ISO 100, f/8.0, and 1/200 second with a 19mm m4/3 lens.*

EXPOSING TO THE RIGHT

As discussed in Chapter 2, it is important to maintain highlight detail; in fact, that is probably the most important part of good exposure. While you learn to use the histogram, start thinking about exposing to the right. That means essentially that the pixel bars on the camera's histogram should be just coming to a point at the bottom-right corner of the histogram graph. This allows the image to have some bright tones and a good overall gradation of tones without losing any highlight detail. Use the highlight warning option on your camera and set the exposure to get the histogram information to slide right up to the right side — just not too much.

This may mean that you actually are overexposing the scene just a little bit in some cases. That should be okay, but for a scene with a lot of dark tones in it, it may take some computer work to increase the blacks and the richness of the dark tones. If that means there is plenty of tonal range to work with, it is a good problem to have.

In instances when the lighting is very bright or dramatic, it can be tempting to underexpose the image just a bit to make it appear slightly richer on the LCD. This is okay to do in some cases, but when you try to use the exposing-to-the-right theory, it is better to use either manual exposure or exposure compensation to get the pixel bars to come right up to the lower right-hand corner of the histogram. This gives the image plenty of light tones, but will not overexpose the highlights (see 3-9).

It may take a bit of practice with the histogram to get this right, but in the end it gives you more information in the image. This in turn allows you to take your photographs further than you had previously, and helps you create a better final image.

73

ABOUT THIS PHOTO *The amount of contrast and texture in the front of England's Salisbury Cathedral in mid-afternoon was immense, but with careful exposure, it was pretty easy to get a great image with full, rich, black-and-white tones by exposing to the right. Taken at ISO 250, f/8, and 1/250 second with a 14-45mm m4/3 zoom set to 14mm.*

FILE SETTINGS

File formats are indicated by the .jpg or .tif (for example) extensions at the end of the filenames of the photographs. There are many different types of digital file formats, each of which has its pros, cons, and best uses. In the black-and-white world, there are only a few that really need to be discussed at great length; the purpose of this section is to explain and perhaps de-mystify them, and to help you focus on the things that really matter in black-and-white photography.

IMAGE QUALITY

Although there are many different in-camera options when it comes to creating the actual photo file, the JPEG file format is a universal, compressed photographic file. JPEGs can be e-mailed, printed, put into slide shows or Word documents, and used on Web sites. JPEGs are probably best on a screen or a monitor, although they can be printed if they are high-resolution.

Most digital cameras can create JPEGs with two types of specifications for that photograph: the settings for file size, which selects how many

74

pixels actually make up the photographic image; and the settings for the *compression ratio*, which determines how much those pixels are compressed into that file.

When you shoot JPEG photos, it is very important to shoot the largest file size available and use the least amount of compression. The size of the JPEG photo file is often designated as Small, Medium, or Large, with Small being Web quality and Large being a good enough quality for printing.

The compression ratio is often called *quality*, and has settings such as:

- **Basic.** Highest compression. Makes the file size small.

- **Normal.** Medium compression. For small prints or large Web images.

- **Fine.** Low compression. Can be used to print.

- **Superfine.** Lowest compression. Makes the largest, highest quality, image.

Use the largest file size and whatever compression rate is lowest, fine or superfine, to get the highest quality digital photo files, which in turn produce the highest quality images. Check out your camera's manual if you have questions because each camera has slightly different ways to access the quality settings and may have different designations.

The dSLRs and higher-end compact digital cameras are able to save RAW files. RAW files are truly analogous to the digital negative. They contain all the image information at its most complete. RAW files enable you to get the best image quality and the most flexibility in your digital files.

The amount of options you have for fine-tuning a photograph from a RAW file once it is in the computer are nearly limitless. This is not so with JPEGs, which are already processed in camera, so any changes made to the JPEG are made on top

of the settings that are already there. This is very important in black-and-white photography because the tone and contrast are largely locked in with a JPEG photo, while you can process the RAW file to get much better image quality and control in the tones and contrast.

All digital cameras capture the same amount of information, but unless the camera is able to save images as RAW and the option is selected in the camera, the camera discards extra information and only saves what fits in the JPEG file. Additionally, most basic photographic software — such as iPhoto and WindowsLive Photo Gallery — cannot process a RAW file.

It is necessary to use a RAW converter to process the image into a file format that can be used, such as a JPEG or TIF file, for printing or to use on the Web. Most digital cameras that will save RAW files include a disc of software to install in your computer that will allow processing and conversion of the RAW files from that particular camera manufacturer. The most common RAW converters come from manufacturers such as Adobe. Adobe has an application called Adobe Camera Raw (or ACR), which is included in Photoshop and Photoshop Elements and is integrated into Lightroom. There are other RAW converters available, such as Aperture from Apple, Bibble from Bibble Labs, Phase One, and even Picasa from Google.

note

Some cameras can create TIF files. TIFs are very large, uncompressed files processed by the camera, so they are much larger than JPEGs, but don't have the versatility of the RAW file. I think shooting TIF straight out of the camera is really of no use to anyone. I suppose if you need the biggest, best quality image available and have no time to process it in the computer, using the TIF file format might work, but for as good as some camera's JPEGs are, it probably still isn't worth it.

One of the biggest benefits of shooting in RAW is you can capture in 12 or 14 bit color, which is then converted to 16-bit color in the image editing software, versus the JPEG's 8-bit color. With 8-bit color, the image captures 16.8 million colors, while with 16-bit color, it captures an incredible 281 trillion colors.

There are people who might say it is impossible to see even 16.8 million colors, let alone trillions of colors, and question how it can possibly affect black-and-white photography. The answer is simply that it provides flexibility and smoothness. Even when you are working in only gray tones, having the additional information of 16-bit color allows for far smoother tones as the image goes from light to black. It also allows for more detail in the shadows and highlights and minimizes a problem called *banding*, which is when you literally see steps of different tones instead of a gradation of black to white.

After you have converted the image in RAW, and perfected the white balance, tones, and exposure, you can then covert the image to black and white, where you can really perfect it. The end result can then be whatever you need for the optimization of the image, whether you are going to use it for a Web site, book, or print.

RAW + JPEG

Most current digital cameras that shoot RAW files can shoot and save both a JPEG and a RAW file concurrently (some even put the different file formats on different memory cards, but that is another story). Even though there are limitations to the JPEG file, shooting both at the same time gives you even more flexibility than just shooting one or the other.

I am sure that there are those who would say that this is just a waste of digital storage and processor power, but there are a few reasons to shoot this way that can make your life a little easier.

The first is simply that by shooting a black-and-white JPEG, you have a visible marker that black and white was part of your thought process when you took the image; when you use RAW files only, when they are initially viewed in most photo browsers, they appear with the default settings, not the settings applied in camera. If you took a lot of images at different settings or if it takes a while for you to get to the editing part of the shoot, it is good to have that reminder.

The second reason is simply so that you have a usable image right away. If you need to send a JPEG to family, friends, or a client, it is great to have that JPEG file available for immediate gratification.

WHITE BALANCE ON BLACK AND WHITE While it is not nearly as important to get the white balance correct for a black and white photograph as it is for a color image, it can be important. Adjustments in the black and white conversion process are done through groups of color. Knowing that your color is correct gives you a better baseline with which to make adjustments to your black-and-white image's contrast and tone. If the image has a heavy color cast, when the luminance of a particular color group is adjusted this may mean that almost no changes are made or that the changes are too drastic.

Last, every once in a while, the camera's settings are *exactly* what you had in mind. Whether it is due to the way the camera interprets the color or makes the black and white conversion, or it may even be a fortunate accident, sometimes that JPEG just nails it.

When I shot this image of a young boxer in 3-10, I had the camera set to take black-and-white JPEGs along with RAW files. During the editing process, most of the RAW images were converted into black and white, but for some reason, no matter how much I adjusted the contrast and tone, the image that the JPEG created was exactly my vision of that photograph. The quality was good enough to print the image at roughly 40 × 40 inches. However, I did still have to convert many of the other images from that shoot from the RAW files to get the most out of them.

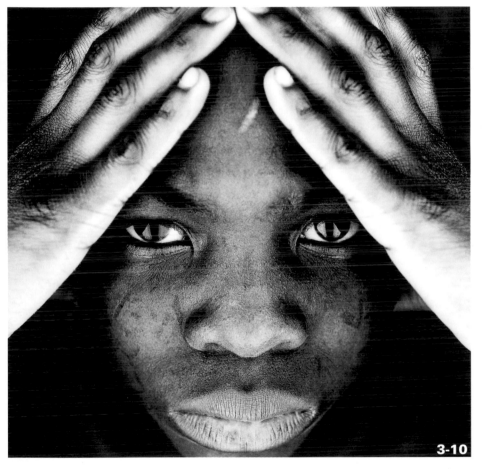

ABOUT THIS PHOTO
Even though RAW is best for most applications, this image is created from the original black-and-white JPEG photo file. No amount of changes to the tones and contrast in the RAW file could match what appeared in the JPEG. Taken at ISO 200, f/4, and 1/60 second with a 50mm lens.

3-10

ADJUSTING TONE AND CONTRAST IN CAMERA

The best way to get the most out of your digital black-and-white photograph is to take a RAW photo file, process the image in one of the RAW converters discussed earlier in this chapter, and then fine-tune it. You can do your post-processing in Adobe Lightroom, some version of Photoshop, or perhaps even use an aftermarket plug-in like Silver Efex Pro from Nik Software. The steps for converting RAW images are covered in Chapters 6 and 7.

However, there are ways you can adjust the look of your black-and-white JPEG files right in the camera. Remember that the settings that you make to your photographs in the camera are only applied to the JPEG image; the RAW image does not get the full host of adjustments. You make these changes to your RAW files in the computer.

Although each camera is different, most camera menus include settings that change the look of the photos. These settings have names like Picture Control, Film Mode, or Picture Style, Vivid, Neutral, or Standard; these are color settings, but there will be Monochrome or Black-and-White settings as well.

Once you are in a Monochrome or Black-and-White setting, there are additional ways to fine-tune the setting. Each camera is different, so please check your manual, but there are usually ways to increase or decrease the contrast, as well as add a tone to the monochrome image, giving black-and-white images blue, sepia, or yellow tones, or even more.

In the days of film, photographers used color filters to give different tones to black-and-white film. These colored filters increase and decrease

contrast in an image depending on the color of the filter and the colors in the image. For more on filters, see the section on using filters later in this chapter.

It is possible to use a digital filter to create a similar effect when you are creating a digital image within the camera. With a red filter effect, red tones end up lighter in tone and a blue sky becomes much darker, while a green filter effect enriches the reds, the sky becomes more neutral, and overall the image has somewhat less contrast (see 3-11 and 3-12). Neither image is right or wrong; they are just interpretations of the scene with the different filter effects from the camera.

Effects in black and white can be substantial or minimal depending on the color palette of the scene as well as the existing lighting and the contrast. After you set your camera to a particular filter setting that you like, most digital cameras enable you to save the settings. This is a great way to experiment with how different effects compare in different situations, or to make sure you have the settings perfect for each type of photography you encounter.

If you plan to use color JPEGs to convert to black and white, it is probably best to keep the color settings in the camera set to neutral or standard. If the JPEG is set to Vivid or Vibrant, or the saturation and contrast are turned up to a high level, getting smooth tones and subtle contrast becomes a challenge, and the gray tones become kind of blocky and unnatural.

tip — Make sure to keep the camera manual close for reference on how to best access the different types of black-and-white photo filters and how to save the settings until going back to them becomes second nature. It won't take long.

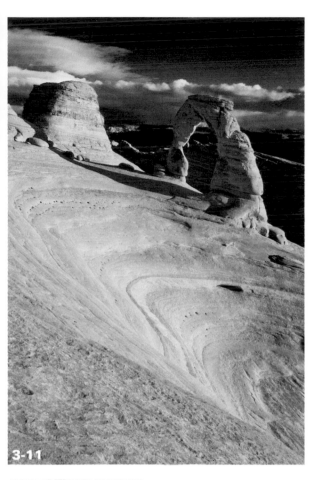

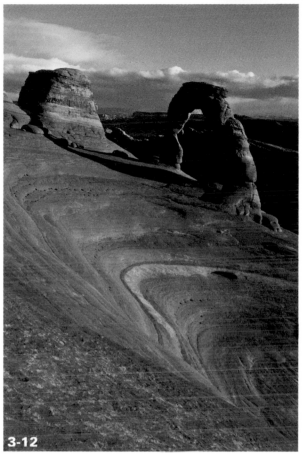

ABOUT THESE PHOTOS *Red rocks and blue skies are always interesting subjects for black-and-white photography. Taking advantage of the camera settings to change the contrast enables you to make quick and dramatic changes to your images. The image with the dark sky is taken with the equivalent of a red filter, while the image with the pale sky is taken with a green filter. Both photos taken at ISO 200, f/10, and 1/250 second with a 17-35mm zoom set to 22mm.*

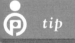 *tip*

Remember the settings that you make in camera are made to the JPEG photo only, and if you set the camera to RAW + JPEG, you can try all manner of things and experiment all you want because when it is time to work on the images in your computer, you still have RAW files that are perfectly pure and ready for new experimentation.

WHITE BALANCE QUESTIONS

The *white balance* is the ability for the image to get the correct color depending on what the color of the light source is. For example, sunlight in the middle of the day is very white to almost blue, while sunlight at the dawn or dusk is much more amber in tone, and the light color on a cloudy

day is much more of a blue tone. Additionally, the color of artificial light is extremely variable, with flash light blue, fluorescent lights greenish, and regular incandescent light bulbs very warm, with an amber color.

As you saw in the last section, different colors make changes to the tone and contrast of a black-and-white photograph. So maintaining the correct white balance for the scene is a good place to start. You can set white balance by evaluating what the light source is in the scene and then selecting that setting from the different white balance options on your camera's menu.

When you shoot images like portraits, it is usually preferable to see people's skin with more of a warm tone; to do that, simply set a slightly warmer setting than the actual light source. For example, if the subject is in midday sun, use the cloudy setting. Slightly warmer settings will not create huge differences in your black-and-white images, but having the correct white balance for the scene should start you off on the right foot for success.

One way to see just how much the white balance changes a black-and-white photograph is to open the image into a RAW converter like Adobe Camera Raw or Lightroom or Apple Aperture; for this test, it's okay to use any type of photo file. After the image opens in the software, select Black and White or Monochrome and then just slide the White Balance Temperature slide from one side to the other to see just how much change can happen in a black-and-white image.

Just using the white balance changes the image from "really terrible looking" to "hey that looks pretty close to how I want it" in a very short time, so it can be a great place to start when you get to the computer and start working on the images.

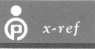

x-ref

More information on how colors affect black and white is in Chapters 6 and 7.

USING FILTERS

Using filters in black-and-white photography used to be an absolute must. If photographers could not change contrast and tones with red, orange, yellow, blue, and green filters, many of the classic black-and-white images that have been created over the years would appear in muddled-up gray. With digital photography comes all new tools in the computer that give you even greater contrast control, as well as tools that emulate the look of filters. Although, there are a few filters that cannot be replaced in the computer.

BLACK-AND-WHITE CONTRAST FILTERS

Although this book is aimed at the digital photographer, it is important to discuss how things worked in film to really understand how images translate in the digital world. Photographers don't attach the solid-colored, screw-on, black-and-white contrast filters in front of the lens anymore because they are generally using a color RAW file to capture all the information and then converting it to black and white. Technically, you can shoot black-and-white JPEGs and use those filters to change the colors, but then your RAW files will have far too much color in them to make the image useful. Additionally, without the filter on the camera, it is much easier to see, focus, and compose through the viewfinder.

The contrast filters have to do with the transmission of light color. A red filter, probably the most popular one, allows red light through, but not so much blue or green light; for example, red rocks

from the desert southwest appear bright and blue skies become nearly black. Red filters create an extreme black-and-white skin tone, even making skin look translucent. Even a simple landscape shot in the middle of the day can become quite dramatic when a red filter is applied. The contrast becomes quite extreme, and the image quite compelling (see 3-13).

A yellow or orange filter causes skin to appear softer and perhaps have a bit of glow. In 3-14, the orange filter makes the boy's skin look bright and healthy, and it pops out from the background. Remember that when you are changing the color of the filter effect, it changes the look of every color in the image, not just part of it.

With a lot of foliage, the effect of a green filter may seem subtle, but it really gives a lot of definition to all the textures. Green filters are often overlooked because of how dramatic the skies may look with a red or orange filter, but if you want some enhanced contrast, and an image with skies that looks a bit more realistic, the effect of a green filter is fantastic (see 3-15).

Although the effects in the previous three images were done digitally, they are accurate representations of how different black-and-white contrast filters affect images. When you look at the settings in the camera and in the computer, the effects are still designated in many cases as Red, Orange, Yellow, and Green filters in the

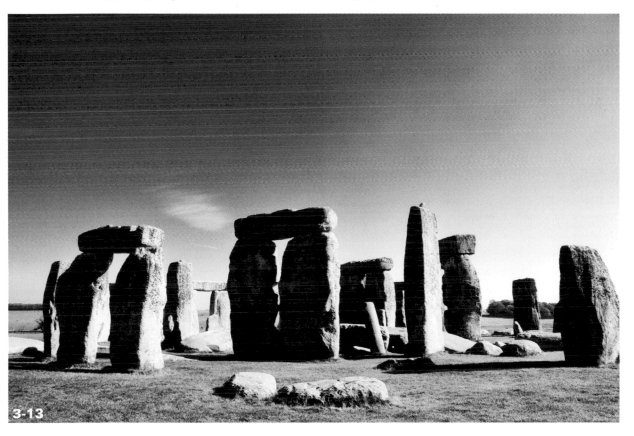

3-13

ABOUT THIS PHOTO *Hard sunlight, along with the high contrast of a red contrast filter effect added in the computer, makes for a very high contrast image, with bright highlights on some parts of the rock contrasting against deep shadows. Taken at ISO 200, f/10, and 1/250 second with an 18-200mm zoom lens set to 18.*

3-14

3-15

ABOUT THIS PHOTO *Early in the morning, with just a peak of sunlight lighting up the child, made for a great portrait. The orange filter makes him looks bright and his skin perfect. Taken at ISO 400, f/4, and 1/1250 second with a 70-200mm lens set to 120.*

ABOUT THIS PHOTO *Using a green filter is very helpful for getting some great definition and detail out of foliage. Other filters may make the foliage look like a mass of green busyness, but with a green filter, the separation of all the different green tones is obvious. Taken at ISO 100, f/8, and 1/200 second with a 28mm lens.*

Monochrome settings. Even though the old glass filters are not used in digital photography, understanding the process that creates these effects will go a long way in helping you understand more of how filters work with black-and-white photography.

Pay attention to color and how it is rendered in your black-and-white photographs. As I go further into how to make adjustments in the

computer, you'll benefit from the ability to see bold and subtle changes within a black-and-white image that different filters render. Understanding that a red filter allows more of the light from a red object into the exposure (rendering that object lighter in your exposure) and less of the light of opposite colors (rendering them darker) will help you start visualizing what your black-and-white images can look like.

POLARIZING FILTER

The polarizing filter remains indispensible. There are computer effects that do just about anything imaginable to a photograph, but the look you achieve with a physical, polarizing filter just cannot be duplicated. There are even Photoshop filters and plug-ins that purport to create a similar effect, but these computer-based solutions cannot match what a polarizing filter does.

A *polarizing filter* is a neutrally toned filter that aligns the light waves as they pass through the lens and into the camera. In nature, light rays bounce all over, ricocheting from each surface at whatever angle they hit. The polarizer directs those light rays in the same direction as they pass through the filter. This enables you to better control the light-ray reflections; by turning the polarizing filter to maximize the angle of the reflections, the reflections can be almost eliminated or exaggerated.

With a polarizing filter, colors become more saturated, skies can become darker, and overall, the image is richer and has more contrast. This works in black and white fantastically, sometimes making scenes have a more defined look because the colors that are being transformed into gray tones are much more saturated than otherwise. Gray skies suddenly look dark gray or black; a polarizing filter with a red filter guarantees dark, rich skies with a lot of contrast between sky and clouds.

Polarizing filters are best used outdoors for landscapes and architectural images. Depending on the angle of the sun, the effect of the filter may be stronger or weaker. There tends to be more of an effect if the sun is at a right angle to the lens; for example, if the light is coming from the sides

or top of the scene, as opposed to a scene where the camera faces into the light or is behind the photographer, the effect is less pronounced.

With a wide-angle lens, it is important to pay attention to exactly what the polarizing effect is doing to the sky. It may be creating a dark area across the middle of the sky with brighter edges. Try to turn the polarizing filter so that there is a gradual darkening of the sky in the area that looks the best. This may mean the graduation comes from a particular corner as opposed to just straight from the top (see 3-16).

When you are shopping for polarizing filters, I have two suggestions. First, it is important to get a circular polarizing filter as opposed to a linear polarizer. There are already sensors inside the camera that have built-in polarizers, such as the autofocus sensor, so depending on the orientation of the filter, a linear polarizing filter may not allow light to strike those sensors properly. The circular polarizing filter essentially has a coating that allows for the light to pass into the camera's sensors at multiple angles. Second, buy the best polarizing filter possible. Inexpensive filters may cause unwanted color shifts and fringing. In black-and-white photography, this makes the images not look sharp and crisp.

NEUTRAL DENSITY FILTERS

Much like polarizing filters, *neutral density* (ND) filters have no color to them, but unlike a polarizing filter, all an ND filter does is cut the amount of light that comes through the filter. The biggest reason to use an ND filter is to allow for a lower shutter speed. This allows for the blurring of a

3-16

ABOUT THIS PHOTO *Later in the day the polarizing filter may not have quite as much effect because the direction and quality of the light is better than at midday. Turning the polarizer enables you to change how much and where the sky may darken. Taken at ISO 100, f/8, and 1/40 second with an 18-200mm zoom lens set to 18.*

subject, even in relatively bright light (see 3-17). On a bright day, there is simply too much light to get a slow-enough shutter speed to get an adequate blurring of the movement of the water without using a neutral density filter.

There are many different kinds of ND filters. Examples include circular glass ones, ones made of high impact polyester, and large square or rectangular glass filters that fit over large lenses like those on movie cameras and large-format lenses. ND filters also come in different strengths, with each strength letting a different amount of light through.

 note ND filters are designated by the amount of f-stops of light that they cut. For example, you may want to get a 1-stop ND filter or a 3-stop ND filter for the effect that you want to create.

There are also *variable ND* filters where the filter elements turn, changing the amount of density and effectively cutting more and more light. These can be expensive, especially if they come from one of the better filter makers, such as Singh-Ray, but if you take care of them and use them often, they pay for themselves over time.

You can usually adjust variable ND filters from 2 f-stops to 8 f-stops. If you wanted to use a 3 f-stop setting for a scene like the one shown in 3-17, it would change the exposure from ISO 100, f/22, at 1 second to ISO 100, f/22, at 8 seconds. This would greatly change the effect of the blurring water.

There are also *graduated ND filters*, which are clear on the bottom and gradually become darker at the top. These are used to bring the amount of brightness in a sky closer to the low-light level in

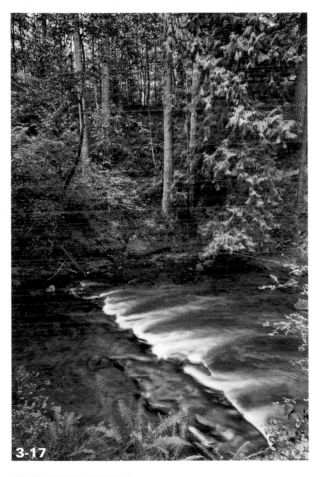

3-17

ABOUT THIS PHOTO *Using an ND filter cuts several f-stops of light from coming into the camera. This enables you to use a very long shutter speed without closing the aperture all the way down. Remember that a tripod and remote release are essential with long exposures. Taken at ISO 100, f/11, and 4 seconds with a 17-35mm lens set to 24.*

a foreground, such as what you would see in a sunset or sunrise. These filters are also very useful, but you can largely recreate their effect using tools in the computer.

 x-ref

For more information on how to create ND effects digitally, see Chapter 7.

SETTINGS TO START WITH

Whether there is a new image in your mind's eye waiting to be created or simply a new camera waiting to be explored, there are always some good places to start when it is time to take great black-and-white photography. Make sure the battery is charged, the memory card is formatted and ready, and the lenses have been cleaned and packed in the bag along with accessories like filters and remote releases. A tripod is always one of the best accessories to help you take sharper and more deliberate photographs. Be ready for anything, but have an idea of what you want to create already in your head.

EVERYTHING IS A SITUATION

"Everything is a situation" is a quote from one of my favorite classic TV cop shows, *NYPD Blue*, and I have appropriated it into my photography and practically my everyday life. Although the next few sections are about particular photographic situations, no two photographs are alike, nor two visions of a scene, nor two photographers creating the new images. What might be the perfect settings for one image might be nothing like what you want for the very next image simply because one tiny thing changes in some other part of the photograph.

Each situation is totally different: different subjects, different lighting, different weather, and possibly even a different mood or thought process

than five minutes ago. So remember that these are jumping-off places to get you started, but it is so important to experiment and try new things as often as possible. Take deliberate photographs, but don't stop taking them until you have exhausted all possibilities; you will never have the same situation again.

PORTRAITS

In most cases, when people think of portraits, they think about images of people with a blurred background because of a shallow depth of field. This shallow depth of field separates the subject from the background. Additionally, portraits are often taken with a moderate telephoto lens. Telephoto lenses usually make for more flattering images of people's faces, but if you get too close with a wider lens, your subject's features tend to distort a bit: Their noses look too big and so on. Additionally, telephoto lenses allow you to get close to the subject and still maintain a comfortable working distance.

The 85mm and 105mm focal length lenses are often called *portrait lenses* for these reasons. They also have wide apertures, which allow for a nice shallow depth of field. When you are setting up for a basic portrait, use a telephoto lens or telephoto zoom, or if you only have a standard zoom lens, zoom it all the way out and set your aperture to f/5.6 or larger. Make sure the exposure is correct for the subject. That is the most important part of that image, so change what you need to see the subject's face and eyes.

These settings should be good for nice head-and-shoulder–type portraits, maybe even like some of the portrait examples shown earlier in this chapter. Most portraits are taken to show the person in the image, to show some of who they are and their personality. Try to incorporate some of the environment into the image. When there is a day

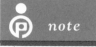

note Discussing focal lengths gets tricky because the size of the sensor determines much of the field of view. With a moderate telephoto lens, that means a focal length like 85mm to 105mm or a zoom set around there with a 35mm or full-frame camera. A dSLR with an APS-C–sized sensor would use a moderate telephoto in the neighborhood of 55mm to 75mm, or 40mm to 60mm with an m4/3 camera.

with dramatic weather, it practically begs you to get a wide-angle-lens and capture the subject within the drama of the scene (see 3-18). When using a wide angle for a portrait, make sure to get the subject close enough to the camera to best see his features and expressions.

x-ref For more discussion on portraits, including light quality, see Chapter 6, or check out my book *Lighting Photo Workshop* (Wiley, 2007).

LANDSCAPES

Wide-angle lenses and a lot of depth of field function as the foundation of landscape photography. When setting up the camera, make sure there is adequate depth of field for the scene. Start with an aperture with an opening smaller than f/8. If there is a subject in the foreground anchoring the image, it is important to make sure that it is the focus point.

In a landscape photograph with no particular anchor, make sure that the actual focus point is near one-third of the way into the image, but with a wide lens and small aperture, most of the scene remains in focus. Make sure the camera has the correct white balance for the scene to have the right look for your vision. Think about what is compelling in the image, the lighting, the composition, and if there are extra interesting shapes that draw the eye to the scene.

3-18

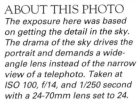

ABOUT THIS PHOTO
The exposure here was based on getting the detail in the sky. The drama of the sky drives the portrait and demands a wide-angle lens instead of the narrow view of a telephoto. Taken at ISO 100, f/14, and 1/250 second with a 24-70mm lens set to 24.

Think beyond just taking a big vista of a landscape to find something more dynamic. This may mean using more or less depth of field, or a tighter view than just a wide angle of vast space. Imagine layers in the photographs for the viewers to work through with their eyes. Think about what opportunities for a vertical landscape there may be. Remember to really evaluate the look that you are trying to impart in the final photograph. In 3-19, the scene was underexposed from the meter reading one full f-stop to get the drama and richness I desired in the scene.

STILL LIFES

The only easy part about setting up a still life is simply the fact that the subject is not moving. A still life could be a scene that you come across at a market or an antique store, or something you set up yourself. If you are afforded the time and opportunity, a tripod will help you make sure that the framing and composition are exactly the way you want them, and it can be good for longer shutter speeds that are inevitable when you are shooting close-up subjects indoors.

There are still-life images everywhere around us. When traveling, I am always fascinated with the subject matter on tables. Old tableware and salt shakers on a worn Formica table top always show interesting textures and shapes (see 3-20). Try to get as much depth of field as possible as you get close to small subjects, because as you get closer, the depth of field gets ever smaller (although there are times when the out-of-focus part of an image is as much of the image as the subject). Remember to set your white balance for the lighting indoors if it is necessary.

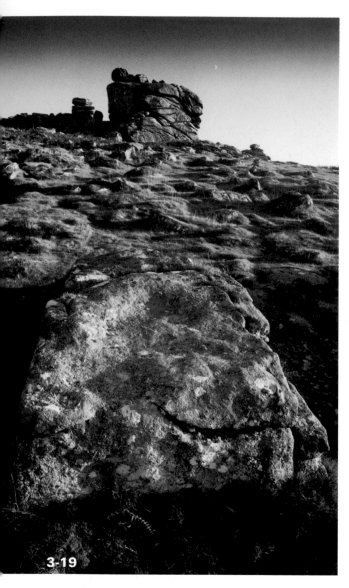

3-19

ABOUT THIS PHOTO *The low angle of the sun creates a lot of texture in this field of boulders. A vertical image was perfect to show this exotic scene with the foreground against the large stone tor in the background. Taken at ISO 100, f/8, and 1/50 second with an 18-200mm lens set to 18.*

STREET PHOTOGRAPHY

Shooting candid street images is part anticipation, part timing, and part luck. One thing to try is to set your camera to manual focus with an aperture that gives you adequate depth of field around the distance that you think your subject matter will be at. This is called *trap focus* and allows your images to be passably sharp in most cases when you are shooting from the hip. Sadly though, trap focus is harder with digital cameras because the newest dSLR lenses do not have depth-of-field scale to help guide you.

The advanced autofocus abilities of digital cameras today can help make up for the lack of depth of field scales. I recommend using the widest or largest focus zone to capture something quickly and using a medium aperture to get an adequate depth of field, somewhere around f/5.6–f/11. Rarely would you want the extremes of wide open (too shallow depth of field), and too small of an aperture often causes too much blur. Many times it just doesn't even matter. I will often love the happy accident with a little bit of blur or slightly out of focus (see 3-21).

The bigger challenge in street photography is maintaining good exposure regardless of the light. While the image in 3-21 is relatively straightforward because of the overcast day, ISO 400 at f/7.1 meant a 1/40 second shutter speed, which caused the blur. ISO 400 is a great place to start with street photography because of the latitude it gives. Plenty of depth of field is necessary, and it is good enough in low light. Take care and stay vigilant as the light level changes though. In a city, there could be deep shadows with soft contrast one minute and screaming, harsh sunlight the next.

Street images are perfect for shooting with the in-camera JPEG. That way you can see the image in black and white in the first place, which helps bring out your inner Cartier-Bresson. I almost always shoot RAW + JPEG to give me that immediacy of seeing the image in black and white and the flexibility to go back and do what I want in case the JPEG isn't everything it should be.

3-20

3-21

ABOUT THIS PHOTO

Still-life black-and-white images are all around us, even at lunch. Look to juxtapose different sorts of textures to make for interesting contrasts and tones. Many times the exposure will be whatever light is possible in the scene indoors, which makes for cool out-of-focus elements. Taken at ISO 400, f/3.5, and 1/30 second with a 20mm lens on an m4/3 camera.

ABOUT THIS PHOTO

Paying attention to what is going on is really the most important thing in street photography. There are so many variables and the opportunities are always there if you keep evaluating the light and watching the scenes around you. Taken at ISO 400, f/7.1, and 1/40 second with a 20mm m4/3 lens.

Assignment

Street Photography

Get out of your comfort zone. Attempt to not use any automatic settings, at least not fully automatic ones, and get out and take some photographs in your town. Try out the different settings on the camera, and adjust the shutter and aperture to see what sorts of affects they have to your images. Do you like images with a little bit of blur, or do you prefer images that are fully sharp with plenty of depth of field? If you are using Aperture or Shutter Priority mode, make sure that you are able to quickly access the exposure compensation to change the darkness or lightness in the image.

While walking out near the fish market very early one morning, I saw the fishermen getting their fish smokers cranked up. The light level was low for outdoors, and shooting into the smoking booth's vast blackness meant I needed to trick the meter because I wanted to make sure there was plenty of nice tone on the fisherman's light-colored gear. The exposure here was taken at ISO 400, f/4, and 1/40 second with a 50mm lens.

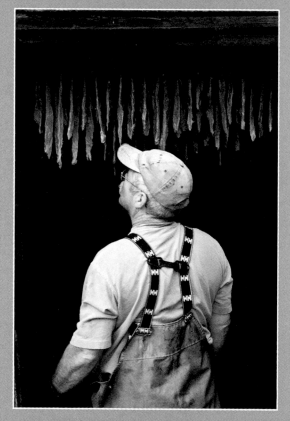

Remember to visit www.pwassignments.com after you complete this assignment and share your favorite photo! It's a community of enthusiastic photographers and a great place to view what other readers have created. You can also post comments, read encouraging suggestions, and get feedback.

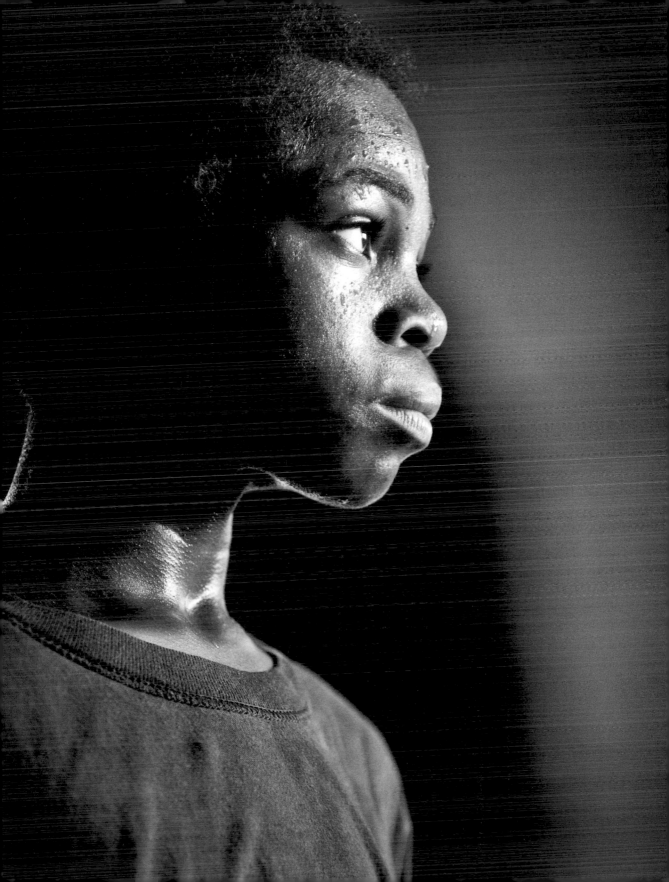

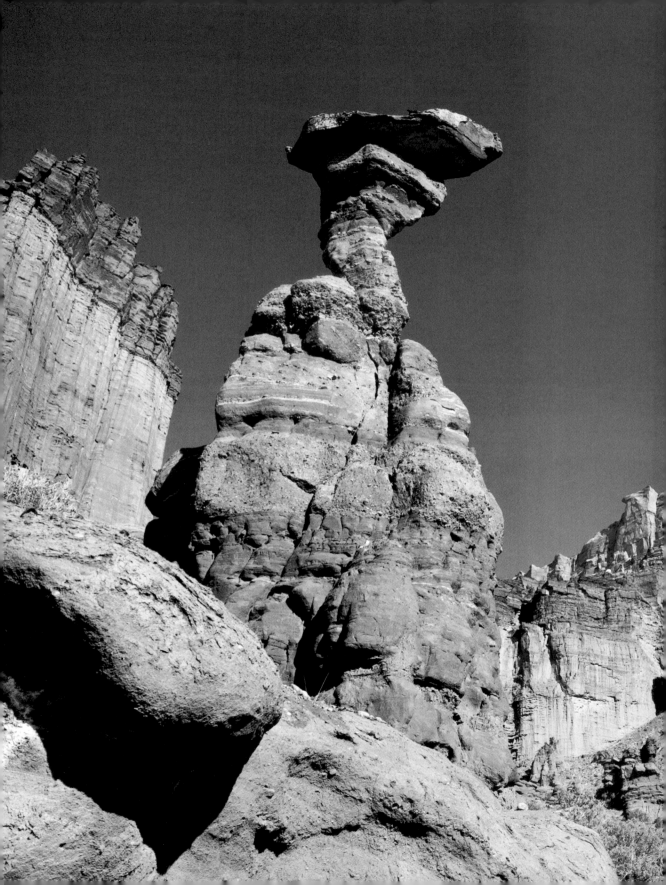

The information I have covered on f-stops and ISOs, and how the camera operates, is relatively straightforward: Adjust this, the result is that. Working with the light in front of the camera is different. It takes practice and vision to see what the light in front of the camera is doing and how the sensor will record it. Knowing how the camera operates enables you to take advantage of that light.

Every scene has different lighting, whether it's photos of a family or a mountain range. Sometimes you can adjust the light, but other times, you simply need to make the most of what is there.

Without color to define certain subjects, the light within the scene can have the most influence in how an image looks. The interplay of light and shadow will determine the success of your black-and-white images. Learning to see light quality, and its inherent contrast and direction, is also a large factor in the difference between creating a great black-and-white image and taking a snapshot.

METERING AND EXPOSURE FOR BLACK AND WHITE

There are many different schools of thought about metering and exposure. There are those who are adamant that the only way to truly grasp exposure and make the correct creative decisions is to set your camera to Manual exposure mode. However, it's difficult to use Manual when the in-camera meter is your only guide for exposure. Apart from paying attention to depth of field and focus blur, there is no real difference between using Manual and automatic exposure modes.

As with so many things in digital photography and with computers, there are many ways to get the result you desire. Therefore, my theory is generally to work with what is comfortable and what makes sense. If you make the effort to work with exposure compensation, there is not a big difference in how much control can be exercised when you are using Aperture Priority or Shutter Priority modes versus Manual.

x-ref The Aperture Priority and Shutter Priority modes are covered in Chapter 3.

Being able to read the scene and the histogram, and knowing how the LCD translates the end result are equally important for getting the exposure correct. In black-and-white photography, this means paying attention to the lights and darks of the scene and making sure that all the tones in the image are captured adequately. Knowing which colors may appear as similar or contrasting in tone helps as well.

A high-contrast scene, such as one with directional sunlight, often has a lot of very dark tones as well as a lot of very light tones. As the meter attempts to create an exposure with middle gray tones, consider how much highlight and shadow are in the image. Use the tools explained in Chapter 3 (the aperture, shutter, and ISO) to affect the exposure, and expose the image to the right; in other words, move the pixel brightness bars so they come right up to the right edge of the histogram but are not bunched up there. The biggest issue is to make sure that you can still see details in the shadows of the scene, and that they aren't totally black (see 4-1).

Lower-contrast scenes have fewer hard highlights because the light is more diffuse, but a cloudy day will still have contrast issues you will need to address. This is because the sky is still relatively bright, and the entire sky is the light source as opposed to just a point light source, which is the sun on a clear day. Because the light source is so big and bright, the foreground is often much darker by comparison on an overcast day.

Therefore, including a lot of the sky on an overcast day inevitably causes the meter to skew, exposing for the bright sky. The image's foreground will usually end up too dark. Getting the exposure you want means finding a compromise for the dark foliage and a bright sky (see 4-2). Exposing to the right keeps the sky from totally blowing out, while ensuring the trees have some texture.

ZONE SYSTEM BASICS

The *zone system* was originally a process, largely developed by Ansel Adams, for printing black-and-white film negatives. The basics of the zone system are still valid in digital black-and-white photography and are a great foundation to build on for controlling contrast.

The zone system is based on a scale of ten tones of gray, ranging from black to white. By establishing the exposure of the most important part of your scene and then calculating where that tone is on a scale of ten, it is possible to make sure that all the tones in the scene, or at least most of them, appear in the image.

There are many people who say that the zone system is overkill in the digital world, but it can be a good guide if you're struggling to get better exposures right out of the camera. Using the zone

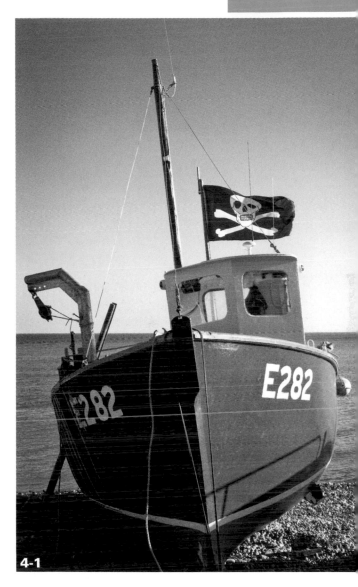

4-1

ABOUT THIS PHOTO *A red boat with hard side lighting presents the opportunity for several interpretations. The pale blue sky along with roughly equal amounts of light and dark tones gives the image a nice balance. Taken at ISO 200, f/9, and 1/320 second with a 26mm setting on a 14-45mm m4/3 lens.*

system successfully should decrease the amount of post-processing you will have to do; any changes to exposure in post-processing will be comparatively minor, thus reducing the impact on image quality.

The scale of tones in the zone system is similar to an expanded range of the tones used in the histogram, with a continuous gradation from black to white (see 4-3). Each of the zones is one f-stop apart and is described in Table 4.1.

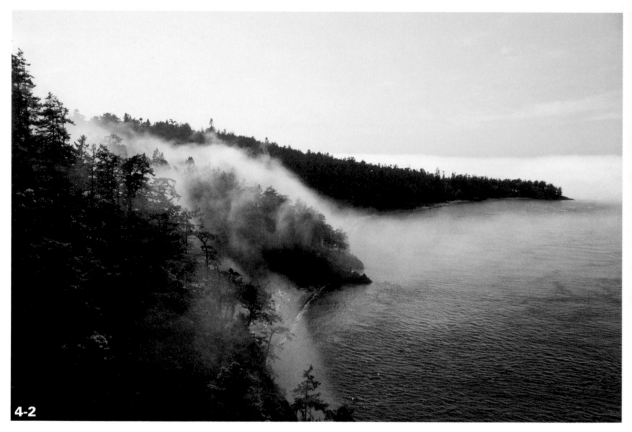

4-2

ABOUT THIS PHOTO *Dark green foliage with a bright sky is always an exposure challenge. For just a short time, the fog rolled into the small bay in the Pacific Northwest, enveloping the trees, which provided additional contrast to the dark parts of the scene. Taken at ISO 200, f/6.3, and 1/320 second with a 24-70mm lens set to 35.*

I	II	III	IV	V	VI	VII	VIII	IX	X

4-3

ABOUT THIS IMAGE *This gradation shows the ten levels of the zone system.*

Table 4.1

Zone	Tone
I	Pure black.
II	Near black with some slight texture.
III	Average dark with some texture.
IV	Average shadows and dark foliage.
V	Middle gray, dark skin, clear north sky.
VI	Light skin and grass, shadows on snow in the sun.
VII	Very light skin, silver hair, sidelit snow.
VIII	Almost white. Lightest tone with texture.
IX	Light tone without texture.
X	Pure white light sources. Reflections.

Classically, the zone system is used along with a *spot meter*, which many, but not all, dSLR cameras now have. A spot meter evaluates the level of light and dark in only a very small area (the different metering systems in digital cameras are discussed in the next section).

By evaluating different levels of light and dark within the scene, it is possible to determine the exposure for each of these areas and apply them to a zone. The actual exposure of the photograph will be one that puts as many of the tones within zones II through VIII (2 through 8).

It's pretty easy to see the variation between the many different tones in the stone shown in 4-4. Just above the arch is darker stone that has some shadow, which is about zone V. On the left-hand side of the stone, the sun is very bright on light-colored stone. This is the highlight base, about

ABOUT THIS PHOTO *Seeing the tones around the top of the rotunda at the Texas State Capitol in Austin is a great way to see the rich amount of tones available in a scene. There is a preponderance of tones in the middle zones, with a few f-stops either way of middle gray. Taken at ISO 100, f/8, and 1/250 second with a 24-70mm zoom lens set to 62.*

4-4

zone VII. The shadows underneath the arch or behind the rotunda columns are very dark but have some detail, about zone III. My exposure settings eliminate blown-out highlights and have only the tiniest amount of zone I pure blacks, which make the image pop. Sometimes if a scene does not have any blacks, the image can feel dull.

LEARNING YOUR METERING SYSTEMS

Virtually all digital cameras, from the high-end dSLR cameras to the compact models, now have multiple metering settings or modes. These different options give you more flexibility and precision with finding the correct exposure. Meters used to simply tell you what the light level was at a particular place. Learning how to interpret the meter reading from these old meters was truly the mark of a good photographer.

There are many different types of light meters, each one determining middle gray slightly differently from the others. The meter that is built into a digital camera is called a *reflected-light meter*. These meters take a reading of the amount of light that is reflected off the subject and back into the camera. Reflected-light meters are set to take readings for average scenes to get a middle-gray tone. There are advantages and disadvantages to this, but if you learn how to master the meter and its modes, you will get superior exposures in your black-and-white images.

CENTER-WEIGHTED METER

Imagine a circle that takes in about one-third of the center of the viewing screen of the camera; that is where a center-weighted meter takes its

reading. Many dSLRs have this circle etched on the screen. The *center-weighted meter* is the tried-and-true in-camera meter. Many photographers swear by this metering mode mainly because it is the one that they have had in their cameras forever.

When you place the circle on the most important part of the image, the meter reads what is in that circle and it tells you that in order to make that part of the scene middle gray, your settings must be a particular exposure. At this point, the exposure can be locked by either setting the camera to Manual and starting to shoot, or by using the Auto Exposure Lock (AEL), which locks the exposure where you set it, and then you can recompose and shoot at the locked exposure.

Center-weighted metering is particularly great for shooting portraits. If you place the center-weighted circle around the subject's face, the meter takes only a reading of that face, and any unwanted lighting or extreme tones in the background are largely ignored because the meter is focused on just that small area. The scene in 4-5 has a lot of distractingly bright and dark areas, and the subject is primarily backlit. All of this can fool the light meter. Using the center-weighted meter locks in the correct exposure of her face, largely ignoring the background levels.

note

If the lighting situation stays the same in the scene, then the tones of gray in the scene should stay the same.

x-ref

The key to using the center-weighted meter — meter and recompose — is covered in Chapter 3.

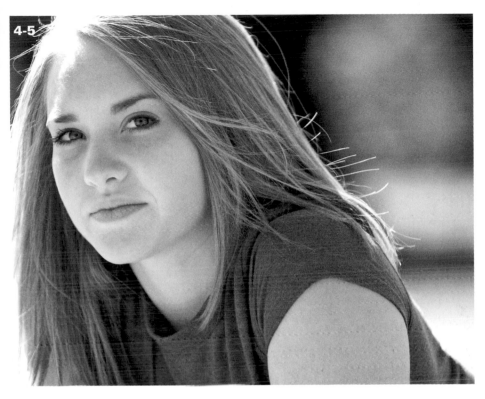

4-5

ABOUT THIS PHOTO
A center-weighted meter reading on the face focuses the exposure on the subject of the photograph. After setting the exposure for her face, I recomposed the image, placing her face off-center. Taken at ISO 100, f/2.8, and 1/320 second.

AVERAGING, EVALUATIVE, AND MATRIX METERS

Starting in the late 1980s, meters began to wise up. Instead of taking a simple meter reading from the middle of the scene, the more advanced Matrix (Nikon) and Evaluative (Canon) metering systems would take meter readings from multiple places in the scene individually; the camera's computer could then use an algorithm to more accurately see the tones in the scene and get a more accurate meter reading.

By the time this book is published, there will be a meter in a popular camera with more than 2,000 matrix segments that will evaluate all the tones in the scene and will factor the distance to the subject and the color into the meter reading. Each of these advances in metering technology ratchets up the level of accuracy another notch.

These *averaging meters* or matrix meters are now the default meters in digital cameras. They can be extremely reliable, especially for everyday photographs. Matrix meters are designed so that scenes lit in a basic manner are metered to a very good average for the amount of tones in the scene. But when the lighting gets more complicated, such as in a scene where the lighting is coming from behind the subject or scenes with extreme contrast, the averaging or matrix meters can still compensate for the extremes in the scene without too much fiddling from the photographer.

Averaging meters compare the pattern of brightness levels with data of images already in the camera's database to determine what the exposure should be. Move the viewfinder around to sample the different exposure readings from an averaging meter; often there is very little change in the image when some bright sky or other highlight enters the scene because the meter has already calculated the exposure for much of the foreground. The averaging meter really excels in scenes with challenging backgrounds, extreme darks and lights, and backlight on subjects (see 4-6 and 4-7), which is especially important for photographers who are still figuring a lot of things out.

Averaging meters do a superb job in most cases, which is why they are the default meter on cameras. However, they aren't perfect, so cameras enable you to use Manual mode or Exposure compensation. Remember that averaging meters are doing just that: averaging the tones in the scene to get a good exposure. You will want to try to go beyond average and look deeper into your vision to determine the exposure needed for the scene that you are creating.

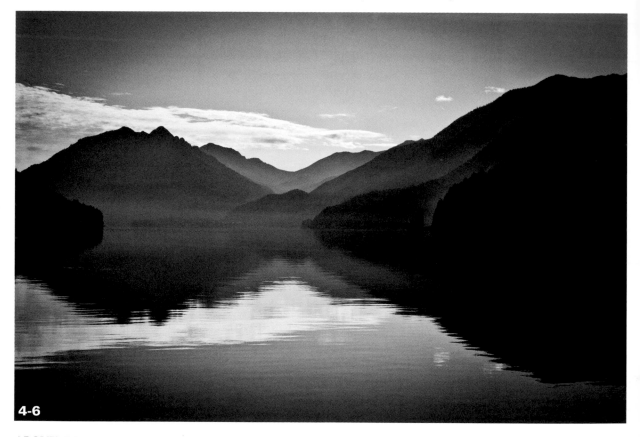

4-6

ABOUT THIS PHOTO *Backlighting often causes a lot of issues for photographers; using an averaging meter can compensate for light coming from behind. It allows subtle shadows to be visible without making them a black blob or washed-out mess. Taken at ISO 200, f/16, and 1/320 second with 28-70mm zoom lens set to 60.*

4-7

ABOUT THIS PHOTO *Light coming from behind a subject can highlight hair and give the subject shape and definition. Averaging meters make sure that the subject's features don't plunge into darkness if the meter tries to tame bright highlights with a darker exposure. Taken at ISO 200, f/2.8, and 1/250 second with a 70-200mm lens.*

SPOT METERS

Accessing the spot meter on a dSLR camera is usually as easy as a twist of the meter-mode selector. It is far and away the best way to get the most accurate exposure in a distant scene, but it can also cause the most problems if used improperly. Zone system devotees are constantly using the spot meter, whether it is in the camera or handheld. There are landscape photographers who still use handheld spot meters; they are like a monocular with a trigger and an exposure readout.

A *spot meter* takes a reading from a very small angle in the field of view of the scene and tells the photographer what the exposure would be to make that tone middle gray. Spot meters are perfect for black-and-white photography because they enable you to focus on just the tones of brightness. Each camera works differently, but for the most part, the spot meter is generally 1 percent of the scene right where the center focus indicator is. For some dSLRs, the spot meter will remain paired to the selected focus indicator. Refer to the camera's owner's manual to determine exactly how the spot meter operates.

> **tip** The spot meter's area of metering is usually about 1 percent of the scene. The amount of the image that is metered will be different depending on the focal length of the lens being used. Most photographers use a telephoto lens to do their spot metering to get the most precise readings because of the accuracy with which they can place the meter.

The best way to use a spot meter is to select a point that appears to be middle gray in tone, or zone V, and note the reading. Select and note other tones that are both lighter and darker, from highlights to shadows, and determine just how bright the overall scene should be. By noting how many f-stops in difference there are between the highlights and shadows, it is easier for you to determine a whole scene exposure that is best for the vision of the image, and it helps to determine if more exposure changes are needed in the digital darkroom.

In a scene with no real solid areas to take a middle-gray reading, determining the exposures for many of the tones is the way to go. Simply select

points in the image with varying tones of gray, determining the darkest and lightest points that still have detail. In the scene shown in 4-8, the highest exposure was ISO 100, f/22, and 1/250 second in some of the brighter snow. The darkest tone was near the base of the foreground bush, and the exposure for that was ISO 100, f/6.3, and 1/250 second. With a final exposure of ISO 100, f/13, and 1/250 second, it was easy to ensure there would be just enough detail in both shadows and highlights with the exposure just two f/stops darker than the meter reading for the darkest part of the image.

Many photographers also use the spot meter to confirm exposure in extreme lighting situations, such as when only a small amount of light tones are surrounded by a field of dark ones — anytime the regular metering system will not be able to decipher the many different tones in an image.

Meter the scene for the tone that is desired, set the exposure, and recompose. This may mean that certain parts of the image may be too dark or too light, and that is usually exactly what you want. This is usually the case when there is strong directional light and the exposure on the subject is the only thing that matters (see 4-9).

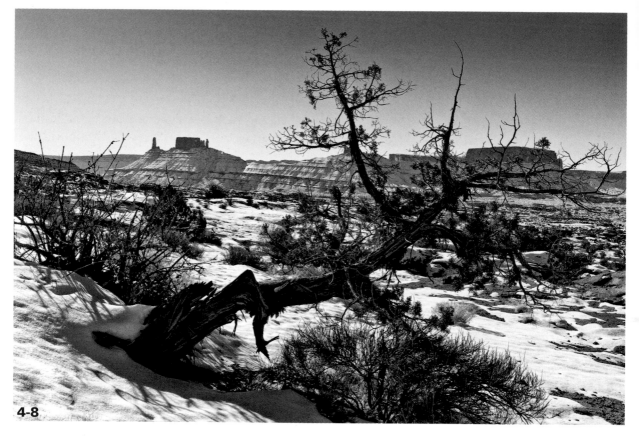

4-8

ABOUT THIS PHOTO *The texture of a straggly juniper tree always draws me into a scene. Using the spot meter to determine the exposure by figuring out exactly what the brightness was on the shady side of the tree allowed for great accuracy. Taken at ISO 100, f/13, and 1/250 second with a 50mm lens.*

4-9

ABOUT THIS PHOTO *By zooming in to take a spot reading on just the long boarder's face, I got the exposure needed for the sun hitting his face without any regard to any other tone in the scene. After the reading, I set the exposure to Manual mode to get several different poses. Taken at ISO 100, f/7.1, and 1/250 second with a 24mm lens.*

note After using the spot meter, make certain that the meter mode returns to center-weighted or averaging for general photography. If you aren't paying enough attention to exactly where the spot meter is reading, you will have a high rate of inaccurate and inconsistent readings.

LIGHT DIRECTION

Lighting is situational, and in many cases the images you plan to shoot before you begin photographing end up different than you had envisioned because the lighting is different from what you anticipated. This can be either good or bad; what matters is that you take advantage of the existing light to make the best image possible.

Lighting in black and white can be both helpful and challenging. For some, a cloudy day can make for images that appear slightly flat and dull, while for others, it is an opportunity to maximize the full tonal range of the grays without the contrast of the sun, or to make images that are more moody or dramatic.

FRONTLIGHT

Light direction means orienting the light to the subject. Light that strikes the front of the scene, (that is, coming from behind you, the photographer) is called *frontlight*. Front-lit scenes can look somewhat flat in a black-and-white image because there is a lack of that shadowing that gives texture to a scene. This does not mean that you should disregard front-lit images; they are relatively easy to meter, and if there are other strong elements in the scene, they can be as effective as any other images.

An image that is front lit will have the most separation between the tones that different colors create, which can make for very interesting shapes within the image. The effect of filters with a front-lit photo will be very pronounced. This goes for filters such as the polarizer that is in front of the camera, as well as color effect filters such as red, yellow, and green, which increase the contrast in a scene (see 4-10).

4-10

ABOUT THIS PHOTO *Midday in winter, the sun never really gets very high in the sky and there are lot of front-lit scenes. The contrast in the rocks and against the snow with the dark sky makes this image pop, but it needed a strong yellow contrast filter. Taken at ISO 100, f/8, and 1/1000 second with a 28mm lens.*

There is an old tip about keeping the sun at your back for good photography. This is the very definition of front lighting and, because it is often coming right at the subject, it can be too bright. When using a matrix or evaluative meter, think about underexposing bright, front-lit scenes by 1/3 to 2/3 of an f-stop. This will bring bright highlights down a bit as well as increase the dark tones just enough so that the images are rich and not washed out.

SIDELIGHT

When light comes from either side, this is called, you guessed it, *sidelight*, or *cross light*. Side-lit images are what photographers are constantly looking for: light that is coming from one side of

the image to the other, such as sunlight early and late in the day. Sidelight shows the most texture in black-and-white photography, showing highlights on the light side and shadows on the opposite side. As the sun goes down, the shadows lengthen and the contrast deepens between the different sides of the subject.

It does become more difficult to manage the lighting in black-and-white exposures with side-light as the contrast goes up. Make sure to use the tools previously discussed, whether it is the averaging meter, the histogram, or both, to maximize the amount of tones in the image to best capture your desired image. When there is a full range of gray tones spread out within the image, it is awesome to see the texture of the scene (see 4-11).

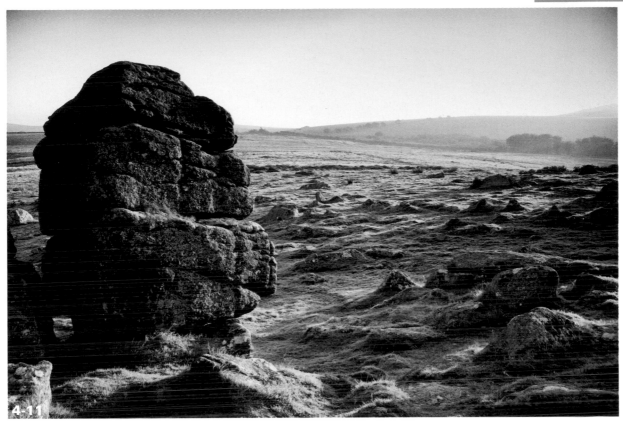

4-11

ABOUT THIS PHOTO *In the British moorlands are amazing rock formations which are called tors. The formations are as unique and interesting as the stones themselves, sidelight coming across them accentuates the feeling and texture. Taken at ISO 200, f/8, and 1/100 second with a 28mm lens.*

Not only can you fully see the texture of the rocks in the ground, you can also make out the texture of the stones. It is almost possible to feel the rough character of these stones and the peeling lichens when they are lit like this.

Take advantage of the strong direction of the sidelight to get dramatic portraits. By bringing the light around from one side of the face, you can really see the structure of the face. In the case of 4-12, there was a window with morning light coming through a sheer curtain. The contrast between dark to light gives the scene a little more drama, with the bright lights stopping abruptly,

halfway around the boy's face. This black-and-white portrait presents an interesting dichotomy: The sidelighting is very dramatic, but the boy's expression is cheerful.

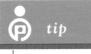

tip — It is great to use any sort of light source to get dramatic side-lit portraits.

Pay careful attention to the angle of the sidelight across, around, and through the scene. Think about whether or not the light is striking the subject in a way that is pleasing to that subject. The angle of sidelight can create its own drama, so

4-12

getting the best result may mean rotating a subject somewhat or even photographing the image at a different time of day or year.

BACKLIGHT

A scene that is *backlit* has light coming from behind the subject and toward the camera. Backlight is the most difficult angle to manage, yet when you do it well, you can be rewarded with some fantastic images. By placing the light between your subject and the camera, subjects with any translucence begin to glow

and bring their own special tones into the image. Additionally, depending on the angle of the backlight, the subjects can be outlined with a rim of light, giving the subject extra impact (see 4-13).

The difficulties with backlight occur when a light source, behind the subject, is actually in the scene or is shining very directly onto the lens. When the sun or whatever light source is shining into the lens, there is a propensity for flare. *Flare* is anomalous bright spots and lines in the image. You can usually detect them in the viewfinder, and you certainly can see them on the LCD after

the picture has been taken. These bright spots are reflections of the light source on the surfaces of the glass in the camera's lens.

Flare can also cause a general flatness to the tones in the image; as the light strikes the front of the lens, it makes the dark tones go dull gray. The best way to combat flare is to use the recommended lens hood for that lens. Most lens hoods shade as much of the lens as is possible without actually intruding into the scene in the form of a black line on the edge.

Additionally, you can use other objects, such as a collapsible reflector, a piece of cardboard, a clipboard, a book, or even a ball cap, to help block some of the light coming back into the lens.

Some flare can add interest and life to an image, so don't think that it is something that you always need to eliminate; it's simply something to pay attention to.

In fact, using backlight to light an image of people can add depth to the scene. The biggest concern with backlit people is that there often isn't enough light on their faces (because the source light is coming from behind them).

Use the averaging meter to get the correct meter reading for a subject's face or a spot meter if it appears that there is too much light coming from behind to get a good exposure (see 4-14). With subjects that are smaller, like people compared to mountains, it is relatively easy to get light onto the subject either with a flash or by reflecting some of the backlight back into the subject.

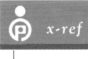

x-ref

There is more information on portrait lighting in the coming pages of this chapter.

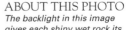

4-13

ABOUT THIS PHOTO
The backlight in this image gives each shiny wet rock its own little rim light, creating a very interesting texture across this stone beach. Taken at ISO 200, f/22, and 2.5 seconds with a 28-70mm zoom lens set to 35.

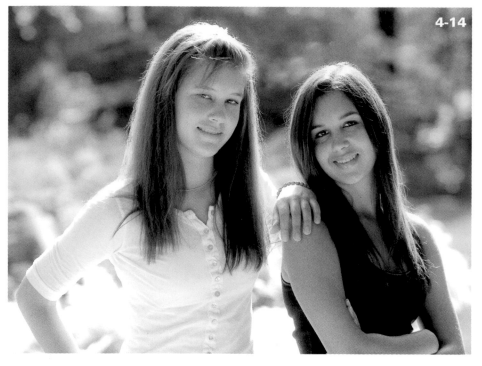

4-14

LIGHT QUALITY

Because of the latitude of tones available with black-and-white photography, don't hesitate to try new things with light direction. Just because things are usually done a particular way doesn't mean that images created differently won't be exceptional. For example, in 4-14, there are bright highlights of blown-out white across the tops of the sisters' heads and shoulders from the backlight. For as much as I have discussed watching histograms and making sure there is detail in the highlights, the highlights here are totally fine with me. It would be nearly impossible to get rid of those highlights without destroying the wonderful atmosphere of glowing gray tones that comes from the lighting in this image.

Light quality can be most simply described as soft or hard, but there are probably more different levels of soft and hard light than there are zones of gray tones in the Zone System. Images can even have multiple types of light that interact to create the desired image. This is shown in the previous example, 4-14. On a bright sunny day, there is a hard light from the sun striking the backs of the two sisters. The light hitting their faces is softer because it is sunlight reflected off the side of a building.

note There are endless examples of lighting that is beautiful. Each example is probably perfect for some images and not so much for others.

HARD LIGHT

The smaller and further the light source is from the subject, the harder the light is. Hard light is best defined by the harsh shadows it causes.

LIGHT QUALITY: BLACK-AND-WHITE OR COLOR? A landscape photograph might be perfectly mated to the hard light of the sun. Colors that are bright and saturated present definition and the opportunity for colored contrast filters, and there will be plenty of shadows to create shadows and contrast. Black-and-white images are far more forgiving than color images when it comes to the harsh light of midday, whereas those fantastically beautiful color sunsets rarely have quite the impact in black and white that they do in color.

Sunlight is the perfect example of a hard light source because the shadows created are very hard edged. Hard light accentuates the hard surfaces, stark contrast, and dramatic lines of the desert (see 4-15).

As clouds roll across the sky, the hard edge of the sun's rays stays the same, but the reflections of the clouds can give the sky some photographic interest. The clouds fill in the shadows just a tiny bit, taming the harshness of the light. Each little change creates a different light quality.

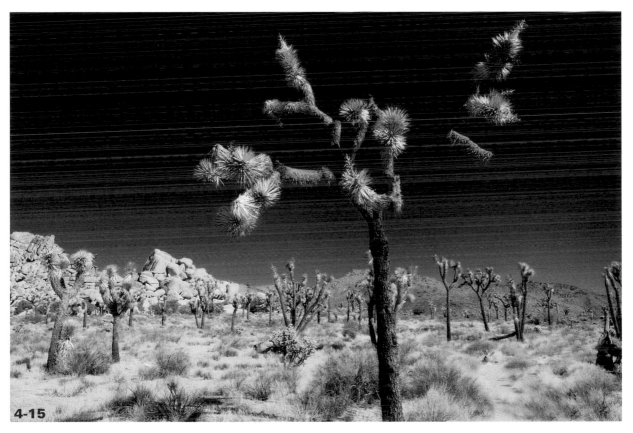

4-15

ABOUT THIS PHOTO *Bright sunlight helps create the strikingly dark sky and brightly lit landscape scenes. This hard light helps create the contrast that makes this gritty desert scene feel hot and dry. Taken at ISO 100, f/16, and 1/125 second with a 20mm lens.*

SOFT LIGHT

When thinking about soft light, think about the contrast between the darks and lights in a face. Softer light wraps around a person or face, while hard light is bright on one side of the subject and dark on the other. Most images of people are best with a gentle contrast from one side of the face to another, although black and white can give you very dramatic images with hard, high contrast light that color images cannot.

There can be different levels of softness; for example, when the sun's light softens near the horizon, it is still very directional, but it doesn't have quite the edge or contrast as when it is

higher. So there can be some real direction to the light, giving the appearance of softness, but maintaining contrast and pop in the image (see 4-16).

LOOKING FOR LANDSCAPE LIGHTING

Landscapes aren't just the great vistas of the Sierra Nevada mountains that Ansel Adams is best known for. His examinations of smaller scenes and details of trees are just as moving and important. Landscape photographs can be cityscapes, lakescapes, farmscapes, and even suburbscapes. With each type of landscape, you can take advantage of many different lighting situations.

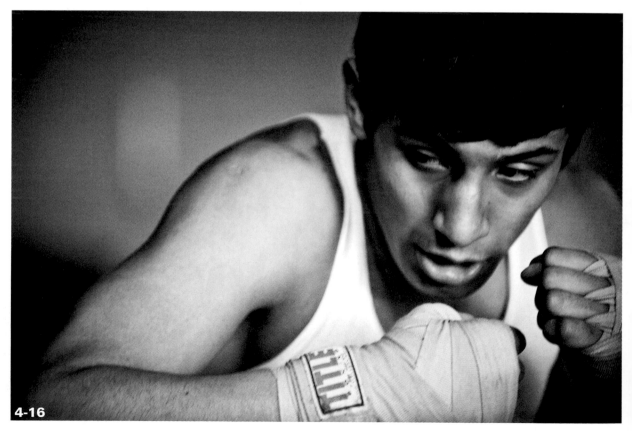

4-16

ABOUT THIS PHOTO *A large open door pours daylight into a boxing gym. No direct light strikes this boxer, but the quality of this soft light has great contrast and it sculpts the lines of the boxer's body. Taken at ISO 2000, f/2.8, and 1/640 second with a 200mm lens.*

The image of a lone tree on a nearby golf course on a foggy fall morning makes for real drama. The light was very soft, without any real direction, when I shot the scene shown in 4-17, yet the contrast brings about an undeniable excitement. Take advantage of any sort of interesting weather when you are thinking about black-and-white photography. On a bright sunny day, this scene may have gone unnoticed, and there might have been all sorts of distracting elements that suddenly are gone when a fog rolls in.

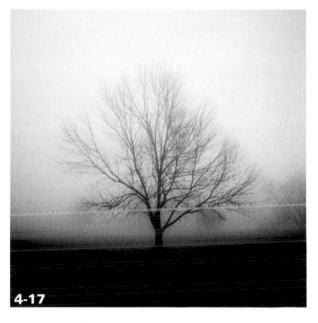

4-17

ABOUT THIS PHOTO *Stark images really attract my eye. This lone tree is usually obscured by many others around, but the light afforded by the weather enabled me to focus on just the one. Taken at ISO 100, f/7.1, and 1/250 second with a 50mm lens.*

Light that becomes diffused just a bit allows for more subtlety in tones, making the texture seem effortless and light, not heavy-handed and rough. In 4-18, the softness of the light may not create a dramatic sky, but there is some texture in it. The way the light wraps around the wood shows great gradation. The soft glow of the evergreens and the detail on the cliffs on the right-hand side have much better detail than they would with hard sun blasting across the scene, and the image ends up exactly how I wanted it: People can see this scene as I did when I was there.

Now that you know about light direction and quality, you can use the quality information to get better black-and-white photographs. This often means doing some planning and preparation and probably some waiting. Watch for weather, waiting not only for the right time of day, but also for the right time of the year for the sun to be perfect for the image you want.

Not only should you pay attention to what the weather might be for a specific day or time, but spending a few moments looking at maps and previous images of the area may pay off big when you get the light you want, or at least save you from wasting a trip when the light you are looking for is on the wrong side of the scene.

Take advantage of the information out there. Park maps, online photo services, and other photographers' images are all easily accessible online. Spend some research time with weather Web

ORDINARY OBJECTS, EXTRAORDINARY LIGHT There is interesting light all the time, and black-and-white photography, with its inherent creative options, affords you some advantages that color photography does not. Take some time over the course of a few days to focus on how the light affects an object you see every day, and watch how different it looks at different times and on different days.

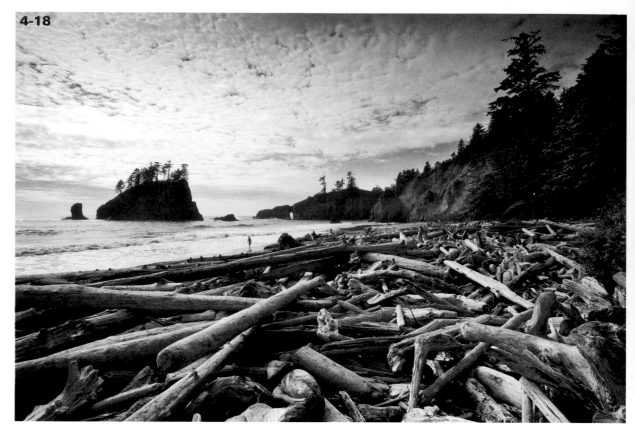

4-18

sites and sun charts before you head out for your photo adventure, and your success rate for great images will go up considerably.

GREAT LIGHT FOR PEOPLE AND PORTRAITS

You can use so much creativity with the light when photographing people in black and white. Not only are there many ways to work with the nuances of light, but also experimenting with the light quality and direction can be immensely rewarding. Black-and-white portraiture is as classic as photography itself; when you photograph people in black and white today, those images have a certain timelessness that color images do not.

Black-and-white portraits can convey so many different feelings and much of that relates to the lighting. Some lighting may lend a sense of nostalgia, while other light may make an image appear contemporary.

Although the current style of portrait lighting usually entails a certain amount of front lighting, soft light that comes across a person's face has been the standard for many years. This helps to give the face some shape and helps the viewer to see the depth in the person being photographed. How soft this sidelight is depends on the intent of the black-and-white photograph.

You can bring light across the face by paying attention to the direction of the sunlight, no matter where it is coming from, by using a reflector,

or by bringing a strobe or other light source in to direct the light. As discussed earlier, the larger the light source, the softer the light. Window light is perfect lighting for people, and it tends to be softer and more forgiving when there is no direct sun coming in the window (see 4-19).

4-19

ABOUT THIS PHOTO *Light coming through a window provides great directional light, which can be soft yet still have enough contrast to add interest to the face. Taken at ISO 400, f/7.1, and 1/100 second with a 13.7mm lens with a compact digital camera.*

As the light falls away from the light source, the amount of light decreases. This is true with all light sources, but with window light and strobes and other artificial light sources, this is more pronounced.

In 4-20, the light from a large open garage door comes in to light the boy's face, but that light falls off as it gets further past his head. This gives his face all the focus because the light makes it the brightest point in the image. Try squinting at this image as you look at it and you will see how even as everything else in the image falls into darkness, his face remains the focus because of the light on it.

REFLECTORS AND FILL LIGHT

In general, it is more common to use softer light, which tends to lessen the appearance of wrinkles or any other flaws in the skin, on women than on men. Harder light makes for more contrast on a face, making features more prominent. When hard light is used, it is usually augmented by some sort of *fill light*, which is light that fills in the shadows. In a studio setting, you can create fill light using another light source set at a lower power setting, and in any type of situation, you can create fill light using a reflector. Reflectors are often used outdoors to fill in the shadows from the sun's hard light.

MY FAVORITE REFLECTOR. One of the products that I find particularly useful is the Lastolite TriGrip. It is a collapsible reflector that you twist in and out of its pouch, but the advantage is that the TriGrip isn't circular; it is a rounded triangle shape. The handle at the end of the triangle makes it easy to hold and move in close to the subject, and because it has a straight edge, you can move it right up to the edge of the frame and still get maximum coverage of the light on the subject.

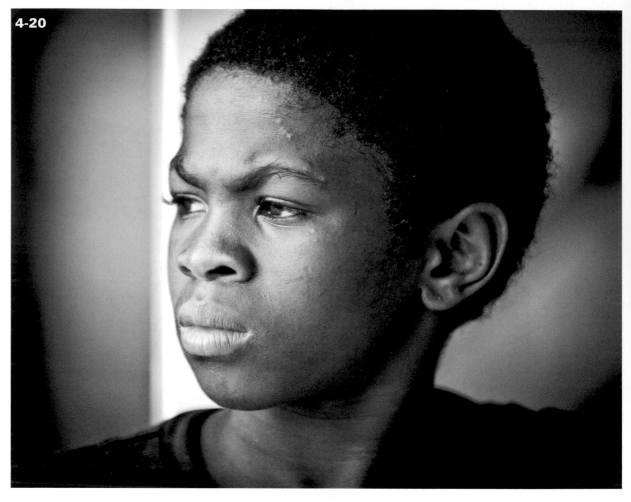

4-20

The reflector can be anything that reflects the light back into the shadows, giving them some detail and keeping them from becoming totally black. You can use something as simple as a piece of paper, someone's white shirt, or even a piece of fabric stretched out over a PVC frame as a home-made reflector for black-and-white portraits. You can also purchase many different reflectors at your local camera store. The prices run the gamut.

Reflectors come in different types of fabrics, which reflect the light differently: White simply bounces the light back into the shadows, but silver adds a bit of harshness to the light and gold

warms up the light just a bit. For shooting in black and white, the silver and white reflectors make the most sense.

While shooting a woman with soft light might make the most sense in most cases because it makes the images the most flattering, there are times that creating black-and-white portraits with a harder-edged light helps create the mood that you are looking for. In the case of 4-21, all the diffusion was removed from in front of the strobe so that the light, modified by a large dish-like reflector, was hard and dramatic, creating some dark shadows and edges to the shape of her face.

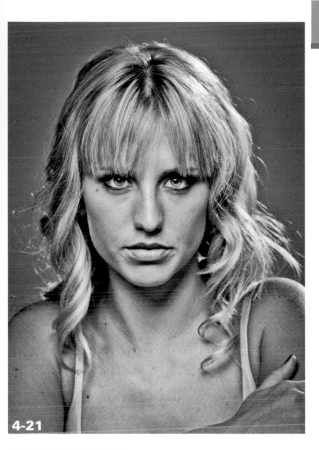

4-21

ABOUT THIS PHOTO *Using hard light on a woman can be a challenge, but it is perfect for some looks. Most important was maintaining great skin tone in black and white and making sure the shadows didn't get too dark in this moody shot. Taken at ISO 100, f/7.1, and 1/160 second with a 105mm lens.*

It is still important to make sure that the contrast does not exceed the range of tones possible to capture with detail; in order to make sure that the shadows were not too dark, I placed a TriGrip underneath the subject's face, just out of frame, to fill in those shadows. Lighting in this manner gives a pretty girl a very gritty, tough look, and the middle-gray tones of her skin are just amazing.

SHADE AND EVEN LIGHT

Using lighting that is more even is a great way to get fantastic black-and-white tones in portraits. Even light is best found in open shade areas on a

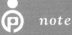 *note* Two types of reflectors are discussed here. There are the reflectors that you use to bounce the light back into the subject to create fill light into the shadows, and there are the reflectors that you attach to the front of the studio strobes that are light shapers to help control the direction and shape of the light coming from the strobe. These are often called *dishes* and there are seemingly endless sizes that fit on any particular brand of strobe head. Reflectors are just one of many types of light shapers for studio strobes.

sunny day. You can find it almost anywhere and you can usually adjust how much contrast is in the image by how close the subject is from the edge of the shade. The light in the shade can sometimes be a bit flat and lack contrast, so in order get some additional pop into the gray tones, have the subject move closer to the edge of the shadow and nearer the sunlight.

I truly love finding interesting characters with great, weathered faces. The textures found in the faces of wizened men who still work with their hands and wear their years around their eyes are endlessly fascinating, and the black-and-white images that they help create are some of my favorites. But on a very bright day near noon, the light in the sun is just unbearable. There is too much contrast, and the light coming from above creates harsh and deep shadows in the eye sockets, reminiscent of raccoon eyes.

By moving the subject just into the shade, the look improves greatly. Use the center-weighted meter to get an accurate reading on the subject's face; then set the camera to Manual to keep the exposure the same, enabling you to try different compositions and still maintain the proper exposure. The subject is now in the shade but the amount of light in the background is still high; the center-weighted meter ensures that any extreme exposures in the background do not affect the image. With the man in 4-22 just inside the shade, the light from behind comes

ABOUT THIS PHOTO *A local beekeeper is photographed just inside the open shade of the barn. The wrap of the light comes from behind the subject, creating some amazing tones, from highlights to dark shadows, revealing great character. Taken at ISO 200, f/2.8, and 1/1000 second with a 24-70mm lens set to 70.*

4-22

around and gives him some nice highlights on his temples, which really add to the rich fabric of tones on his face.

LIGHTING GROUPS

When there are many people, it is often very difficult to get light that has much direction without one subject blocking the others, or

116

4-23

ABOUT THIS PHOTO
Getting a group of people into the shade gets them into nice even light. Look for backlight, which adds some highlights to heads to further separate faces from the backgrounds. Taken at ISO 200, f/4, and 1/320 second with a 70-200mm lens.

the light falling off, making one side of the group much darker than another. Once again, by getting the subjects into some open shade, you can create some very even light, lighting most of the subjects nicely. Look around for shade trees or around the side of a building for open shade for group photographs. Although the light may not have the dramatic sculpting nature an image with beautiful cross light does, it is easy to see everyone's faces and get a good feel for their skin tones without distracting shadows (see 4-23).

Although it is great to get nicely textured backgrounds, make sure that it is possible to separate the subjects from the background adequately. Either place heads and faces against contrasting tones or use a shallow enough depth of field to make sure that everyone's face is easily distinguishable. Remember, there is no color to separate faces from the background tones.

DEALING WITH TONES AT TWILIGHT

Shooting black-and-white images at the edges of the day enables you to explore movement a bit more, but on a far more grand scale than simply blurring a person. Without the brightness of the sun, the movements of the earth, sky, and water can be seen in a single, albeit long, exposure.

The tones in the clouds and sky seem to invert as the sun drops below the horizon, and the color reflected into the clouds can create ethereal

tones. It is a different look to shoot a sunrise or sunset in black and white. Many people get so excited, and justifiably so, when they shoot a brilliant sunset in color, but keep in mind that the full tones of black and white that are available can be just as brilliant.

As highlights wane, the shadows deepen, and longer and longer exposures are needed to keep the limited light coming into the camera for any exposure at all. Silhouettes are created against the lingering sky, and it is okay to let them go dark; when you can only see the shape of things at twilight it helps create a sense of mystery and timelessness, but if you can keep some detail in those shadows, it can better show a full range of gray tones, and give the images a bit more texture and sense of place (see 4-24).

As the light gets even lower, the water's movement becomes a glowing blur of silver tones as the surf crashes ashore. Much longer exposures, sometimes several seconds, are needed to keep any tone in the image. Without light, the images become a study in shadow tone and richness.

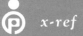 x-ref

Many books are dedicated to the amazing experience of low-light and nighttime photography. To really examine this subject further, *Creative Night: Digital Photography Tips and Techniques* by Harold Davis (Wiley, 2009) is primer par excellence on this subject.

It is still important, if not more important, to take note of the histogram, but without any real highlights in the scene, the histogram does not have to have any pixel bars over to the right side of the

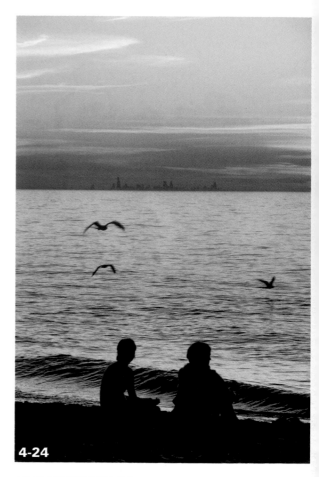

4-24

ABOUT THIS PHOTO *A telephoto lens helps compress the scene of people watching the sunset going down over the lake with the Chicago skyline in the background. The multiple gradations of tones show great texture. Taken at ISO 200, f/10, and 1/100 second with a 70-200mm lens set to 160.*

graph to be an okay image. Just don't have all the pixel bars jammed up against the left side; Make sure there are middle tones because that is where the richness of a scene like this comes from (see 4-25).

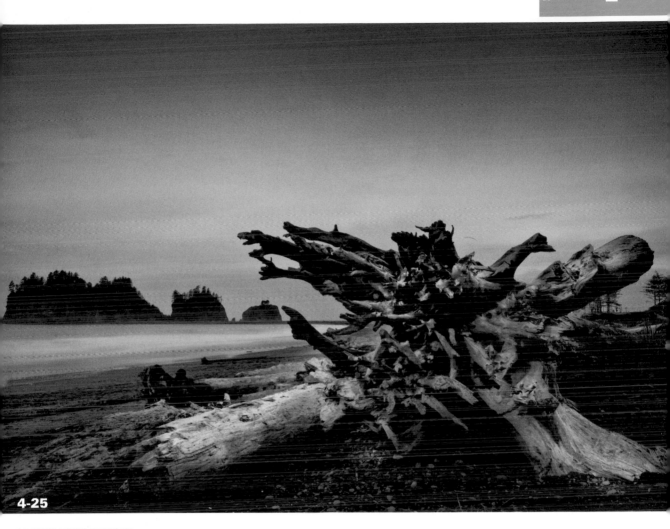

4-25

ABOUT THIS PHOTO *A long exposure helps to create a silver blur of water in this scene anchored by the huge drift tree. The darkness becomes a study in shadow tones in an image rich with dark grays. Taken at ISO 200, f/18, and 15 seconds with a 28mm lens setting.*

BLACK AND WHITE AFTER DARK

When the sun is finally gone, the opportunity to shoot is not over; in fact, it can be just starting. The two most important tools you need after dark are a tripod and a cable release because the exposures are no longer fractions of seconds, or even whole seconds, but minutes and hours.

Make sure that you keep your camera locked down and that you have a flashlight to get you to and from the location safely.

The first time that you experiment with really long exposures very late at night, you will be truly amazed at the amount of light that you are still able to capture with a long enough exposure. The movement in the scenes now appears as pale

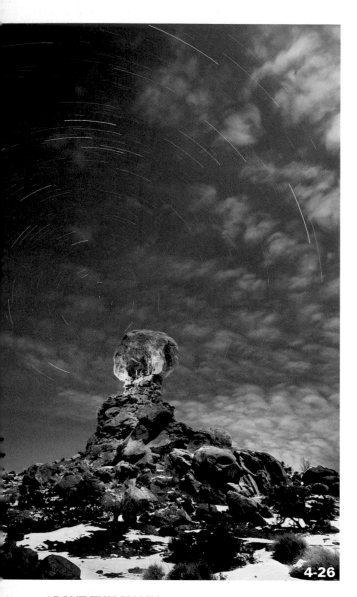

4-26

streaks of white and light gray as clouds come across the sky. What can be even more exciting is the movement of the stars across the sky.

To best see the stars, it probably is best to have limited moonlight. It is truly amazing just how much light the moon sheds on the earth at night, especially when it is full; with moonlight on the subject, there can be too much light to get the long-enough exposure needed to see star trails.

In 4-26, the brightness of the clouds is from a quarter moon, but the light hitting the underside of the balanced rock comes from a large battery powered spotlight from a guide during the exposure. This image has a total exposure of over an hour to create the star trail movement effect.

ABOUT THIS PHOTO *It took over one hour to capture the light of the stars and their movement in this image. It takes careful focusing, a steady tripod, and an electronic cable release to really maximize your ability to create great images after dark. Taken at ISO 200, f/5.6, and 75 minutes with a 17-35mm lens set to 17.*

Assignment

Light Quality

Create some new images where your focus is on the quality of the light. Use the appropriate type of light for the image you wish to create. Plan ahead, check weather conditions, and use good or inclement weather to your advantage. Think about the way that light interplays with the subject and how the light helps to create the tones that you are trying to capture in your black-and-white photography.

A black-and-white image of a newborn is the perfect situation for the softest of light. Using very diffused window light, images of this one-month-old little girl are virtually all tones of soft light gray. The exposure for this image is ISO 500, f/4, and 1/100 second with a 105mm macro lens. The only place I really wanted any contrast was in her dark blue irises with shades of dark gray.

Remember to visit www.pwassignments.com after you complete this assignment and share your favorite photo! It's a community of enthusiastic photographers and a great place to view what other readers have created. You can also post comments, read encouraging suggestions, and get feedback.

Besides using a standard dSLR camera, there are many ways to capture interesting and fun black-and-white images. Using some of the tools discussed in this chapter can help you make images that are impossible to create any other way.

INFRARED DIGITAL PHOTOGRAPHY

An infrared (IR) black-and-white image has an entirely different look than any other type of black-and-white photography. Skies become stark black, foliage has an ethereal glow, and faces become nearly translucent. It is not for everyone or for every situation, but it can create amazing images that grab the viewer's attention.

IR light is not visible; the wavelengths captured are just outside of the visible spectrum of light, opposite ultraviolet light. So in order to create IR images, you need to have special equipment.

IR FILTERS

One method is to use a filter that eliminates visible light coming into the camera and only lets in IR light. There are a number of IR filters you can use, including *gel filters*. These are very thin pieces of optically pure plastic. They are relatively inexpensive and can be placed in front of the lens using filter holders that are threaded onto the front of the lens. Gel filters can also be cut — carefully — and placed in front of the lens of a compact camera.

Another good option is the Hoya R72 filter. This is a regular thread-in glass filter that also only allows IR light into the camera. The difference among all these filters is the wavelengths of light that are passed through: Each one allows for a slightly different effect.

x-ref

Check out Chapter 4 for more information on using filters in your black-and-white images.

Using a filter that only lets IR light through creates one relatively significant issue: IR filters don't let any visible light into the camera. In other words, when you place them in front of the camera, there is no light to compose or focus with; therefore, you will need to mount your camera on a tripod and do all composing, focusing, and so on before putting the IR filter on the lens. This definitely slows down the process and makes this sort of IR black-and-white photography deliberate and difficult. When you use these filters, you may also need to use lengthy exposures, which can be limiting.

There are, however, great rewards to spending the time and energy to create black-and-white IR images. Because of the unusual look of these images, IR photography is the perfect medium to really separate your images from the norm. For example, in the image of Stonehenge in 5-1, people were all around, and there were limited opportunities to get images that were really

WRATTEN FILTERS. Kodak's Wratten filters are available in many different colors and strengths, and the Wratten numbering system has become universal amongst filter manufacturers. There are Wratten filters that affect IR light (gelatin filters #87, #87C, #87B, #88A, or #89B) and ultraviolet (UV) light, color filters that change black-and-white images, and countless others.

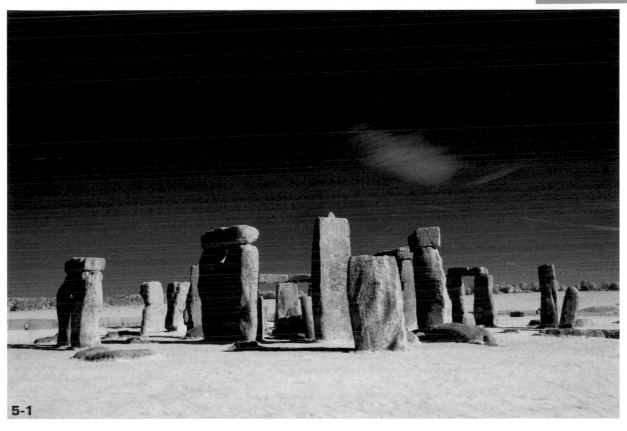

5-1

ABOUT THIS PHOTO *Shooting at Stonehenge is a challenge due to the touristy nature of the place. Shooting in IR black and white allowed me to come up with something a little different from the norm. Taken at ISO 100, f/11, and 1/160 second with a 24mm lens.*

different. Since I was trying to show how rare and unusual this place is, this was the perfect place to explore some IR angles.

DEDICATED IR CAMERAS

If you are truly committed to IR photography, the next step is investing in a *dedicated IR camera*. Having a camera that only captures the IR light in a scene gives you much more flexibility and speed when it comes to shooting. You need not worry about the filter, and you have absolutely no need for a tripod.

A dedicated IR camera is an unusual tool. Digital sensors detect more wavelengths of light than humans can see, so ordinary cameras have a filter that cuts out IR wavelengths. To create a dedicated IR digital camera, this filter is removed and one that only allows IR light in is placed in front of the sensor. A typical conversion entails removing the anti-alias/hot-mirror filter and installing a 720mm longpass filter.

There are a number of shops that specialize in IR conversion. These shops have cameras in stock that are already converted to IR or are able to make the IR conversion quickly to the camera of your choice; it is also possible to have your own

camera converted into IR only. If you already have an older digital camera that you rarely use or use only as a backup, consider converting it to a dedicated IR camera. It's a great way to save a bit of money and use an old camera in a creative manner rather than letting it collect dust.

If you are considering getting an IR-converted digital camera, make sure to get one that works with the system of cameras and lenses that you already have. It is even possible to have compact digital cameras converted to capture IR light only for your black-and-white images. This is a way to get the speed and flexibility of having a dedicated IR camera, but at a more modest price. It also means you can keep an IR digital camera with you, or in your bag, much more often. Having it accessible means you will use it more.

If you do have a professional convert your camera to IR, they most likely will adjust the autofocus system because IR light waves focus at a slightly different distance than the visible light spectrum. This may mean that your images look slightly soft in the viewfinder, and that using manual focus may be a challenge.

SHOOTING IN IR

Black-and-white portraits done with an IR camera can have a ghostly glow; skin appears very pale, even translucent. Depending on the light on the subject, the subtle tones of light gray are extremely intriguing, with unreal contrast (see

5-2). In this example, the photograph was taken in the fall so that IR energy is very high and the entire scene is very bright and high key. One side effect of an IR portrait is that subjects' irises are much brighter; hence the pupils appear much darker.

5-2

ABOUT THIS PHOTO *An IR black-and-white portrait can be exceptionally soft and can create unreal tones and contrast depending on the light. In overcast situations, it may be necessary to set the camera to overexpose to get enough IR light onto the sensor. Taken at ISO 200, f/2.8, and 1/30 second with a 35mm lens.*

Because of the unreal contrast with IR black-and-white portraits, it may be interesting to place the subject against a darker background so the brightness of the skin pops off the image. When the

subject is lit by bright sunlight, skin tones in black-and-white IR images tend to get slightly blocked up and plastic-looking. Use the knowledge you already have about portrait lighting to help guide you, but because IR light is not the same as visible light, you will need to experiment.

One very interesting thing about shooting in black and white with an IR camera is the contrast that appears on an overcast day. In a standard black-and-white scene with an overcast sky, there is often too much contrast between the sky and the ground and trees; the ground and the trees don't receive very much light while the sky is slightly overexposed. With IR photography, because the leaves and pine needles and grasses all record as much lighter tones, there is better texture and interest in the ground, yet still detail in the clouds above (see 5-3).

When you shoot IR for black and white, I highly recommend that you set the camera to black and white in the first place. The way that the colors are translated in IR is quite different from how people see the scene, so it may be difficult to translate strange pinks, golds, and blues into black and white in your head. Being able to see

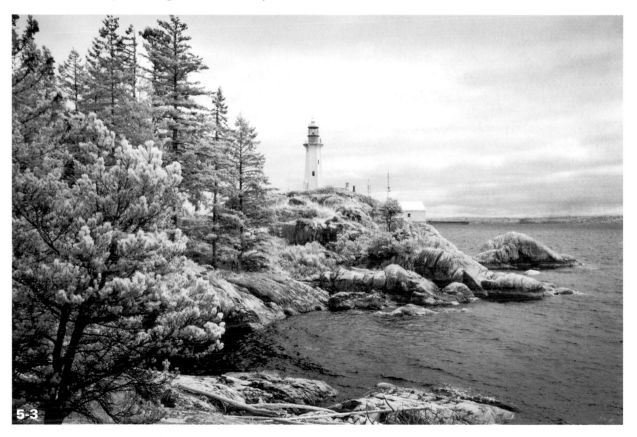

5-3

ABOUT THIS PHOTO *Shooting these images with a standard digital camera created relatively flat images with a sky that was too bright and a foreground that was too dark. When I used an IR-converted digital camera, the way the light was recorded in the scene was far more interesting. Taken at ISO 400, f/10, and 1/125 second with a 24mm lens.*

the scene in black and white will not only help you to visualize the translation of color, but also determine the exposure.

In the case of 5-4, the color of the scene on the IR camera LCD appeared an overall brownish pink and looked rather dark, yet the histogram seemed appropriate, which was a little confusing. After quickly resetting the color mode on the camera to black and white, I determined that the exposure was actually too bright, not too dark, and that the histogram was fooled a bit by the IR tones.

LENSBABY

A Lensbaby is a toy-style lens that can be attached to most interchangeable-lens dSLRs. There are a number of different models, but the most recognizable one is a simple, single element lens on the end of a tube bellows that allows you to twist and turn the actual element. This creates an image with a shallow-focus sweet spot, around which is soft-focus blur.

Lensbabies create the look that is similar to toy cameras, such as the Holga, but with better exposure and focus control. Additionally, due to the

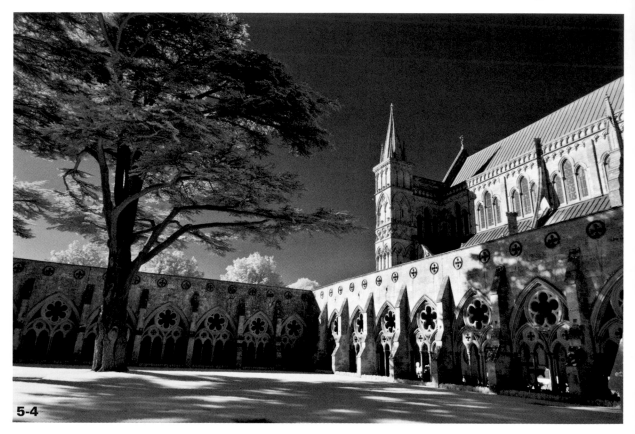

5-4

ABOUT THIS PHOTO *The effect of the IR image here is subtle, but I think it makes the image pop. The brightness of the leaves and grass is nice; it's the great detail and smooth gradations in both bright and shady parts of the cathedral that I find fascinating. Taken at ISO 100, f/13, and 1/60 second with a 12-24mm lens set to 16.*

design of the lens element, the out-of-focus area seems to have a slight direction to it, steering the eye toward the focus sweet-spot. This direction of the bokeh is called *spherical aberration*, and it is something that makes the Lensbaby unique, particularly because regular lens manufacturers spend a lot of energy trying to eliminate this effect. By pushing, pulling, and turning the front of the lens, it is easy to move the sweet spot where you want it; in the case of 5-5, the sweet spot is the subject's eyes.

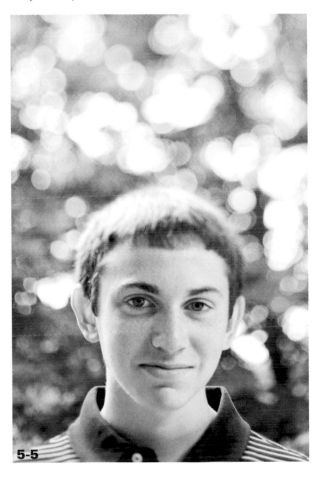

5-5

ABOUT THIS PHOTO *Once the light and everything else is set for the scene, it is easy to place the sweet spot of the Lensbaby right on the eyes in a portrait. This is a very simple lens with no autofocus; you focus by moving the front of the lens around. Taken at ISO 200, with an f/4 aperture disk, and 1/40 second.*

The Lensbaby itself has a natural aperture of f/2.8, but you can insert aperture discs into the lens that change how much light comes into the camera. Having the aperture discs inserted also cuts the amount of light you have to get the sweet spot in place, and makes the sweet spot slightly larger as the depth of field increases. But the whole point of the Lensbaby is to have that sweet spot within a much larger, out-of-focus area, so the aperture discs are there for bright scenes and to keep the shutter speeds down.

Without all the electronic contacts and the auto aperture in the lens, you will need to set most cameras to manual to operate a Lensbaby correctly, although with some cameras, you will be able to work in Aperture Priority.

The newest versions of the Lensbaby use a large ball joint instead of the bellows; some can lock the sweet spot into place for use with longer shutter speeds or a tripod. There is also the ability to actually change the element for different effects, including a plastic element, making the images taken with the Lensbaby even more like a Holga or Diana.

The plastic element is part of Lensbaby's Optic Swap System, which is available on the Muse, Composer, Control Freak, and Scout models. The Optic Swap system is not available on the older Lensbaby models. Not only does the Optic Swap system offer a plastic element to look like the Holga or Diana cameras, but there are also options for a sharper double glass element, a pinhole camera look, a soft focus optic, and a fisheye option.

Lensbaby models are available for most digital SLRs including m4/3s and Sony Nex cameras. When using a Lensbaby with a dSLR, you may be limited to manual only exposure due to the lack of electronics in the lens.

Check out the different models of Lensbabies to see what works best for you. Because of the lack of autofocus and the shallow area of the sweet spot, getting an image that is razor sharp is difficult. For those photographers who are looking to make more abstract and impressionistic black-and-white images with their digital cameras, the Lensbaby is a great tool and toy. The price makes it even more desirable, creating more opportunities for fun images (see 5-6).

BLACK AND WHITE BY YOUR SIDE

Contemporary commercial photographer Chase Jarvis coined the saying, "The best camera is the one that you have with you." Capturing a black-and-white image of any memorable moment or scene should be quite easy, not to mention fun, with whatever camera you have by your side. It doesn't always have to be the newest technological marvel.

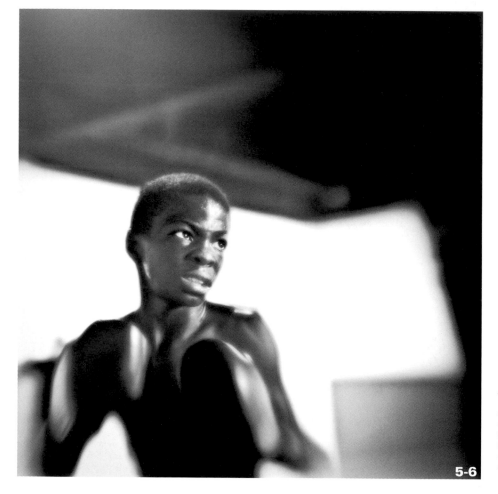

5-6

ABOUT THIS PHOTO
Trying to follow focus with a moving boxer and a Lensbaby is a challenge, but getting the face in the sweet spot and letting the rest of the scene fall out of focus gives the look of smooth motion. Taken at ISO 1600, f/2.8, and 1/80 second.

CAMERA PHONES AND EFFECTS

The advent of digital cameras built into mobile phones has been a revolution in capturing priceless moments. The image quality is usable, at least on digital devices.

Most of the cameras on camera phones have limited functionality — they simply take color pictures. More advanced devices, such as smart phones, can include applications and small programs. You can use a number of these apps to create interesting black-and-white images from your mobile phone photographs.

Mobile phone apps that are able to convert photos into good black-and-white images are plentiful and can be had for cheap if not free. A couple of the best mobile phone apps for converting images to black and white are MonoPhix and Photoshop Express. MonoPhix has two sliders for adjusting both highlight and shadow contrast and shows you a preview of the adjustments before they are applied, while Photoshop Express is exactly what you might think: a scaled-down version of the classic image-processing software.

With both of these apps, it is possible to make black-and-white images out of pictures that are taken with the mobile phone's camera as well as photographs that have already been taken and then uploaded to the mobile phone. Using an image taken with an iPhone, the tools in Photoshop Express enabled me to affect the contrast and sharpness so much so that it is reminiscent of early days in the darkroom. The dark border is emulating the emulsion around an image when the negative is in the carrier of a real enlarger (see 5-7).

5-7

ABOUT THIS PHOTO
I used the sharpening and contrast tools in Photoshop Express, along with the emulsion-look border to create an image that reminds me of my photo-school days. The sharpening tool helps make the image look grainy like Tri-X. Exposure unrecorded by mobile phone.

This is a great way to make black-and-white images on the fly. It is quite easy to upload photos from the computer into your mobile device, apply black-and-white changes to the image, and then download them to the computer to print or to post on the Web. Using the contrast sliders in MonoPhix, you can get very nice black-and-white tones with relative precision on a mobile phone from an image uploaded from the computer (see 5-8).

The small size of a mobile phone's sensor, the relatively limited computing power of a mobile phone, and the rudimentary nature of the apps are limited tools, but all that shouldn't limit your creativity when it comes to the black-and-white images that are possible. In fact, with the apps discussed here as well as others like Hipstamatic, there are thousands of ways to make interesting and fun black-and-white images.

> **note** The images that are processed through a mobile phone are usually quite compressed JPEGs, so the limitations are really apparent when you are creating prints. However, for most Web applications, these images can be amazing.

POINT-AND-SHOOT BLACK AND WHITE

Many photographers keep point-and-shoot cameras with them at all times. When you slide a camera into your pocket for a party or a hike, keep it set to black and white and see how much different your everyday photos seem.

Because most point-and-shoot cameras only shoot JPEGs, spend some time shooting only in black and white on your point and shoot. This can help guide you to find images with strong shapes and textures. Much like with the camera phone, simply having a camera with you is a huge step in taking better black-and-white photographs.

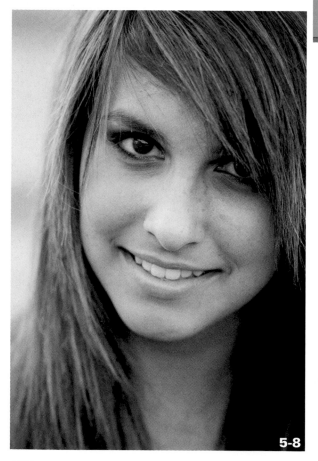

5-8

ABOUT THIS PHOTO *It takes no time at all to make nice black-and-white images in applications like MonoPhix. By adjusting both a shadow slider and a highlight slider, it is possible to get the contrast right on. Taken at ISO 200, f/4, and 1/160 second with a 200mm lens.*

With their small size and many features, including amazing autofocus, point-and-shoot cameras are perfect for getting black-and-white images. Because you are not relying on a proper viewfinder, you tend to get a point-and-shoot camera into places and angles that are bit out of the ordinary (see 5-9).

Without the myriad dSLR settings, using a digital point-and-shoot camera to take black-and-white images can be liberating. For as much as I have discussed getting the perfect exposure with fantastic contrast (and those things are important), at times just being able to reach your hand into your pocket or purse to capture the scene without a care is so awesome. The light and shadow, the balance and harmony of the lines and contrast in the scene at that moment, will never be the same again, so capture that black-and-white image, and then keep the camera close and ready for the next image (see 5-10).

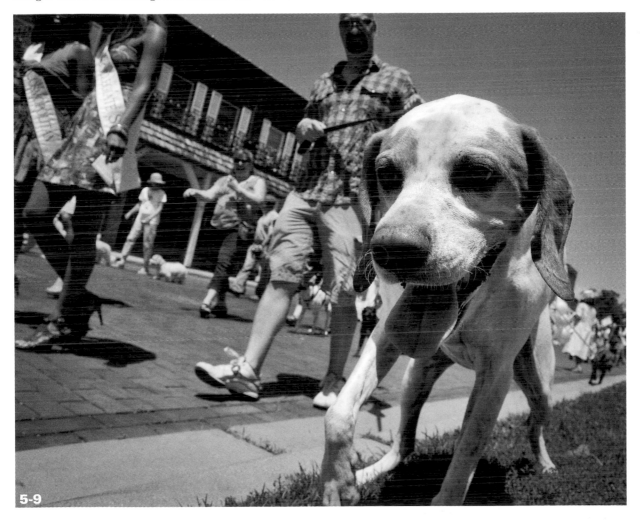

5-9

ABOUT THIS PHOTO *It would have been nearly impossible to get a photo this low with a dSLR without lying on the ground. Using the automatic settings with the camera set to black and white, I was able to get several great shots of the parade of pets. Taken at ISO 200, f/9, and 1/640 second, 4.6mm setting 28mm equivalent.*

5-10

DSLR SPECIALTY CAMERAS

The size and weight of a dSLR can be cumbersome and using one can be obtrusive in many ways, but the image quality of a point-and-shoot compact camera often leaves a bit to be desired. There is a whole new range of cameras available with the image quality and large sensors of a dSLR in a much more compact body. These cameras probably can't fit in the pocket of a pair of jeans, but they do fit into a jacket pocket or the pocket on a pair of cargo shorts.

Most of the big camera manufacturers have jumped on this bandwagon, and many offer form factors and features that are very photographer-centric. These cameras are for the hobbyist who is looking for something a little more compact or the point-and-shoot user who wants better image quality.

One of the fun things about these new compacts is that they don't stand out like dSLRs. Their small size enables you to get great photos; in situations when a larger camera might not be

SPECIALTY CAMERA MODELS. There are a number of different names and models in this new niche of digital cameras. Olympus and Panasonic started much of this with their 4/3 cameras, which they then made even smaller with the Micro 4/3s (which is noted commonly as m4/3). Eschewing the standard mirror and prism, Panasonic's full line of G cameras and Olympus's EP series are cameras with only electronic viewfinders in very tidy units. Sony's Nex family has a larger sensor in a smaller body; Leica has the X1; and Samsung and Ricoh offer similar cameras.

Virtually all of these cameras have the full complement of automatic and manual controls, and many are set up similarly to older cameras. These cameras also shoot RAW files, so they provide much better image quality and flexibility with processing the images.

5-11

appreciated, you can still get the image quality you desire. The large size of the sensor helps image quality quite a bit, especially with handling noise at higher ISO settings (see 5-11).

Removing color in a scene makes the texture so much more important, as the tones, and their modulation across the scene, enable us to gather even more sensory information. We know what the scales of a fish feel like, and we know the smells and sounds of a big city street, so imparting that texture to the viewer becomes a vital part of the black-and-white image.

Being able to capture that texture no matter where you are is the biggest advantage to using some of the smaller tools available in this digital age. In a big city, some photographers might feel having a dSLR bag hanging off their shoulders makes them prey to theft or look too touristy; or the bag could simply be too heavy to carry all day. Smaller cameras are easy to use and transport, and because of that, they are used just as often, if not more, to capture and share the texture of the life in front of the camera (see 5-12).

ABOUT THIS PHOTO *While the textures for black-and-white images are so amazing at the market, the guys selling fish don't always like people zooming in on their wares. An m4/3 camera with a fixed normal lens is practically the same size as a point and shoot. Taken at ISO 800, f/2.8, and 1/320 second with a 20mm lens.*

ABOUT THIS PHOTO *At the end of the day, much of the city had sunk into shadow, making the texture of the buildings smooth gradations of rough stone and brick, with a stream of sunlight hitting the pub-goers. Having a small m4/3 camera with me enabled me to easily capture these scenes. Taken at ISO 400, f/4, and 1/1000 second with a 20mm lens.*

STROBES

Even with the amount of technical wizardry built into digital cameras today, the thought of using strobes is still scary to many. Perhaps people are wary of the harsh, unflattering light that can come from the built-in flash or the thought that strobes are only used at night or indoors; the fact is that using a strobe can help your black-and-white images immensely.

Do consider using a strobe in the daytime. It gives you much more control of the contrast in many types of images, especially portraits as fill flash.

x-ref Fill flash is discussed in more detail in Chapter 4.

One of the first ways to control the flash in your black-and-white images is to learn to control the power of the flash on the camera. With most dSLRs, you can easily do this using the Flash Exposure Compensation button. This button, or menu item, should look like the +/– of the Exposure Compensation button, but also include a flash or other lighting icon. In many cases, simply setting the camera to lower power and turning

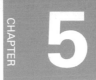

the exposure compensation to the – side reduces the power and will drastically lower the apparent brightness from the strobe.

Using an accessory strobe that mounts on top of the camera will also go a long way toward making better black-and-white images. Getting comfortable with Speedlights (Nikon) or Speedlites (Canon) is the first step in truly working with more creative lighting and contrast control with your strobe. By learning to turn the power up and down, and, even more important, by learning to turn and swivel the head of the strobe to bounce that light onto the subject instead of blasting it straight on to the subject, you will get great light that is more pleasing to the eye. Try bouncing the strobe's light off a reflector or even a wall; the apparent source of the light is much larger and thus softer, and provides a bit of nice direction and contrast on the subject (see 5-13).

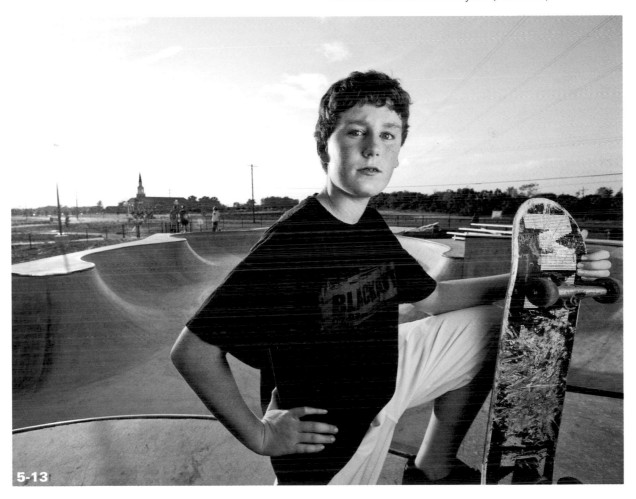

5-13

ABOUT THIS PHOTO *I swiveled the strobe head to the side so the strobe's light would hit a Lastolite trigrip reflector and bounce back across the skateboarder's face. Can you see the highlight on his cheek from the sun? Without the strobe, this highlight would be all you could see of his face. Taken at ISO 200, f/7.1, 1/200 second, with a 17mm lens.*

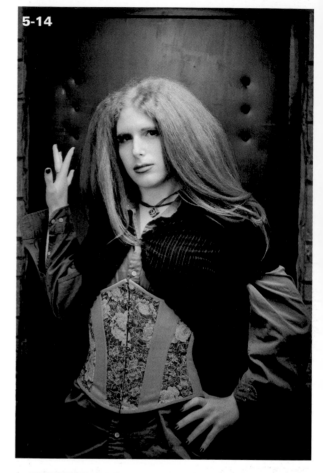

ABOUT THIS PHOTO *Moving the strobe from above the camera to above the model makes a much more striking portrait. Using the digital trigger built into many dSLRs, you can get the strobe to fire when it is not attached to the camera. Taken at ISO 100, f/5.6, and 1/200 second.*

5-14

OFF-CAMERA FLASH

Getting the flash actually off of the top of the camera makes a huge difference in your ability to control the light. Using just a few relatively inexpensive accessories, it can be simple to get your strobe off the camera and start adding a lot of drama and excitement to your portraits. With some dSLRs, the tool to trigger a strobe when it is not attached to the camera is built right in.

Using off-camera flash makes images with strobes better for a number of reasons. The first is that you control the direction of the light on the subject instead of being at the mercy of the ambient light. The second is that once that light is not attached to the camera, you have far more control over the light quality. It is possible to attach a Speedlight to an umbrella or softbox, or use a Lastolite trigrip or any sort of reflector to manipulate the way the light hits the subject.

In order to have the light distribute evenly on this model's face and then have the rest of the light fall away, making her face the focus, I shot a Speedlight into a white translucent umbrella, which is just barely out of the frame of the image (see 5-14).

HOW STROBES COMMUNICATE. Each camera manufacturer has its own strobe and Speedlight system. The Nikon and Canon wireless systems are the most advanced and are used by many hobbyists and professionals. The capability for the cameras and strobes to communicate to each other is an amazing tool for getting better light. Sometimes the strobes need to be in the line of sight with each other to work properly. In that case, there are a multitude of remote triggers you can attach to both the camera and the flash so that the flashes fire at the exact instant they are supposed to via radio signals. Some use the IR signals sent by the commander strobe via radio waves to trigger the strobes intelligently.

I triggered the Speedlight with the pop-up flash using the Commander mode. The Commander mode enables the pop-up flash to tell the Speedlight when to fire and how much light to put out to get the correct flash exposure. The two flashes "talk" to each other with a series of IR pulses; this can be done in a fully automatic mode or a fully manual mode.

STUDIO STROBES

Studio strobes have a number of advantages over Speedlights and other small strobes. Studio strobes have much more power for increased depth of field; they recycle faster and do not rely on batteries. The options for light shapers, such as umbrellas and reflectors, and how they work are much more diverse. Of course, most studio strobes rely on a household A/C current, which may not be readily available out on location. Studio strobes have a wide range of price points to fit your needs and budget.

Much like when you use Speedlights off-camera, being able to sculpt the subject is the key to using studio strobes. Each light shaper — softboxes of all different shapes and sizes, including tiny squares, long rectangles, and giant octagons — has its own way of moving, forming, and shaping the light created by the strobe.

With a large softbox, a subject might be bathed in soft light that practically makes pale skin glow almost as much as it would in an IR image. In 5-15, the soft tones on the baby's skin are light gray tonal gradations as the light wraps around her body. Without the power of the studio strobes, there would be much less depth of field

(and there is very little already). The baby's eyes and face are sharp but the hand at the top of the scene is quite soft at f/9.

Many studio strobes come in sets of two or more lights. Having more than one enables you to give the subject some more depth. When you set the strobes to a low power setting, the lights recycle quickly, and the depth of field is still adequate for the distance to the subject.

5-15

ABOUT THIS PHOTO *A large softbox, 4 × 6 feet, creates a very soft light when it is brought in close to the baby's skin. Having the power of the studio strobe helps you get enough depth of field, and having a fast recycle time ensures that you capture the perfect expression in time. Taken at ISO 200, f/9, and 1/200 second with a 24-70mm set to 70.*

The first light in 5-16 is a studio strobe head with a large reflector dish that creates a harder light than a softbox would, but the light for this image is more about direction than hardness. A second light comes from the left side of the image, highlighting the girl's hair and bringing some shape to her body as the light comes around her shoulder.

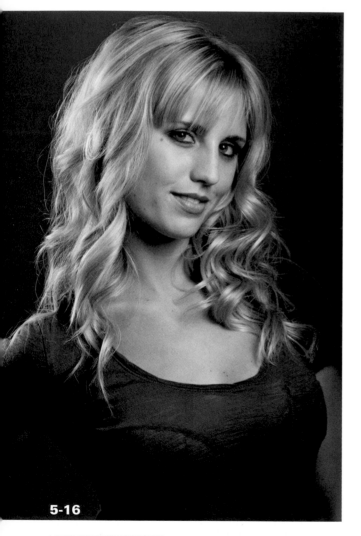

5-16

ABOUT THIS PHOTO *Two Elinchrom studio strobes with reflectors give this model a nice shape. Even in black and white, you can almost see how golden her hair is. Taken at ISO 100, f/5.6, and 1/160 second with a 70-200mm lens set to 125.*

TRIPODS

No tool is more valuable for making great black-and-white images than a good tripod. That is not to say you should always use a tripod, but you should use it when you are doing longer exposures or when framing and sharpness are critical.

GETTING THE MOST FOR YOUR MONEY

If you are serious about black-and-white photography, a good tripod is a must. When the images need to be incredibly sharp, it is important to have a tripod that is solid and strong. If you are going to be hauling a lot of equipment, you will want a tripod that is light enough to carry.

A tripod that is strong, light, and durable means one thing: It is not going to be inexpensive. There are many good tripods available, as well as probably even more bad ones. Look for a tripod that has parts that can be replaced. Manfrotto has many lines of tripods, and there is certainly a tripod in their catalog that fits the bill for you. Gitzo makes the premier line of tripods; they are expensive but worth it, if for no other reason than they last forever.

Most good tripods available today are made out of one of two things:

■ Aluminum

■ Carbon fiber

Aluminum tripods are light, but not as light as carbon fiber, and cost substantially less money for the same size and features. Carbon fiber tripods are the strongest and lightest, and the material naturally dampens vibration.

One thing to keep in mind while shopping for tripods is that you get what you pay for. Saving a few dollars in tripods, even if you are a hobbyist, probably won't pay off in the long run. No one

wants to spend unnecessary money, but buying a tripod at a big box retailer is a recipe for disaster. Many of those tripods are made of plastic and do not have replaceable parts, so if the smallest part breaks, it is probably time for that set of sticks to head to the trash. Go to your local camera store and bring your camera to make sure that you are getting the tripod that you need for the photography that you want to create.

TRIPOD HEADS

The tripod head is the link between the tripod and the camera and the part that you actually touch and use. It is just as important as the tripod, and maybe even more so because if the way it works and handles don't make sense, you won't use it, or worse you may use it incorrectly, leaving something loose or unlocked, which might spell true trouble for your camera.

There are a multitude of different styles of heads. Much like with the tripod, it is good to take your camera into the local shop and attach your camera to the head and make sure it operates smoothly and in a manner that is ergonomically positive for you. Many landscape photographers use some sort of ball head so they can get exactly the right angle even if the rest of the tripod is not level. Photographers who spend more time doing architectural-type photography tend to use heads with multiple layers of tilt options to maximize their precision when creating their images.

A good tripod head will have smooth movements and lock into place solidly; the combination of a good tripod and head will make you feel as though your camera is secure and safe, even when you are in a precarious position (see 5-17).

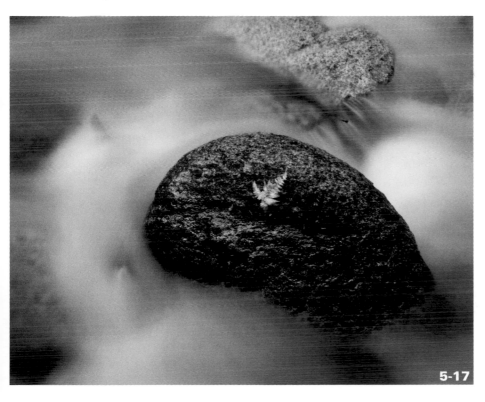

ABOUT THIS PHOTO
Standing in a freezing cold stream, a piece of fern contrasts against the rough texture of the stone, while water rushes all around. Without a rock-solid tripod, one that is well over 20 years old, this image would have been a gray blurry mush. Taken at ISO 100, f/29, and 6 seconds with a 28-70mm lens set to 38.

5-17

Assignment

Start Freeing Yourself

Now that you have learned rules about lighting and exposure, it is time to break some of them.

There are so many tools and toys out there to help you create great, or at least fun and interesting, images, it is time to shoot from the hip, so to say. Use some of the camera's simplest settings, such as Aperture Priority or Shutter Priority, and set the camera to black-and-white JPEG or at least black and white + RAW. If you have a point-and-shoot digital, use it and start shooting some images that aren't necessarily framed up precisely or shot with exactly the right settings.

What does a scene look like if you make it 1 or 2 stops brighter or darker? What if you just point the camera at some action and then look away when you are actually shooting? Do you have an old film camera or some sort of toy camera? What can you actually do with that camera that you would have never thought about doing with a digital camera? In this example, I specifically wanted to create an image that was out of focus. It didn't take much to turn off the autofocus and get just the amount of blur that I wanted on this monolithic cooling tower, getting the impressionistic look that I was going for. The exposure for this image is ISO 100, f/4.5, and 1/320 second with a 14-45mm m4/3 lens set to 18.

Remember to visit www.pwassignments.com after you complete this assignment and share your favorite photo! It's a community of enthusiastic photographers and a great place to view what other readers have created. You can also post comments, read encouraging suggestions, and get feedback.

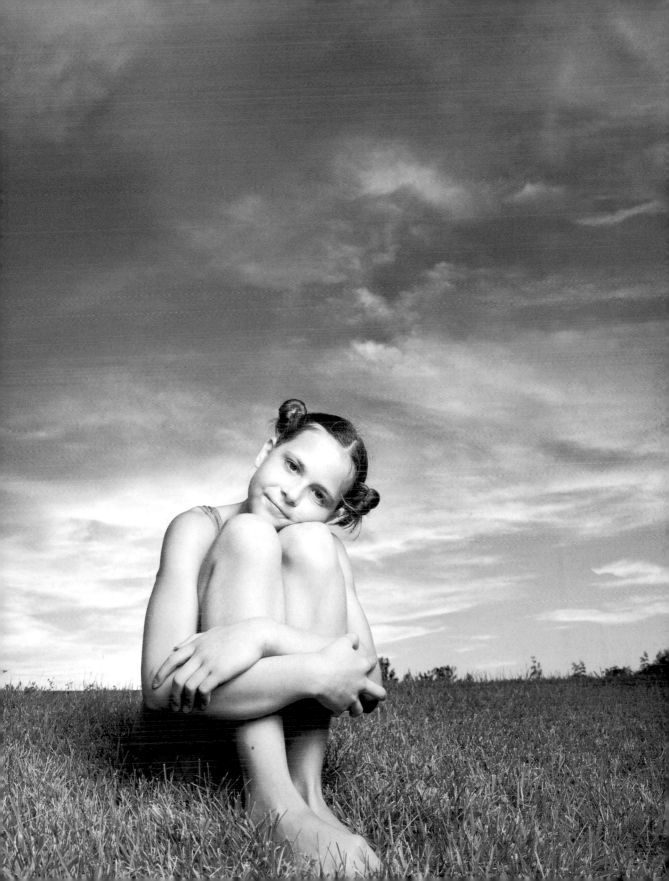

TONAL QUALITY IN BLACK AND WHITE

Being able to control the tones in your black-and-white photographs is a vital part of making successful images. Without color, it is the gradations of gray that give the image life and body: The depth, as well as the separation, of the gray tones enables you to make creative compositions within a monochrome image.

The *tonal range* in a particular image can be long, with a lot of gradation, or short, with high contrast. It is important to be able to determine how the tones will appear in black and white. In this chapter you learn how to best capture the tones in the scene by looking at the lighting and the color of the original scene.

COLORS IN BLACK AND WHITE

Different colors translate into different tones of gray. Further, each camera interprets how colors will be rendered into gray tones differently and each does a slightly different job when translating the color into gray tones.

In Chapter 4 you learned how colored filters affect the tones of the entire image. If you change a color image in the computer, you can adjust the tonal interpretation with much greater precision, which enables you to interpret a photograph many ways. Naturally, the changes are most prominent when the colors are bold, but you can also use color adjustment to make subtle changes.

Using the black-and-white adjustment tools in programs such as Adobe Lightroom and Photoshop Elements, you can make huge differences in tone with relatively small adjustments. For example, a red flower can be bright, glowing white, which makes it pop out from the dark background, or its red tones can be rich with layers of gray, which is perhaps a more faithful rendition of the tones of the image (see 6-1 and 6-2).

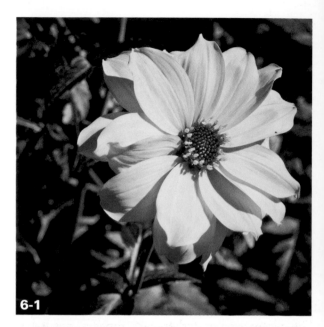

6-1

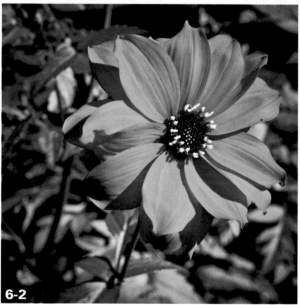

6-2

ABOUT THESE PHOTOS *A red flower can be interpreted many different ways, each one making the scene look vastly different; any one is perfectly acceptable. You can adjust the brightness of a particular color in an image to suit your vision. Taken at ISO 100, f/8, and 1/200 second.*

When you convert a color image to black and white, you can change the luminance of each color in the image, making particular colors lighter or darker. *Luminance* is a brightness setting for different color ranges. These ranges are:

- Red
- Orange
- Yellow
- Green
- Aqua
- Blue
- Purple
- Magenta

You can lighten or darken each range as needed. In 6-1, the luminance was set to 60, and in 6-2, it was set to 0, or right in the middle. I made these changes in Lightroom. The luminance sliders in Lightroom are similar to those in Adobe Raw or in the Black & White module of Photoshop and Photoshop Elements, but they have slightly different colors to work with.

note Adjusting the luminance settings is one of the easiest and quickest ways to make both subtle and bold changes to a color image that is being converted to black and white. It should be noted that extreme luminance settings may cause noise and banding in parts of the image where there is smooth gradation.

The fine-tuning options the luminance sliders provide are virtually endless. Because you can use the luminance sliders to change the brightness of individual color groups, it is also a great tool for affecting the amount of contrast in a black-and-white

photo (see 6-3). When you see the number of changes you can make, it is much easier to understand why black-and-white images have such different looks in different cameras. You can change the tonal response of different colors in a black-and-white image entirely with a slight change in the luminance with the in-camera image processing.

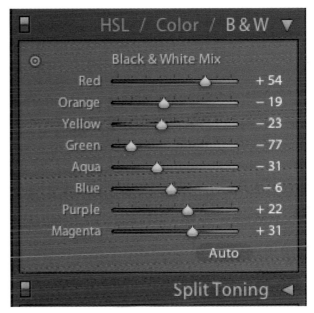

6-3

ABOUT THIS IMAGE *Notice how much you can do to the tone and contrast in an image by adjusting the tonal response of a color in a black-and-white image. Remember, this brightly lit flower is red, so the amount of changes to that red flower can be relatively great. Taken at ISO 100, f/8, and 1/200 second with a 105mm macro lens.*

TONES AND CONTRAST

The tones of gray in a black-and-white image set the feel for the photograph. It is much more about conveying a feeling and attitude in a photograph than maximizing every pixel level of gray tone in a particular image.

Using the tools in the camera to get an exposure that is "correct" may give you a good exposure, but is it the right exposure for the scene? You need to take special care with tones and contrast in black-and-white images because these factors create the mood you are trying to impart to your viewer.

This may mean that an image shouldn't always have an exposure that exposes to the right or that doesn't block up at either end of a histogram. You have more latitude with black-and-white images than you do with color ones, because lighter or darker shades of gray can have powerful effects, unlike washed-out or dingy colors.

When there is a lower contrast level, it can be good to have white tones that are still relatively gray. Without any bright lighting, there are often no hard black or whites in the scene unless you under- or overexpose the scene substantially. For example, if a white paper package were exposed all the way to the right, it would end up being much brighter than desired, and the subtle textures of the white package would become a white blob. This would also make the entire scene far too bright, and the beautiful tones of the cheeses would end up washed out (see 6-4).

These theories all come back to contrast. Being able to recognize the amount of contrast in a scene helps you to create the exposure necessary to set the tone of the scene.

The image in 6-5 has similar lighting as the previous example and a similar contrast range. The difference is that 6-6 has light tones that show the texture in the bark, with its knots and black markings, and that the white bark really calls out to be as white as it can be and still have some

6-4

ABOUT THIS PHOTO *Although there are blacks and whites in the scene, there is no need to make the white paper completely white. There is an interesting tone in the package, and too much contrast will ruin the overall tone of the scene. Taken at ISO 500, f/4.5, and 1/800 second with a 20mm m4/3 lens.*

tone. The white of the fallen birch tree contrasts in both tone and texture with the dark leaves surrounding it.

6-5

ABOUT THIS PHOTO *Use the contrast in both tones and textures to bring interest to a scene. Evaluate the contrast before you start to shoot to help with your end vision. Taken at ISO 400, f/5.6, and 1/160 second with a compact digital camera.*

WORKING WITH SHADOWS AND CONTRAST

It is important to use the shadows in a scene to create the contrast. That may even mean that the shadows themselves become the subject. Shadows help define the shape of objects, something especially key in black-and-white photography. Without color, you must use shadows to create texture and interest.

6-6

ABOUT THIS PHOTO *Shadows against white snow are often nearly monochrome, even before the image becomes black and white. Using the shape of the bench's shadow brings interest to the field of white but the black of the bench really brings the contrast. Taken at ISO 200, f/4, and 1/500 second with a Lensbaby.*

For as important as it can be to make sure that there is detail in the dark tones in many images, there can be many times when it is just fine to

make shadows go black to give an image more pop and richness. The contrast of having really defined black tones against lighter tones can make a black-and-white scene even stronger. Many times the black tones in the shadows can help anchor an image that doesn't have strong subject matter.

The shadows themselves can offer great interest and bring balance into a composition. With hazy sunlight, there was a lot more tonal range in the scene in 6-6, making the shadow a middle gray and the black bench the anchor. On a bright day, the contrast between the shadow and the snow might have been literally black and white.

Pools of light surrounded by shadow bring even more focus on the subjects and a different sort of feel to a scene than one that is more evenly lit. The contrast of dark areas framing a scene or subject can be either detailed shadow or nearly black, depending on your style. However, the huge contrast between the bright areas and the dark areas make this type of image difficult to photograph. In many cases, the camera's meter tries to balance the bright areas and the shadows, which often leads to washed-out highlights and dull shadow areas.

Determine what is most important in the scene. As you can see in 6-7, the shadows lend the tone for the image. Light coming into a dilapidated barn illuminates a row of rusty old cans, with the brightest area on one particular light-colored can. The most important part of the image is the texture of the cans and weathered silver barn wood, so retaining detail in those dull highlights is important. In this case, there was enough diffuse fill light to retain some detail in the darkest parts of that shadow; it is just fine with me that the shadows around the edges go completely black.

6-7

ABOUT THIS PHOTO *The shadowed areas framing the cans give the subjects a sense of place and time; and it was most important to make sure the tones of the cans and barn wood looked rich and weathered, not washed out. Taken at ISO 100, f/4, and 1/125 second with a 20mm lens.*

LIGHT QUALITY

To really understand how lighting affects tones in black and white, it is important to have a good handle on how light and contrast go hand in hand. Light quality can be very ephemeral and transitory, meaning that available light is always changing and moving and can be very different on different subjects. Even the light quality from a strobe, which can be consistent from frame to frame, can be endlessly affected by different reflectors, umbrellas, and soft boxes, not to mention the distance to the subject and how the light bounces off other surfaces.

The terms *hard light* and *soft light* are used fairly loosely in the photography world, but how they describe light is pretty appropriate. Describing the light by the way the shadows transition back to it is a perfect way to explain basic light quality. The only problem comes when people think that they must have a particular light for a particular scene. This isn't always the case, and many times the perfect light is there if you just take the time to think about it or make just a few changes to the situation.

SOFT LIGHT

You can get soft light with both light and dark objects; it certainly can exude bright or dark feelings. When there is diffuse light coming through

a window, a still life, a baby, or even just a baby's toes become wrapped in that soft light (as seen in 6-8). Indoors, this may mean you need to use large apertures or slower shutter speeds to get enough light on the subject to get smooth light that has bright tones. Think about how the gray tones are just soft gradations from light to dark across the scene or subject.

The best way to get smooth gradations of tone from light to black is most often by using soft or slightly diffused light. There are so many different levels of soft light and each one will bring about

different amounts of contrast. Use the camera's exposure tools to exaggerate the effects of the light on the subject.

On a heavily overcast day, all the tones can become a rich dark-gray. Take advantage of this to build a mood. In an old stone statue, the dark shadows beneath the figure's hand showed amazing texture, and the reflective nature of the stone fingers had just enough highlight to create a nice contrast. There was plenty of detail in all of the tones, from the darkest to the lightest, and the soft light of the overcast day made that possible (see 6-9).

6-8

ABOUT THIS PHOTO *The contrast level on a high-key scene with soft light is relatively low. There are no real bright highlights, and no deep shadows, just beautiful smooth tones of gray. Taken at ISO 400, f/5.6, and 1/160 second with a 105mm macro lens.*

6-9

ABOUT THIS PHOTO *Getting up close to a subject helps you really see the detail and texture. Soft light wraps around the stone hand to help show that texture without too much contrast. Taken at ISO 200, f/5.6, and 1/30 second.*

HARD LIGHT

Crisp shadows and bright highlights are created
with hard light. Besides using the hard lines of
the shadows as elements of composition, you can
use hard light to create drama, with deep dark
tones and bright highlights.

Hard light is the light quality available at most
times of the day, and many photographers eschew
it in favor of shooting earlier and later in the day.
Sometimes, this simply isn't possible: The image
is right here, right now. The flexibility that black
and white affords you is often exactly the reason
to use it. Images that are mediocre in hard light
on a color image become brilliant images full of
rich, hard contrast.

Midday sunlight on a bright truck creates a black-
and-white image just waiting to happen (6-10).
In this case, I had precisely a black-and-white
image in mind. The black shadows around the
grill and hood, as well as the dark tones of the
background, make the shapes of the truck the sole
purpose of the image. What makes this image
work is that you can see the subtle bright tones of
the shape of the grill and body work. If this scene
were overexposed even a bit more, that little bit
of texture would needlessly be lost, since the dark
tones would still be plenty dark.

Use hard light to your advantage when you can.
Hard light creates deep dark and black tones that
are unmatched by soft light; you can pit those

6-10

ABOUT THIS PHOTO *The shape, balance, and contrast of this scene enabled me to visualize it as a black-and-white image. Hard light helped
create the cool design elements. Taken at ISO 100, f/8, and 1/800 second with a compact digital camera.*

dark tones against bright highlights. Images with high contrast caused by hard light draw in viewers, but they are difficult to do well because of the range between the dark shadows and bright highlights.

Pay attention to the histogram, and refer back to the exposure hints in Chapter 3 to get the most detail out of both the shadow and highlight areas of the photograph. Being cognizant that the level of contrast in a scene is a huge part of creating a great image.

Just because light causes strong highlight and shadow does not mean that smooth gradations of tone are impossible. It simply means that the subject matter must allow for it. Hard light coming from the side or behind the image can give a subject some accent instead of just lighting it up. Because of the angle of the light, this often makes those highlights completely white; but, because that hard light is rim light, accenting the subject, blown-out highlights may be okay if not even desirable. In 6-11, the graduation of gray tones comes from the shadow areas being part of a large curved wall.

LIGHT DIRECTION

Light from different directions can make images look totally washed out in one instance and completely black in another. Look through the viewfinder to see not only the shadows that appear, but also where exactly they fall, and determine if they are interesting in the scene.

Sidelight is easily the most desirable type of light because it can come from many angles, each of which has a different effect on the look of a scene. Light that comes from just slightly off the front of

6-11

ABOUT THIS PHOTO *Using the angle of the hard light to accent a shadowed scene is a great way to get a lot of interesting contrast as well as nice tonal gradation. Taken at ISO 200, f/5.6, and 1/500 second.*

the scene is good to use when you want to light up most of the scene but want some shadow contrast. When light comes from directly off the side of the scene, there is often a lot of contrast, and subjects have opposing bright and shadowed sides. A very dramatic portrait might have one side of the face well-lit and the other in shadow.

When light comes from slightly behind the scene but not truly directly from the back, long and interesting shadows can result. Shadows that are just dark enough bring the strength of heavy elements into the design of the scene, which is perfect for a black-and-white image (see 6-12).

Use windows as light sources for portraits in your black-and-white photography. There is something amazing about natural light, and when you learn how to control it in your black-and-white photography, the results are exceptional. It creates great gradations of tones, yet there is still some good contrast.

In 6-13, the light is coming from directly behind the camera. The sun hit another side of the building and the window was in the shade. When the sun comes through a window, the light is very hard and directional. This type of light is difficult to deal with because of the huge amount of contrast, unless you have a way to fill in the shadows with additional light.

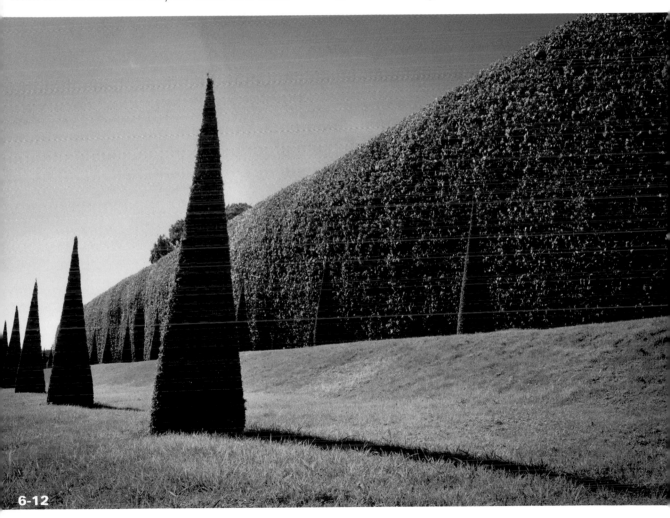

6-12

ABOUT THIS PHOTO *Side light coming from slightly behind the scene makes for strong shadows. Use this type of lighting when you are looking for a lot of shadows as elements of the image. Taken at ISO 100, f/10, and 1/400 second with a 14-45mm m4/3 lens set to 20mm.*

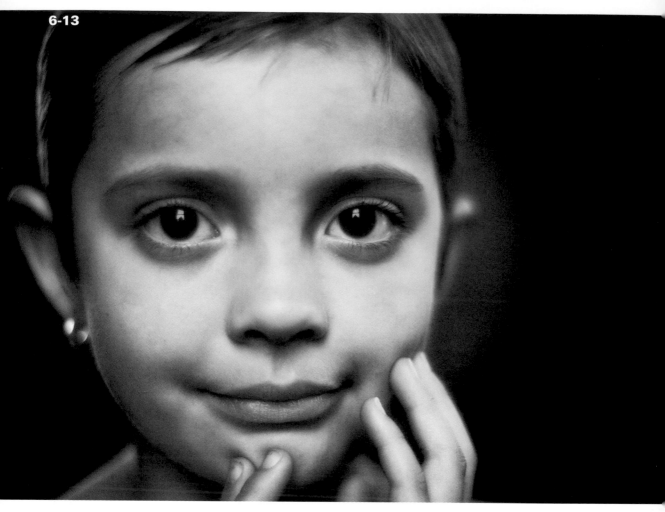

6-13

TIME OF DAY

Although some of the most amazing photography happens in the tiny window of time right around dawn and dusk, I find that time is far more interesting for the color photographer. The tones and contrast are so subtle and the color so glorious, that is the one time of day that I often find myself making the easy choice of shooting in color.

But there are always exceptions to the rule, and during the twilight when the sun is below the horizon and the light level is low, I often find soft contrast black-and-white images that are amazing, images that could never happen in the light of day. There is a light quality in that twilight time that is indescribable: The light is soft yet there is contrast, and the light direction is from everywhere and nowhere all at the same time. With light technically coming from behind the scene, across the water the reflection of the sky becomes a beautiful gradient, and yet there is still plenty of light on the pier so it appears to be lit, if even a bit sidelit (see 6-14).

6-14

ABOUT THIS PHOTO *Shooting beyond daylight brings a different sort of lighting to black-and-white images. Spend time seeing the quality of light at all times of day in many situations to help build your black-and-white vision. Taken at ISO 200, f/4, and 1/320 second with a 50mm lens.*

DEALING WITH WEATHER

Digital cameras are truly amazing tools, but they are still electronic equipment. They should not be exposed to inclement weather except for the rare exception when they are *sealed* cameras, such as some of the waterproof compact digital cameras and a few of the very high-end professional dSLRs. Photography in truly severe weather situations is really beyond the purview of this book.

With that said, there are many places where the weather is a day-to-day issue. Shooting black-and-white images in places like Seattle or the south of England is a far different experience from shooting in Phoenix, California, or the Mediterranean. As with most things, it is simply a matter of using your creativity to get the most of any situation to create great tones in your black-and-white photography.

OPPORTUNITIES IN BAD WEATHER

Life is too short to wait on weather, and it is much more important to make the most of the weather you have in front of the camera that very moment. Not only are there good images to create when the weather is less than optimal, but bad weather creates a challenge and provides good practice when it comes to creating black-and-white images. If you can create interesting photographs when the lighting is a bit blah, then surely when the weather is better, you should be able to really step it up.

When the light is soft and largely directionless on an overcast day, you can focus on just the shapes and tones in front of the camera without worrying about extreme contrast.

Use the texture in the sky to create simple, minimal images. Show how rich and shiny rocks or streets can be after a rain. Use fog to eliminate unwanted distractions and, of course, snow as a blanket of emptiness, covering up busy textures and rough backgrounds.

Snow can be a challenge to photograph because everything contrasts against its pure whiteness. The results in black and white are often fantastic. There are many examples of images with snow in them throughout this book, and I envisioned most of them as black-and-white images right from the start. Shooting falling snow in black and

white is similar to shooting in fog, where the background elements tend to fall away into nothingness as layers get more pale the further from the camera they are.

Depending on the shutter speed of the camera, snowflakes can appear as anything from odd, white, out-of-focus dots against darker tones to short lines of pale gray as the snow falls in front of the camera. In some cases, this is distracting, but in others, the snowflakes become something that completes the scene (see 6-15).

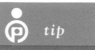
MAKING THE MOST OF WHERE YOU ARE

The tones that come about on a gloomy day can have a solitude and serenity to them. In black and white, they can be full of their own quiet drama. Think more critically when the situation

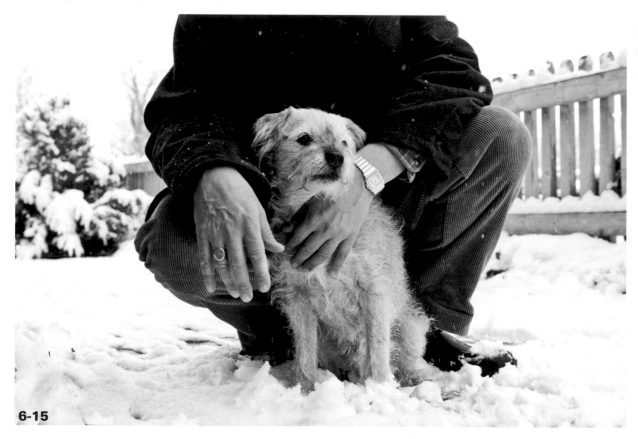

6-15

ABOUT THIS PHOTO *Snow came early enough to capture a portrait for a friend's holiday card. With the overcast scene and falling snow, 2/3 f-stop of overexposure was needed to make sure there was plenty of detail in the coat. Taken at ISO 320, f/6.3, and 1/160 second with a 24-70mm lens set to 44mm.*

is not what was planned. Find the essential parts of the scenes in front of the camera and use them to express the feelings you wish to impart to the viewer.

This may take more time and more creativity, but the quality of the image and the beautiful gray tonal range when the weather is a bit inclement make it worth it. Attempt to push the mood if it suits the scene and underexpose some frames, making them even darker and more dramatic, or push against the weather and try to wash out dingy gray tones and capture only the essential tones of the scene.

By using a creative composition and waiting until there was some active movement in the water, I was able to capture this very simple scene (see 6-16). The bit of darkness in the sky helps give the scene just a tiny bit of a moody texture. When I made this image, a tour was happening and I could hear people around me complain about the gloomy day; however, this image was only one of many amazing black-and-white photographs I captured with a similar simple drama during the outing.

LOOKING FOR HIGHLIGHTS

Lines of highlight can bring just as much interest and substance as shadows. In most cases though, highlights should be exactly that — highlights — something that brings a bit of focus and brightness to the scene. Highlights are most influential in the image when they are placed against darker tones and shadows. Highlights in this case are different from just bright or white tones. They are usually bright reflections or shiny surfaces flashing brightly, and unlike with regular light tones, sometimes it is okay to let some highlights blow

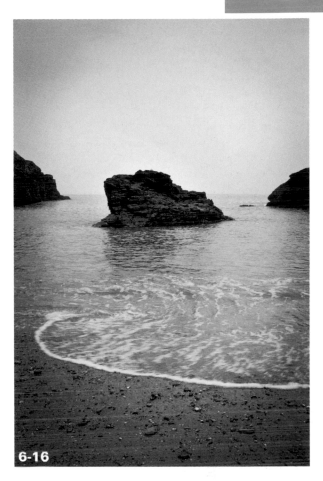

6-16

ABOUT THIS PHOTO *Waiting for the surf to create an interesting line against the beach was the key to this image — that and the simple composition and beautiful gray tones from top to bottom. Taken at ISO 100, f/13, and 1/15 second with a 18-200mm lens set to 22mm.*

out and be pure white in a scene. When you attempt to corral small bits of highlights in a scene, it often results in the image being too dark.

Metallic surfaces or liquids are typical places to find bright highlights. The metallic-looking surface of the inside of a nautilus is full of soft reflections and highlights. The ribs of the chambers become curved highlights that contrast against the tones on the insides of the chambers (see 6-17).

6-17

When there are a lot of dark parts in the black-and-white image, the middle gray areas of the black-and-white image can have a silvery look because the contrast is sharp but not overblown. By mixing hard and soft lighting, you can create even more depth in the shadow areas. This mix of light qualities comes mostly when hard light is diffused through just a bit of hazy clouds or a leaf canopy. As with many light quality situations, the light is somewhat hard to quantify, but in this case, there is hard light all around, but the scene itself is largely full of soft light diffused under the trees (see 6-18).

BUILDING DEPTH IN THE SHADOWS

One of the most dramatic types of images you can create in black-and-white photography is an image with deep, rich, dark tones that are nearly black, but still have texture in them. These are often called low-key images and are the opposite of high-key images. Low-key images are images composed mostly of dark tones and shadows with minimal light areas. Many times images like this are underexposed to make sure that the middle tones in the image don't get washed out.

However, it is important to pay attention to the histogram and make sure that all the pixel bars aren't bunched up on the left-hand side of the graph. If that is the case, the shadows are simply going to be black, not full of interesting tones.

6-18

Assignment

Focus on Tone

Use the tools from this chapter to start building your vision for tones in black-and-white images. Create a black-and-white image with a rich tonal range by focusing on the light quality and direction and maximizing the exposure with your histogram. Make sure there are no unwanted bright or dark areas in the scene, and the image has rich, beautiful gray tones.

In an ancient cathedral, light filters into the room from the huge windows at the top of the building, filling the sanctuary with soft light. The stone all around is full of gray tones along the gray stone arches and ceiling. With very little full white or deep black tones, the texture of the gray tones becomes the focus.

This exposure was taken at ISO 400, f/5, and 150 second.

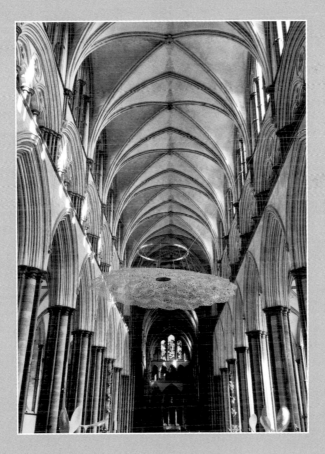

Remember to visit www.pwassignments.com after you complete this assignment and share your favorite photo! It's a community of enthusiastic photographers and a great place to view what other readers have created. You can also post comments, read encouraging suggestions, and get feedback.

THE BLACK-AND-WHITE DIGITAL FILE

There seem to be countless ways to make a black-and-white image from a color photograph, and you can certainly use infinite variations to create many different looks for the same image. Once you begin the creative process of changing the contrast and brightness in your black-and-white photo, it may be hard to stop making adjustments to the image.

CONVERTING TO MONOCHROME

The amount of saturation in an image relates to the amount of color in it. Some photographers take their color images and *desaturate* them using one of the many software tools at their disposal, simply eliminating the color from the image. You can usually do this by moving a color or saturation slider to the left, or by pressing a black-and-white conversion button; so, instead of a photograph with bright, saturated colors, the photograph has no color whatsoever.

This is a perfectly reasonable approach, and it is a super-easy way to get a black-and-white image, but it leaves a lot of possibilities on the table. This is why the black-and-white JPEG that your camera creates is often not optimal; in most cases the image is desaturated and the little tiny computer inside the camera cannot create the variability of tones that you can using the tools on your computer.

The desaturation of a color image can result in a perfectly good black-and-white image, but you need to know if it is going to show the picture's tones in the best way possible. The basic photo software that is already on your computer, such as Apple's iPhoto or Windows Live Photo Gallery, uses the desaturation method of black-and-white conversion. If you have adequate contrast and brightness in your image, the simple contrast and

exposure tools built into these software solutions can give you adequate control of your black-and-white images, especially if ease of use and speed are what you need (see 7-1).

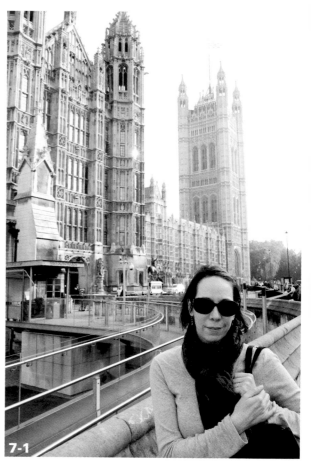

7-1

ABOUT THIS PHOTO *iPhoto and other simple black-and-white conversion tools simply desaturate the image, eliminating the color but leaving other tones alone. They are great for quickly creating black-and-white images for e-mail or social network sites. Taken at ISO 200, f/4.5, and 1/320 second with a 28mm lens.*

Think about desaturation as the point-and-shoot or compact camera version of the black-and-white conversion. It is the entry-level way to make black-and-white photos. Because black-and-white digital photography can be considered a novelty, any sort of black-and-white conversion looks fine at first glance.

However, using color information to create better black-and-white images is the way to get the most out of an image.

Colors that have similar levels of luminance end up being similar tones of gray when the image is desaturated and converted to black and white. In other words, a middle blue and a middle green and a middle red can all end up having the same sort of middle-gray tone that makes the image just a gray muddle with no good contrast level. This effect is even more pronounced with less-than-optimal lighting.

In an example of extremes, with a market table full of red and green peppers, when the image is simply desaturated, all the peppers become roughly the same middle tone of gray, which shows no particular visual contrast to bring any dynamic to the scene. A few of the peppers are a bit lighter and others a bit darker, but overall, the tones of the peppers are the same (see 7-2).

Using the tools in your software, in this case Adobe Photoshop Lightroom, accessing the Black and White luminance mix tool enables you to adjust the brightness of the colors directly. It also enables you to adjust each color group separately.

7-2

ABOUT THIS PHOTO *When an image of red and green peppers is desaturated, the similarity between red and green tones means the peppers look almost alike and have very similar gray tones. Taken at ISO 500, f/2.5, and 1/250 second with a 50mm lens.*

Without making any other changes to brightness or contrast, and by adjusting the mix of luminance of different color groups, it is possible to make the contrast of gray tones as different as the contrast of red and green. In the first example, I adjusted the tones of the red colors to be brighter and the greens to be darker, while in the second image, the reds are darker and the greens are lighter (see 7-3 and 7-4). The great thing about black-and-white photography is that none of these examples are right or wrong, just different interpretations of how colors can be defined when there is no color.

7-3

7-4

ABOUT THESE PHOTOS *These images are both interpretations of how color can be defined in a black-and-white image. In the first image, the red tones are lightened and the green tones are darkened, and in the second image, the red tones are darkened and the green tones are lightened. This gives contrast to both the image as a whole as well as the tones. Taken at ISO 500, f/2.5, and 1/250 second with a 50mm lens.*

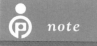

LEARNING FROM FILM FILTERS

Using the primary-colored black-and-white contrast filters in front of the lens doesn't really make a lot of sense with digital photography, given that the colored photo is what gives the photographer the opportunity to maximize the tones. The theory of contrast filters (that is, colored filters let light the color of the filter through while blocking the opposite, or complementary, color) still holds true in the digital world; it is just done in the software.

x-ref Contrast filters are discussed in more detail in Chapter 3.

Applying a digital filter does the same thing as placing a piece of glass in front of the lens, but instead you fine-tune the affect with a slider in photo-editing software (see 7-5). This gives you virtually unlimited options when it comes to how much of a particular affect you desire in any image, as well as the capability to mix and match the tones affected.

To review the basics, use a yellow filter to cut some of the blue ultraviolet light and to darken a blue sky. A strong yellow filter makes a black-and-white image look normal, with no changes to tone. An orange filter makes a blue sky even darker and really intensifies the contrast in a landscape. A red filter makes for the deepest of

blue skies, renders greens very dark, and makes skin very translucent. A green filter darkens flesh colors and makes foliage look lighter.

There are digital tools that approximate each of those settings directly; and when you know old-school filter nomenclature and effects, you can use that knowledge to improve your black-and-white photos.

x-ref One of the software solutions to digital black-and-white contrast conversion is Silver Efex Pro. This is an add-on program to Lightroom and Photoshop, as well as a stand-alone application, that best replicates the look and feel of the black-and-white filter sets and brings even more to the table. For more information on Silver Efex Pro, see Chapter 8.

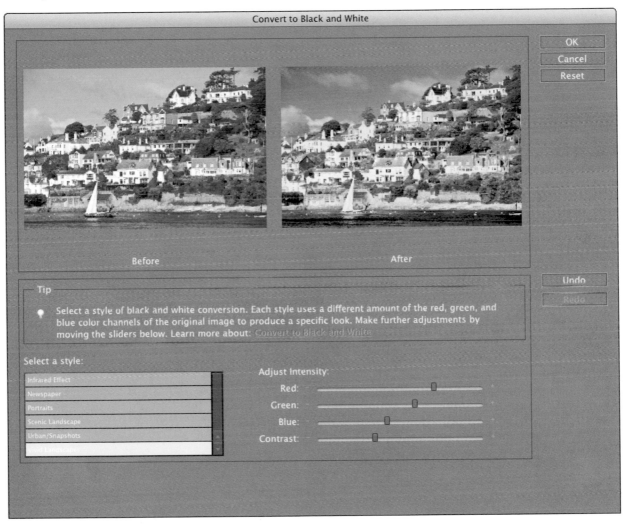

7-5

ABOUT THIS PHOTO *This shows the sliders you use to mix the amount of contrast from the different tones in the image. By sliding them either way, you can lighten and darken each color group's tone along with the contrast.*

There is a black-and-white mixing tool in Photoshop Elements that approximates the affects of the color contrast filters. You can find the Convert to Black and White option in the Enhance menu of Photoshop Elements. Use the sliders to make each color group lighter or darker to suit the needs of the image or the look you are going for. Additionally, you can use a contrast slider to increase and decrease the base level of contrast.

The Convert to Black and White window shows both the color and the black-and-white conversion image. Use the color image to determine whether the color group in the image that you are using needs to be intensified, lessened, or left

alone. One of the best parts of using the digital contrast filters is that they are easier to learn and more intuitive. If you want the blue skies to be darker, slide the blue slider to a darker setting. If you want the foliage to be lighter, slide the green slider towards the light side. The tools here are just the first step in being able to vary the amount of gray tone gradation in your images (see 7-6).

If you are not quite sure where to start with your black-and-white conversion, there are a number of mixed presets for you. Each of the mixes uses various amounts of the red, green, and blue in the original color image to achieve a certain look. There are styles that emulate infrared as well as the look of newspaper photography, and they

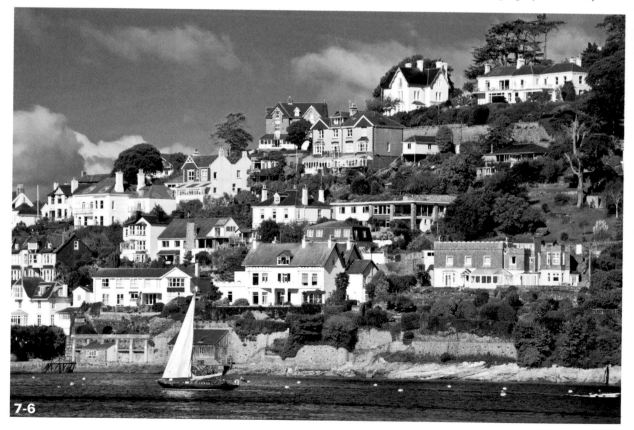

7-6

ABOUT THIS PHOTO *The sky has been darkened and the dark green foliage lightened, and a nice contrast between the lights and darks remains. You can be far more precise and have far more contrast using these digital settings than you can using just a basic contrast filter. Taken at ISO 320, f/9, and 1/320 second with an 18-200mm lens set to 120mm.*

include some nice settings for portraits, land-scapes, and street scenes. Try out the different settings by selecting a style in the black-and-white conversion tool and then adjust each color a bit more to create the exact look that you are going for.

> **note** Several different methods for black-and-white conversions are discussed throughout the chapters. Each method works great in relation to a particular goal, and you will find similar solutions in different photo-editing software. In most cases, I use Lightroom because it's already a powerful program and I can base additional software, such as Silver Efex Pro and Photoshop and Photoshop Elements, around it.

RAW OR JPEG?

As you begin to see the benefits of shooting an image in color and then converting it to black and white with photo-editing software, the question of RAW or JPEG comes up again and again. There are pros and cons for using both, and choosing one shouldn't be a decision you are afraid to make. There are trade-offs for both, and you can find debates on the merits of each on online forums.

DO I NEED TO SHOOT A RAW FILE?

RAW files give you the best image quality. There is more information — actual photo data — in RAW photos, which makes for smoother transitions and finer detail. Further, in RAW photo files, all the color and white balance data is built in, enabling you to fine-tune color corrections more easily and precisely. RAW files are digital negatives, and they give you the most options and opportunities when you are creating your black-and-white images.

On the down side, RAW files are significantly larger than JPEG files, at least twice as large; therefore, an 8-gigabyte memory card that holds 300 RAW photos might be able to squeeze in more than a thousand JPEGs. File size can be an issue when you are on an extended trip and cannot download, back up, and reformat your memory card, not to mention the long-term storage issues that come when you accumulate many large files over the years.

Also, you need additional software to open RAW files and make use of them. Some camera manufacturers offer free RAW converting software, while others provide free software with only the most basic viewing tools for RAW files. There are many RAW conversion solutions you can buy, which are discussed in the next section, and though they are not free, some are very affordable.

The best part about JPEG files is that they are compact and ready to use. You need to do very little editing to the image before it's ready to print or post online. The image quality on a JPEG, when set to its highest resolution and least amount of compression, is excellent. With the compact size of the JPEG file, you can get many images on a memory card and many years' worth of photos housed on a small hard drive or even on a cloud-based storage system.

Virtually any photo software can use and read JPEG files, as can word-processing applications. There's a reason JPEG is the standard file format for the Internet. It's the universal image file at this time.

JPEG files are for the most part finished images. Many of the settings that are applied in the camera essentially lock in the final look of the image. As a black-and-white photographer, you can use a JPEG to maximize all the different tones

available when you convert the image from a color photo to a black-and-white photo, but depending on the camera's settings, you may have some challenges. The problems come mostly when the camera's picture style or color settings are set to Vivid or Vibrant. The colors, especially primary colors like red and blue, tend to be a bit blocky, and this lack of subtlety makes the gray tones flat. If the contrast is already cranked way up in the camera, there is often very little you can do to bring back deep blacks or washed-out whites with a JPEG.

JPEG files are compressed images, meaning that when they are closed (or saved), they actually lose photo data in order to save space, and when they are opened back up, the computer must figure out what was in the places where data was lost. Of course, this doesn't happen every time you open the JPEG; only when you save or re-save a JPEG. So re-saving the image multiple times and using a very high compression ratio or level causes the image to lose its quality. This is most noticeable in the smooth areas of tone in a photograph.

Many people say that JPEGs look just fine and even have examples of extremely large prints made from JPEGs. I have printed original JPEGs myself with some outstanding results. Black-and-white digital photographs that are converted from color JPEGs can even be more forgiving than corresponding color images, but in the end, to get the most out of your images, to get the best image quality, and to have the most flexibility, it is best to shoot RAW.

BLACK-AND-WHITE MODE FROM THE CAMERA

Shooting a black-and-white JPEG straight from the camera is obviously the easiest and fastest way to get a black-and-white image. With many digital cameras, there is a plethora of options for contrast, brightness, and tone. Some cameras will have terms for the many black-and-white options,

such as dynamic or smooth, and others will give you the ability to control the contrast of the in-camera JPEG and even add the effect of the colored black-and-white contrast filters. Some cameras even enable you to do color toning in the original monochrome black-and-white JPEG.

Try the different settings in your camera when you can. Using the smooth black-and-white setting in a scene with many hard light sources creates a little less contrast (see 7-7). The soft gradation of each of the pipes drew me to the scene, but the

7-7

ABOUT THIS PHOTO *Both the repetition and the way the light wraps around each pipe drew me to this image. Even in color, this image is nearly monochrome, but setting the camera to black-and-white JPEG with a lower contrast setting enabled me to capture the scene exactly as I envisioned it. Taken at ISO 500, f/2, and 1/20 second with a 20mm lens.*

shadows on the sides of the pipes on the right side of the scene seemed to go very dark; if I were to use a dynamic setting, they might be captured too dark or with too much contrast.

Different cameras convert images to black and white with different results, just as different software does. The more advanced cameras come with more advanced settings and enable you to do much more with the in-camera black-and-white JPEG. The less advanced cameras, such as compact digital cameras, often just desaturate images, creating black-and-white images that are flat and lack real depth or contrast.

Use the camera's options to check out the different tools and creative opportunities available.

MAXIMIZING RAW + JPEG

I took the image in 7-7, and in fact virtually all the images in this book, with the camera set to RAW + JPEG. While it is extremely inefficient and consumes a huge amount of space and plenty of extra time in post-processing, for me, shooting RAW + JPEG is the perfect approach.

The best quality black-and-white image that I am going to capture or create is going to come from the RAW file. The RAW file will most likely be the file you edit, and the one holding the most creative options, but by having the JPEG as well, you often have further options.

Digital photography is all about options, and making sure that you have all your options open is always important. Having the black-and-white JPEG along with the color RAW gives you the opportunity to see what the image will look like, at least roughly, in black and white, and still have the color version if you want it. When you have both a color and a black-and-white version, it is possible to show them as a pair quickly and easily.

Different software presents the paired RAW and JPEG files different ways. In Bridge, they are viewed as separate images, but in Lightroom, you have the option to import both images as a pair, so you only see the RAW file, but the JPEG is still saved on the hard drive with the same naming convention except for the .jpg extension.

Many photographers use RAW + JPEG so they have the RAW as a backup if there is something wrong with the JPEG. For example, if you set the camera to an incorrect white balance, or if the black-and-white JPEG setting has too much contrast, you can use the RAW file to create the image you need. For others, having the JPEG simply means having extraneous photos; however, when it is time to e-mail a few images or print a quick test, having a JPEG that is all ready to go might save time and energy.

DIGITAL RAW BLACK-AND-WHITE CONVERSIONS

In the majority of the examples in this book, and with a great number of professional photographers, the RAW image is used most often. Whether it is used on a job or for artistic purposes, the RAW file gives you the most options, the most flexibility, and, as I mentioned earlier, the best image quality. While for all practical purposes, there is no real difference between processing and editing a RAW file and a JPEG file, in many cases, the additional steps you go through to process the RAW file enable you to get the most out of your images and are well worth it.

ADOBE CAMERA RAW

Each camera manufacturer uses its own propriety file format. Adobe Camera Raw is a very powerful RAW converter that allows users to open these

formats in photo-editing software. It is a separate but integrated part of Photoshop and Photoshop Elements. The tools and the processing engine of Adobe Camera Raw (or ACR for short) are also used in Lightroom, which means that all the colors, tones, white balance levels, sharpness, contrast, and so on maintain fidelity between these programs.

To begin working with a RAW image in ACR, follow these steps:

1. **Select a RAW image to open in Photoshop.** ACR automatically opens. There are countless options for adjusting the image in the ACR window.

2. **Make basic adjustments such as contrast and lightness.**

3. **Click the HSL/Grayscale tab.** For a color image, use these sliders to adjust the hue, saturation, and luminance of each color group in the image.

4. **Because you want a black-and-white image, select the Convert to Grayscale check box to adjust the tonal range in each of the color groups on your RAW image (see 7-8).**

5. **Make adjustments to the luminance of the tonal groups.**

6. **Save the settings for another, similar image if you want.**

7. **Click Open Image to open the black-and-white image in Photoshop.**

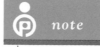

note — Selecting the Convert to Grayscale check box adjusts the image with the color information that is present in the RAW file and gives you a lot of variability. Do not mistake this for Grayscale mode in Photoshop, which is not a good black-and-white option. That is very similar to the desaturate mode and discards all the color data, which you don't want to do.

note — The ACR bundled with Photoshop Elements has been slightly trimmed down because it is consumer-level software. Thus it does not have all the same tools and is missing ones like the black-and-white conversion tool. So simply make your RAW conversion in ACR and then use Photoshop Elements' black-and-white tool, which is covered later in this chapter.

LIGHTROOM

While Adobe Photoshop Lightroom is fantastic for producing black-and-white images, it is an all-in-one program that does a lot of things very well. Most notably it is a RAW converter as well as a photo catalog, and it also lets you output your images to a slide show, create prints, or post images online. Lightroom does not include extensive retouching and special effects capabilities, but it does have some basics. The Lightroom user interface is also very easy to understand for those who are coming from iPhoto or Windows Live Photo Gallery.

To convert a RAW file to a black-and-white image in Lightroom, follow these steps:

1. **Select the photo that you wish to convert to black and white.**

2. **Click the Develop tab, which is in the top Lightroom pane.**

3. **In the Develop module, the histogram appears in the top-right corner of Lightroom.**

4. **Use the histogram to determine where all the tones in the image are.**

5. **Use one of the many white balance tools available in the Basic window to adjust the colors of the image to achieve the tones you want.**

HSL Grayscale

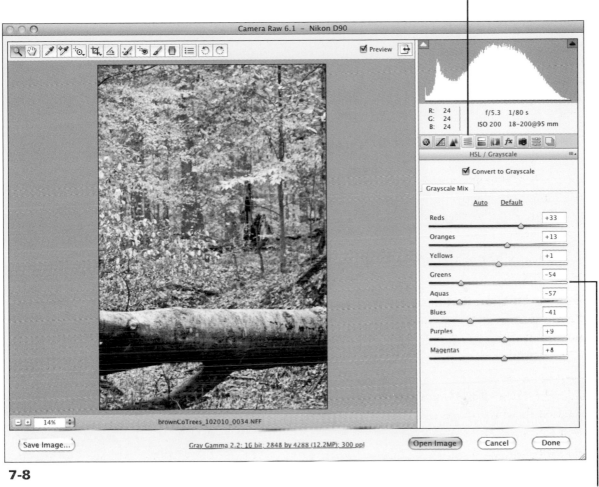

Tonal groups

7-8

ABOUT THIS PHOTO *Adobe Camera Raw has its own black-and-white conversion mixer. This enables you to adjust the luminance of every color group's gray scale individually. Then you can open the image in Photoshop to make additional refinements to the image.*

6. **Make any needed basic exposure, highlight, and shadow adjustments as well as ones for contrast and brightness.** Your adjustments are reflected in the histogram at the top-right corner of the window.

7. **Click the Black & White button just below the histogram.**

8. **Begin developing your black-and-white image.** Alternatively, make some overall changes to the image, such as fine-tuning the exposure and contrast, and then do the black-and-white conversion (see 7-9).

9. **Scroll down the Develop pane until you get to HSL/Color/B&W.**

ABOUT THIS PHOTO *Accessing and developing your image in Lightroom is quick and easy. Once the images are imported into Lightroom, the black-and-white tools are as good as those in ACR or Photoshop, and definitely better than those in Photoshop Elements.*

7-9

Preset effects

Convert to black and white

White balance tools

Filmstrip

Exposure tools

<table>
</table>

tip

Lightroom comes with preset settings to get you started in creating the image that you want. You can also save your own settings as presets so that you can refer to them from time to time. And you can download presets and buy presets online. In this example, there are presets that emulate the color response of black-and-white film emulsions.

10. **Click B&W to open the Black & White Mix panel.** As you saw in Chapter 6, and very similar to the Black and White mix that is in ACR, this mixer allows you to adjust the brightness, or luminance, of each color group in the scene (see 7-10).

SIDECAR FILES One of the most amazing things about Lightroom is that changes you make to an image (JPEG, TIF, or RAW) are done in a non-destructive way. This means that the changes are simple instruction sets used to show the image in Lightroom with the black-and-white effects you choose, but the actual image remains untouched. Therefore, when you want to make a print, Lightroom applies the settings to the print file; if you want to send a JPEG of the image to a friend or client, you export the image to the desktop or Pictures folder and Lightroom produces a new JPEG from settings applied to the original file. This is not only a brilliant way to make sure you get the most out of the image, but it also means that it is very easy to make and manage many different versions of the same image.

7-10

ABOUT THIS PHOTO *This is the Lightroom Black & White Mix panel. By adjusting the brightness of each color group in the image, you can fine-tune the contrast of the photograph, both the inherent contrast in tone as well as the contrast between subjects.*

With a scene that is mostly made up of green, dark green, yellow green, some blue, and a little earth tone, getting the greens and yellows to have the right brightness helps give the foliage some separation from the dark water.

11. **Brighten the greens and yellows, and darken the dark tones (see 7-11).** Remember that you can then save the settings for this photograph as a preset, or even just save them for the image next to it, which might have a slightly different composition, or the next several images that are similar so that they all receive the same effects.

12. **Go down to the filmstrip at the bottom of the window to start working on the next image.** Note that there are black-and-white JPEGs and then RAW files side by side here.

This is really just the beginning of the capabilities of Lightroom, especially with black and white. The advanced user will still need the power of many of Photoshop's tools, but even then, in a choice between the interface of Lightroom as the RAW converter and ACR as the RAW converter, Lightroom wins hands down.

Additionally, when you open a RAW file in Lightroom and then use the tools to send the image to Photoshop for editing, after you have completed editing the image, it is saved back to the original folder and is added automatically to the Lightroom catalog as a new edited TIFF file, right beside the original RAW file. It is available to be printed, exported, or posted online, just like the rest of the images in the filmstrip.

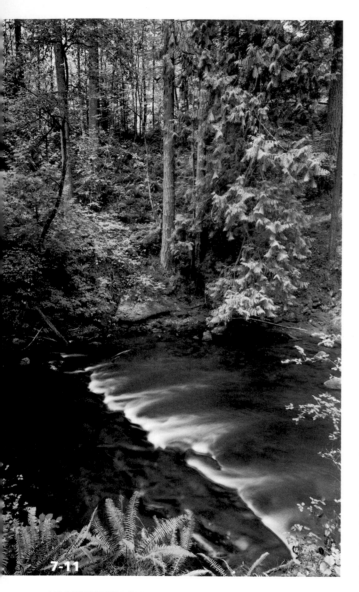

7-11

ABOUT THIS PHOTO *By framing the water with ferns and foliage on each side, the real focus of the image is the line of rushing water. Shooting under a tree canopy, I used a polarizing filter to cut even more light and to get the shutter speed long enough to blur the water. Taken at ISO 100, f/11, and 4 seconds with a 17-35mm lens set to 24.*

APERTURE

Aperture from Apple is similar in many ways to Lightroom in that it enables you to organize, edit, and share your photographs in a comfortable and easy to use manner.

Aperture is a RAW converter first, but as with all things Apple, it is still totally integrated into the Apple world with easy links to e-mail, social networking, and photo Web sites. Aperture is like iPhoto for advanced users — fairly simple to use but still powerful enough for the rigors of professional photographers (see 7-12).

The black-and-white adjustment tools in Aperture are based on the Channel Mixer, where the image is desaturated and then each channel, Red, Green, and Blue, can be adjusted independently. This is the original way to adjust digital black-and-white images, and still an excellent way to achieve specific tonal ranges in the image. There is more about the Channel Mixer later in this chapter.

Aperture also has adjustments to simulate the color filters for black and white along with even the capability to simulate the contrast of graded paper. You can find all of these adjustments in the Adjustment panel on the left side of the application, as well as in Aperture's handy Heads up Display, which brings any tool to the front of the image for easy access.

With kids in their dungarees playing ball and the old Schwinn Phantom, the whole point of 7-13 image was to give the image a feel for the age of the late-'50s bicycle. First I used the yellow filter effect and then adjusted the contrast a little bit more to make the look of the bike pop out against the green grass. This image was shot with a very shallow depth of field in order to isolate the bike and give a sense of timelessness.

7-12

ABOUT THIS PHOTO *The Aperture interface is user friendly and is infinitely adjustable. The black-and-white tools appear near the bottom and function in the channel mixer method.*

DIGITAL NEGATIVE

Several years ago, Adobe came up with a universal RAW file format called DNG for Digital Negative. The DNG file format is an open-

source format, which is freely available, and is the preferred file format for the U.S. Library of Congress and the American Society of Media Photographers.

7-13

The advantage to DNG files is that they take up less digital storage on your hard drives than RAW. It is an open-source format so that it can be around forever, and because there is now a great amount of DNG-capable software available out there, it should free up photographers from worrying about whether their cameras' RAW files will be able to be opened. Also, with DNG files,

sidecar files created by Lightroom can be integrated into the metadata instead of requiring a second data file.

The disadvantages are that if you are shooting a camera that makes a CR2 or NEF RAW file (Canon or Nikon, respectively), it takes another step and additional time to convert one RAW

file format into another. This also means that some of the additional information, such as Picture Controls, will be stripped away, so if you like what the camera does for the image, and you don't have the JPEG to base your color and contrast on, that information is gone.

There are pros and cons to everything in the digital world, and in the end the decision of whether to convert to DNG is yours, but before you make it, I suggest doing some research. There are times when I convert all files to DNG and there are others when I simply deal with the original RAW files. It depends on time, space, what the project is, and how the images are going to be used in the end. For the most part, I create my images with Nikon cameras, and I keep the NEF file format because that is just how I have always done it and the results have been great.

Recently, I have taken to shooting some travel photos with one of the new Panasonic m4/3 cameras, and given my unfamiliarity with Panasonic's RAW format, converting those images to DNG seems optimal. Other times, it is obvious that using something more universal is going to be beneficial and I convert even my Nikon RAW files to DNG. There is no right or wrong to what you do, no matter how vociferous an online forum's chat might get, so if it is something that works well for you, the DNG is just fine. As far as only dealing with black-and-white images, there is no appreciable difference, although the proprietary files processed with the proprietary software can have some very small advantages at times (see 7-14).

Because all camera manufacturers, save one, have a proprietary RAW file, they also have proprietary RAW software to use it. The exception of course is Leica, which uses the DNG, or Digital Negative, file from Adobe as their RAW file; Leica cameras that shoot RAW files ship with a full version of Lightroom. Canon and Nikon both have their own software, which I cover here.

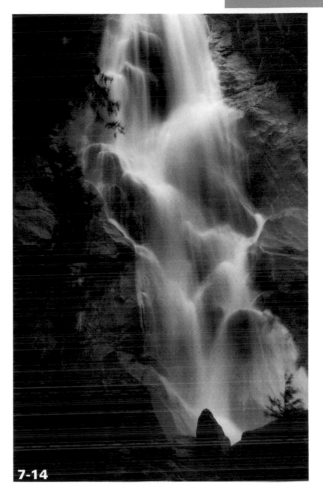

7-14

ABOUT THIS PHOTO *It seems impossible to make the most of the amount of subtle detail in this image without maximizing every step of the photographic process, from exposure to RAW processing to black-and-white conversion to final print. Taken at ISO 100, f/8, and 1 second with a zoom lens set to 35mm.*

Because the same computer engineers who design the computer code for Canon's RAW image files write the proprietary software to read those files, sometimes the Camera's software can do the best job processing those images. In particular, it is the level of fine detail that can be extracted from an image when it is processed by the manufacturer's software and color fidelity. These are small differences between the files processed by the manufacturer's software and third-party software such as

Adobe's, but they do exist. However, the problem with the proprietary software seems to be that the user interface and experience with Canon's and Nikon's software is less than the best.

CANON DIGITAL PHOTO PROFESSIONAL

You can process Canon's CR2 RAW photo files using Digital Photo Professional (DPP). It comes on a disc included with the Canon camera when you purchase it. DPP is designed to be full-fledged photo-editing software and can be used with any Canon camera files, but it is maximized for the proprietary CR2 RAW file. And just as with Lightroom and Aperture, DPP uses non-destructive image processing.

The black-and-white tools in DPP are in the Picture Styles menu. If you use Canon, you know that Picture Styles are the in-camera effects that can be applied to a photo. With DPP and a RAW CR2 file, you can adjust the Picture Styles again once the image is in DPP. In the Monochrome menu, you can convert the image into black and white, and then filter effects, such as yellow, red, and green can be used to change the tone and contrast of the image.

THE NIKON SOFTWARE SUITE

Nikon uses separate products to manage their images.

Nikon View NX2 is a free photo browser that has some editing tools as well as a basic RAW converter for Nikon's NEF files.

Nikon Capture NX2 is a much more powerful software tool. Nikon Capture NX2 enables you to do much more advanced RAW processing with full highlight and shadow control, and it includes U Point Control. These selection control points are part of a collaboration with Nikon and NIK Software, the company that makes some of the best third-party digital image filter tools such as Color Efex and Silver Efex. U Point Control enables you to select small areas of the scene and then make fine adjustments to the localized area.

The black-and-white processing tool in Capture NX2 is much the same as DPP with color contrast filter settings, although it also enables you to make adjustments for each channel of color for a contrast mix and gives you the option to use a color hue adjustment to filter the black-and-white conversion. This is the most advanced of these black-and-white conversions and has adjustments for strength, brightness, and contrast at anywhere on the filter slider.

PHOTOSHOP

A popular way to do a black-and-white conversion is to use the Black and White conversion tool in Photoshop:

1. **Choose Image⇨Adjustments menu.** A sub-menu appears where you can make the adjustments. The functions of this tool are similar to the Black and White menu in Lightroom discussed earlier in this chapter.

2. **Adjust each color group's luminance, lightening or darkening any particular color group to make the tonal range work best for each photograph.**

3. **Open the preset menu inside the Black and White tool.** This gives you access to myriad initial options with which to begin the process of the conversion: high-contrast options, color contrast filters, even an emulated infrared option.

4. **Click one of the presets to experiment.** Remember how different colors will be affected by colored filters; filters will let light of their own color pass through, adding to the brightness of that color and darkening the complementary color (see 7-15).

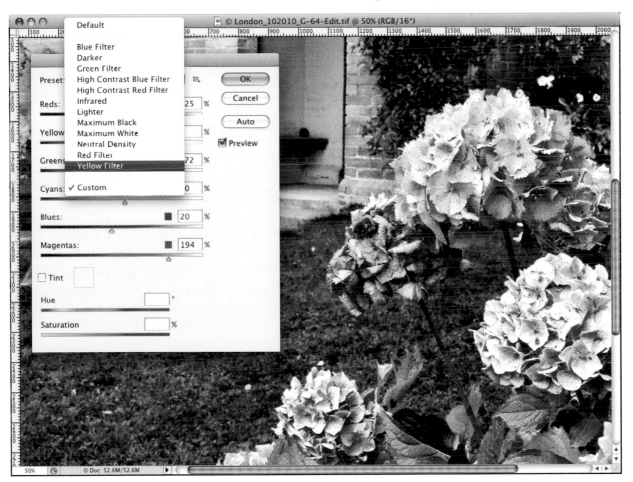

7-15

ABOUT THIS PHOTO *When you begin the conversion, start with a preset option to get a good idea of how the colors in your image will render in black and white.*

5. **Once you have applied the preset option, select the Preview check box in the Black and White conversion window.** This enables you to see any changes to the image in real time.

6. **Once you are done with your conversion, click the preset loader icon next to the preset drop-down menu.** This enables you to save all your settings for the next time that you would like to use the same mix of colors to create similar tones in another black-and-white image.

As shown in 7-15, Photoshop includes sliders for adjusting the luminance of each color group. This means that you can make green grass darker, a large group of magenta flowers lighter, and even adjust the reds from the bricks with precision, separate from one another. You might do this to separate tones that may be too similar in black and white because their actual tones are very alike (see 7-16). You can also do it very creatively to force contrast in a scene.

Using Photoshop's *color mixer* is really all about using the tools at your disposal to optimize the image. In the case of one still-life scene, the light was a bit drab for all the color in the scene, but just adding contrast would only make things appear harsh, with too dark shadows and washed-out bright areas. Using the black-and-white mixer makes the contrast in the scene much more interesting and shows off the depth of tones in the image.

Using the *channel mixer* is like using a red, green, or blue contrast filter in front of your black-and-white film except that the affects and variations are limitless. You adjust each color channel in the image separately with the channel mixer, but the real key is to make sure that the total percentage of the color sliders stays at 100 percent.

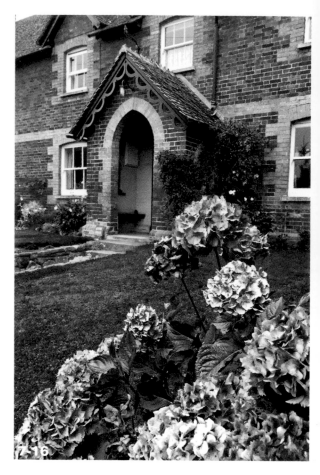

ABOUT THIS PHOTO *The image of the flowers in front of this house in the British countryside seemed a bit drab, but by making adjustments to the luminance of each color group, the image ends up with a nice contrast level.*

The channel mixer was really the first good way to adjust the color tones for black and white in digital photography. By using a Channel Mixer layer, the image is also endlessly adjustable, and it is not damaged until the layer is flattened; in other words, the layer is like a filter on top of the image, adjusting the contrast in the scene until it is right where you want it (see 7-17).

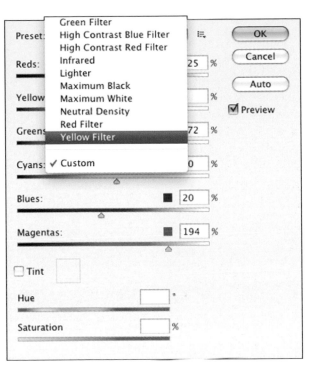

7-17

ABOUT THIS IMAGE *The ability to make changes to each of the color channels individually is the benefit of using the Channel Mixer. In this case, I far exceeded the recommended 100 percent to get the extreme richness out of the image. Using the histogram, I was able to still keep all my tones in order.*

By setting any particular slider to 100 percent while the other two sliders are set to 0 percent, the effect is analogous to having that color of filter in front of the lens. Mixing the sliders, even bringing them to a negative-percent setting, is where the real creativity lies. Exceeding the 100 percent mix can make for some otherworldly looks. Do you want your image to look bright and airy or dark and ominous?

Although using the color mixer to make fine adjustments to an image is really fantastic and allows for great precision in getting the tones exactly the way you want them, the channel mixer enables you to make adjustments that you might have only dreamed about (7-18).

PHOTOSHOP ELEMENTS

When using Photoshop Elements, choose Enhance ⇨ Convert to Black and White to access its Convert to Black and White tool. This tool uses the same theory of tonal adjustments as the Channel Mixer.

The Convert to Black and White window shows the color image as well as a thumbnail of how the image will look when it is converted using the Red, Green, and Blue Sliders (see 7-19). This tool in Photoshop Elements does not have the percentage settings, but it is pretty easy to see when you have gone overboard or when there isn't enough contrast in the scene. On the left side of the adjustments area is a preset menu for easy access to settings that Photoshop Elements already thinks work great, as well as the opportunity to save your own.

The bright colors of this cowboy boot are a great example of how the different colors relate in tone to black and white. The colors themselves are very bright, but they are also very similar in tonality, so the image needed some serious contrast adjustments. The channel mixer is perfect for this because you can already see red and blue, as well as the green-related yellow, so making each color pop out of the scene ends up being great (see 7-20).

7-18

Convert to Black and White

OK
Cancel
Reset

Before

After

Undo
Redo

Tip

Select a style of black and white conversion. Each style uses a different amount of the red, green, and blue color channels of the original image to produce a specific look. Make further adjustments by moving the sliders below. Learn more about: Convert to Black and White

Select a style:

Infrared Effect
Newspaper
Scenic Landscape
Urban/Snapshots
Vivid Landscapes

Adjust Intensity:
Red:
Green:
Blue:
Contrast:

7-19

7-20

Assignment

Learning to Adjust

With so many ways to convert your images to black and white, it is time to start figuring out which one makes the most sense for your line of thinking and fits with the images that you are creating. Find the black-and-white conversion tools in the image-editing software you already have and begin making those changes to the images that really make them your own and speak to your creative vision. Think about the color in the image, and visualize how you want to see those gray tones in the final product, and then convert the image to those tones.

When putting this chapter together, I was reminded of all the different ways there are to do black-and-white conversions, but because I get used to one certain way to do it, I end up using one tool the most. With this high-contrast image of a palm tree in Hawaii, it was important that I capture the scene with a lot of drama, and with brightness. Not that it had to be a particularly light image, but just not dark and moody.

So many images of tropical places appear in color because the color is lush, so it was important to show the image as a lush place with long contrast. I used the method of desaturation and Temp and Tint adjustment to an original color JPEG file. It was important to create contrast in the conversion because there was not too much latitude in contrast left in the JPEG. This image's exposure was taken at ISO 200, f/10, and 1/125 second.

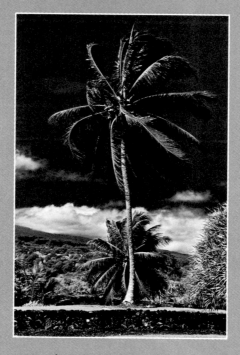

Remember to visit www.pwassignments.com after you complete this assignment and share your favorite photo! It's a community of enthusiastic photographers and a great place to view what other readers have created. You can also post comments, read encouraging suggestions, and get feedback.

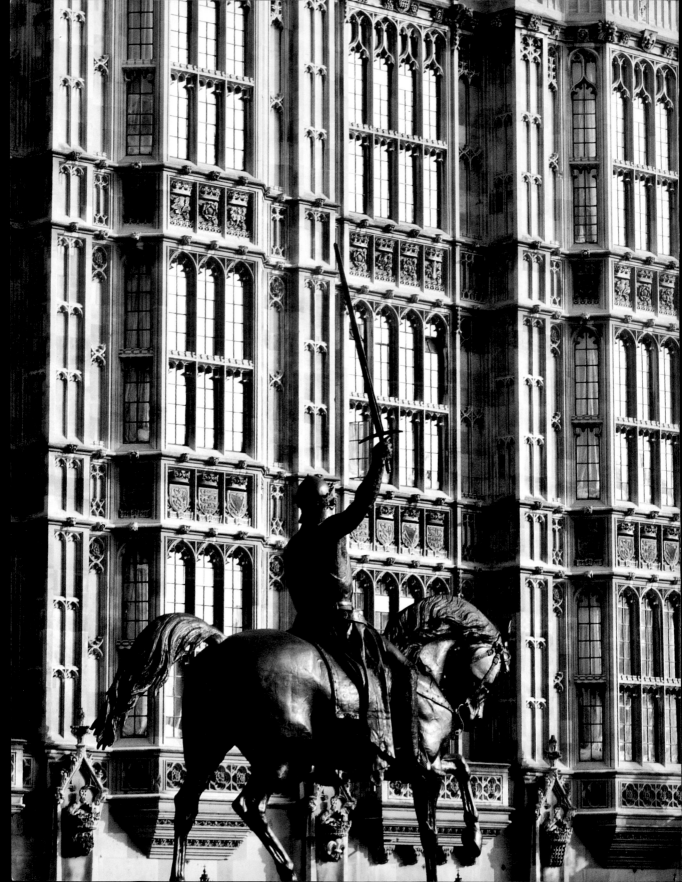

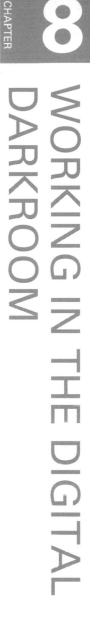

CHAPTER

8

WORKING IN THE DIGITAL DARKROOM

Using the digital darkroom presents many exciting new opportunities that were not available in the wet darkroom. Changes you make to black-and-white images happen in front of you immediately (this goes both for seeing a slight change that moves the image from good to brilliant and for witnessing a bold mistake).

While the immediate response is extremely helpful when you are creating your black-and-white masterpieces, don't think for a moment that it takes only two seconds to create fantastic images. It is important to spend time learning how photographs respond to different input and trying new things to get an image perfected. After a while, knowing which changes to make and how to make them will be second nature, as will knowing when to press ⌘+Z to reverse a change you do not want to keep.

This chapter shows you some of the many ways to take the images beyond just a black-and-white conversion. While simply perfecting the black-and-white conversion with the options discussed in the previous chapter may satisfy some, you can fine-tune an image even more, making it meet your photographic vision. Use the tools discussed here to expand upon what you already know about your photo-editing software. Use some of the images and ideas to visualize the vast options you have for making changes in your own imagery; this chapter is just scratching the surface of what you can do.

UNDERSTANDING LOCAL AND GLOBAL CHANGES

The whole premise of the digital darkroom is that you are making changes to the image to further your creative vision. These changes happen at essentially two levels:

- global
- local

How you make these changes to the image and when in the process you perform them can affect the quality and precision of the image.

Global changes are changes that happen across the entire image, or at least over most of it. You make global changes to things such as exposure, brightness, contrast, and sharpness. These are some of the first elements you should adjust when editing an image.

Depending on which program you use, global changes may affect all or virtually all the pixels in the image. When you use a non-destructive editing program such as Adobe Photoshop Lightroom or Apple's Aperture, these global changes still affect the pixels but only in the exported copy of the image after it leaves the program. However, when you make global changes to an image in Photoshop, the pixels are changed forever, especially after you click Save.

Making sure that you are making changes to the copy of an image is so important. No matter what level of changes you make, often you will not want those changes to be final. Whether it is in the next day or in a few years, the once-perfect image may not look so perfect any more. The masters do this often: They go back to an original image from years previous to reimagine how it should look, and reprocess it. This happens often with color images. After a few years, the image may look a bit dated. Converting the image to black and white or making other tonal changes may make the image much better (see 8-1).

Local changes can be considered retouching or *spot editing*. These are changes to smaller areas of the photograph, and include doing spot removal, using dodging and burning, adding or subtracting elements from the image, creating graduated tones, or even adding localized contrast changes. Anytime you use tools such as brushes, a clone stamp, and gradients as part of the imaging

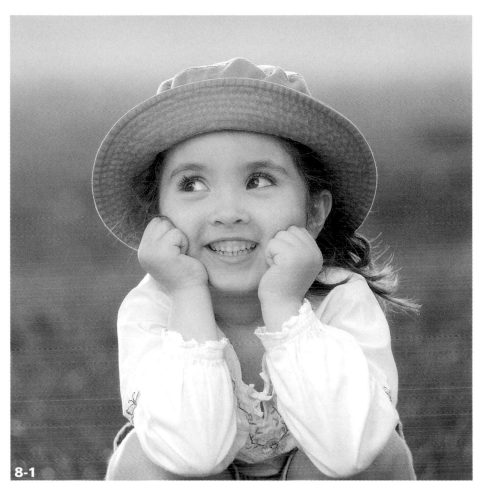

8-1

ABOUT THIS PHOTO
Repurposing an image after some time is a great way to use global changes. Returning to a toned monochrome image I made six years ago gave me the opportunity to create something that is more contemporary, using contrast and tone changes. Taken at ISO 100, f/2.8, and 1/160 second with a 70-200mm lens set to 116mm.

process, you are making local changes to the image.

Whether you are darkening a large sky with the Burn tool or making tiny changes to just a couple of pixels with the Clone tool, the local changes will render an entirely new image. You should make the local changes after making the global ones. In order to keep the clean look of this high-key image, I eliminated wall sockets and a bit of artwork, as well as made some local brightness adjustments during the local-change phase of image editing. These changes happened after I set the contrast and converted the image to black and white (see 8-2).

MULTIPLE RAW PROCESSING

There are often times when an image has a particular highlight or shadow detail issue where no matter how much you use the exposure or brightness sliders, or adjust highlights and shadows, the image is still not right. The amount of data that is in the RAW image is indeed amazing, but sometimes it just can't be seen all at once. Multiple RAW processing is a way to blend two images together to get the complete tonal range out of your image. This could be considered a High Dynamic Range technique, although the Multiple RAW process is more of a blending technique with two versions of the same image.

191

8-2

Depending on which image-editing software you are using, some of these steps may be slightly different, but for the most part, once you put the RAW images together in Photoshop, everything is the same. In 8-3 and 8-4, I processed the RAW files in Lightroom, but Aperture and Adobe Camera Raw will work very similarly.

1. **Make the initial image as good as you can get it in the first place.** It may take a bit of time to get the RAW file's tones, exposure, and contrast right, but unless this first step is right, you will need to spend additional time and effort down the road.

Making the water and the rocks, as well as the forest in the background, have the best tone and contrast is relatively straightforward with the even, overcast light, but the highlights of the rushing rapids are totally blown out. There is some detail in all that rushing foam, but not much (see 8-3). When the entire exposure is brought down, there is detail available in the highlighted area of the water, but the rest of the image plunges deep into shadow tones (see 8-4).

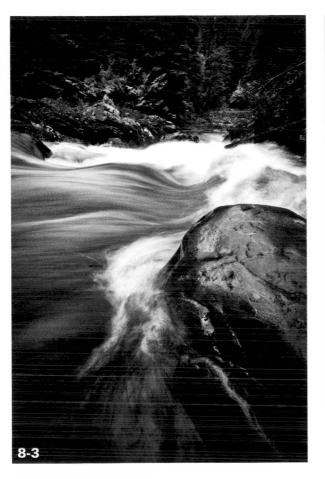

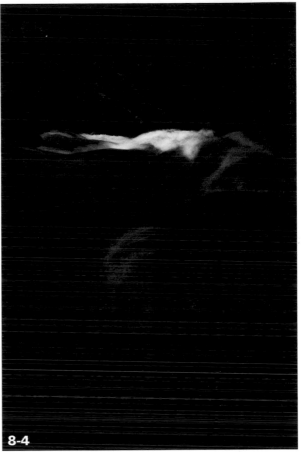

ABOUT THESE PHOTOS *These images are both interpretations of one original RAW file processed in Lightroom. The first image was processed to get the best overall tones for the entire image but has a large white area where the rapids are just too bright for the scene. The second was simply darkened until the detail in the rushing white foam was visible, which made the entire scene very dark. Taken at ISO 100, f/22, and 1/4 second with a 17mm lens.*

2. **After you create a black-and-white image that is almost how you want it (except for the blown-out highlights around those rapids), make a *virtual copy* of the image in Lightroom.** A virtual copy is a set of instructions for an additional version of the original RAW file. The virtual copy is exactly the same as the original, which is perfect except for the washed-out sections.

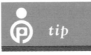 *tip*

The virtual copy in Lightroom is the easy way to create and experiment to your heart's content. Every time there is another virtual copy made, it is simply another set of instructions written for the original, and takes no appreciable extra space on the hard drive. When you right-click (Ctrl/⌘+click) the image in question, the pop-up menu appears; simply choose Create Virtual Copy and another photograph pops up right next to the original.

3. **Adjust the virtual copy so that the white detail comes into view.** As you can see in 8-4, this makes the image very dark, but it is obvious that there is now some detail in the white. The best part of using the virtual copy in this case is that you know that the image is perfect except for the exposure. It's a copy of the image you perfected, after all; any adjustments you've already made, such as spot fixes, toning, sharpness, or cropping, remain exactly the same.

4. **Now that you have all the tones perfect between the two images, select both images, the original with exposure changes and the one that is darker, in Lightroom's filmstrip and right-click.**

5. **In the drop-down menu, choose Edit in and then choose Adobe Photoshop or Open as Layers in Photoshop.** The two virtual copies are now exported into Photoshop as TIFF files, appearing just as they do in Lightroom, and are ready to be further edited. The difference between these two options is if you choose Open as Layers in Photoshop, you will have one image that is all ready to go, but if you choose Edit in Adobe Photoshop, there will be two images that are opened separately and you will have to drag one over the top of the other with an Option+click and drag to line up the pixels.

 Once both images are on two different layers of the same image, there are a number of ways you can get the detail onto the washed-out area. The best way is to make sure that the darker image with all the good detail in the highlights is on top.

6. **Click the Layer menu and choose Layer Mask and then Hide all.** A black layer mask will appear on the top layer.

7. **Choose the Brush tool and set the foreground color to white.**

8. **Brush over the overexposed white portion of the image, effectively transferring the detail from the darker version of the image onto the good version.** This may take you a few attempts. It is easy to change the foreground color to black, which erases the white in case you have brushed on too much.

9. **Set the opacity level to get the exposure of details right (see 8-5).**

8-5

ABOUT THIS PHOTO *The multiple RAW creation from two versions of the same RAW image has the right depth of tone and detail throughout the image. Layering the copies presents all the detail in one merged image. Taken at ISO 100, f/22, and 1/4 second with a 17mm lens.*

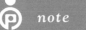 *note*

If you don't have Lightroom, multiple RAW processing is nearly as easy to do with Adobe Camera Raw. Make all of your black-and-white conversion adjustments, including brightness and contrast, to the image in question. Before clicking the Open Image button, make sure to save the settings, then click Open Image. After the image is open in Photoshop, open the same RAW file in Adobe Camera Raw again, first applying the recently saved settings, and then making whatever adjustments are required to get all the detail needed. Once the second version is open in Photoshop, use the same steps with the layers as discussed earlier.

WORKING WITH ADJUSTMENT LAYERS

Once your image is in Photoshop, using adjustment layers is a non-destructive way to make changes to the image. Using layers makes it possible to make edits to the image without actually changing the original image data; each layer can be adjusted in many ways, even having its opacity changed.

Adjustment layers specifically allow you to maintain or save corrections to the image, and you can readily change and readjust them by clicking the adjustment layer icon. If you change the contrast in an image without using layers, and, after a second look, it appears to be too much, there is no reasonably good way you can reverse the change, except for starting from scratch with a new copy of the original image.

Layers also enable you to see how the image looks with and without the changes you've made. You do this by simply clicking the eyeball icon next to the adjustment layer to turn the visibility of the layer on and clicking it again to turn it off. With adjustment layers, like all layers, you can use masks and other blending options to select just how much of the image will show the effect.

It is important to use layers for both local and global changes in your images. Use layers when you are adjusting contrast and exposure and even with your black-and-white conversions. Layers enable you to make endless changes to the image if the layers are left alone and allow you to return to make other changes later. Using an adjustment layer is often the first step in creating your black-and-white images, as you saw earlier in this chapter in the section on multiple RAW conversions:

1. **Open the image in Photoshop.**

2. **Click on the Layer menu and choose New Adjustment Layer.**

3. **If the image is not already in black and white, there is an option for a black-and-white conversion layer; simply click Black & White to apply that layer to your image.** All the options for adjusting each color group as well as presets for color contrast filters are there. In the case of this example, I used the blue filter setting, which made the biggest, best effect to the white tree in the image, and then I adjusted the green to achieve the custom mixed look I desired (see 8-6).

Levels and Curves are the fundamental tools for contrast and exposure control in Photoshop. Using Levels and Curves as adjustment layers gives you even more control and flexibility because you can mask the layers or make them opaque at different levels.

LEVELS

Levels changes images based on the histogram graph and uses a white point, a black point, and a midtone slider (also called a *gamma slider*). Moving the sliders along the bottom line of the graph can stretch the amount of blacks, whites, or

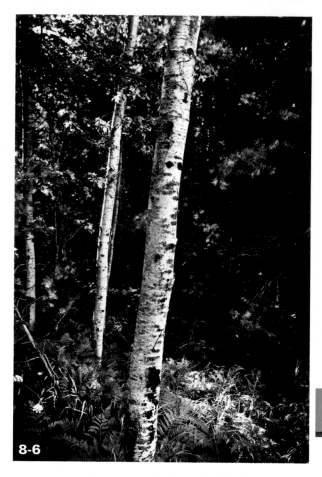

8-6

much movement from either way can cause some unwanted, extreme contrast. In most cases, it is best to bring the white point and black point sliders just up to the edge of where the pixel bars begin (see 8-7).

Watch the image as you move the slider in towards the pixel bars: The image will darken or lighten as you move the sliders in and out. Pushing in too much on the histogram inevitably causes banding in large areas of the sky as the amount of picture information in the image begins to disappear.

Making sure that the sliders are still just to the edge of the histogram's pixel bars should keep the contrast well within limits. Judicious use of the midtone slider helps brighten or darken the image without affecting the highlight or shadow areas too much. When the image is a bit on the dull side, using the Levels layer can add some much needed pop and drama to the image (see 8-8).

note When you are using the adjustment layers, you cannot save the image as a JPEG file. It is recommended that you save the file as a TIFF with layers or as a PSD (Photoshop) file. After you have saved the entire full resolution image with the layers, click on the Layers menu, and at the bottom of that menu, click Flatten. This compresses all the layers into a final image. At that point, make sure to choose Save As to save the flattened image as a JPEG and a separate file from the original. Of course, you can also import a TIFF or PSD file into Lightroom as well.

grays across the image. Sliding the black or white slider in from the edges means that image data will be forced to become darker black or lighter white, while the midtone slider moves the middle grays lighter or darker.

In a scene that is overall a bit dark, sliding the white point slider into the image brightens the image by stretching the pixels out to the white point. If the image needs a bit more depth in the dark tones, moving the black point into where the pixel bars begin to be seen in the histogram so that the pure black point can be seen in the image. Use your histogram and watch the image as you move the sliders across the graph. Too

CURVES

Curves is a powerful tool for adjusting the tone and contrast in a black-and-white image. Both Levels and Curves do much of the same thing, but Curves can give you far more control with how the image is rendered. It also takes a bit more time and precision to achieve this more

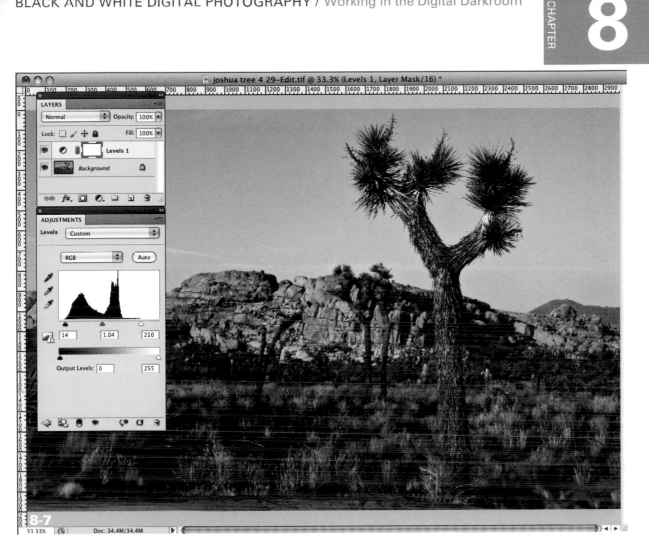

8-7

ABOUT THIS PHOTO *The Levels layer appears at the top of the panel and the Adjustment tool is in the bottom portion. By moving the white slider towards the left, to just the beginning of where the brightest tone begins, and the black slider to where the dark tones begin, an otherwise flat image gets a big boost.*

advanced imaging process and get good results. Much as with Levels, small movements will make big changes, so be careful and subtle with your settings.

Using Curves takes a little getting used to, but in the end, the process is simple. Pushing the curve upward brightens the image, and pulling it downward darkens the image. The real skill comes in when you try to put additional points

on the curve, making the curve more like an S, which brings about more contrast in the image (see 8-9).

For the best results in black-and-white images, move the curves bar in small increments to achieve a curve that flows. A curve that is jagged with multiple points looks posterized, with extreme contrast or totally flat tones throughout. Take the time to play with the image with a

ABOUT THIS PHOTO *While the soft colors of a setting sun brings interest to the scene, the lack of contrast in a black-and-white image makes it look a bit drab. Using the levels to bring in the white point and black point sliders helps add some pop and interest. Taken at ISO 200, f/11, and 1/125 second with a 28-105mm lens set to 28mm.*

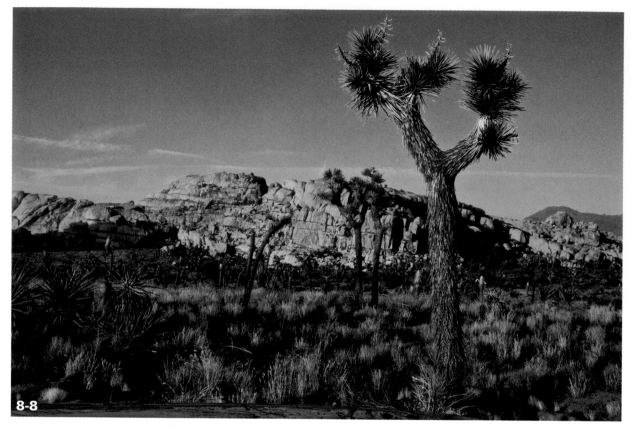

8-8

Curves layer on it. By adjusting the tones slowly at first and then with a more heavy hand, it is easy to see how out of control the contrast can get. For some of the more creative photographers out there, using the curves might be just the ticket for some extremely cool and different images. Remember that playing around with these tools in layers means that you can quickly and easily erase any changes and delete a layer if it becomes too convoluted.

When much of the image is in shadow but the sun is still lighting part of the scene, it is great to use the curves to increase the contrast, adding a bit of drama, without making a mess of the extremely bright part of the images. In this case, the overall image was brightened a bit toward the midtones, and the shadow area was also brought down just a bit, adding richness to the darker tones (see 8-10).

SETTING BLACK POINTS AND WHITE POINTS

Using a black point and a white point is the best way to confirm that you have a true white and a true black in the image or to create a very high-contrast image. You can do it in either Levels or Curves, whichever you are more comfortable using. Setting a black or white point helps you get better tonal control of the image because you can determine where the ends of the grayscale in a particular scene are.

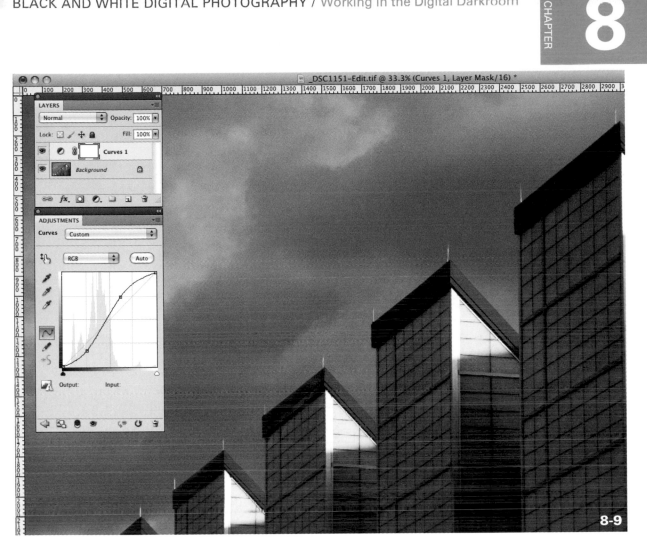

8-9

ABOUT THIS PHOTO *This shows a relatively high contrast curve setting with a part of the curve pushed up for more brightness and the other point pushed down for richer shadow tones.*

The Eyedropper tool is very easy to master, but it isn't quite as easy as just getting a quick grab from some random area in the image that might be the white or black point. The easiest way to get the most accurate white and black point is to use a multi-step process:

1. **Open a new adjustment layer and select Levels.**

2. **After you have a Levels layer, select the white Eyedropper tool, and then press the Option (Alt) key.** This makes the scene entirely black unless there are already pure white tones or blown out highlights in the image, in which case they will be the only tones that appear.

3. **To see where there are white tones in the image, very slowly slide the white slider to the left.**

4. **When you see the first white tone, place the eyedropper here and select it (see 8-11).** This part of the scene becomes a true white, changing the color cast of the rest of the image, and now there is a new white point for the photograph.

199

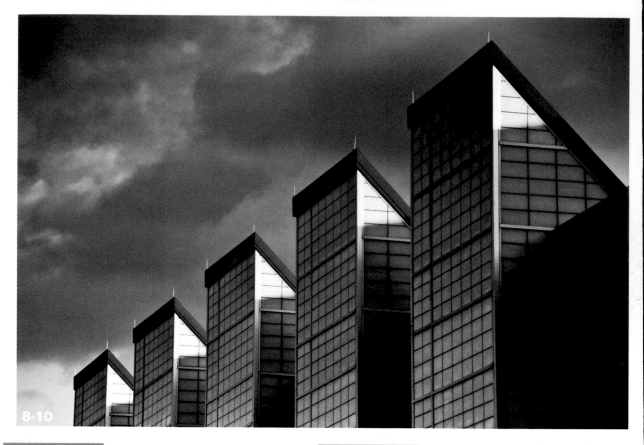

8-10

note When selecting a white point, make sure not to use a specular highlight such as a reflection of water or other shiny object, or a point light source like the sun or a light bulb. Those things should be past white in most cases anyway, so just find a real white object in the scene.

note In color photography, you can use the eyedropper along with the Levels tool to correct color issues. You find a point in the image that you know is white, click that area, and any sort of color cast should be eliminated. Using the gray point and a known midtone is also possible, but unless you have a gray card or some other known gray tone, this may lead to erroneous results.

You use the same steps for the black point, except that you must first select the black eyedropper and then press the Option (Alt) key to make the image completely white except for any black tones in it. If there are already a lot of pixels that are completely black or completely white, doing both eyedroppers may be unnecessary.

The image of the church in 8-12 was a bit dark in general, but the stained glass windows provided some bright areas. It was most important for this image to have a white tone around the bright edge of the very light-toned sculpture. I tested the

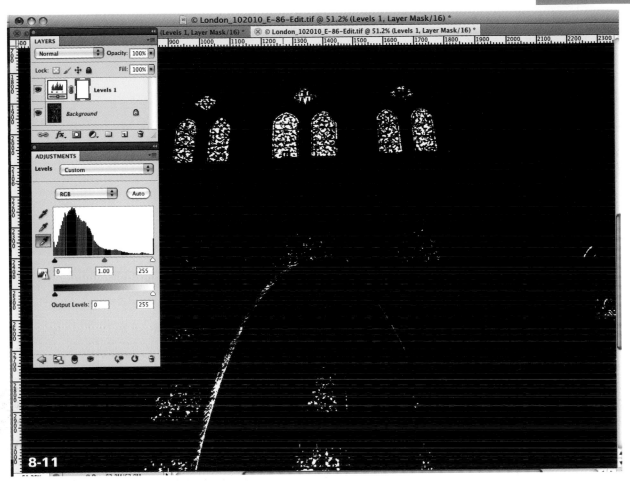

8-11

ABOUT THIS PHOTO *Pressing the Option (Alt) key with the white eyedropper accessed shows the image on the screen with only the brightest areas appearing. This gives you the option of where to select the white point; in this case, I chose the bright edge of the large arcing sculpture.*

eyedropper at a couple different points on the arc to find the white point I wanted, and just kept pressing Ctrl/⌘+Z to redo the setting until I pressed Option to really determine the white point in the scene.

Testing the eyedropper at different points in the image shows some alternate options and perhaps new opportunities to see something different, with perhaps some extreme contrast or to create an interesting high or low key image.

In scenes that appear relatively overcast, using white-point selection can quickly brighten things up and bring the contrast where it needs to be. As with most techniques, you can take it too far: It can quickly lead to a completely washed-out image if you select the wrong point.

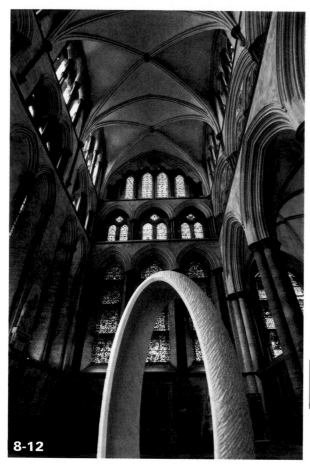

8-12

In some ways dodging and burning are past their prime. Using layers with masks to selectively add brightness or darkness can be more precise; color images have odd color shifts when they are dodged and burned. Digital tools that make changes to larger parts of the image, such as *gradients* (which can lighten or darken in from the edges) or *vignetting* (which changes the tones in the corners of the image), decrease the need for old-school dodging and burning. That said, these are still tools that are easy to use, and they get great results quickly.

In the Photoshop toolbar, you will see a tool that either looks like a lollipop or a fist; click and hold that button to access the Dodge and Burn tools (see 8-13). The Dodge tool is the lollipop icon, and the Burn tool is the hand or fist. When you select one, a new submenu appears. This gives you access to a vast amount of fine-tuning options for dodging and burning.

> **note**
>
> In the wet darkroom days, photographers used pieces of cardboard of various sizes taped to wire to block the light of the enlarger. Hence the lollipop look of the Dodge tool's icon. The Burn tool looks like a hand because in many cases, a photographer would use her hands to block all but the tiny bit of light coming through her hand to *burn in* an area, making it darker.

DODGING AND BURNING

You use dodging and burning to make areas of an image lighter or darker. Besides color contrast filters, this is probably the set of tools most reminiscent of those used in the wet darkroom. *Dodging* refers to dodging or blocking the exposure of certain areas of the print, making it lighter. *Burning* is exposing part of the print to more light in order to make that area darker. In the digital darkroom, you do this with simple brush tools in photo-editing software. You can resize the brushes and change the strength of their effect as well as control the tones that are most affected.

The Options bar at the top of the screen gives you a host of different ways to dodge and burn as well as ways to apply the amount and quality of the effect.

The first drop-down menu enables you to access your own presets, so if you have particular settings you use over and over, you can save them and easily access them from here. The next drop-down menu offers a palette of sizes, degrees of hardness, and textures for the Dodge or Burn tool. These settings are universal with most of the brush tools in Photoshop. Larger brushes affect

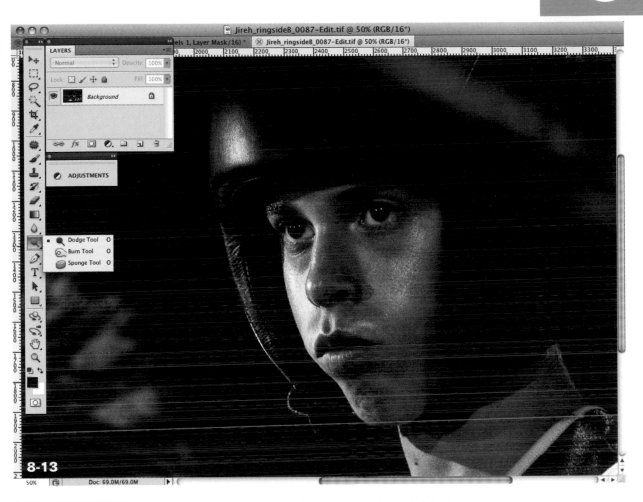

8-13

ABOUT THIS PHOTO *The Dodge and Burn tools are about halfway down the toolbar on the left side of the screen. The Dodge tool (lollipop icon) lightens things, and the Burn tool (hand icon) darkens things.*

larger areas of the image, and smaller brushes do the opposite. The softness of the brushes is of equal importance: A soft brush means that the difference in affect between the center and edge of the brush is very large, while a hard brush affects the entire area of the brush equally. Softer brushes allow for more subtlety, while hard brushes give you more precision (see 8-14).

Being able to fine-tune the affect of the Dodge or Burn tool gives you great versatility. Determine the type of tone that is being affected, and then set the brush for Shadow, Midtone, or Highlight appropriately in the drop-down Range menu (see 8-15). In some cases, it is even possible to do different dodge or burn strokes with different tone settings to get more interesting effects. Use the exposure slider to dial in just how much of the dodge or burn affect you desire for the section of the image (see 8-16). Try different amounts of exposure depending on how dramatic the dodge or burn needs to be in your image. There will be opportunities for all sorts of settings in your black-and-white images, and trying different options will give you experience with all of them.

The photograph of the young boxer in 8-17 was a bit dark, but lightening the whole image made the large amount of black background a bit muddy and dull. It is important that the boy's face keep the viewer's focus and be one of the brighter if not the brightest part of the image. Because the entire exposure is on the dark side, there were a number of things I needed to dodge and burn.

I dodged the out-of-focus face of the coach just a little bit to show a fraction of his face. I used a large and very soft Dodge brush, set to affect midtones because his face has so much contrast. I also dodged the coach's satin jacket a bit in the shoulder to bring out the shiny quality of the fabric, with an exposure percentage of 20 percent, but I burned down his white sleeve a little using the same size brush and quality midtones with a burn exposure of 50 percent. I did the same amount of burning on the lettering on the far-right side.

Because all those areas were out of focus and part of the background, I could dodge them in a loose, broad-brush manner. I then dodged the boy's face with more precision. One side of his face already had a fair amount of highlights, so it was important to only dodge the one side so that the far side didn't wash out. I selected a smaller brush and bumped the hardness up to about 15 percent, which is still pretty soft.

I put the Range setting to Highlights to make any sweat sheen pop out. This also brightened the eyes and the catchlights in the eyes. I did a second dodge with the range set at Midtones to get the overall skin tone brighter without washing out any of the highlights on his face. The last

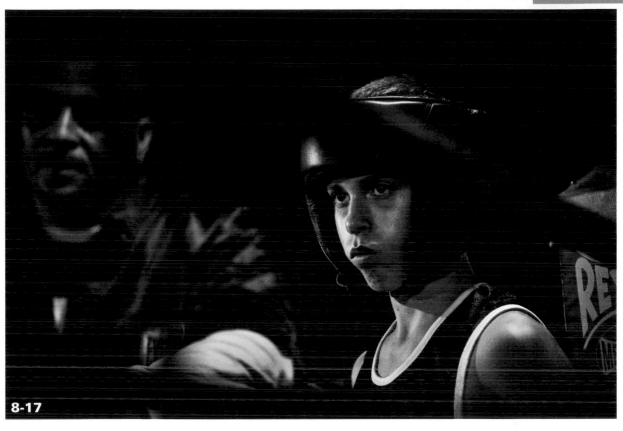

8-17

ABOUT THIS PHOTO *Judicious dodging and burning was done to get the right amount of tonal dynamics on the boxer's face, as well as the background elements. Images with exposure and contrast challenges often benefit from localized changes. Taken at ISO 4000, f/2.8, and 1/200 second with a 200mm lens.*

thing I did was a quick dodge of his headgear with the range set to Shadows so that the seams and texture were slightly more pronounced.

LAYER MASKS

Layer masks are another essential feature Photoshop users employ to enhance their images. With layer masks, you selectively make changes to the image, such as making adjustments in contrast or exposure to only a part of the image. Virtually any adjustment can be done on a layer mask so that it only affects a certain part of the image. Even adjustment layers can have a layer mask applied.

After you have completed the black-and-white conversion as described earlier in this chapter, and the rest of the image has your desired settings, you can use layer masks to further your creative vision of the scene. To bring the interest of 8-18 right to the flower and help minimize a very busy background, I used a Levels adjustment layer:

1. **Open a Levels adjustment layer in the Layers palette.** A white box appears next to the levels icon; this is the icon for the layer mask. A white layer mask reveals all, meaning that you can see every change on the layer. A black layer mask hides all, meaning that you cannot see the changes until the

mask has black or white brush strokes added to the image, which will restrict the view of the mask to some extent.

2. **Once the new adjustment layer is available, make the changes to the image you desire.** In this example, the levels are moved, specifically to darken the background so that the entire image is much darker, but this also makes the flower much too dark.

3. **Click in the white box (layer mask icon) to select the layer mask.**

4. **Select the brush tool.**

5. **Select black as the foreground color.**

6. **Adjust the brush size and hardness appropriate to the image.**

7. **Brush over the area of the image that you wish to mask from the new changes.**

Brush tool Layer mask icon Adjust brush

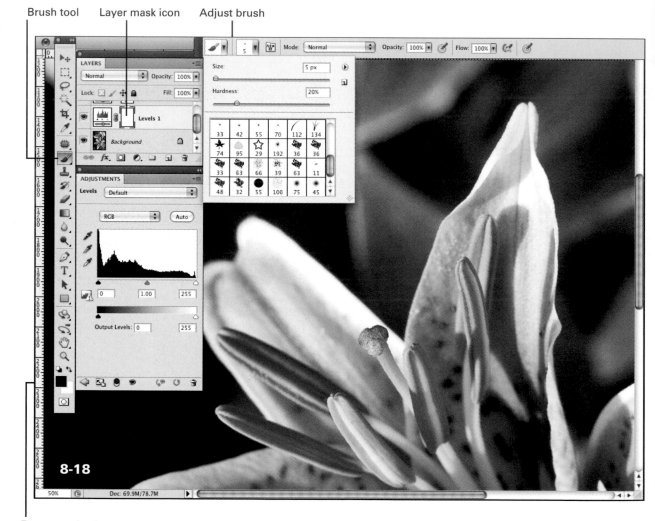

8-18

Foreground color

ABOUT THIS PHOTO *With a white layer mask, all changes to the layer are visible until some black is brushed onto the layer to stop seeing that effect. A black layer mask would restrict any changes from the image, except for when white is brushed on the layer so it is possible to see that effect.*

8. **Now that the entire image is much darker, use the brush tool with black to hide the effects of the layer mask on just the flower.** This leaves the flower exactly where it was in the first place as far as the tones and so on, but keeps the new darker background very dark (see 8-19).

If there were other changes that you wanted to do to the image later, whether making the background darker yet or perhaps making it a bit lighter, it would be easy to get back to that adjustment layer and make those changes. You can also add a bit of the effect back by selecting the brush tool and then selecting white as the foreground color.

The brush with white simply exposes what the brush with black had hidden. It is also easy to go to the Options bar on the brush tool and adjust the opacity of the brush, which will make the brush effectively gray and will hide or reveal only part of what is brushed in. This is really the key to making fine changes and creating many different layers of tone in the image.

To add a layer mask to a regular or background layer that is already applied to the image, follow these steps:

1. **Click on the menu and choose Layer.**

2. **In the drop-down menu, click on Layer Mask.** At that point, it is up to you whether to choose Reveal All, creating a mask that shows all the changes of the layer except what is masked out with a black brush, or to choose Hide All, creating a mask that hides all of the changes except what is revealed with a white brush.

 After you have completed each change to the mask, the layer mask icon shows the affected area in a thumbnail form.

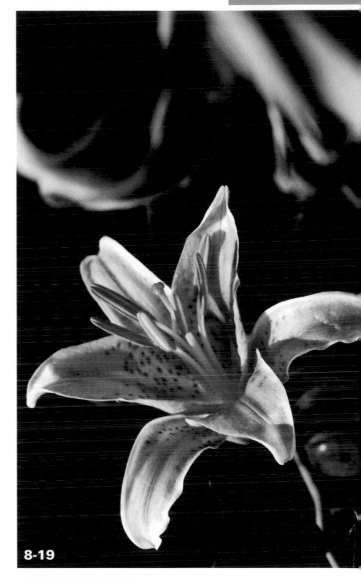

8-19

ABOUT THIS PHOTO *The background in this image was very distracting, but by using a levels layer and mask it was easy to make adjustments to most of the image and still preserve the most important part with the original tones. Taken at ISO 100, f/5.6, and 1/180 second with a 105mm macro lens.*

3. **Take a quick look at the thumbnail to make sure that the mask is covering or uncovering the appropriate areas (see 8-20).**

8-20

SHADOW AND HIGHLIGHT TOOL

When the image has more extreme contrast issues, such as deep shadows or nearly blown-out highlights, the Shadows/Highlights tool comes in handy. To access the Shadow/Highlight tool, click Image, choose Adjustments, and then select Shadow/Highlights, which appears halfway down. It is recommended that you use the Shadows/Highlights tool on a new layer so that you can further adjust or mask it if necessary.

Tools like Levels work from the outside in by stretching the pixel information to increase contrast in most situations. Think about Shadows/Highlights as filling in from the inside of image, adjusting the contrast in the midtones so that there is more complete image information in the black-and-white image.

Shadow/Highlights is great for backlit images where there is exposure information but the contrast level is high with a lot of shadow and highlights from the light coming into the camera.

Using the Shadows/Highlights is similar to adding a bit of fill flash, showing the detail in the dark areas (see 8-21).

Use the Shadows/Highlights tool judiciously, as it can cause an image to get a bit of a halo around the areas of contrast. Photoshop is amazing, but its tools can only do so much when the amount of the light is just beyond the limits of the sensor.

Shadows/Highlights is also very similar to the Recovery and Fill sliders in Adobe Camera Raw and Lightroom. If the exposure changes in the shadow and highlight areas is going to be extreme in the image and there is a RAW file available,

making those changes at the RAW image process level should extract better results. This does not mean it is necessary to go back and re-process an image, but it is something to consider during the initial image evaluation.

note

When shooting images that have even the slightest backlighting, the chance for flare increases. This can be good or bad depending on the look you want to achieve. Use a lens shade or hood if at all possible or use other items to shield the face of the lens from the light, such as a hand, hat, clipboard, or black card.

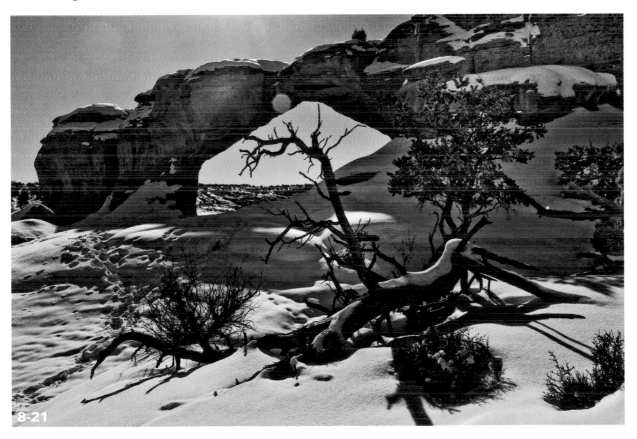

8-21

ABOUT THIS PHOTO *Sun coming from straight behind the arch means that the arch will be in shadow, but there is still enough light to see some detail, not a silhouette. Shadows/Highlights both brings down the brightness of the snow, as well as lightens the shadows of the arch. Taken at ISO 100, f/9, and 1/250 second with a 28mm lens.*

ADDITIONAL FILTERS AND TOOLS

There is a phenomenal amount of software available to help you create better black-and-white images and to add special effects. Most of these filters and tools simply harness the power of the application you are using and put it into a more user-friendly format or provide a way of doing things that is easier to comprehend.

Adobe has done a great job with Photoshop: Every new version of the program offers more useful tools for the black-and-white photographer. This additional help that is available for the black-and-white photographer is not limited to just Photoshop; there are similar new settings for Lightroom and other image editors.

NIK SILVER EFEX PRO

Nik Software has long been a producer of great software for photographers. Its digital filters can not only emulate glass filters and effects filters that go in front of the camera but can also give you opportunities for brand-new visual effects. A few years ago, Nik came out with Silver Efex Pro, which is designed to create black-and-white images that can look as much like film as possible, as well as go beyond the limits of what is possible in film.

Silver Efex Pro can be used in conjunction with both Photoshop and Photoshop Elements, as well as Lightroom, Aperture, and other editing software. This allows image adjustments to happen at the RAW or color level, and then Silver Efex Pro is accessed through your favorite image-editing software to create your black and white image.

Many of the images in this book were processed through Silver Efex Pro. The interface is simple, and a number of Silver Efex presets offer some

great places to start the black-and-white process, as well as some really interesting effects that emulate things like the images from a Holga or infrared camera.

Tools within the program fine-tune each image with simple settings for color contrast filters, contrast, brightness, and *structure* (which appears to be midtone contrast, like *clarity* in Adobe Camera Raw and Lightroom). There are also buttons for film grain effects; one very popular feature is the emulations for many popular film stocks, with grain and contrast response characteristics similar to those films.

Once an image is opened in Silver Efex through one of the other image-editing programs, it appears to be desaturated. In 8-22, it was important to translate the natural drama of the clouds to the black-and-white image.

After sampling several different presets, I chose the high-contrast orange version because it added a lot of impact in both the dark sky with white clouds as well as the light-toned grasses that contrast against the sky. Next, I played with contrast and structure. It was also important that this image have a bright tone to it but still have detail, even if just a little, in the goat's fur, as that small bit of white anchors the scene.

> **note**
> If the black-and-white tools in other programs seem difficult to understand, you will find that Silver Efex Pro provides easy conversions to black and white, with amazing options. Without trying to sound too much like a commercial for Nik, Silver Efex Pro is really worth the money given all that it offers. It is indeed possible to do anything that Silver Efex Pro does in Photoshop, but not as well or as quickly.

8-22

ABOUT THIS PHOTO *There are never enough days with deep blue skies and beautiful clouds. The contrast of the white goat against the pale grasses set against the dark sky makes for a compelling image. With Silver Efex Pro, I made this black-and-white conversion quickly and easily. Taken at ISO 200, f/4.5, and 1/4000 second with a 20mm lens.*

PLUG-INS, ACTIONS, AND PRESETS

There are a multitude of third-party tools to help you with processing your digital black-and-white images. These offer more user-friendly options to help quickly create a certain look. These range

from very basic presets to help automate a process all the way to Silver Efex Pro, which is an advanced plug-in that has the feel and capabilities of a stand-alone program, but it is in actuality a grouping of advanced image adjustment tools with great digital ergonomics.

The first tools to consider are *plug-ins*, which are third-party bits of software that extend the capability of Photoshop, and they run the gamut from free to darned expensive. In most cases, plug-ins provide a menu of options you use to make adjustments to the black-and-white image through Photoshop. This menu is usually presented in its own window and includes various options for applying contrast, film grain levels, and color contrast filters and for emulating certain film stocks. You can find them with an easy Web search, and they are even available through the Adobe Marketplace.

Plug-ins enable you to do advanced black-and-white image processing without a lot of frills, but they can provide a smoother way to do it than using Photoshop itself. Generally the one thing that is lacking in a stand-alone filter suite like Silver Efex Pro is a large preview built into the plug-in's window.

Use some of the free trials for the black-and-white plug-ins and see how they work for you. One product I recommend is the BW Workflow Pro from Fredmiranda.com. This product was used extensively before the advent of Lightroom and the black-and-white adjustment tools currently in Photoshop. It makes the process of converting to black and white quite easy and, even more important, quite precise. It is a very affordable plug-in and can add a lot to your black-and-white imagery in short order. *Actions* are often a series of Photoshop steps and settings that are saved and can be easily played back to create a certain black-and-white look. They are usually

simpler than plug-ins, save time, and can make image processing more productive because the steps are played back quickly and, more important, automatically.

There are seemingly endless sources for new actions that create a particular look or workflow for your images. You can buy them on several online sites, and you can easily create them yourself. If there are settings that you often use, creating an action will save you the time and effort of re-creating the steps over and over for each image. You can even create settings in your action to process many images in a batch.

To create an action, first recall the steps you usually perform to create the image. Then follow these steps:

1. **In Photoshop, choose Windows ⇨ Actions to open the Actions palette.** The Actions palette appears on the top-right corner of the menu.

2. **Click the Actions tab (see 8-23).** Most of the tools to create your own action are located in that menu.

3. **Choose New Action, which brings up the New Action window.**

4. **Give your action a name that provides a good reminder of what the process does.**

5. **Click Record to save a record of the steps that you perform for this action (see 8-24).**

6. **Perform the steps for your process.** In this case, my steps included using the Photoshop Black & White tool, creating a layer for softening the image, and then fiddling with the contrast just a bit more with the Brightness/Contrast sliders.

7. **Click the blue square button at the bottom of the Actions palette to stop the recording of the action (see 8-25).** The tools at the bottom of the palette are repeated in the menu, as described in Step 2.

8. **To apply the action to another image, simply select the action and then press the Play button.** Photoshop will perform those steps for any image.

To give you some ideas for adjustments you might like to save as actions, consider that black-and-white photographs of babies and children look good with skin tones that look lighter, and even have a glow to them. Adjust the warm color group sliders, such as Red, Orange, and Yellow, towards the brighter side to get that look. Cautious moves are good, given too much of an adjustment may make the skin look ghostly and the lips too pale. Moving the blue and green sliders too much can make skin look blotchy and dark. Additionally, you can add a bit of softness in the form of Gaussian blur to a layer to increase the glow on the skin just a bit. Adding it as a layer means that you can adjust the effect even further by adjusting the opacity of the effect layer (see 8-26).

With programs like Lightroom, Aperture, and Adobe Camera Raw, image settings are saved as *presets*. Presets are very similar to actions, but instead of recording the sequence of changes made to the image, you make the adjustments to the image, and then the presets save all the changes at the end.

note Not only can you save adjustments to the image as presets, but in Lightroom, you can save virtually every step in the image-editing process as a preset. From how images are imported, named, saved, and organized to how they are placed on paper and exported out as JPEGs to share, you can utilize presets at every step of the way.

8-23

Actions menu

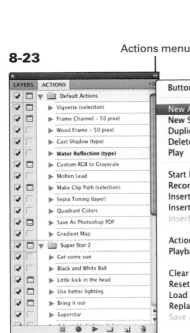

Button Mode
New Action...
New Set...
Duplicate
Delete
Play
Start Recording
Record Again...
Insert Menu Item...
Insert Stop...
Insert Path
Action Options...
Playback Options...
Clear All Actions
Reset Actions
Load Actions...
Replace Actions...
Save Actions...
Commands
Frames
Image Effects
LAB – Black & White Technique
Production
Stars Trails
Text Effects
Textures
Video Actions
Close
Close Tab Group

8-24

Stop recording Play

8-25

ABOUT THESE PHOTOS *Actions are a simple way to save and repeat a set of Photoshop changes to the image. This can be a real life saver for people who have a lot of images they need to retouch, as well as a creative boon for those who love to keep the same look for many images. Actions are also available from many sources on-line and from other photographers. Use and manage your actions to help you complete your creative vision.*

213

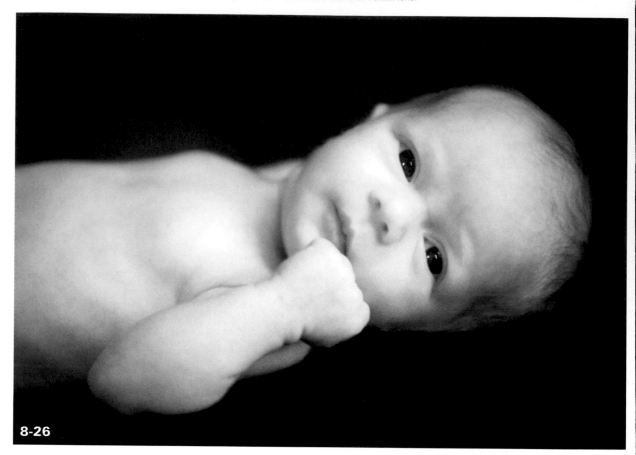

8-26

The steps to save a preset are very easy. Once you have adjusted the image so it looks just the way that you want it to in the Lightroom Develop module, you are ready to save it. On the left-side pane, under Presets, follow these steps:

1. **Click the plus sign (see 8-27).** The New Develop Preset window opens.

2. **Choose the settings that you wish to save as a preset.**

3. **Name the preset.**

4. **Select the folder for the new preset.**

5. **Click Create to save the setting as the new preset.**

Not only can you create your own preset, but there are also a ton of presets available to download. While some do charge a nominal amount for their presets, many of the best creative people in the world freely give their presets away, making it possible for you to learn and use some great tools. These presets often simply get the juices going and show you how just a little change can make a big difference in the image.

In the Develop pane in Lightroom, a large thumbnail view appears at the top. Hovering the mouse over any preset reveals a quick thumbnail of what that preset will look like on your image without actually making those adjustments to the image. The image shown in 8-28 was one such

ABOUT THIS PHOTO *There are just a few simple steps to creating you own presets. Once you have a great black-and-white mix, it is good to know that you can go back to it for a particular look.*

New Develop Preset button

New Develop Preset

Preset Name: Black White Farmscape

Folder: User Presets

Auto Settings

☐ Auto Tone ☐ Auto Black & White Mix

Settings

☑ White Balance ☑ Treatment (Black & White) ☑ Lens Corrections
 ☑ Transform
☑ Basic Tone ☑ Black & White Mix ☑ Lens Profile Corrections
 ☑ Exposure ☑ Chromatic Aberration
 ☑ Highlight Recovery ☑ Split Toning ☑ Lens Vignetting
 ☑ Fill Light
 ☑ Black Clipping ☑ Graduated Filters ☑ Effects
 ☑ Brightness ☑ Post-Crop Vignetting
 ☑ Contrast ☑ Noise Reduction ☑ Grain
 ☑ Luminance
☑ Tone Curve ☑ Color ☑ Process Version
 ☑ Calibration
☑ Clarity

☑ Sharpening

(Check All) (Check None) (Cancel) (Create)

8-27

happy accident where the image by itself was fine, but after scrolling through a few black-and-white presets, it was obvious it could be something more. After I selected a high-contrast preset, and then tweaked it even more to show off the detail in the sky and show the interesting texture, the image came out far better than I hoped, and I simultaneously created a new preset.

By using the presets in conjunction with virtual copies, it is easy to build a folder full of trials and errors of any image, which inevitably will lead to the finished piece. Spend the time you saved by using a preset to examine and explore new ways to work on your black-and-white vision.

PRESETS AS THE BASELINE. With all of the presets and actions available, is there ever a fear that it limits the creativity? Remember that presets and actions help with productivity, but shouldn't substitute for creativity. Make sure that when you apply a preset, it is exactly the look needed for that image. Rarely will a preset for one photograph be exactly the right thing for another photograph. Use the presets as a baseline to start the image-developing process. For example, there might be a great black-and-white mix that you prefer for sunny landscapes; simply select those settings as a good baseline to get you started and there will still be plenty of adjustments yet for you to make to finish the creative vision of the photograph.

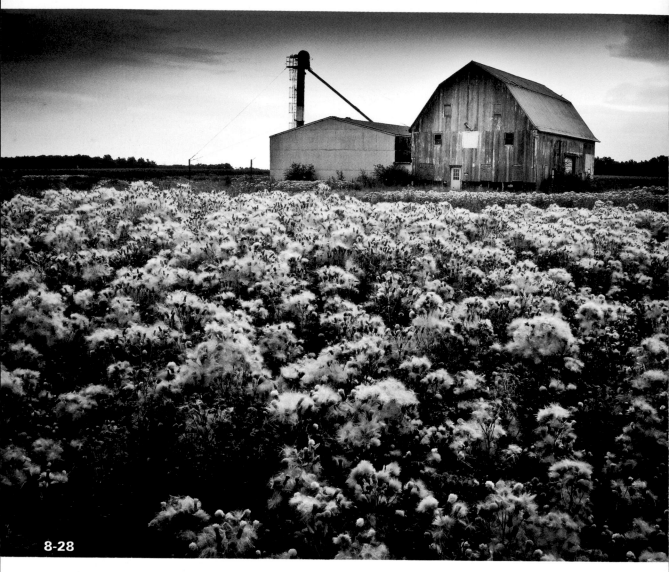

8-28

GRADIENTS

When only part of an image needs some help, a *gradient tool* can be useful. Graduated filters can be used in front of the camera to make a lightening or darkening, but making these adjustments in the computer is more convenient and more precise. Gradients used for contrast control are usually used on a layer to fade the amount of brightness gently from the edge of the photograph toward the middle.

You can use a gradient to make a foreground brighter, a background darker, or vice versa. Use gradients with exposure adjustments on a layer with a multiple-RAW processed image, or simply with a graduated exposure. A gradient applied to a layer mask on an adjustment is effective in applying or adding a graduated effect. This is used in black-and-white landscape photography most often to darken a sky to give it visual weight and impact.

After making other exposure and contrast adjustments to the image, create a new adjustment layer for levels or curves (discussed earlier in this chapter). Then follow these steps:

1. **Click the layer mask icon and make sure that black is the foreground color.**

2. **Click the gradient tool.** With a white layer mask, the black foreground blocks the changes. There is now a cursor that looks like a +.

3. **Click and drag the cursor in the opposite direction that you want the effect to be strongest** — in this case, from bottom to top. No changes will be apparent, except now the layer mask icon has a gradation of dark to white on it.

4. **Start making changes to the levels layer.** Immediately the part of the scene being revealed by the mask is shown with the adjustment made while the amount of adjustment fades away with the gradient (see 8-29

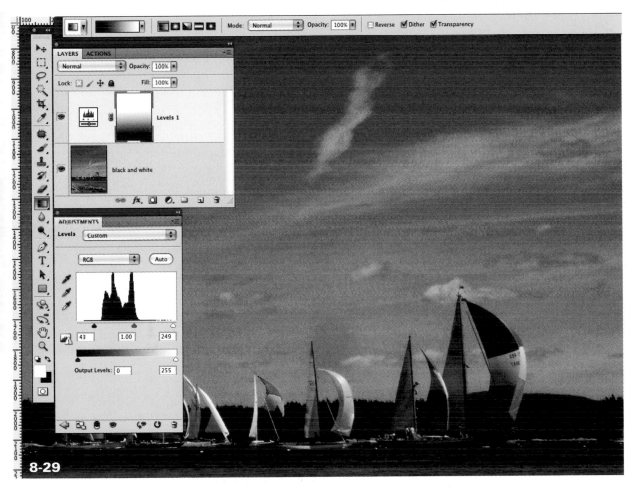

8-29

ABOUT THIS PHOTO *The gradient tool is in use on the Levels adjustment layer. The entire image is made darker, but the bottom of the image is masked off, gradually brightening towards the bottom.*

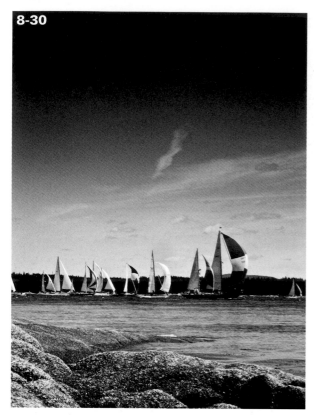

8-30

and 8-30). You can also perform these settings in reverse, with a black, hide-all, layer mask.

5. **Click and drag the cursor across the image from where you want the effect to be strongest towards the direction that the effect fades out.**

Lightroom also has a tool called Graduated Filter (see 8-31). This is slightly more intuitive and easy to use than applying an adjustment layer mask gradient, but it also has a different sort of precision:

1. **With the Graduated Filter tool, click and drag the cursor across the area that you want affected.**

2. **Use the three white lines to gauge how fast the gradation will change.**

3. **After the tool is in place, move the sliders to make adjustments as needed.** For example, lower the exposure to darken a sky, or raise those settings to make areas brighter. There are also options for additional contrast, color, and sharpness.

SELECTIVE EFFECTS

Use the many tools and brushes available in any editing program to further enhance your creativity when working with your black-and-white photographs. You can make selected areas of the image have more impact by giving them more brightness, contrast, or even sharpening or softening. Take some time to think about how to create additional focus on certain areas of the image with some of the tools listed here.

TONES

Adjusting the tones in a particular area of an image will help separate and accentuate those areas. It is possible to use dodging and burning, or a brush tool along with an adjustment layer mask, to make changes to an image's tones in Photoshop.

Use the brush tool in Lightroom to make tonal changes in your black-and-white images as well. Every area in the image can have different brush strokes that you can adjust separately by clicking New before every new adjustment. Then use the Edit Pins left after each brush stroke to go back and adjust each brush stroke by clicking the Edit button in the Brush tool, and then move the sliders to achieve the affect.

ABOUT THIS PHOTO *The Graduated Filter tool is very powerful and can be used to darken skies and brighten foregrounds, or multiple filters can be used as a vignette around the whole image. Use the various sliders to fine-tune the adjustment settings.*

By lowering the brightness on the lowest tube and raising the brightness on the uppermost tube, the staggered curves have a nice gradation, which adds some visual interest. Using a brush tool to change the brightness along the length of each tube, each with a separate adjustment, is the key to making the tones precise (see 8-32).

tip

Edit Pins are used in Lightroom to define where the adjustment tools have done work. They are small white circles with a black border. To edit the content of the brush stroke, just click the Edit Pin and a black dot appears in the middle. Then you use the sliders to adjust the effect of the brush stroke, or you can add more brush strokes with the same effect.

8-32

SHARPENING

Digital cameras are built with a filter in front of the sensor. This filter is called a number of things, but usually it is called a *hot mirror* or *anti-aliasing filter*. It is there to make sure that only certain wavelengths of light pass through the sensor as well as protect it from scratches. This filter can slightly degrade the sharpness of an image, and while a camera-processed JPEG usually corrects for this softening, the RAW file must be sharpened to get the highest quality image.

With softer subjects, such as people, the amount of sharpness at the pixel level often needs to be less in order to get the best tones for smooth skin in a black-and-white portrait. Eyes, on the other hand, should be in focus and sharp. Use a separate layer to add sharpness to the image with the Unsharp Mask filter in Photoshop, and then use a layer mask to focus only on the eyes (and perhaps the lips). It is also possible to add a separate layer that adds blur to the entire image, such as Gaussian blur or lens blur, and then add a layer mask that blocks that blur from the eyes.

A brush tool in Lightroom or Aperture is also available to make selective sharpening effects. Add brush strokes across the eyes and then use the sharpness slider to add sharpening to only that area. Use the brush adjustments to make sure the feather of the brush has good softness and that the selected area that is adjusted has a smooth gradation effect and is not hard edged. Clarity is midtone contrast, which adds some apparent sharpness to an image, so that can be used for selective sharpening as well (see 8-33).

COLOR

Ever since photography was invented, photographers have used color to accentuate certain parts of their images. A fascinating example of this can be found in old college gyms where the team photos were taken in black and white and then each image was hand painted to add in the team colors and skin tones. Digital photography gives you many advanced opportunities to add a splash of color to a black-and-white image.

You can use one of two methods to add color to a black-and-white image: You can add color or subtract color. Try adding color by using the brush tools on different layers of your black-and-white

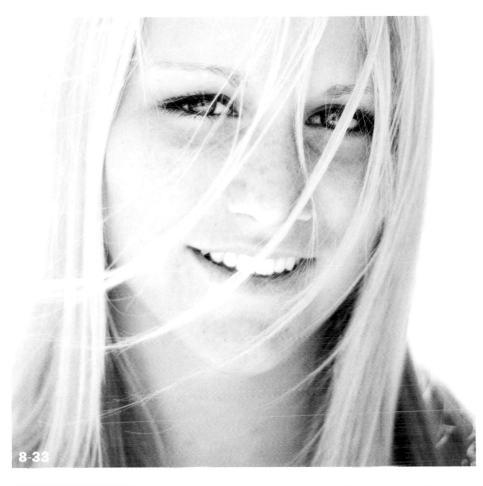

8-33

ABOUT THIS PHOTO *Getting the focus on the eyes is always important. Remember to actually focus on the nearest eye to the camera, and then use selective sharpening to make sure the eyes are bright and sharp and the focus of the image. Taken at ISO 100, f/1.8, and 1/640 second with a 50mm lens.*

images to create entirely new images. Use the color palette and the eyedropper to select colors that have the same look and tone as were originally in the scene, or pick colors to create surreal or hyper-colors. Paint each color on the black-and-white image onto separate layers so that you can change the opacity of the color to your liking (see 8-34).

When you subtract colors, think about which colors you would like to keep and which should go. To maximize the quality of the black-and-white image, use separate black-and-white and color layers and then use a layer mask to subtract the color from the scene by hiding parts of the layer. A quick fix option for subtracting color is to use a desaturation brush in Lightroom.

8-34

BRIGHTNESS AND CONTRAST

It is possible to add or subtract selective contrast and brightness to a scene to add pop and texture in an area. Enhancing the visual texture in a scene is one of the best ways to show life in a black-and-white image. Bring the viewers' eyes to a particular part of the image by enhancing texture in a small part of the scene.

When overall contrast might detract from the image by blocking up shadow details or washing out highlights, focusing additional contrast on just a small area of the scene will help draw the

viewers' eyes to that part of the scene. It is also possible to do the opposite and lessen the contrast on secondary parts of the scene. You can do this with many editing programs by brushing additional contrast and clarity on a selected area, or by using a layer to add or subtract extreme contrast and then using a mask to only show part of the adjusted area (see 8-35).

Selective brightness is often used when photographing a group of people. Brightening their faces just a hint brings the viewers' eyes to those faces. Use any of the tools that you have learned in this book to do this, from a brightness brush to make a separate adjustment layer and mask to the old dodge-and-burn method.

FILM SIMULATIONS

Film simulations are another, more specific preset or action for black-and-white photography. Each type of film has its own contrast characteristics and grain pattern, as well as its own color response. Many black-and-white photographers love to emulate the tones they used to get in the black-and-white wet dark room. Certain films were designed with higher sensitivity to particular colors, which made those colors brighter (or darker) in the tonal range of black and white, and with each film's different grain structure, the texture of images made with those films was different.

Each of these differences can help create distinctive digital black-and-white images. You can simulate these effects on your own if you have a knowledge of certain film stocks, but programs like Silver Efex Pro have an extensive list of film

8-35

ABOUT THIS PHOTO
To increase the depth of the image, I used the Brush tool on the barn to give clarity and sharpness. I softened the branch slightly to give the barn extra pop. Taken at ISO 200, f/10, and 1/100 second.

simulation settings. There are also plug-ins that can add these simulations to Photoshop and Photoshop Elements, and there are countless simulation presets for Lightroom as well.

Each set of film simulations may be a bit different. Even though many of the color response characteristics have been defined by the original film manufacturer, there are so many variables between the software and the scene that just clicking on the preset doesn't guarantee the image will look just like film. Use film simulations just like any other preset — as a baseline to create your own vision of the image.

CREATE YOUR OWN WORKFLOW

In broad terms, your *workflow* is the process that you go through to create your image, beginning with adjusting the camera's settings all the way to showing an end product to a viewer.

More specifically, your workflow is often defined as the process of creating the digital image once it is imported into the computer. For each photographer, these steps are different, and each photographer may have different workflows for different sorts of photos. Photographs of family and friends

that go to social-networking sites have a different workflow than personal artistic images that are going to galleries or will be used for teaching, which have a totally different workflow from images whose end destination is the commercial client.

No matter where the images are destined to go, you need to make sure the original images are clearly organized and backed up. Without a good plan of how the images are organized, file-named, and key worded, they might as well be negatives in a shoebox. Without at least a decent backup plan, you just never know how long you will have those images.

Think through the steps you need to take to create your black-and-white images and even write them out to help you keep track of them:

1. **Capture**

2. **Import**

3. **Rename and organize**

4. **Convert to RAW**

5. **Convert to black-and-white**

6. **Contrast and exposure**

7. **Retouch**

8. **Selective effects**

9. **Final output**

This list is not the be-all and end-all to the workflow, but a place to start. There are steps from the previous list you may combine or even ignore, and there may be additional steps that aren't listed at all. The point is to create a workflow for your needs and use it. The evolution of that workflow is inevitable, but it is the place to start from and to begin practice building your creative black-and-white vision.

CREATE A PROTOCOL FOR STORING IMAGES

A good first step in any workflow is to create a system, a protocol with which to add the images to the computer, complete with properly named and dated folders and files. Aperture and Lightroom both excel at this task. iPhoto and Windows Live Photo Gallery have their own benefits, albeit at a much lower level of image sophistication.

Adobe's image browser Bridge (which is integral to Photoshop and Photoshop Elements) also works well, and is good for photographers who prefer to organize their photo files independently of a program. Bridge simply accesses the system that is already there, while Lightroom and Aperture have the image-organizing system integrated into the program.

With all the different options discussed in this book to this point, it is obvious that there are multiple ways to do a single thing. The next steps in your black-and-white workflow may be very different from another photographer's, but it is very important to use the tools discussed here in a manner that makes sense to you and that you can repeat so that your images reflect a consistent vision and you do not waste time.

PROCESS YOUR IMAGES

Using tools like Lightroom and Aperture will shorten the workflow a fair amount because the settings are much easier to access and to apply to multiple images than to each individual image in Photoshop or Photoshop Elements. Lightroom and Aperture also help you with organization after you have made the adjustments to the image because there are few options that use *Save As*, which is an opportunity for you to accidently place images in the wrong location.

The decisions about when to make the black-and-white conversion, and with which program, are very subjective. Each photographer has favorite programs because of ease of use and even because of how the image files will look. Find the best process for you and continue to use it, and though it may evolve over time, doing it again and again will help you become proficient at each step.

MANAGE YOUR IMAGES

After processing the image, you need to determine how you will manage the final image. Is the image going to be printed, part of an online portfolio, or sent to publications? Each type of use calls for different end results. Maintaining the uncompressed files such as RAWs, TIFFs, or PSDs makes the most sense in order to ensure image quality, but obviously this takes up a fair amount of space. Using Lightroom or Aperture can help here by using virtual copies as opposed to saving many versions of the same image.

High resolution JPEGs with minimal compression take up little space versus uncompressed file formats, and they have excellent image quality for most things except for printing for publications. Images that are viewed and shared online are always JPEG files, because the size of the image has to be much smaller to be seen on the screen than in print. Photoshop, Lightroom, and Aperture all have output options to assist you in selecting your Web resolution, such as Photoshop's Save for Web & Devices (accessed through the File menu).

Lightroom and Aperture work slightly differently. Images may be re-created at different times and deleted because they are processed as a batch. For instance, if I need to send ten images to different galleries or clients, each with their own resolution requirements, it is very easy to batch process each set of ten images to a separate folder from the master photo files and then send each set out individually. After those images are sent out, I can delete them because the originals are still there. It may take a bit more time, but it saves space and the confusion of having multiple versions of a particular image.

> ℗ *caution* Remember that if you are using Lightroom or Aperture and moving images, folders, or files, it is very important to manage those folders and images through your program, not just via your computer's operating system. If you start moving images without Lightroom or Aperture knowing what you did, the program doesn't know where the image went. It may be in the catalog of images, but when it is time to access the image again, the photo's file cannot be accessed to be worked on.

Assignment

Learning Layers

Given that so many of the most precise and important tools in imaging are optimized using layers in Photoshop and Photoshop Elements, it is a vital tool to know how they work, even if you don't use them every day. It is important for this assignment that you utilize at least one layer for the image. This can be an adjustment layer or a background layer to which you add the black-and-white conversion tool so you can adjust, enhance, or eliminate changes later.

If you are an advanced user, you should try using layer masks for more selective enhancement to your images. Try both the Reveal All and the Hide All modes.

Simple subjects can create simple compositions, but sometimes the light isn't quite there. This girl's face was a bit in the shadows, and just lightening the scene overall washed out too much of the image. Using multiple layers and layer masks, the face was lightened and the sky was darkened to frame her a bit, and her eyes were brightened and sharpened. The exposure was taken at ISO 100, f/3.5, and 1/250 second with a 24-70mm lens set to 42mm.

Remember to visit www.pwsassignments.com after you complete this assignment and share your favorite photo! It's a community of enthusiastic photographers and a great place to view what other readers have created. You can also post comments, read encouraging suggestions, and get feedback.

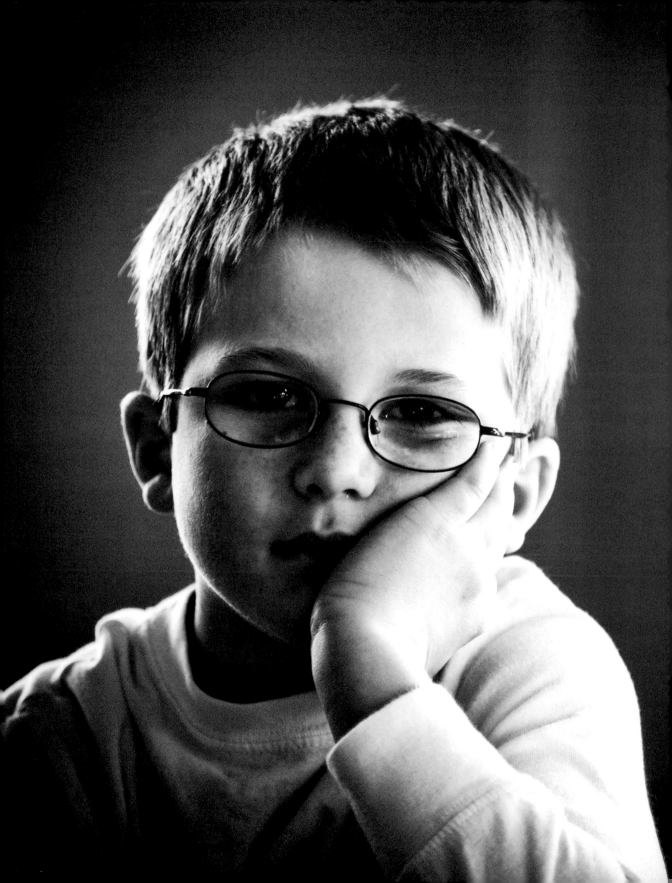

TONING, COLORING, AND SPECIAL EFFECTS

When many people think of black-and-white images, they think of old images that are monochrome, but still have an overall slight color to them. These tones could be due to how the chemicals and paper react to age and the environment, just as much as they could be an added effect.

Adding color to black-and-white images can add interest and feeling to an image. And it can be a great way to emulate the look of old images.

OLD-PROCESS EFFECTS

There are a few effects that make images look vintage. The darkened corners, called *vignettes*, are from lenses that were not quite up to par on old cameras. Additionally, older photographs tend to have some color tones to them from the developing process and from age. The tones can range from warm to cool, and can even be a bit blotchy.

One of the first things that I notice in older photographs is the contrast. Many old photographs were taken with very simple cameras by photographers with very little technical expertise, or without techniques that we take for granted now, such as flash. Few photographers had their own black-and-white darkrooms; the photographs were sent to the Kodak factory to be processed. Because of this, either the contrast of these images tends to be full of dynamic contrast because they were done well, probably well exposed with plenty of light, or the images are a bit dull and washed out in order to show plenty of shadow detail.

Additionally, because cameras from before the 1950s used much larger film than 35mm, and much of it very large sheet film, the depth of field in many images can be quite shallow, especially with photographs of people.

 note

Remember that if your camera has a preset old photo or antique photo setting, shooting JPEG+RAW can be a good first step in getting the image to look vintage. It may not give you the perfect old-time look, but if you still have the RAW file, you will have optimal image-processing opportunities.

To create old-time looks digitally, it is important to think about how those images appear now. It is more than being black and white; it is a mix of many things. It is good to make a plan for the look you desire before you take the photograph. Keep in mind that the contrast in old photos won't always match up with what you think your regular histogram should look like; and in the case of 9-1, the pixel bars are pushed out to the very edges of the graph, meaning that there are a lot of lights and darks, and minimal middle grays. The washed-out look of the background suits the flat tone of an image on an overcast day.

A slightly wide lens with a moderate aperture will lead to an image that has a fair amount of depth of field. To make a scene that appears to have less depth of field, as though the aperture is wider or the quality of the lens is not so good, you can add some softness to the image. There are a number of ways to do this, the most effective of which is to follow these steps:

1. **Create a new layer of the background in Photoshop.**

2. **Add the lens blur or the Gaussian blur to that layer.**

3. **Create a Reveal All layer mask.**

4. **Select black as the foreground color and then brush away the softness from the subject.**

5. **In order to get the most realistic effect, brush away the main subject with the brush set to 100 percent opacity.**

6. **As you move away from the subject, brush away less and less of the blur beginning with a brush stroke at 80 percent opacity around the subject, then a brush stroke at 60 percent opacity, and so on, until the edges still have the entire blurred effect.** In the case of the example here, the blur is slightly more irregular as there is substantial softening on the subject's jacket and still some sharpness around the bridge.

Note that the vignette on the corners of the photograph and its square format also help give it a vintage look.

You can create more specific old-process looks easily in the computer. The tintype, calotype, and ambrotype processes are all part of the building blocks of photography in late 1800s. These *wet-plate processes* were very labor intensive: The image was created while the emulsion of the image was still wet, and then the plate holding the latent image was developed.

In today's digital world, there are still ways to mimic the actual look of these old-process images. These images are usually warm in tone, yellowish, amber, or even brown. Additionally, they are generally very dark, with a lot of rich

ABOUT THIS PHOTO
Using a number of simple effects, this everyday travel shot gets the look of an old-process image. Darkening the corners, softening parts of the image, and pushing the contrast all help with the effect. Taken at ISO 200, f/5.6, and 1/80 second with a 28mm lens.

9-1

231

blacks. The old process of creating these images used a lot of silver oxide, which allowed for substantial detail in the dark tones of the image.

It is very possible to create a similar look by adding just a hint of warm tone into an image, along with a strong vignette. You can create the warm tone by adding a bit of yellow, red, and magenta to a scene through any of the color adjustment settings in Photoshop or Lightroom, or with a Photoshop Color Balance adjustment layer, which enables you to make the best adjustments and gives you the ability to change the layer's opacity. As much as it takes careful adjustment to maintain the detail in those dark areas, remember that most of the old images had very little in the way of pure-white highlights (see 9-2). You also can find similar types of adjustments in programs such as Silver Efex Pro.

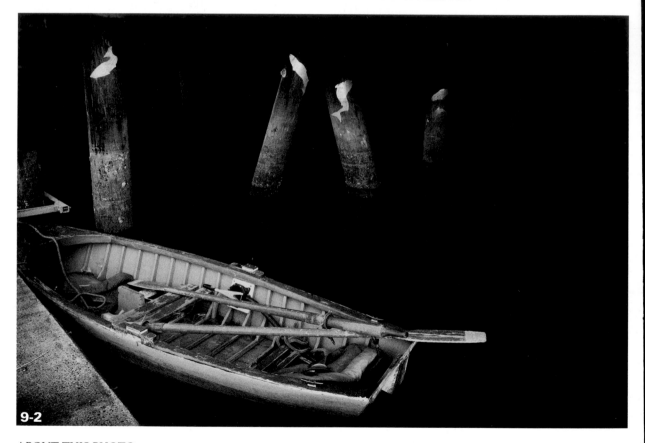

9-2

ABOUT THIS PHOTO *The rich tones of shadow detail are beautifully recorded in an image that has ambrotype-looking adjustments. Warm tones, great tonal range, and vignette corners create a timeless image. Taken at ISO 125, f/6.3, and 1/40 second with a 14-45mm lens set to 14mm.*

 tip

It is always interesting to look at old images to find inspiration. Look at old books of photographs to study how the images look, and examine the technical aspects of the image, the tonal range, and the color of the toned image, and see how those things might change the actual image, and how those changes might affect images that you are currently making.

ADDING TINTS AND TONES

Toning an image in the wet darkroom did two things: The chemical process helped ensure that images would last longer, and it added a color element to images that at the time had none. In the digital darkroom, tinting and toning the images is purely an aesthetic choice, as it can make them seem older, but it can also impart new feelings based on the tone.

SEPIA

Sepia-toned images have a distinct amber to brown tone, and although the amount of tone is at your discretion, it is definitely a warm tone over a black-and-white photograph. Sepia is the simplest way to give an image the feeling of an old photo and consequently add a sense of warmth and nostalgia to a new digital image.

There are a number of ways to create a sepia-toned image in black and white using any of the image editors. After making the appropriate adjustments in the black-and-white conversion tool, follow these steps (see 9-3):

1. **Click in the Tint check box.** This gives you multiple options on how to adjust the tint.

Select target color

Selected color zone

9-3

ABOUT THIS FIGURE
To create a sepia-tinted image in the black-and-white conversion tool, click in the Tint check box to access unlimited colors and tones to add to your black-and-white photograph.

233

2. **Click the colored box next to the Tint check box.** This opens the Select target color window.

3. **Use the slider to find the desired color zone.**

4. **Select the shade that you want the tone to be.**

5. **Click OK.** Alternatively, use the Hue slider to access the correct color using the original image as a guide.

6. **Use the Saturation slider to determine how much color tint will be applied to the image.**

7. **Click OK.**

Remember that you can use this toning solution for any sort of color tint to a black-and-white photograph, and you can do it easily for the selenium or cyanotype tones, which are very blue. To get the most flexibility and to be able to revisit these changes, it is best to make these adjustments on a separate layer.

You can adjust the amount of sepia, and really any toning, by using the saturation sliders or the opacity layer. In this image of mother and baby in 9-4, I used the sepia tone along with a softening filter to really accentuate the warm fuzzy feeling of this scene. The soft contrast in the image, with virtually no strong black, meant that the sepia tone should be very light in its application. Too much sepia would overwhelm the delicate tones of the image.

note No matter what color the tones are that you add to a black-and-white image, from warm to cool to acid green, the process largely remains the same. Use the software solutions that work best for you to add the tones you desire in your images.

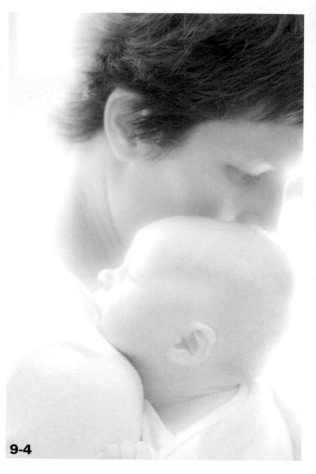

9-4

ABOUT THIS PHOTO *The light from a large picture window floods the room with hazy sunlight, making this image full of soft highlights. The gentle sepia tone of the image helps add even more warmth to a loving image. Taken at ISO 500, f/4, and 1/80 second with a 24-70mm lens.*

SELENIUM

Selenium toning creates a much cooler tone than sepia. The process of creating a selenium-toned image is not any different in the digital darkroom than the one for creating a sepia image, but because of the color itself, the subject matter is usually different. Austere subjects, cityscapes, and wintertime scenes tend to work well with selenium toning.

The difference that toning can make to your images is huge (see 9-5). With the effect of a selenium tone on the image, the branches rising out of the blue water have an icy feel of desolation. The blue tone almost lets you feel how cold that water must be in the middle of winter, exactly the feeling that was desired for this image. Think about how different that image would appear with a light sepia tone similar to the tone in 9-4: It might almost look like a warm summer morning. Think critically about the color of the tones that you add to an image and the emotion they will invoke.

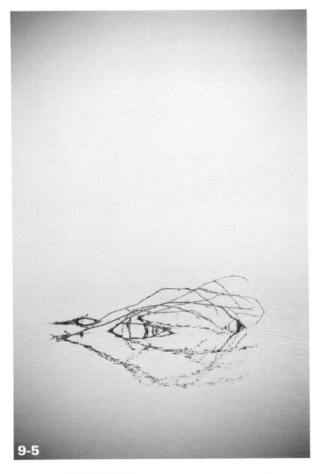

9-5

ABOUT THIS PHOTO *A branch rising out of the water gives a cold and lonely feel to the selenium-toned image. The solitary feel of this image was accentuated by the cool, blue tone of the image. Taken at ISO 400, f/8, and 1/640 second, with an 18-200mm lens set to 180mm.*

The selenium tone in this image was created in Lightroom. In Lightroom, there are a number of creative black-and-white presets, such as sepia and selenium. You can further adjust the preset and save it as a new preset. In the case of the previous image, I created the effect in the toning portion of the Lightroom Develop pane, and then made adjustments for contrast, additional vignetting, and a lightening of the blue tone. The same tools can be used for other toning colors.

SPLIT TONING

Split toning adds drama to a black-and-white image. When you use multicolor toning, the highlights and shadows in two different colors can create exciting new images. Keeping things simple yet dramatic and using warm tones for the highlights and cool tones for the shadows is a great way to start working with split-toned images.

To split tone an image in Photoshop, follow these steps:

1. **Open a black-and-white image.**

2. **Open up a new Color Balance Adjustments layer.** At the top of the Adjustments window, you see radio buttons for Shadows, Midtones, and Highlights.

3. **Click the Highlights radio button first and then adjust the color sliders as needed.** In this case the image has a warm yellow color for the Highlights tone.

4. **Next click the Shadows radio button and then adjust those sliders to add blue tones to the shadows (see 9-6).**

5. **Use the layer to allow for further adjustments later or to change the opacity of the effect on the image.**

9-6

ABOUT THIS FIGURE *A Color Balance Adjustments layer can be used to create a split-toned image by separately selecting the tones for Highlights and Shadows. Remember to make small adjustments; large color adjustments here may seem brash and cartoonish.*

You can also do this effect very easily in Lightroom: There is a panel for split toning in the Develop pane. Adjusting the sliders to your desired color tones and their saturation for both

Highlights and Shadows can achieve the same effect you get with the Color Balance Adjustments layer. Additionally there is a slider you can use to affect the balance between the tones in Highlights and Shadows, and this is really the key to getting the image's tones adjusted precisely (see 9-7).

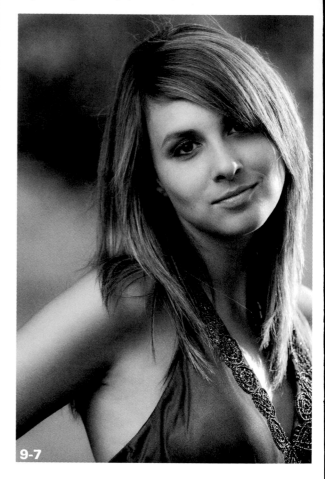

9-7

ABOUT THIS PHOTO *Split toning an image creates exciting color mixes on a black-and-white image. The contrast of the scene is shown in the blue tint in the shadow areas and the warm tint on the highlights. Taken at ISO 100, f/5.6, and 1/250 second with a 300mm lens.*

note Using similar tools to the ones explained for split toning in Photoshop and Lightroom, you can do the process at the RAW level in Adobe Camera Raw and in Nik Software's Silver Efex Pro. You can use Apple's Aperture to create tinted and toned black-and-white images, but split toning is a bit of a chore with tinted effects brushed on. You can create great looks, but it takes a bit more time and effort.

COLORING MONOCHROME IMAGES

Selectively adding color to black-and-white images is often called *coloring*. While I briefly discussed how to add color using layers of the original image in Photoshop in Chapter 8, actually adding color to an image is something Photoshop really excels in, more than any other image editing software, although several programs include similar brush tools.

Add color to your monochrome images by following these steps:

1. **Clicking the brush tool.**

2. **Choose the color that you wish to add to the black-and-white image.**

3. **Simply add it over the top of the image using a new layer.** It is a great idea to use a new layer for each color or even for basic areas so that you can adjust each area later independent of the other sections. Try different sizes and hardness of brushes to get the color where you want it and applied in the manner that you want it.

4. **Start with a low opacity, like 20 percent, to initially fill in the area.** The opacity of the brush is very important when colorizing an image.

Every time that your brush goes over the area, it adds to the amount of color that is going onto the image. So if a brush is set to 20 percent opacity, but there are five brush strokes on the same area, it will be 100 percent color and you will not be able to see the texture of the black-and-white image beneath. Because of this, coloring black-and-white images usually gives images more of a pastel or other soft color look, instead of a brilliant primary color one.

In 9-8, each of the oranges was brushed in with bright colors, but to see the detail in the black-and-white photograph beneath the color, the opacity was brought down substantially. This places the oranges in a surreal, creamsicle color palette.

The density of the dark tones in the image also makes a difference in coloring a black-and-white image. If there are a lot of dark tones, those areas will still either be largely very dark or take on an unnatural color effect as the color overwhelms the shadow detail. When you are coloring a black-and-white image, use the color mixer in the black-and-white tool to make the tones as bright as possible.

This particular mix was done in Lightroom with its orange-specific slider. As 9-8 shows, the orange in the mixer was adjusted to a very bright area, so there was just some detail and texture of the orange. So if you were planning to paint green over a yard of grass, make sure that the black-and-white mix is adjusted so that the green is light enough to have color brushed over it.

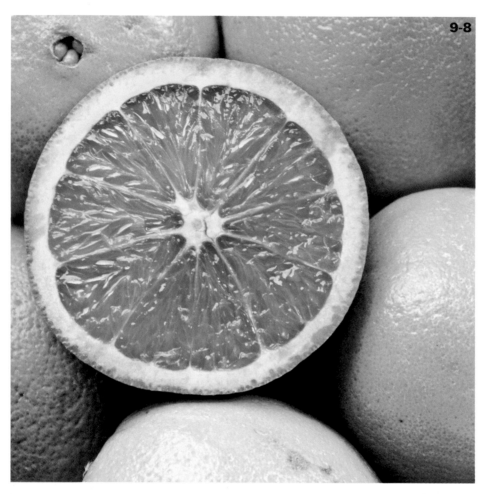

ABOUT THIS PHOTO *A monochrome color image of all orange is converted to black and white and then painted with surreal color with the brush tool. The pale colors are reminiscent of creamsicle orange. Taken at ISO 100, f/8, and 1/6 second with an 18-200mm lens set to 112mm.*

INFRARED EFFECTS

Although using a customized infrared sensing camera is immensely cool and fun, it may not be particularly practical for someone who simply wants to get the infrared effect occasionally. When a digital sensor captures infrared light, it is essentially capturing things that are emitting energy. Plants in the spring and the fall, as the energy moves out into the leaves or recedes into the plant as it becomes dormant, show some of that energy best. Things that don't have a lot of that infrared energy, such as the sky, water, and people's pupils, become very dark.

 caution Be cautious when making bold moves with the sliders, even though a good infrared mix might have the green and yellow set to 100 percent brightness. Pulling the blue back to dark can cause banding in the skies, especially as the blue contrasts against the bright tones of a landscape.

Apply this knowledge when you create your own infrared black-and-white mix. Whether you are using Lightroom, Aperture, or Photoshop, adjusting colors with a lot of energy, such as yellow and green, to be brighter, and adjusting blue to be much darker brings you close to emulating the tones of a black-and-white infrared image (see 9-9).

Further increasing the contrast and even adding some grain will also help you emulate the look of infrared. Some photographers even add a bit of

negative clarity to a simulated infrared image, which gives the middle tones the appearance of a glow.

Just as it is easy to create your own infrared black-and-white-looking images, virtually every black-and-white conversion tool has its own infrared emulation process. These tools are good places to start, but because they try to be all things to all images, they often leave images a bit dull. Knowing how an infrared image is created will

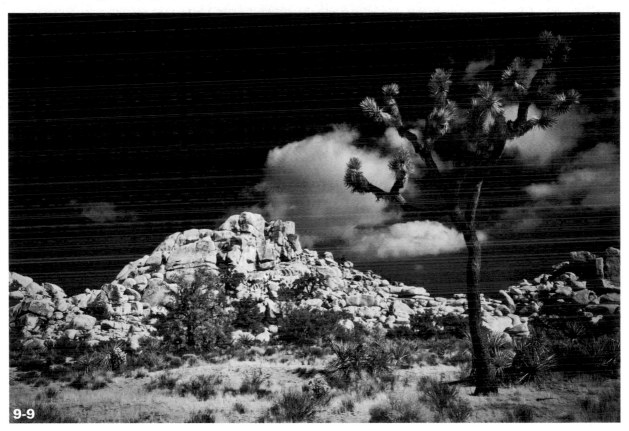

9-9

ABOUT THIS PHOTO *The bright tones that are captured from the energy of the Joshua tree and the other desert brush create a lot of contrast against the stark black sky. Even though this image was shot originally in color, it is very close to an infrared image. Taken at ISO 100, f/16, and 1/250 second with a 20mm lens.*

help you take those settings beyond the baseline, enabling you to get the image to properly reflect your black-and-white vision.

HIGH DYNAMIC RANGE

Expanding the amount of tones in an image beyond what is normal in one exposure is something photographers have done for many years, far before digital. For example, the zone system mastered by Ansel Adams is used to get every f-stop of exposure information onto the initial sheet of film, and then with careful processing, the proper time and chemicals are used to add detail to the highlight and shadow areas. Using multi-contrast papers and certain other developers, that black-and-white negative can then be printed, and the finished print captures far more of the contrast range than a straight image would.

Although it is possible to create HDR imagery with extensive masking and layering of multiple exposures, most photographers now use automated software to get the most out of their HDR images. Photoshop and Photoshop Elements have Photomerge software built in. Additionally, there are countless other HDR photo-processing options, such as Photomatix or Nik's HDR Efex Pro.

The discussion on multiple RAW in Chapter 8 is a simple way to create an image with extended dynamic range, albeit on a small scale. Any sort of expansion or blending of exposures, or even the use of graduated filters, changes the contrast range and is technically called *HDR* (High Dynamic Range). HDR is also somewhat controversial because the results can often look surreal because all the detail in that range is visible on an image.

High-contrast images, those images whose shadow detail or highlight detail is compromised due to the contrast extreme, are most used for HDR. Getting the most from the original images is important in HDR imagery, so plan to shoot RAW files from the beginning.

Additionally, it is important to bracket your images. *Bracketing* means creating images that are exposed at different exposures, with the correct exposure as the baseline, plus darker and lighter exposures, each capturing different levels of the contrast in the scene. Doing this well generally necessitates that the images be identical, so having a camera locked on the tripod helps the process immensely.

With many HDR programs, expanding the bracket by two stops on either side of the exposure is usually sufficient, although bracketing five exposures gives you a lot of flexibility; you would expose a frame at –2 f-stops, –1 f-stop, normal, +1 f-stop, and +2 f-stops.

Creating a good bracket of images is the key to good HDR photography; HDR is not a tool to save a bad photograph. When you have frames that capture all the elements of the sunlit areas and the shadow areas of an image in different exposures, opening them in Photoshop Elements' Photomerge is simple. It may take a few tries because getting the right results doesn't happen automatically, but once you get the hang of it, the process is not terribly difficult.

In 9-10, the foreground shadow area now has plenty of detail and information, while the brightly lit sea stacks in the bay are still richly toned and well exposed.

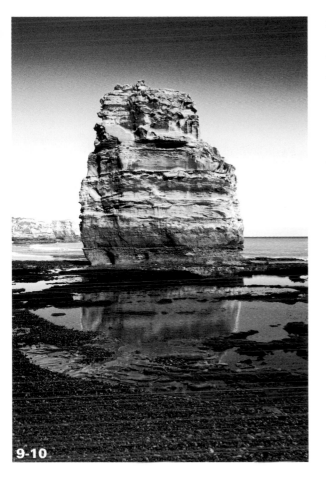

9-10

ABOUT THIS PHOTO *HDR photography allows for multiple exposure of an image to be processed into an HDR image that has plenty of detail in both the shadow and highlight areas. Taken at ISO 200, f/9, with the shutter bracketed at 2/3-stop increments: 1/500 second, 1/320 second, and 1/200 second.*

COMPOSITING NEW IMAGES

Photoshop and Photoshop Elements enable you to easily build new images by compositing elements from different images onto one single image. You do this by building layers with the new objects on top of the original and then using a mask or eraser tool to blend the areas together. In many cases, subtle things such as making sure that everyone in a group shot has a good expression, or even has their eyes open, and compositing a few images together, makes for a better image. You can use the same tools you use to swap heads for a group shot to build whatever composite of an image you can imagine.

When you are compositing images, think about scale and proportion. Trying to add a tight portrait that you shot of your best friend as a RAW file onto a photograph of a model downloaded from the Internet will end up looking like a random mash up, with the difference of the file sizes being only the first small issue. The files for a good composite should be roughly equivalent in file size, both in proportion and pixels per inch. So using images taken from the same camera or same-sized sensor camera works best.

Another thing to consider when creating the composite is to look at the lighting from the different images. Look at the light direction and quality and ask yourself if the two images make sense and look like a slice of reality (if that is what you strive for). Exposure and contrast are other elements to factor into your composite as you begin to put the images together in your head.

You should do compositing either at the beginning or the end of the editing process. To make composites appear seamless, both the main image and the new pieces should have the same exposure, contrast, and lighting. You can either create a composite of the images before doing the major changes, or do all the changes identically on all the images.

To create the composite, follow these steps:

1. Select the area on the first image to add to the main photograph.

2. Copy and paste it onto its own new layer.

3. Open all the images needed for the composite (see 9-11 through 9-13).

4. Use one of the selection tools, either the Marquee tool or the Lasso tool depending on the shape you want.

5. Select the area of the image you want from another image.

6. Copy that selection by either choosing Edit ➪ Copy or pressing ⌘+C.

Marquee tool

Lasso tool

9-11

ABOUT THESE FIGURES *By selecting and copying two heads from one image and then pasting that image onto a new layer, it is easy to get good expressions from everyone. Use the layer mask to help blend the edges of the selection with the rest of the main image. You can do this with as many different areas of the image as needed, and you can blend the edges better by changing the opacity of the brush if needed.*

7. **Open the main image that is to be the base for the composite and paste that image onto the main image by choosing Edit ⇨ Paste or pressing ⌘+V.** This automatically adds the new selected area onto a new layer.

8. **Use the Move tool to arrange the new favorite image over the top of the main image.**

9. **Use landmarks around each image, such as collars, faces, and jewelry, to line up the new selection.**

Move New layer
tool with selected area

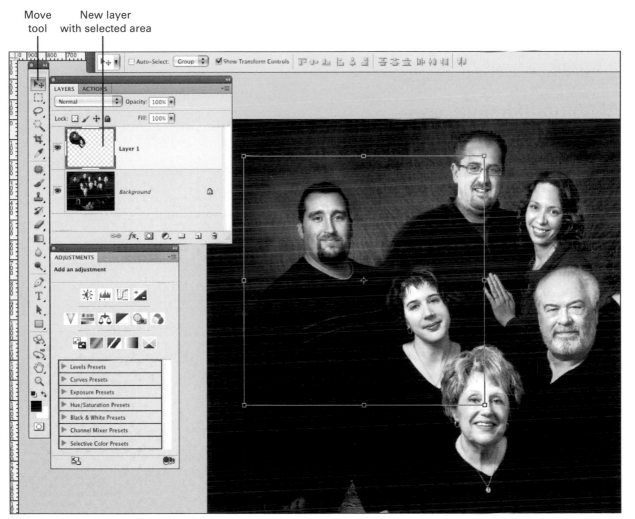

9-12

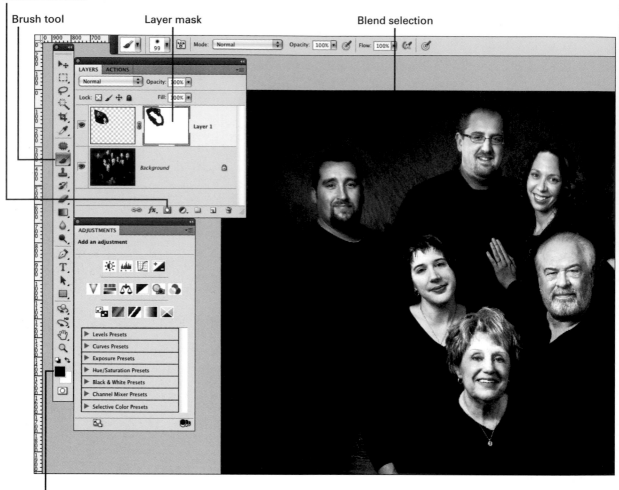

Reveal All/White

Brush tool Layer mask Blend selection

Selected foreground color

9-13

10. Add a layer mask (Reveal All/white).

11. Select a brush.

12. Select black as the foreground color.

13. Select the layer mask.

14. Paint black over the edges of the selection to blend the selection with the main image.

15. Repeat as necessary.

With a group shot, keeping the camera on a tripod and maintaining the same zoom range is very helpful for making the images consistent. When planning a large portrait where compositing may be a possibility, keeping the wardrobe simple and similar can pay dividends.

In the case of the large group shot in 9-14, having everyone in dark tones provided a little bit of leeway with the retouching when not everything lined up just right. This final shot ended up to be a composite of the original, plus three layers of new heads, but don't tell my dad; he thinks we just always look this perfect.

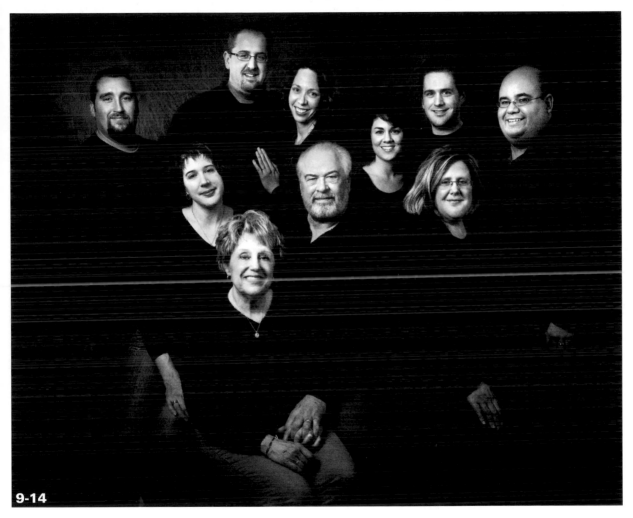

9-14

ABOUT THIS PHOTO *I did the compositing for this image after I made all the black-and-white changes and exposure and contrast adjustments in Lightroom to all the images that were going to be used for the composite. I then opened all the images in Photoshop and added each layer to the main image. Taken at ISO 200, f/16, and 1/200 second.*

Assignment

Add a Tone to Your Gray Tones

Adding a colored tone to your black-and-white image can affect the emotional tone of an image, not to mention add impact, interest, and even a sense of place or time. Some photographers also use colored tones to emulate the look of a vintage photograph.

Use a color tint over your image using one of the ways discussed in this chapter. Find a color or tint that enhances feelings or emotions that are already in the image. Try a few different colors, or at least use the tools to see the different colors and how they affect the feel of the image.

The tone on this image is really more a brown than a sepia, and it is very similar to the color tones of an ambrotype image of the 1800s. The contrast of the pale flower against the dark background makes it pop out of the scene, yet the texture of the background helps give the flower a sense of place. This exposure was taken at ISO 100, f/2.8, and 1/400 second.

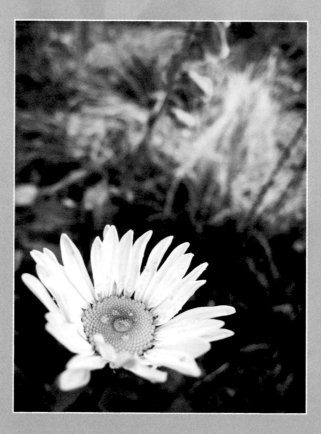

Remember to visit www.pwassignments.com after you complete this assignment and share your favorite photo! It's a community of enthusiastic photographers and a great place to view what other readers have created. You can also post comments, read encouraging suggestions, and get feedback.

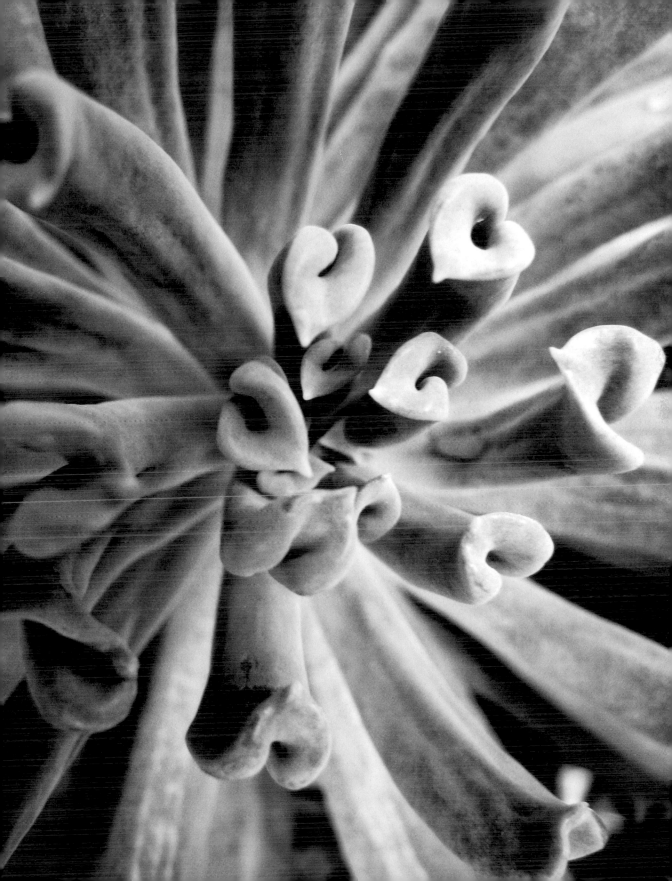

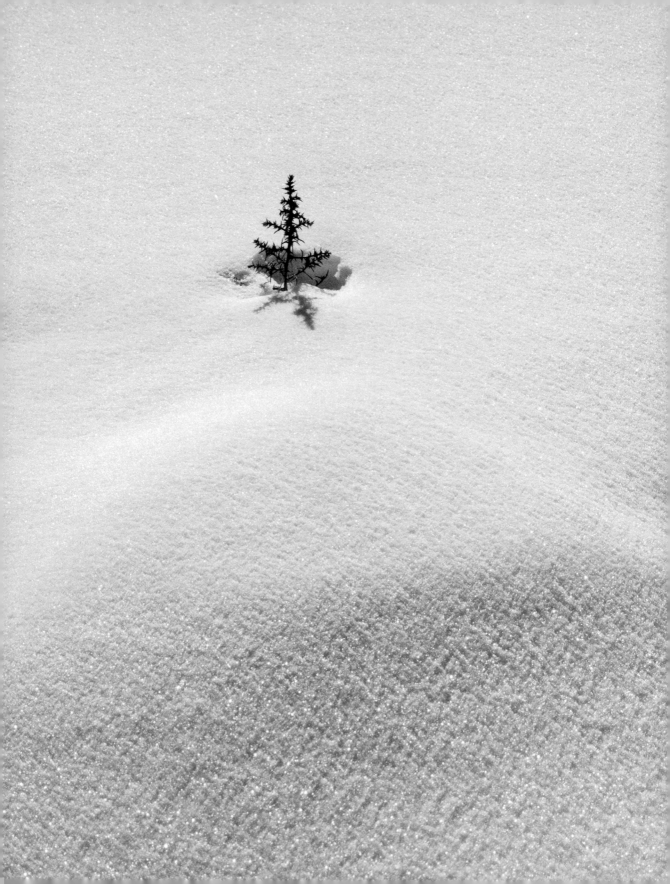

OUTPUT: PRINTING AND PRESENTATION

After spending the time shooting your images and perfecting them in black and white, it is time to show them off. Whether you are making prints to hang on your wall, show a gallery, or keep in an online portfolio, there are plenty of great ways you can display and share your black-and-white photographs. It takes some time to make the final image meet your specifications, but with a little effort, your final images will be worthy of the wall space.

INKJET PRINTERS AND PAPERS

The most common way for photographers to create great black-and-white images is by using an inkjet printer. As with cameras, the selection of good quality is vast. While many models are capable of creating excellent quality prints, each printer has distinct characteristics. There are a number of factors to consider when deciding which printer will be best for your black-and-white images.

The first is whether you want a printer that uses pigments or dye-based inks. Along with evaluating the differences between these ink types, you are also making a longer-term decision: whether you are going to expand your black-and-white photography to the point where it's important to have a photo-specific printer. *Pigment-based* printers, which are available from Canon, Epson, and HP, are designed to give photographers the most out of their images, while *dye-based* printers can print photographs but are more universal printers.

Dye-based inks are generally less expensive, have brighter colors, and are less likely to clog at the *print head*, which is where the ink actually comes out. The downside is that dye-based prints tend to fade somewhat faster than pigment-based ones. Pigment-based inks have excellent archival characteristics and more natural colors, and today's

modern pigment-based printers do an excellent job of creating black-and-white prints with exceptional neutral tones. All three of the major companies that produce excellent photo printers use pigment-based inks in their lines of photo printers.

note
Printing in black and white does not mean that the printer only uses black inks. Just as a color photograph is needed to get the most out of a black-and-white image, color inks are needed to help create the best black-and-white print. Without the other colors, getting a smooth tonal range is difficult, if not impossible. The final print still looks black and white, because the droplets blend together, and even with a magnifier, any color is imperceptible.

Although there are differences in how each company's technology goes about laying the ink onto the paper, there are beautiful prints to be had by each one. The small differences lie in the different sorts of papers the printers use, and how certain papers render various colors.

Having used or owned printers from Epson, HP, and Canon, I can speak to these companies' products, and I found no significant image-quality problems among any of them. Because the technology from model to model tends to remain the same, when you buy printers of different sizes within a particular line of printers, they will be very similar. Therefore, if you are looking at a midsized photo printer with the biggest paper size at 13 ×19, the print quality and technology level should be equal to what you would get from much bigger printers as long as the printers are from the same series and generation.

Prints that are larger than 8 × 10 show how dramatic a scene can be, as well as the subtlety in the gray tones you might not see as well when the image is smaller. Your local photography specialty store should have examples of prints made by

different printers, and it is important to see how those differences will affect the type of black-and-white images that you are creating. The gentle tones of the rushing water are far more visible on a large print than a smaller one (see 10-1).

Printers that can handle 13 × 19–inch paper are the hot segment of printers right now. The prices range from around $300 for a dye-based printer to around $800 for a pigment-based model, and you can get very good quality for around $500. With the rapid advance in technology, the image quality for the amount of money that a printer costs has largely flattened out, with new models offering very slight increases in quality, but greater increases in print speed and ease of use.

The maintenance for a photo-quality printer is relatively simple, but does take a bit of thought. As with all things digital, the owner's manual is an immense source of information and help. Find out exactly what the manufacturer recommends as far as turning the printer on and off. When a printer is constantly On or Off, the heads can become clogged with dry ink. The On-and-Off cycle uses a tiny bit of ink to keep the system fresh and ready to go. Although this may cost you a bit in ink, it is far less expensive than having the printer go through a number of cleaning cycles to clean out dried-up ink.

10-1

ABOUT THIS PHOTO *Ten seconds of rushing water creates a velvety-toned bed for the rock to lie on. The contrast of the dark rock with the light leaf and water shows some quiet drama. Taken at ISO 100, f/36, and 10 seconds with a 112mm lens setting.*

Speaking of cleaning cycles, it is important to determine how to best do it for your particular printer. Learn how to troubleshoot printer problems and how to solve those problems. You can avert most problems with proper maintenance, and any that do crop up are usually relatively easy to fix if you are familiar with your manual.

There is no end to the list of types, surfaces, and weights of photographic inkjet paper. While there are some specific papers for dye-based or pigment-based ink, the question of glossy or matte paper doesn't even scratch the surface of which paper type you use. Not only does each paper manufacturer have their own paper lines, but also the same people who make photographic paper for the darkroom, as well as virtually every paper manufacturer that has ever had a hand in the photographic arts, are now making inkjet paper.

There are papers that are glossy, ultra glossy, and even metallic in texture and tone. They are super smooth, very shiny, and have high contrast. On the opposite side of the spectrum, there are papers that resemble watercolor paper and have a heavy texture. These matte papers tend to have a long contrast range, can be heavier, and allow for some additional creative options after the printing is done.

In the middle of this spectrum are so many different papers it will make your head spin. Photographic supply stores have sample books showing how different images look on different papers, and that is a great place to start. Most manufacturers also sell sample packs of paper that have two to three sheets of each of their paper lines and types of surfaces.

The paper a photographer chooses is indeed a reflection of her creativity, and the right image on the right paper can really make for an exceptional image. Currently in the world of black-and-white photography, the *baryta-type* papers are the "in" thing. These papers have a smooth reflective coating, which is great for producing exhibition-level prints from your black-and-white images.

Try different papers with the same photo to get the best sense of what a paper is capable of and how it best represents the feelings you want your image to convey. This is largely a matter of personal taste and style, so don't hesitate to try new things — just when you think you know what is perfect for a particular type of image, a new type of paper will better exemplify the feelings of the image or better enhance an element of it (see 10-2).

After you have tried some different papers to see what works best for you, it is important to stick with just a few of your favorites. Mastering the nuances of a few specific papers will help you refine your vision and will allow you to really learn how to master your imagery. Learning how your sensor, monitor, printer, and just a few specific papers act and react will ultimately lead to superior results. But never forget that it is always fun to experiment.

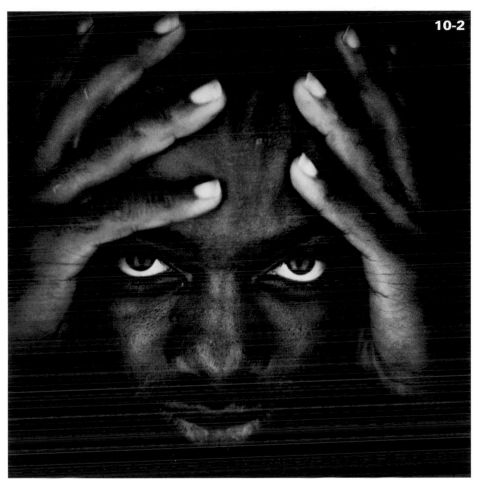

10-2

ABOUT THIS PHOTO
I had used a matte cotton rag paper consistently for several similar prints, but then I tried a metallic paper, which gave the skin tone an amazing silver tone. Taken at ISO 100, f/4, and 1/80 second with a 50mm lens.

CALIBRATING YOUR EQUIPMENT

In order to ensure that the image quality that appears on your monitor carries through to your print, you need to properly calibrate the devices. This maximizes the efficiency of your printing workflow and substantially helps you achieve the look for the black-and-white image you are after.

The color space of an image is simply the properties that describe how the colors are defined. The color space defines how blue, red, or green any of those colors actually appear, especially when it comes to the most saturated of colors. This also applies to black and white in that the profile gives a definition to just how black a particular black is in any image. When the profiles are accurate, the colors, or in this case, the tones of gray, remain the same throughout every step in the system because they have a reference point.

You do the first step to calibrating the colors in one of the editing programs discussed in this book. This places your image into a recognized, universal color space, such as sRGB, Adobe RGB, or ProPhoto RGB.

To start your machine's calibration, go to the menu bar at the top of the screen in Photoshop or Photoshop Elements and choose Edit ⇨ Assign Profile. For most photos, selecting ProPhoto RGB to do most of your work gives you the biggest color space and excellent control of colors within the larger gamut of today's monitors and printers. Adobe RGB has been another great universal color space for years and remains so. sRGB is designed to work within the smaller gamut used for photographs on the Web.

Although this discussion of color space in a black-and-white book may seem unnecessary, it is important because the gray tones will be tied to these spaces as well, and very few people work only in black and white.

MONITORS

Without a good, well-calibrated monitor, most of the other color management steps will largely be unneeded because the baseline, what you see on your screen, is not consistent and thus printing will be trial and error. Imaging professionals use the highest quality equipment available because their livelihood depends on it, and they are constantly calibrating it. If you are a hobbyist photographer who simply wants to take better photographs, buying additional expensive equipment may be a challenge, but the next time you are upgrading your computer, do some research to find the monitor within your budget that will work best for you.

Although you can calibrate your monitor using your eyes and the computer's software, this can be inconsistent. When you try to match colors and tones on the monitor by eye, there are just too many variables, such as ambient light in the room and how tired you are. To make sure that you have the monitor calibrated correctly, you need to use a monitor-calibrating tool, called a *colorimeter*, and its supplied software (see 10-3).

10-3

You can purchase colorimeters from a photography supply or camera store or online starting at around $150. The process is straightforward: Simply load the software and then attach the colorimeter to the screen and let the process happen. It takes a few minutes while the software works with the monitor's controls to get the screen to neutral, and then the colorimeter saves those settings as your monitor's profile (see 10-4). So now that you have a solid profile for your monitor, the colors in your image can be correctly displayed through your appropriate color space accurately because all the numbers that express the color at each pixel will correlate.

PAPER AND PRINTER PROFILES

Every paper and printer combination has its own profile as well. These profiles are usually just called *paper profiles*, and with each pack or box of paper that you purchase, there will be instructions on how to download the correct profile for that paper and your printer. These are technically called *icc profiles*, and after you download these profiles and they are installed into your computer, any of your photo-editing software can access them.

Adobe Photoshop, Adobe Photoshop Elements, Adobe Photoshop Lightroom, or Apple Aperture is then able to equate the colors that appear with the printer profile to the colors that are in the color space of the paper profile to get the closest matching colors and tones on all fronts (see 10-5).

If you are a more advanced user, you can create your own paper profiles or buy third-party paper profiles. This may yield only slightly better results, but this may be more than worth it to some of you.

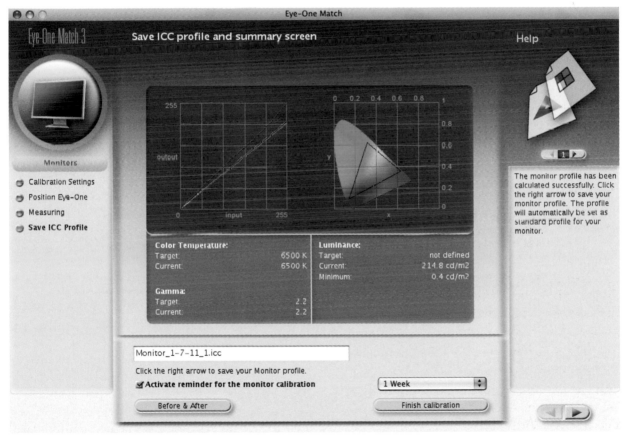

10-4

ABOUT THIS IMAGE *After the calibration, this monitor's new profile, with the new color space, appears in the window on the right. This profile and color space is automatically saved in the color sync folder in the computer's library.*

10-5

You can create paper profiles by printing a test chart of all the colors and gray tones of a particular printer on that paper, and then use a colorimeter to measure the color density of each color. Some of the more high-end printers even have built-in colorimeters that give you the profile of a new paper stock with the click of a button. The corresponding colors in that profile have a number that correlates with the color's number on the printer profile. This is a very simple explanation of a relatively complicated process, but once you understand the concept, it really shouldn't be too difficult. This is also why there is so much work to mastering just a few favorite papers.

CREATING BLACK-AND-WHITE PRINTS

Once you have your image perfected, your monitor calibrated, and your paper profiles installed, you need to do a few additional steps to make sure that your prints come out looking like they did on the monitor. There are a few other ways to make the process a bit simpler and to save some time, paper, and ink.

PRINTING CONTACT SHEETS

Contact sheets are the classic way to evaluate your images on a small scale before you start working on larger prints. The printed contact sheet of the digital age is much more advanced and helpful than the contact sheets of film negatives used to be, and digital contact sheets give you much more flexibility. You can use Bridge, the photo-browsing program that comes with Photoshop and Photoshop Elements, to build a contact sheet of images. You can also create contact sheets in Lightroom using the Print module.

To create a contact sheet in Bridge, follow these steps:

1. **Click on Tools.** A drop-down menu will appear with an option for Photoshop Elements.

2. **Select Photoshop Elements to get to the Contact Sheet, as well as other options.**

3. **Once the contact sheet maker opens, create contact sheets with different size photos by selecting how many photos will be in each column and row on the paper size you will print on.** Lightroom has a similar set of options. After the contact sheet is processed, it opens up in PSE elements with layers for each photograph (see 10-6, 10-7, and 10-8).

10-6

10-7

ABOUT THESE IMAGES *You can make any folder of photographs or selected photos into a contact sheet with images of various sizes. Placing five rows of four photos creates a contact sheet where the images are still big enough to easily evaluate. 10-6 shows the set-up/options menu for the contact sheet, and 10-7 and 10-8 show the contact sheet just before printing.*

Depending on how many and how large the images are, it may take a bit of time to create the contact sheet. In Bridge/Photoshop it takes time to build the images into the new contact sheet document. With Lightroom, the contact sheet is created in the program instantly, but when it is processed out to the printer, it takes some time.

MAKING TEST PRINTS

The contact sheet process not only gives you the chance to evaluate images, but if you use the same profile and paper as the final print, you can use this option to make several smaller prints to use as test prints. To make a test print, follow the same steps you did to create a contact sheet and then follow these steps:

10-8

1. **Select only, for example, two columns of two images.** If you have a few images you want to see as test prints, this is great, and if you have multiple different exposures, you can make a print of all of them at once and see how things look on paper.

2. **Confirm that you have the correct profile for the paper and printer that you are printing to, and then click Print (see 10-9).** This is a great way to see how different options will render on the particular paper that you are using without wasting a lot of ink and many sheets of paper.

3. **Once you have the settings the way you want for that particular image, it is time to print it.**

10-9

ABOUT THIS IMAGE
Images in a 2 × 2 format allow you to create a contact sheet of test prints to determine just how images will work on that particular paper. Seeing how variations look will further your knowledge of that paper with certain images.

YOUR FINAL PRINT

When you are using a color-managed workflow with profiles for the monitor and paper, Photoshop, Photoshop Elements, Lightroom, and Aperture handle the color decisions for your prints. Each program does things slightly differently, but your approach is largely the same. To make a final print, follow these steps:

1. In the Print dialog box, select whether Photoshop or Photoshop Elements is managing the color.

2. Select the correct printer profile to print to. In Photoshop Elements, you access these options through the More Options ⇨ Color Management window (see 10-10 and 10-11).

10-10

ABOUT THESE IMAGES *The print dialog boxes for Photoshop (10-10) and Photoshop Elements (10-11). Please note that the color space is set to Adobe RGB, Photoshop is handling the color, and the printer/paper profile is IGSPP9_EPR2400_PSPPn.icc. That is the profile for the Ilford Gallerie Smooth Pearl paper and the Epson R2400 printer.*

10-11

3. Select the proper paper type, size, and surface in the final Print dialog box.

4. Make sure the print quality is set to Best, or whatever the highest resolution setting is for your printer driver.

5. **Turn off the color settings (see 10-12) and make sure that it says Off (No Color Adjustment).** That eliminates the auto settings that the printer and operating system use for less sophisticated users.

note

The settings shown here are for these Photoshop-related products along with Epson printers. HP and Canon have similar settings for their printers, but they are not identical. The process of matching the profiles and using Photoshop, Elements, or Lightroom will be essentially the same with most photographic printers. Make sure to save your settings when you can and make notes to make sure that you are consistent with your settings. Read your printer's manual or access one of the many online photography users' forums when you have questions with your printing.

Print

Printer: EPSON Stylus Photo R2400

Presets: smooth pearl 2400

Copies: 1 ☑ Collated

Pages: ○ All
○ From: 1 to: 1

Print Settings

Basic | Advanced Color Settings

Page Setup: Standard

Media Type: Premium Luster Photo Paper

Color: Color

Color Settings: Off (No Color Adjustment)

Mode: ○ Automatic
◉ Advanced

Print Quality: Best Photo

☑ High Speed
☐ Mirror Image
☑ Finest Detail

? | PDF ▼ | Preview | Supplies... | Cancel | Print

10-12

ABOUT THIS IMAGE *In the final Print dialog box, it is important to note that the color settings are off. This allows you to properly manage colors in the image through the profiling system. If you are printing from iPhoto or Windows Live Photo Gallery, the other color settings may give better results.*

Printing is one thing in black-and-white photography where there really aren't several ways to do things. Do adequate testing and research before you get too deep into creating your prints. It can be very frustrating if things aren't coming out the way that you want, but when things come together and you are able to realize your vision for the image, suddenly the control that you have exercised over the image is apparent and the time you spent will be totally worthwhile (see 10-13).

There is one last setting worthy of note when you are making your black-and-white prints, and that is Epson's Advanced B&W Photo. Color inks are used in creating black-and-white images, and the least stable of these inks is yellow. Advanced B&W Photo uses a feature that limits the amount of yellow used in the final black-and-white print to help you get great black-and-white images without having to do the entire profile process. This is certainly worthy of experimentation, as it is underutilized and not often recognized. Many photographers are creatures of habit and once they get the system that they use dialed in, it is difficult for them to embrace new options, especially when they expect the color profile system to deliver consistent results.

MATTING AND FRAMING When matting and framing your black-and-white photographs, it is important not create a distraction. For the clean classic look that black-and-white images demand, a white mat works best, and a black or gray mat is fine as well. Rarely will a colored mat look good with a black-and-white image. The color of the mat may actually distract the viewer. If you are planning to submit to a contest or gallery, this line of thinking is even more important. Unless there is truly a definitive reason for a colored mat, always use a white or black mat with your black-and-white photograph.

Simple white mats allow the work to be shown in virtually any situation and still look great. The same goes for frames. A simple black or dark-colored frame helps accent the image, not detract from it. Leave plenty of room on the mat for the eye to rest before focusing on your image.

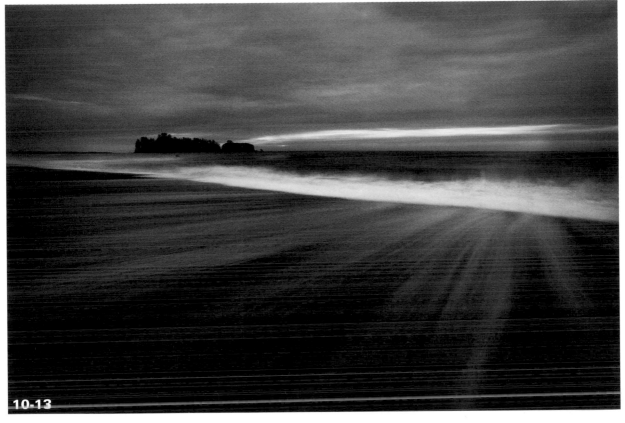

10-13

ABOUT THIS PHOTO *Shooting the crashing waves and steely sky past sunset makes for a very ominous scene and the surf adds movement and action. It took a lot of time to get the image right where I wanted it, but once I had set up all my profiles, the first print was right on the money. Taken at ISO 200, 1/20, and 6 seconds with a 20mm lens setting.*

CREATING YOUR OWN BOOK

Today's digital printing presses enable you to create books from your black-and-white photographs quickly and easily. There are a number of options available, including Apple's iPhoto, Blurb, Kodak, and Snapfish. You might also be able to create books at your local photo lab or big box retailer. To make the books, the images are laid out with the bookmakers' software and then uploaded to the printer.

The key to creating a good-looking photo book is allowing yourself enough time. The books are easy to create, but make sure that you have sufficient time to really create the layout and look that you want; it's not something that you want to throw together at the last minute:

1. **Use a program like Lightroom to organize a collection of favorite black-and-white images that you are considering for your book.** Perhaps even put them in order of importance within the collection.

2. **Figure out the resolution that is needed for the size of book you are creating.** For most of these books, you will be uploading JPEG images, and to save upload time, you shouldn't make the images bigger, or have a higher resolution, than needed.

263

3. **Export the images with the correct resolution and specifications into a single folder.**

4. **You should now be able to import the images into the book-making software.** If you have spent the time organizing ahead of time, putting the book together should be a snap. These books are great for wedding photos, collections of large family portraits, and pictures from vacations and trips. And, they are a really great way to show off your portfolio of new black-and-white images.

ARCHIVAL PRINTING AND STORAGE

Inkjet prints made from the pigments used today have nearly the same lifetime as silver gelatin prints when they are stored and preserved properly — at least longer than our lifetime. You will want to print on archival papers, such as cotton rag, or at least paper that is acid free. Many different companies make archival paper (two favorites of mine are Hahnemuhle and Moab Papers), and the paper from most good inkjet paper manufacturers is archival.

 tip

To learn more about the archival nature of your favorite papers, visit the Wilhelm Imaging Research Web site (www.wilhelm-research.com), which is the preeminent site for learning about the archival nature of papers and inks.

It is important to let inkjet prints air dry for 24 hours before framing or storing them. After drying, it is good to use a spray sealer, such as the Hahnemuhle Fine Art Protective Spray, to harden the ink onto the paper and add UV resistance. You can store the prints in polyester sleeves or separate them with acid free tissue paper in acid free boxes.

Storing the digital files is another issue. Large, high resolution files will take up space on a hard drive quickly, so for your photographic work, make sure that your images are stored on a separate hard drive from your everyday computer projects. This allows you to operate each easily. Making sure that you have your images backed up to another hard drive that is a mirror image of the first drive is the best way to make sure that you do not lose an image. You may keep this hard drive off site, or keep a back-up drive in a fireproof safe and back it up frequently. Burning hard copies to DVD is another great way to keep copies of image data, but DVDs do not have the longevity a hard drive does.

If you take away one recommendation from here, it is simply this: Make sure that you have a back-up copy of your images. Beyond that, it's also important to have a good naming and organizing convention that you stick to, with appropriate keywords and dates. This makes retrieving images much easier. Rarely does a disaster happen, but being prepared makes it much less traumatic and time-consuming if it does.

DIGITAL OUTPUT OPTIONS AND IDEAS

In the digital age, photographers simply don't create as many prints of their work as they used to. Now that every image is easily viewable, making many prints to get just one optimal one is practically pointless. So how do you share your black-and-white images online?

CREATING DIGITAL CONTACT SHEETS

Using only a few steps beyond those you used to create the contact sheet discussed earlier in this chapter, you can create a digital version of the

contact sheet. To create the layered contact sheet document in Photoshop or Elements, follow these steps:

1. **Run the Contact sheet program.**

2. **Choose Layer from the menu.**

3. **Choose Flatten from the drop-down list that appears.** This is a step that you cannot undo, so make sure that you save your contact sheet as a layered document such as a TIFF or PSD if needed before you flatten the image.

4. **After the image is flattened, save the contact as a JPEG or even a PDF for easy reference, for printing, or to send to others later.**

5. **Make sure to keep these digital contact sheets with the rest of the images from that shoot.**

BUILDING WEB GALLERIES

A Web gallery is the online version of a digital contact sheet. You can also easily create one in Lightroom or Photoshop Elements:

1. **Select your favorite images.**

2. **Click the Web module in Lightroom or the Create module in Photoshop Elements.**

3. **Choose from a few basic templates in both Flash and HTML.** Additionally, you can download other templates that provide additional Web gallery functionality to Lightroom.

4. **You can customize every element of the Web gallery in both programs.** Whether you want a clean and simple look like I use in my Web galleries (see 10-14) or want to add some drama and wild colors, you can individually adjust everything from the text and numbers to the background and gridlines.

ABOUT THIS IMAGE
This is an example of the Web gallery module with a selection of images from this book ready to be exported in the same very white template as the rest of my Web galleries. Using the same template keeps my layouts consistent and allows me to update my Web site easily.

10-14

5. **You can vary the size of the large image and add a title to each image for reference later.** The title can be any number of things, from the filename or the date to the camera and lens used for that image (see 10-15).

6. **Consider adding a digital watermark to your image so that others cannot easily use them without your permission (see 10-16).**

One last great thing about creating Web galleries is that they are portable. Because they can be viewed with any Web browser, you can show your photos to anyone anywhere without any fuss, and they are already condensed into a good size for viewing. Once you have built your gallery, follow these steps to save images there:

10-15

ABOUT THIS IMAGE *The drop-down menu shows just how many different options are available in the Web gallery module. Using the filename is great so that you know exactly which image you are looking at, but if you were doing a series of images, the date might be even more important.*

266

1. **Click Export (see 10-17).** A Save As window opens.

2. **Select the correct place to save your new Web gallery.** It automatically saves as its own new folder.

3. **Type in a name for that Web gallery that is simple and makes sense.**

Once the Web gallery is processed and saved, you can take that folder wherever you want. Simply open the folder and click on the index and the entire gallery opens up in the computer's default Web browser. You don't have to put your Web gallery on the Web; it is simply in a form that a Web browser understands. By compressing it into a Zip file, you can e-mail it, place it on a flash

10-16

ABOUT THIS IMAGE *The watermark shown at the bottom of each image in the gallery has my name, a copyright symbol, and the year. If you don't use a watermark, at least fill out the copyright info in the image metadata when you import your images into the computer.*

10-17

ABOUT THIS IMAGE *After choosing where you'll export your files to, what their names will be, and their appropriate formats, click Export to send your gallery on its way.*

drive to share, or use it as it is designed to be used, uploading it to your server so that it can be viewed on your Web site.

As you are building your Web galleries, remember that keeping your backgrounds simple in tone (white, gray, or black) shows the beauty of your

black-and-white images best. Colored backgrounds may cause your black-and-white images to appear as though there is a slightly colored tone on your black-and-white images. If you need to use a color, more muted colors may be better.

SHARING IMAGES ONLINE

Many of the newest image-editing programs have online interconnectivity to the most popular image-sharing sites like www.photoworkshop.com and popular social networking sites. This enables you to work on your black-and-white images and immediately publish them online. These are accessible through Lightroom, Aperture, iPhoto, and Windows Live Photo Gallery. Remember that when you export images for online use, use sRGB as your color space to maintain the correct tonal range with your black-and-white images, especially if you have been working with your images in ProPhoto RGB.

Remember to watermark your images before you put them online, and at the very least add your own copyright information to the photograph. You can do this in Bridge easily, and also in the Import module of Lightroom:

1. **Open the Apply During Import pane.** There is a metadata drop-down menu.

2. **Choose New.**

3. **Put your basic copyright information and contact information into the form that appears.**

4. **Save this form as a new metadata template (see 10-18).** Now, every time you upload new photos, your information is automatically added to the photographs.

10-18

ABOUT THIS IMAGE *The Edit Metadata Presets template in Lightroom enables you to add all your contact information onto every new image that comes into your system, so that if you are sharing your black-and-white images online, people will know whose they are.*

Be proud of your black-and-white photographs and share them with as many people as you can. When you use the photo-sharing Web sites and social media, it is easy to get feedback on your images.

With your own Web galleries, remember that it is all about the image. Make sure that the focus is the photograph, and don't spend your time making a fussy or distracting site that is so complicated that people don't want to look through your images. Simplicity is the key for both the display and navigation of a good photo Web site.

Assignment

Print a Masterpiece

Once you have a printer and have set it up, make sure to download the paper's profile from the manufacturer's Web site and install it as they direct. When your image is complete, get ready to press the Print button. Find an image that you have created that speaks to you.

Whether that image is a portrait, a landscape, or a street scene, share your vision with the people around you — your family, friends, and co-workers — and show them the work you have been doing and your passion for black-and-white images. This image is a particular favorite of mine: The coach's expression is one of great compassion, while the look of the young boxer can be interpreted in so many ways that I keep looking into the eyes of the boy at that moment in time to learn more about what happens in their lives in that next round.

This image was taken at a boxing match in a dark gym lit by halogen work lights. I had visualized the image as a black and white from the beginning and shot it at ISO 4000, f/2.8, 1/250 second with a 70-200mm zoom lens set to 150mm. The final print of this image is 40 × 40 inches, is framed with a simple steel frame, and has been displayed in a number of galleries and museums.

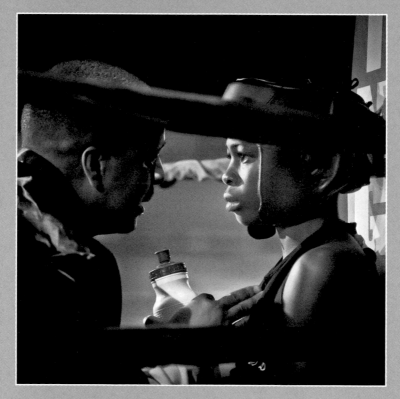

Remember to visit www.pwassignments.com after you complete this assignment and share your favorite photo! It's a community of enthusiastic photographers and a great place to view what other readers have created. You can also post comments, read encouraging suggestions, and get feedback.

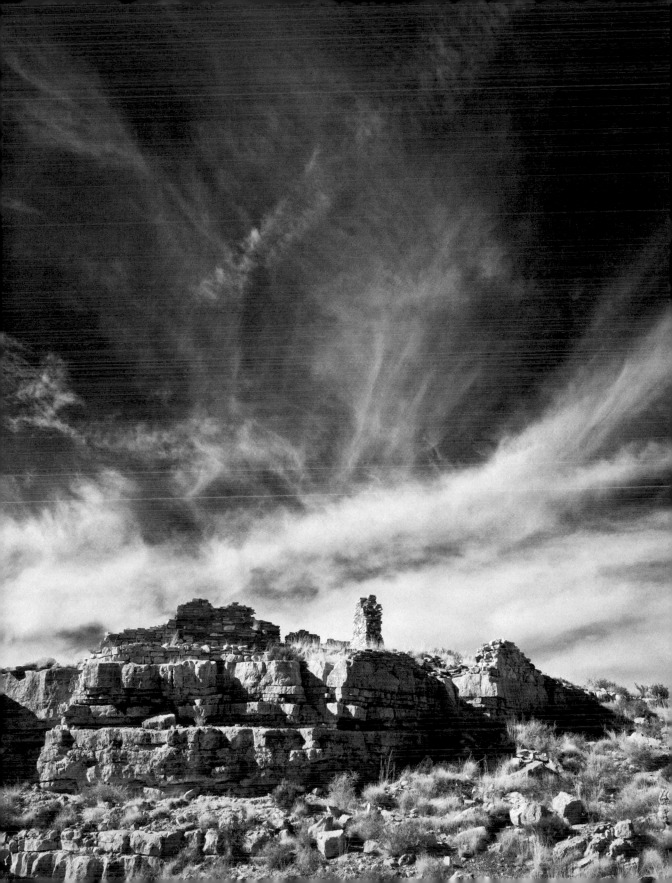

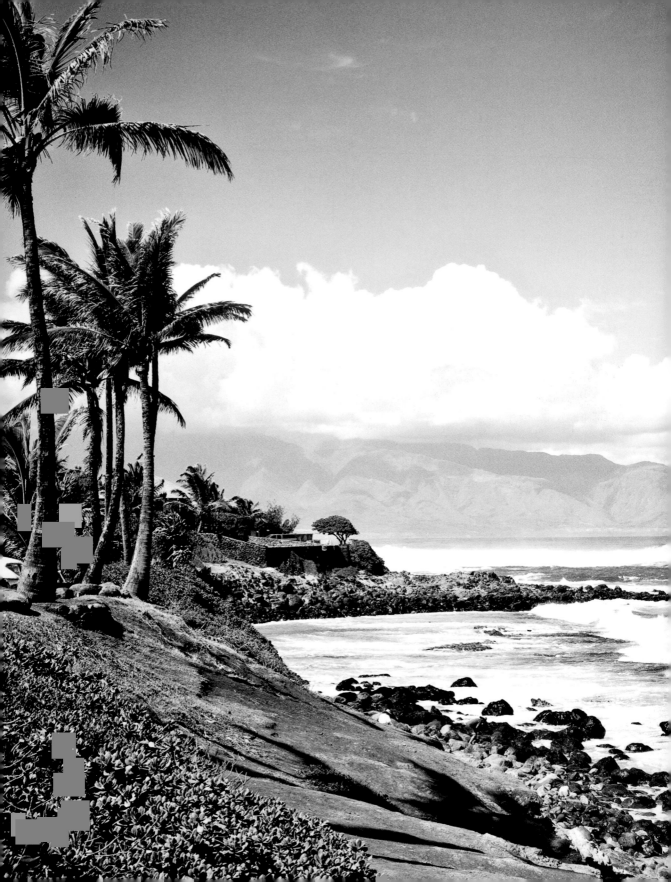

GLOSSARY

ambrotype An early photographic technique used with glass plates that gives the image a very dark brown tone.

aperture The opening in a moving diaphragm within the barrel of the lens. The aperture controls how much light passes through the lens and into the camera.

Aperture Priority In Aperture Priority mode (A or Av), the photographer selects the aperture desired and the camera automatically sets the shutter speed as needed.

archival A term used to describe the long-term stability of a photograph, or elements of that image such as the inks or the paper.

backlighting When light is behind the subject, with the direction of the light coming into the camera.

bit depth The number of bits representing a color in a single pixel.

bracketing A way to create multiple and different exposures of a single scene. One image at normal exposure, one image underexposed by 1 f-stop, and one image overexposed by 1 f-stop creates a 3-stop bracket. Bracketing can be used to make sure there is one good exposure out of three (or more), or can be used to blend multiple different exposures to expand the contrast range.

brightness The amount of light intensity in an image.

burning The process of darkening a portion of a photograph. In image editing, this is done with the Burning tool.

color gamut The number of potential colors that can be reproduced in a photograph, whether it is output on a screen or paper.

color groups Similar colors in a photograph whose luminance can be adjusted in a black-and-white photograph all together; for example, the blue color group can be lightened while the red color group can be darkened.

color temperature The color of light is measured in Kelvin (K), named after nineteenth-century physicist William Thomson, 1st Baron Kelvin. The Kelvin unit is based on energy absolutes; therefore, 0K is the temperature at which all energy is lost. To put this in perspective, 0K is the equivalent of −459.69°F. In the light spectrum, 5500K is white, and higher color temperatures are blue and are cooler in appearance; lower temperature colors, like yellow, orange, and red, are warmer in appearance.

compact digital A point-and-shoot–style digital camera that is usually small enough to put into a pocket, and includes a built-in lens.

composite Multiple exposures or multiple photographs put together to create one single image.

contrast The difference in tones between darkness and light. A high-contrast image contains mostly black and white, while a low contrast image contains mostly tones of gray.

contrast range The ratio between the darkness of shadows and the white of the highlights.

curves An image-editing tool that stretches or bends the amount of and type of tones in the image. Can be used with multiple gray points along the graph of the image tones.

depth of field The portion of the image that has apparent sharpness; the distance in front of and behind the actual focus point in an image that appears to be in focus.

diffused light Light that is scattered somewhat, giving an image a softer appearance, with shadows that have soft edges. Light can be scattered because of fog or a cloud cover, or a translucent fabric.

dodging The process of lightening a selected area of a photograph. In image editing, this is done with the Dodging tool.

dSLR Digital Single Lens Reflex. Cameras with interchangeable lenses that handle both the image-composition process and the exposure process.

dynamic range The difference between the darkest tonal values and the lightest tonal values in a photograph.

exposure The amount of light hitting the digital sensor, and the camera settings used to control the incoming light.

field of view The angle of view that is seen by the lens, usually measured horizontally across the scene. A normal lens has a roughly 45 degree field of view.

fill light Light used to brighten areas of shadow without overwhelming the shadow areas. Sometimes just called *fill*. Can be created with a reflector or a light source.

film simulations The technique of using different color response, grain, and contrast to emulate a particular black-and-white film type.

filters Pieces of glass or optical resin that you place in front of the lens to affect the image in the camera. Filters can also be applied digitally to achieve photographic effects.

flash sync speed The fastest shutter speed at which the flash can fire and still capture a complete image. In most cases, the fastest shutter speed that can be used with a strobe is around 1/125 or 1/250 second, but consult the owner's manual to make certain. Digital cameras with

built-in flashes and dedicated accessory flashes generally do not fire if the exposure is incorrect for their operation.

focal length The distance from the optical center of a lens to the digital sensor or film plane. It directly correlates to the field of view.

front light When the light shines onto the subject from the front. The light comes from behind the camera.

f-stop The numeric designation of the aperture size of a photographic lens. The smaller the f-stop number, the larger the aperture. The higher the f-stop number, the smaller the aperture.

gradation The smooth transition of one tone into another.

graduated neutral density filter The bottom of this filter is clear, the top is a neutral gray, and the middle is a smooth gradation between the two. The gray part, the neutral density, simply lets less light in. This filter is used to darken a bright sky, bringing the exposure closer to that of a shaded foreground. Graduated filters can also be digitally reproduced. Immensely helpful in landscape photography, particularly during sunrise and sunset shots.

HDR High Dynamic Range. The technique of using multiple exposures to expand the contrast range of an image to pull out details from areas of the scene that would ordinarily be too dark or too light to be seen properly in a photograph.

high key Lighting with a white or light-colored subject in front of a white or light-colored background.

histogram The graphic representation of the distribution of different tones (displayed as pixel bars) in a photograph. The horizontal axis shows the dark tones on the left side of the graph and gradates to the light tones on the right side.

inkjet A type of digital printing where inks are sprayed onto a paper or other substrate. Droplets of variable sizes and colors combine to create a photographic image.

ISO International Organization for Standardization. The organization that sets international and commercial standards. In digital photography, the ISO is the measure of the digital sensor's light sensitivity. Digital sensitivity correlates to film speed in traditional cameras.

JPEG Joint Photographic Experts Group. JPEGs are compressed image files (the file extension is .jpg) and are considered *lossy* because they get rid of some of the image data according to specific parameters when they are compressed, and they use advanced algorithms to decompress, or open, the files.

layer A copy of an image on which certain elements can be adjusted independently from other elements of the same photograph during image editing.

Lensbaby A special purpose or special effects lens for a dSLR that utilizes a flexible lens barrel for unique visual effects in photography.

Levels A tool in Photoshop that effectively moves and stretches the brightness levels in a photograph. It specifies points of black, white, and gray in an image.

low key An image containing a lot of contrast and drama. Usually, but not always, this entails a darker subject over a darker background. In a low-key image, the light on the subject is more of a dramatic sidelight or backlight.

luminance The level of brightness of a particular gray tone. When discussing color, luminance is the brightness without regard for the color's saturation or hue.

m4/3 A Micro 4/3 camera, a standard created by Panasonic and Olympus for SLR–style cameras, but without the mirror; instead, an electronic viewfinder is used to compose the image. The image size is approximately one-half that of a 35mm film image. This allows for a much smaller camera than a standard dSLR, while providing image quality that is much better than that of a standard compact digital.

macro photography When the image on the sensor is equal to or bigger than the subject that is being photographed. The ratio of 1:1 means image size on the sensor is equal to the subject size. Getting closer would make the ratio of the image to the subject 2:1, meaning the image is twice as big as the subject. As the ratio goes up, the size of the image on the sensor increases, getting ever closer to the subject.

mask A grayscale template that is used in image-editing software that allows for some parts of an image to be affected by change while other parts are protected.

medium format A type of camera that uses 120- or 220-sized film. Called medium because it is between a compact 35mm format and the format of large 4×5–inch sheet film cameras.

metering Measures different parts of a scene (depending on the meter chosen) and computes or averages the exposure of the scene.

midtone The gray tones in an image that are approximately medium gray on a scale from black to white.

noise The unwanted electronic dots of color that occur from electrical signals that are not part of the image.

pixel Short for PICture ELement. These are the smallest contributing parts of the digital photographic image.

plug-in Third-party image-editing software that is installed within a larger program to expand and enhance its capabilities.

polarizing filter Used for taming reflections and glare on glass, water, and foliage. It can also darken the sky and increase color saturation. The polarizer does all this by aligning light waves as they come into the lens so that they come in from only one direction. No other filter can do these things.

RAW The proprietary files of each camera manufacturer. They contain all the data of the image photographed.

reflector Some sort of reflective material that is used to reflect light back into the shadow areas of a photograph.

resolution The amount of detail in a photograph, measured by the amount of pixels per inch (ppi) or dots per inch (dpi).

sepia A photographic effect to give the image a warm, brownish tone, often making it look antique.

Shutter Priority Shutter Priority mode (S or Tv) allows the photographer to select a shutter speed while the camera automatically selects aperture to get the correct exposure.

shutter speed The speed at which your camera's shutter opens and closes just in front of the digital sensor, allowing light in for only as much time as needed to create the exposure. With each full change of the shutter dial, the shutter is open for twice as long or half as long. Shutter speeds can be as slow as many hours, but in most real-world photography, the shutter is open for just a fraction of a second. For example, a standard daylight exposure might be ISO 100, f/11, and 1/125 second.

sidelight Light that comes across the subject that uses the difference of light and shadow to accentuate the texture of the subject. Also called *cross light*.

SLR Single Lens Reflex. The light from the image comes through the lens and bounces off a mirror in front of the shutter into the viewfinder until the shutter release is pressed. At that time, the mirror flips up; the shutter opens, exposing the digital sensor and then closes; and the mirror flips back down.

spot meter Allows you to select a very small part of the scene and find the exposure for just that area. This technique is particularly useful when you need to find the exposure of your subject and it is surrounded by large amounts of light or dark.

TIFF Tagged Image File Format. An uncompressed file format (its file extension is .tif) for high-resolution images. TIFFs can be used with layers and in multiple bit depths, and are most often used in printing.

tone The visual attitude of the image, or the actual shade of gray or color in a photograph.

TTL Through The Lens. A type of metering for both ambient and flash exposures. TTL metering uses a meter inside the camera to measure the light after it passes through the lens. It provides very accurate metering and is a feature on virtually every dSLR.

white balance The colorcast of an image. The White Balance function of the camera optimizes the color of the image to ensure that white objects in the photo appear as a true white. It does this by compensating for the differences in the color temperatures of different light sources.

continued

continued

continued

continued

RAW files *(continued)*
 vs. JPEG, 169–171
 maximizing, 171
 purpose of, 75
 shooting concurrently with JPEG, 76–77
 white balance, 53
red filters, 80–81
reflectors, 113–115, 277
resolution, 277
retouching images. *See* editing images
rule of thirds, 56

S

S (Shutter Priority mode)
 definition, 277
 description, 67–68
selenium toning, 234–235
sepia toning, 233–234, 277
settings. *See* camera settings
shade, lighting, 115–116
shadow tones, blocked up, 38
shadows
 contrast, 149–151
 editing, 209–210
 illusion of depth, 160
shape, in composition, 57
sharing images online, 269
sharpening filters, 220
shutter speed. *See also* high-speed photography
 blur, 47–48
 definition, 277
 interaction with ISO rating and aperture, 52
 stopping action, 47–48
sidecar files, 175
sidelight
 definition, 277
 description, 104–106
 light quality, 154
silhouettes, exposure compensation, 40–41
Silver Efex Pro, 167
simplicity, in composition, 57
simulating old photographs
 adding softness, 230–231
 contrast, 230
 depth of field, 230–231
 film simulation, 222–223, 275
 selenium toning, 234–235
 sepia toning, 233–234
 split toning, 235–237
 tinting, 233–235
 tone, 231–232, 233–235
 wet-plate processes, 231
skies, darkening, 168
SLR (Single Lens Reflex), 277

smoothing gradations, 152
snow, 34–35, 157–158
soft light, 110, 151–152
soft-focus blur lenses, 128–130
softness, simulating old photographs, 230–231
software. *See* RAW conversion tools; *specific programs*
special effects
 camera phones, 131–132
 coloring black-and-white images, 220–222, 237
 film grain, 210
 infrared, 238–240
 selective
 brightness, 222
 coloring black-and-white images, 220–222
 contrast, 222
 Edit Pins, 218–220
 sharpening, 220
 tones, 218–220
 simulating old photographs
 adding softness, 230–231
 contrast, 230
 depth of field, 230–231
 film simulation, 222–223, 275
 selenium toning, 234–235
 sepia toning, 233–234
 split toning, 235–237
 tinting, 233–235
 tone, 231–232, 233–235
 wet-plate processes, 231
Speedlights, 137
Speedlites, 137
spherical aberration, 129
split toning, 235–237
spot editing, 190–191
spot meters, 101–102, 277
stepping down the aperture, 45
still lifes, camera settings, 87
stopping action, 47–48, 67–68
storing digital images, 11, 224
street photography, camera settings, 88–89
strobes, 136–140
sunlight, white balance, 53
Superfine compression ratio, 75
symmetry, in composition, 56

T

Through The Lens (TTL) metering, 277
TIF files, 75
TIFF (Tagged Image File Format), 277
time of day, light quality, 156
timing the moment
 under cloudy skies, 14–15
 decisive moment, 11–12
 for moving subjects, 12–14

Develop your talent.

Go behind the lens with Wiley's Photo Workshop series, and learn how to shoot great photos from the start. Each full-color book provides clear instructions, sample photos, and end-of-chapter assignments that you can upload to pwsbooks.com for input from others.

978-0-470-11433-9	978-0-470-11876-4	978-0-470-11436-0
978-0-470-14785-6	978-0-470-11435-3	978-0-470-11955-6
978-0-470-421932		
978-0-470-11434-6	978-0-470-41299-2	978-0-470-11432-2
978-0-470-40521-5		

For a complete list of Photo Workshop books, visit photoworkshop.com — the online resource committed to providing an education in photography, where the quest for knowledge is fueled by inspiration.

Available wherever books are sold.

WILEY

Now you know.